Marco Livingstone
graduated from the University of Toronto in 1974
and was later awarded an MA at the Courtauld Institute
of Art, London. He was Assistant Keeper of British Art at the
Walker Art Gallery in Liverpool from 1976 to 1982 and
Deputy Director of the Museum of Modern Art, Oxford,
until 1986. From 1986 to 1991 he was Deputy Editor of the
Macmillan Dictionary of Art, with responsibility for the
19th- and 20th-century entries. He has organized touring
retrospectives of David Hockney as well as Patrick Caulfield,
Jim Dine, Allen Jones, Peter Phillips and Tom Wesselmann,
and a comprehensive survey exhibition of Pop Art for the
Royal Academy of Arts in 1991. His publications include
extended catalogues for these exhibitions, *Pop Art: A
Continuing History*, a monograph on R.B. Kitaj and various
other books published by Thames and Hudson, including
*David Hockney Faces, David Hockney: Etchings and
Lithographs* and *Arthur Tress: Talisman*.

WORLD OF ART

This famous series
provides the widest available
range of illustrated books on art in all its aspects.
If you would like to receive a complete list
of titles in print please write to:
THAMES AND HUDSON
30 Bloomsbury Street, London WC1B 3QP
In the United States please write to:
THAMES AND HUDSON INC.
500 Fifth Avenue, New York, New York 10110

Printed in Singapore

Marco Livingstone

DAVID HOCKNEY

208 illustrations, 81 in color

New enlarged edition

Thames and Hudson

To my sister Alexa

© 1981, 1987 and 1996 Thames and Hudson Ltd, London

First paperback edition 1981
Revised edition 1987
New enlarged edition 1996

This edition published in the United States of America in
1996 by Thames and Hudson Inc., 500 Fifth Avenue,
New York, New York 10110

Library of Congress Catalog Card Number 95-61697
ISBN 0-500-20291-5

Printed and bound in Singapore

Contents

Preface

Bearing in mind Hockney's view that an artist must be judged by what he does rather than by what he says, it must nevertheless be admitted that the present study owes much to his generous compliance in responding to my endless lists of questions. Unless otherwise stated, all quotations have been drawn from this series of interviews, held in Los Angeles between 22 April and 7 May 1980 and in London on 6 and 7 July of the same year. My first thanks, therefore, go to Hockney himself, not only for his patience but also for the forthrightness and clarity of his remarks and for giving so freely of his time to this project.

My research was greatly facilitated by the helpfulness and efficiency of a number of people close to the artist; I should like to thank them all. John Kasmin and his assistants Ruth Kelsey and Maria Holguin of Kasmin Ltd kindly allowed me access to their photographic records and files of press cuttings. Paul Cornwall-Jones and his paper-restorer David Graves of Petersburg Press made available their extensive photographic files of unpublished drawings, and arranged studio visits in the artist's absence. Hockney's assistant Gregory Evans patiently acted as a go-between and offered useful insights into the circumstances under which Hockney's work is made. I am grateful to all those who have given me permission to quote from published and unpublished sources. Charles Ingham, who was engaged in doctoral research at the University of Essex, generously gave me the opportunity to read his unpublished interviews with the artist and with Mark Berger and Larry Rivers. A special word of thanks goes to Geoff Greenhalgh for his helpful comments on the text and also for his stimulating discussions about opera and stage design.

The opportunity to bring this study up to date for a second time, fourteen years after its original publication, has been a very welcome one. As with the 1987 revised edition, I have avoided the temptation to make any substantial changes even in those cases where I would now make a different assessment of particular works or phases of Hockney's development; my criticisms of the naturalistic paintings of

the late 1960s and early 1970s now seem to me unduly harsh, for example, notwithstanding the fact that the evolution of Hockney's art since the early 1980s bears out his own dissatisfaction with that particular form at the time that this book was first published. Thanks to the consistent and thoughtful nature of the artist's long-term project – especially as revealed in the remarks quoted from our conversations in 1980, which relate so vividly to his subsequent work – I am pleased to discover that I can still stand by most of what I wrote in the text published in 1981.

For this new edition I have provided a separate chapter on Hockney's most recent work, incorporating within it text written for the 1987 edition, and have also updated the bibliography and the information in the list of illustrations. While it has been possible here only to touch on the variety and prolific production of Hockney's art since the late 1980s, I hope that these changes and additions will help bring the story up to the present.

Marco Livingstone 1981 and 1995

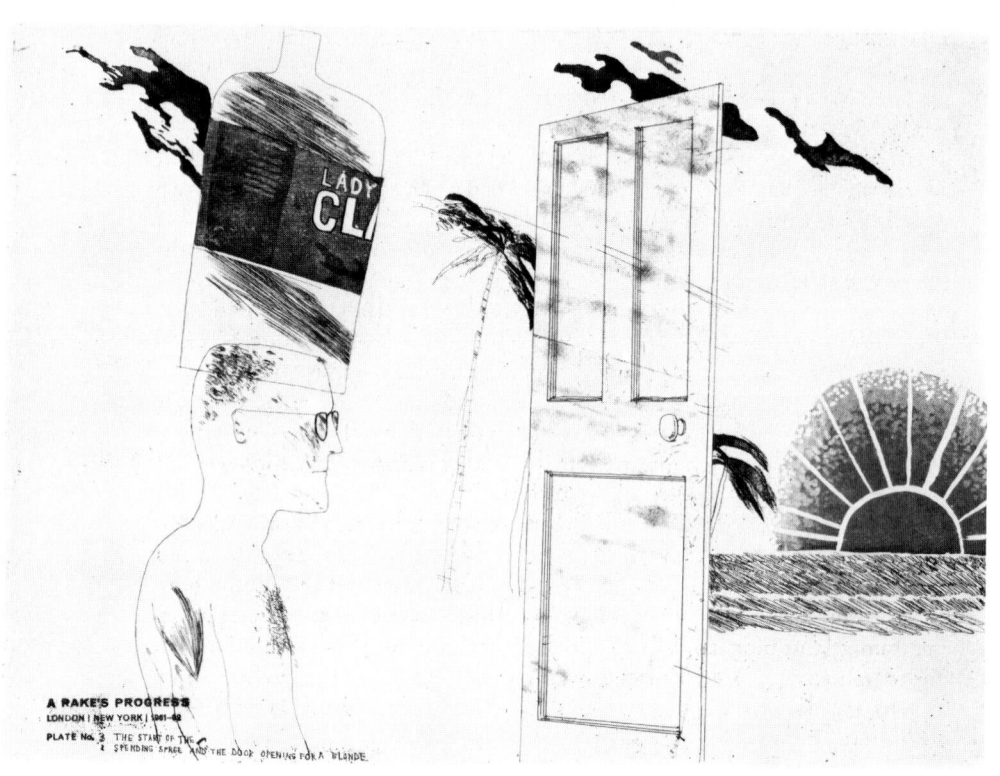

1 *A Rake's Progress: The Start of the Spending Spree and the Door Opening for a Blonde*, 1961–63

1 Demonstrations of Versatility

David Hockney has commanded greater popular acclaim than any other British artist of this century. Born in Bradford, Yorkshire, in 1937, he had acquired a national reputation by the time he left London's Royal College of Art with the gold medal for his year in 1962. The artists with whom he was associated at the College, notably R.B. Kitaj, Allen Jones, Peter Phillips, Derek Boshier and Patrick Caulfield, heralded by the press as the young stars of British Pop Art, all enjoyed early success, but Hockney from the start was in a category of his own. In 1961 he was awarded a prize for etching at the 'Graven Image' exhibition in London, as well as a painting prize at the John Moores Liverpool Exhibition. Before finishing his studies he had already been approached by a Bond Street dealer, John Kasmin, with whom he had his first one-man show in 1963, aged only twenty-six. In 1967 he was awarded first prize in the John Moores Exhibition, and three years later he was honoured with the first of several major retrospectives which have established his reputation internationally. His works now fetch higher prices than those of almost any living British artist.

It is doubtful whether any British artist since the Second World War has attracted so much newspaper coverage and been the subject of so many interviews. A number of substantial catalogues and specialized studies have been produced about his work. Hockney himself has published two volumes combining autobiography with theory (1976 and 1993), a picture book in paperback (1979), and monographs devoted to his *Paper Pools* series (1980) and to his trip to China (1982), all originating with the same British publisher, Thames and Hudson.

The publication of the present study might be regarded as yet another instance of the way in which the Hockney promotional enterprise has been fed. Surprisingly, however, for an artist who has been the centre of so much attention, this is the first critical study of his work. In view of the public's interest in Hockney's art, one can legitimately ask why no other book, nor even any substantial articles, appeared until well into the 1980s. Was it that Hockney was acceptable only as a social phenomenon rather than as a serious artist? Did other writers and publishers consider that their reputation might be discredited if they concerned themselves with his work?

Since the time of Courbet and increasingly during our own century, the committed artist has been considered to be in opposition to the taste of his time. In his essay on *The Dehumanization of Art* (1925), José Ortega y Gasset proposed the view, now widely accepted in the art world, that serious new art is not only unpopular but essentially 'anti-popular'. In these terms, serious achievement in art is measured in inverse proportion to its popularity, for the two have been defined as incompatible.

Hockney's work appeals to a great many people who might otherwise display little interest in art. It may be that they are attracted to it because it is figurative and, therefore, easily accessible on one level, or because the subject-matter of leisure and exoticism provides an escape from the mundanities of everyday life. Perhaps it is not even the art that interests some people, but Hockney's engaging personality and the verbal wit that makes him such good copy for the newspapers. He may, in other words, be popular for the wrong reasons. But does this negate the possibility that his art has a serious sense of purpose?

In the view of some respected critics, such as Douglas Cooper, Hockney is nothing more than an overrated minor artist. To this one can counter that Hockney might seem minor because it is unacceptable today to be so popular, rather than because his work is lacking in substance. Hockney himself is not self-deluding; he is aware of his limitations and thinks that it is beside the point to dismiss his work because it does not measure up to an abstract concept of greatness. Hockney does not claim to be a great artist and is aware that only posterity can form a final judgment on his stature.

It has been said that Hockney's work is shallow because of the life he leads and the people with whom he surrounds himself. Hockney is aware of this charge but finds it incomprehensible: 'I know some people think one leads a glamorous life, but I must admit I've never felt that myself. Even when you're sat here in Hollywood with a swimming pool out there, I still feel my life is just as a working artist, actually. That's the way I see it.' He feels no particular need to demonstrate his cultural credentials or political awareness in his work, although he is extremely well informed not only about current events but also about literature, music and the arts generally. The accusation that his world view is vacuous and circumscribed is based primarily on the *125, 129* drawings which he has produced in luxury hotels on his travels round the globe. It would be highly misleading, however, to base one's estimation of Hockney's art on such drawings, which he himself regards as a pastime peripheral to his main concerns. It is not unusual for an artist today to travel or to stay in luxury hotels, but Hockney is rare in spending his quiet moments drawing, through his very devotion to the activity. It would be wrong to condemn him for wanting to produce art in most of his waking hours.

Perhaps the most serious criticism of Hockney as an artist is that he makes superficial gestures towards Modernism as an illustrator would, rather than committing himself fully to a Modernist approach. Hockney recognizes the extent to which his own work has been conditioned by Modernism, which he regards as 'one of the golden ages of art', but takes issue with what he regards as the academicism of what is known as Late Modernist art. It may be that Hockney is trying to reconcile two things which in our own day would seem to be irreconcilable: serious aesthetic intentions and ease of communication with people outside the art world. It is a dangerous task, but one that is worth pursuing if the artist is to retrieve his position as a working member of society at a time when his isolation has reached an almost intolerable level.

Hockney's popularity and commercial success, even if they have not destroyed his integrity, have nevertheless proved an inhibiting force. 'There comes a point where you see it all as completely empty,' says Hockney, 'being a popular artist to the extent that people who are not necessarily interested in art know about things or take some little interest. I think that now for me it's a burden. It's a bit hard to deal with, and it wastes time as well.' It is partly to escape the public glare that Hockney feels compelled to keep changing his country of residence, moving each time that he finds the social pressures have become too difficult to bear. Inevitably his work charts the path of his life, not only from place to place but also as a withdrawal into a private world populated mainly by close friends.

Hockney, of course, is not wholly blameless for the situation in which he finds himself. His decision to dye his hair blond during his visit to New York in 1961, for instance, is indicative of his desire to be noticed both as a person and as an artist. He 'reinvented' himself, to use his own term, in a sense making himself the trademark with which to market his work.

The confusion between man and work implied in the personal act of dyeing his hair is not altogether inappropriate, since to an unusual degree Hockney has consistently based his art directly on his experiences and on his relationships with other people. To dwell on biographical details, however, would be to promote further the serious misrepresentation of Hockney as a colourful personality rather than as a committed artist. As one of those rare painters who is as well known for who he is as for what he has achieved, he has suffered in terms of credibility in that his social role has tended until now to obscure the importance of the art. The popular appeal and easy seductiveness of that art have likewise masked its sense of purpose. It is necessary to redress the balance.

Hockney's astonishing self-confidence, nevertheless, provides a key to understanding his development. The bravado is evident in the generic title of

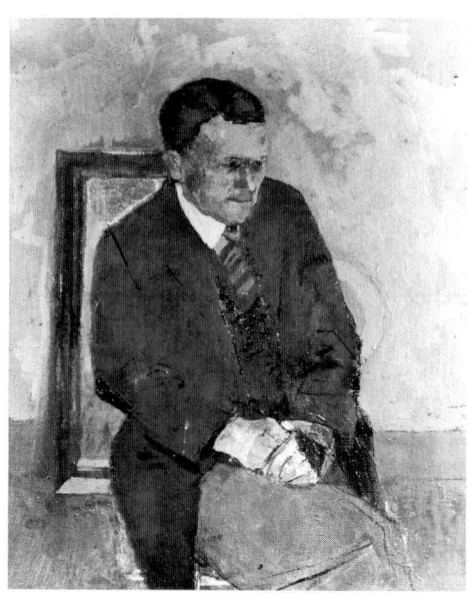

2 *Portrait of My Father*, 1955

24, 25
36, 38 his last student paintings, exhibited as a group in the 1962 'Young Contemporaries' exhibition in London: *Demonstrations of Versatility*. It is a phrase, however, which also reveals the paradoxical coherence of his work at that time. In these pictures Hockney insisted that any style could be chosen at will, that any form of representation, any type of image, any subject or theme was fit material for a picture. Like some of his colleagues at the Royal College of Art, Hockney was in search of a 'marriage of styles' that would free him from the limitations of any one way of picturing the world.

Unlike the change of Hockney's hair colour, the declaration of freedom and detachment in his art was not achieved overnight. His decision to play with style was conditioned to a large degree by his own earlier history and training. It was because he had already experienced the strait-jacket of subservience to particular styles that he especially welcomed the prospect of emancipation through the deployment of contradictory modes.

As a teenager in the mid to late 1950s, Hockney, like many art students, experimented with various ways of making pictures, seeking a single workable process but ending, through restlessness and changes of heart, with a diverse and apparently contradictory body of work. At Bradford School of Art from 1953 to 1957 Hockney received a traditional training which inculcated a respect for close observation from life, for subdued handling of paint surface and colour, and for drawing as the essential process for

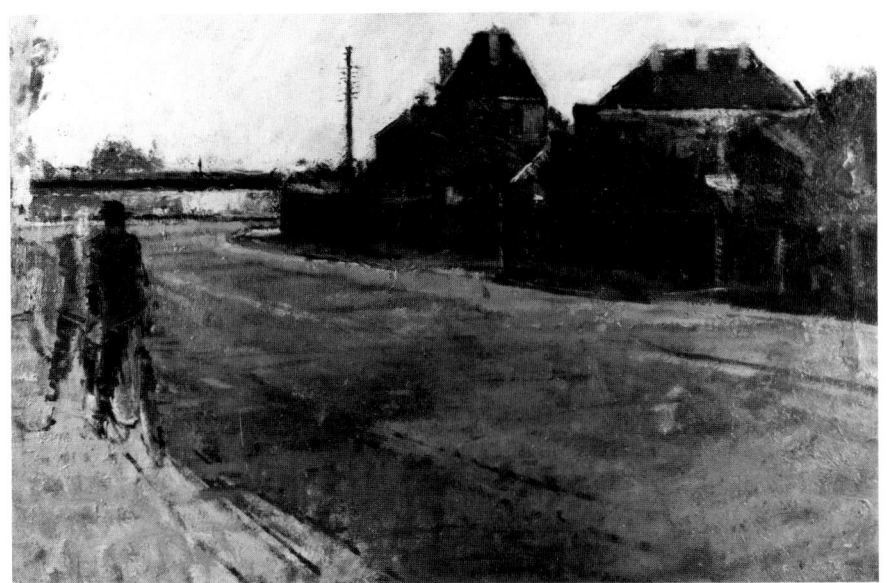

3 Moorside Road, Fagley, 1955–56

transferring perceived sensations to canvas. The works made at this time betray an unfailing devotion to the motif, whether this be a cityscape of his native town or a portrait from life.

2, 3

The task underlying all of Hockney's Bradford pictures is that of finding an equivalent in paint for what the eye can see. In the best of these pictures, notably the 1955 portrait of his father, elegant and accurate draughtsmanship is the essential ingredient in the construction of the picture. Paint is merely a vehicle for the conveyance of an image. Variations in the application of the paint, generally thinly applied, add surface interest, but colour is subdued in order to emphasize the subtlety of tonal variation. This method of working, as well as the insistence on finding all suitable subjects in one's daily life and immediate environment, owes much to the teaching practices established in the 1930s by the so-called Euston Road artists such as William Coldstream, Victor Pasmore and Claude Rogers. Walter Sickert and Edgar Degas were the most modern painters held up as models at provincial schools such as Bradford, and training was based firmly on the traditional academic practice of drawing from life, an activity which greatly appealed to Hockney from the beginning and which he regards as vital to all his later work. To Hockney, drawing has always been a means of learning how to look, as well as a method of making marks in which the immediacy of the image takes precedence over self-consciousness of style.

4 ALAN DAVIE *Discovery of the Staff*, 1957

Hockney appears at the time to have taken the Euston Road approach for granted, simply because in a town like Bradford in the 1950s there was little opportunity for studying contemporary art, and no clear alternatives were immediately available. It was primarily through reproductions in books that other paintings could be seen. Inevitably his awareness was bound to be limited mostly to the work of recognized earlier masters, and then only as something quite remote from his own immediate experience at art school, and to established contemporary figures such as Stanley Spencer.

The exhibition held in 1958 at Wakefield of the work of Alan Davie, recently a Gregory Fellow at Leeds, struck him as a revelation and increased his appetite for modern art. He seems to have realized at once that he had been a slave to a style which was only one of many possible approaches. Paintings by Davie such as *Discovery of the Staff*, 1957, were influenced by American Abstract Expressionism (at that time still little known in Britain outside the capital) and particularly by Jackson Pollock, and consisted of a pared-down imagery of archetypes which to Hockney appeared to be essentially abstract. Here was Modernism as a living alternative to the kind of art he was being taught to make. Instead of

working from the motif and emphasizing the image as the essential fact, one could take a completely opposite approach, inventing images from the imagination and concentrating on the accumulation of paint on canvas as the immediate reality for conveying sensation to the viewer. A painting, he now recognized, need not be a passive receiver of information about the visible world, but may adopt a far more aggressive role in providing the actual impetus to the viewer's experience.

Hockney had no real opportunity to paint during his two years as a conscientious objector in the National Service, from 1957 to 1959, which he spent working in hospitals at Bradford and Hastings. When he took up his brushes again as a post-graduate student at the Royal College of Art in the autumn of 1959, the example of Davie's work, and of other British abstract painters such as Roger Hilton, seems to have been uppermost in his mind. By this time he had seen the Jackson Pollock retrospective held at the Whitechapel Gallery and had heard about, though not visited, 'The New American Painting' exhibition shown at the Tate Gallery in February–March 1959. Both these shows of contemporary American art seem to have increased his ambition to be a 'modern' artist, even if there was little in their work which he wished to apply directly to his own.

Having spent two years away from painting, Hockney was uncertain about what to do on his arrival at the Royal College and spent the first month there making two elaborate drawings, one in pencil and the other with turpentine washes, of a skeleton hanging in the room. These were not 5 intended as works of art but simply as an exercise in self-discipline along the lines of his previous art school training, a method of educating the eye and the hand. The painstaking accuracy and worked-over appearance of these large drawings based on close observation are the very antithesis of the spontaneously painted abstract pictures which followed.

For a short period during his first term, Hockney investigated the possibility of painting pictures which were totally non-referential. Painted generally on three-by-four foot board issued by the College, these were 6, 7 larger than most of his previous pictures, although they stopped far short of the ambitious mural-like scale favoured by American artists of Pollock's generation. In part this can be attributed to the fact that this was the largest size board available free from the College, but it is due also to the fact that Hockney was taking as his point of reference not American but British abstract painting of the 1950s, which was conceived still within the tradition of the easel picture.

Growing Discontent, which dates from the winter of 1959–60, is a 6 characteristic example of Hockney's abstract pictures. Few of these paintings survive, as many were either destroyed or painted over by Hockney or by

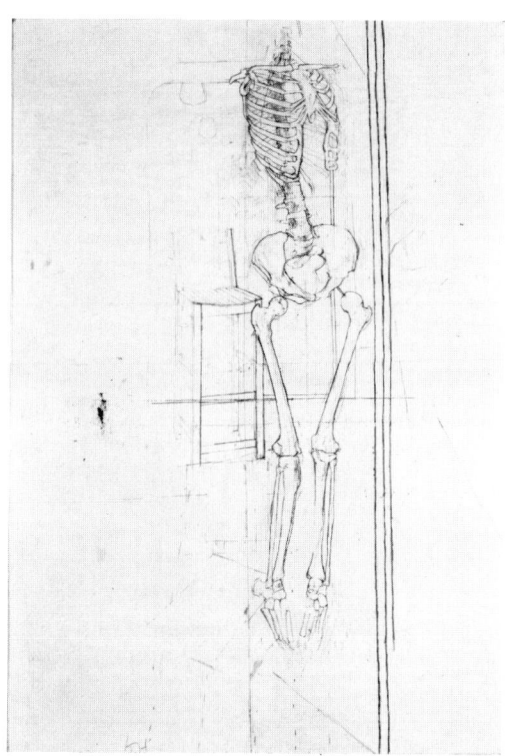

5 *Skeleton*, 1959–60

other students who had run out of supplies of hardboard. Hockney disliked the fashion for anonymous titles such as *Painting No. 1*, a practice he soon parodied in his series of Love Paintings, and thus chose evocative captions that would identify the picture more vividly. These titles are often drawn from poetry. Sometimes the name of the painting would relate closely to its content, as in the case of the slightly later *Tyger*, 1960, which alludes to the William Blake poem 'The Tyger' from *Songs of Experience*; the two wedgelike forms are the last vestiges of a schematized tiger more clearly recognizable in a drawing produced by Hockney shortly before. The titles of other pictures from this period are less literally related to the forms on that piece of hardboard or canvas, but allude more generally to Hockney's attitudes or situation as a human being. Another painting from this winter term, for instance, was called *Erection*, hinting for the first time at the theme of sexuality with which he was soon to be concerned, though one would look in vain for anything but the most abstruse erotic meanings in the imagery itself.

7

6 *Growing Discontent*, 1959–60

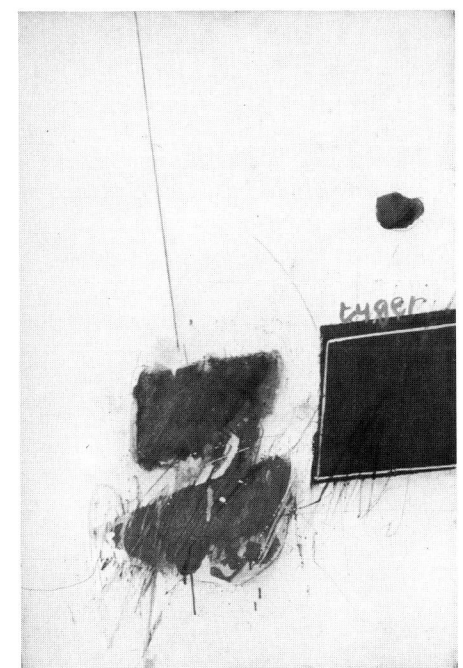

7 *Tyger*, 1960

6 Hockney's increasing dissatisfaction with his own art is firmly stated in the title *Growing Discontent*. He was beginning to understand that in his eagerness to embrace Modernism whole-heartedly he had abandoned the content and subject-matter of his earlier figurative paintings. Worse yet, he had thrown off one stylistic strait-jacket only to find himself trapped in another. Having experienced this sense of confinement before, he was quicker to recognize it this time and to become aware of the need to find a personal voice. Various influences were soon to help him to the conclusion that style should not be imposed on the artist, but that it should simply be one of many tools at his service.

Each of the two phases of Hockney's work of the 1950s was rejected as insufficient on its own, yet there were elements of each that he wished to retain. In the simplest terms, he rejected the extreme of abstract formalism as lacking in human content, while shying away from a traditional conception of figurative art as old-fashioned. He felt a need for subject-matter and recognizable imagery in his own pictures as a means of engaging the viewer's interest, but was intent on demonstrating his awareness of the issues of modern art.

Hockney was not alone in his urge to devise a figurative art which took into account the lessons of Modernism while dealing with a wide range of subject-matter normally considered outside the domain of painting itself. There were, in fact, several other students in his year at the Royal College who shared similar aims, foremost among them the American R. B. Kitaj, whose work and attitudes had a strong impact on Hockney as well as on *8* painters such as Allen Jones, Peter Phillips and Derek Boshier. Kitaj's work revealed ways in which picture-making could, and should, be a vehicle for intellectual as well as sensual communication. The making of images was viewed as the construction of a language of signs which would be 'read' in the way that words can be read. Kitaj was interested, furthermore, in the Surrealist notion of automatism and in the Abstract Expressionist corollary, the concept of gesture, both of which seized on image-making as a kind of writing expressive of the functioning of thought or of the assertion of personality.

Troubled by the apparent lack of content in abstract art, but not yet ready to reassert figurative references for fear of appearing reactionary, Hockney found in words a way of communicating specific messages without confronting the dilemma of illusionism. The idea was suggested to him by Cubist pictures in which words were written on the canvas as a substitute for, or as a clue to the identity of, objects and environments that would otherwise be difficult to decipher. It is a way of bringing in the rest of the world while maintaining the literal identity of all the marks on the canvas; a picture of

8 R.B. KITAJ *The Red Banquet*, 1960

something is not the thing itself, whereas a word, while alluding to another level of experience, retains the same form whether it is written on a sheet of paper or transcribed on to the surface of a painting.

When Hockney began writing on his paintings it was with the intention of communicating his interests to others. Poetry often supplied him with the words he needed; it seemed to Hockney that poetry involved a process of selection, distillation and allusion which was similar to that he was seeking in his painting. *Tyger*, borrowed from the poem by William Blake, was the 7 first occasion on which he wrote on one of his paintings. Following this came a series of pictures still resembling his abstract paintings but including patches of red and green as signs for tomatoes and lettuce, as well as words such as 'carrots' and 'lettuce' as part of his self-declaration as a vegetarian. These paintings have all disappeared, the victims again of repainting or of systematic end-of-year disposal by the College staff.

At about the same time that he was painting the 'vegetarian propaganda' pictures, Hockney began, hesitantly at first, to treat another, even more *31* personal theme: that of his homosexuality. *Love*, a tiny canvas painted at the end of his first year at the College, introduces the subject by pairing an image of a heart with the word 'LOVE' written in small letters along its lower edge. *4* The debt to Alan Davie is still visible, especially in the gestural brushwork, dry paint surface and colour scheme of deep reds and blues, yet the cryptic and very private aspects of his abstract work are now beginning to give way to a much greater openness.

It was precisely at this time that Hockney began to acknowledge publicly his homosexual orientation, largely under the encouragement of another American student at the College, Mark Berger. No longer afraid of being 'discovered', Hockney did not need to hide his impulses in abstract visual symbols; his new sense of confidence seems to have liberated his search for a greater directness than had been possible before. In the space of a few months he changed from a quiet introspection to a flamboyant gregariousness, and the hermetic, sombre nature of his earlier work gave way to an almost hectic exuberance. Hockney agrees that his first overtly figurative paintings following his abstract phase were those that dealt with his 'coming out', and is at pains to insist that it was in fact through his art that he made his declaration:

'The openness was *through* the paintings, it wasn't through anything else. In those days I didn't talk very much. I was aware that I was homosexual long before that, it's just that I hadn't done anything about it. I mean I had done a little about it when I was very young, but then you didn't worry about it, you didn't think it was anything odd at all. The more you become aware of it, at first it simply seems quite private, and then the more aware of that you become, the more secretive you become. You've lost the innocence of not caring at all. Then the moment you decide you have to face what you're like, you get so excited, it's something off your back. I don't care what they think at all now. In a sense, oddly enough, it kind of normalizes you.'

Unlike some of the other students, Hockney did most of his painting at the College, and relished the constant flow of people, among them some slightly older artists such as Peter Blake and Joe Tilson, who visited the studios. To Hockney this created a situation akin to a permanent exhibition, and the expectation of an instant public made him think of his pictures as messages to others rather than as private exercises. He was eager to tell others about himself, and saw that he could do this through his art. It was also a discovery that filled him with excitement and which accounts for the rather aggressive self-assertion of the various vegetarian and homosexual propaganda pictures:

'I think it was both propaganda in the ordinary sense of the word, it was cheeky, and there was also an element of just ordinary excitement that you could deal with these things, that you'd reached a point where you could make paintings about these things for yourself. Painting in Bradford in the streets you're not dealing with anything like that at all. The moment you learn to deal with it in art, it's quite an exciting moment, just as in a sense when people "come out" it's quite an exciting moment. It means they become aware of their desires and deal with them in a reasonably honest way.'

The change of approach in Hockney's work from private messages to open declarations is most clearly evinced in a series of paintings on the theme of homosexual self-oppression, beginning with a tiny picture called *Queer* 9 and culminating in the clearly legible figurative imagery of the final version of *Doll Boy* in the late summer of 1960. The sequence of pictures reveals the gradual evolution of a hunched-over male figure, explicitly labelled 'unorthodox lover' in one of the studies and identified by the slang term 'queen' in another study and in the final painting.

At first sight *Queer* looks much like Hockney's slightly earlier abstracts, and indeed when it was exhibited at a commercial gallery in London five years later it was listed as *Yellow Abstract*, a title which Hockney himself would never have chosen. Barely visible in the centre of the picture, more evident in reproduction than in the painting itself, is a series of scrawled forms which can gradually be seen to make up the derogatory label of the title. The minute size of the picture and the presence of the written message beckons the viewer closer and incites him to scrutinize the surface, which is a thick and dry mixture of oil paint with sand. The words thus have two functions, that of transmitting a message and – a basic goal of the modern artist – that of making the viewer aware of the material composition of the image as paint on canvas. If one stands close enough to these pictures to read the messages, it is possible to lose sight of the images as they seem to disappear into the deliberately rough surfaces of paint, so that one's consciousness of the tactile qualities of the manipulated paint is increased.

The identification of the brown smudged area in the lower section of *Queer* becomes possible if one compares it with one of the studies for *Doll Boy* 10 executed shortly afterwards. The arch surmounted by a blotch can now be read as a male figure, pushed down by the weight from above as a symbol of self-oppression. The more explicit study makes clear through the graphic symbol of a heart pushing on the boy's head that it is his own need for love which is causing him pain. The final painting retains the submissive posture of the figure yielding to the crush of antagonistic forces, but through the addition of further written phrases makes even clearer that the theme is that

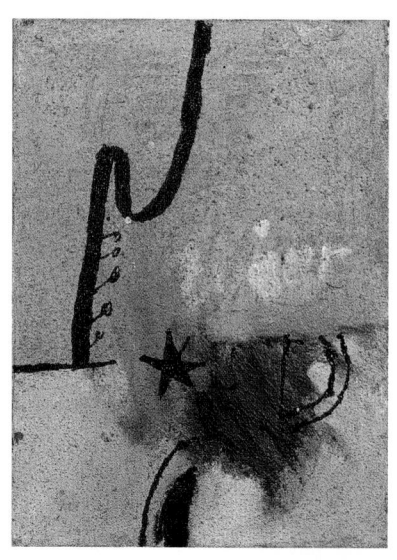

9 *Queer*, 1960

10 *Study for Doll Boy (No. 2)*, 1960

of the homosexual who refuses to acknowledge his orientation publicly. The words in the lower right-hand corner – 'your love means more to me' – suggest the graffiti found on the walls of public toilets, with all the furtiveness and isolation which that implies. The figure is identified through various codes as Cliff Richard, the pop singer on whom Hockney had a 'crush' at the time and whom he thought to be homosexual in spite of his wholesome image as the average boy-next-door. The numerals '3.18' written under the figure identify his initials as C.R. according to the schoolboy code which Hockney borrowed from the American poet Walt Whitman, himself an outspoken homosexual: 1 = A, 2 = B, and so forth. The phrase 'doll boy' functions both as a term of endearment and as a reference to Richard's recent hit song 'Living Doll', and musical notes emanate from his mouth.

During the summer of 1960 a large exhibition of the work of Pablo Picasso was held at the Tate Gallery. Hockney visited it about eight times, impressed by the brilliance of Picasso's draughtsmanship as well as by the scope of his inventions, and recalls it even today as 'a very liberating influence'. The most important discovery for Hockney was that the artist did not need to limit himself to one kind of picture, but could move in any direction he wished. A large section of the exhibition was devoted to the series of fifty-eight canvases executed in 1957 on the theme of *Las Meninas* 11 by Velázquez, all of which are characterized by an audacious mixture of styles, pictorial conventions and conceptions of space. The major canvas of the series, dismissing any pretence at stylistic homogeneity, consists of a confrontation of a number of figures each in an unrelated idiom: an outlined diagrammatic figure, a cartoon character, and figures reflecting different stages of Picasso's own development. The result is co-ordinated rather than visually indigestible not because it is unified in style but because it reveals a consistent attitude towards style. Hockney learned that 'Style is something you can use, and you can be like a magpie, just taking what you want. The idea of the rigid style seemed to me then something you needn't concern yourself with, it would trap you.'

Picasso's example, combined with the stimulating atmosphere of activity among an exceptionally talented and ambitious group of students, produced in Hockney a feeling of exhilaration and limitless possibilities. 'One has the advantage when you're very young,' he recalls, 'that you've nothing to lose. Later on things become a burden, I think your past work sometimes becomes a burden. When you're very young, you suddenly find this marvellous freedom, it's quite exciting, and you're prepared to do anything.'

It was only after Hockney's trip to New York during the following summer that the full impact of Picasso's free-ranging attitude to style made itself felt in his own work. He understood at once, however, how much

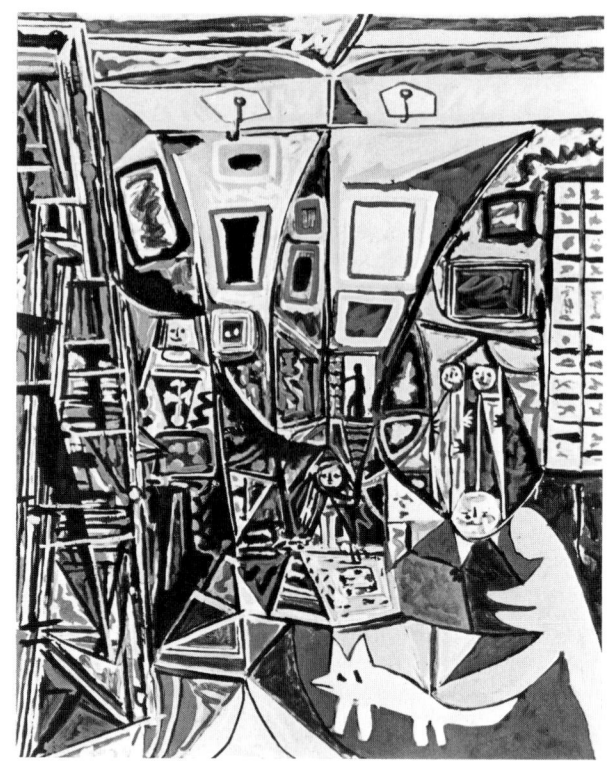

11 PABLO PICASSO *Las Meninas*, 2 October 1957

freedom could be gained by borrowing from any source, whether this be from his own life or imagination, from poetry, from magazines and photographs, from commonplace objects or from the work of other artists. He also found an unexpected means of escaping the confines of an inflexible style. He could make his depictions in a deliberately rigid style such as that of children's art, the characteristics of which seem to be so constant as to make invisible any sign of individual personality. This kind of anonymity was useful to Hockney at the time, for the subject-matter with which he was dealing was of such a personal and passionate nature that the paintings could otherwise have seemed a form of neurotic self-confession. Quoting a depersonalized style such as that of children's art allowed Hockney a certain distance between himself and his subject-matter, and in so doing stressed the application of the theme not only to himself but to others in his situation.

The figure style of Hockney's paintings from 1960 to 1962 owes much to the example of Jean Dubuffet, whose paintings of the previous two decades

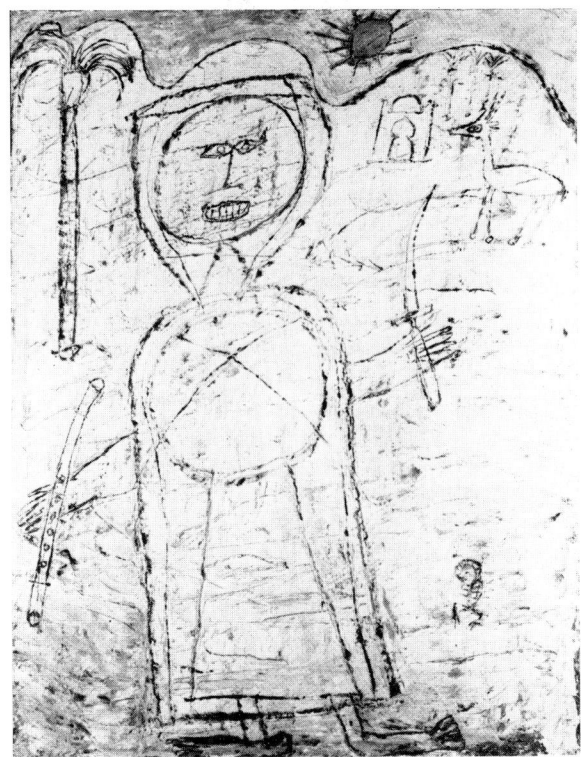

12 JEAN DUBUFFET *Il tient la Flûte et le Couteau*, 1947

employed a similar crude form of drawing inspired by children's art. Dubuffet's work, first exhibited in London in 1955, appealed to Hockney not only for its textural paint effects but also for its use of graffiti on city walls as a public measure of private obsessions. George Butcher, who purchased Hockney's *Third Love Painting*, had written, for example, of the 'unsophisticated sources used as material for the expression of a personal vision' in Dubuffet's work (*Art News and Review*, 21 May 1960). In works such as *Il tient la Flûte et le Couteau*, the figure serves 'as a sign, a direct hieroglyph', like *12* a ready-made example of an anonymous, unchanging mode of depiction merely placed in a new order by the artist.

The two figures in *Adhesiveness*, painted at the beginning of his second *32* year in the early autumn of 1960, are of an even more schematized nature than the rather cursory doll boys which preceded them. Hockney is not interested in telling us what they look like, but only in making clear who they are and what they are doing. It is primarily on account of their spindly

25

little legs and the single bowler hat that we recognize them as figures at all. The numerals '4.8' and '23.23' identify them as Hockney himself with the poet Walt Whitman, whose complete works Hockney had read during that summer. The picture is, in fact, a celebration of love between men expressed as an act of homage to Whitman and his writings. The figures are locked in the sexual position called '69' with such involvement that it hardly seems to matter that the figure at the left has legs where his head should be. The sense of complete immersion in each other is reflected in the title, a term borrowed from Whitman expressive of closely bonded friendship between men.

21 Whitman is a constant presence in Hockney's early work, acknowledged as an admired figure in the 1961 etching *Myself and My Heroes* and used as a direct source of imagery at least as late as the 1963 painting *I Saw in Louisiana a Live-Oak Growing*. The most lasting aspect of Whitman's legacy is the effect is has had generally on Hockney's imagery and subject-matter, for it is in these paintings of friendship between men that Hockney first established the two-figure compositions and the theme of personal relationships which have been such a dominant aspect of his art.

13 The title of *We Two Boys Together Clinging*, painted in the early months of 1961, is from another poem in Whitman's *Leaves of Grass*. Typically for Hockney's work at this time, the subject-matter is at once determinedly public in its theme and cryptically private in its references. The closeness of the two men is made graphically evident by the zigzag markings physically uniting them as an indication of their spiritual bonds and sexual attraction. Two lines from Whitman's poem are copied out on to the surface of the painting along the right edge as a sort of running commentary on the activities of the men: 'Power enjoying, elbows stretching, fingers clutching,/Arm'd and fearless, eating, drinking, sleeping, loving.' On the lips of the left-hand figure is the word 'never', extracted from the line 'One the other never leaving' as an indication of their passionate commitment to each other.

The private mythology of the painting is less immediately apparent. The prominent numerals '4.2' in the lower left-hand corner refer once again to Doll Boy, Cliff Richard, as does the suggestion of a musical stave in the area above. Hockney's attention had been attracted by a newspaper headline 'TWO BOYS CLING TO CLIFF ALL NIGHT LONG'. Although it emerged that the article concerned a climbing accident and not the ultimate sexual fantasy, the humour of this coincidental reference nevertheless plays a part in the total meaning of the picture. So, too, does the alternative labelling of the figures with the numbers '4.8' (Hockney) and '16.3' (his boy-friend Peter Crutch, the subject of another painting of the same year), which transforms the general theme into a specific situation.

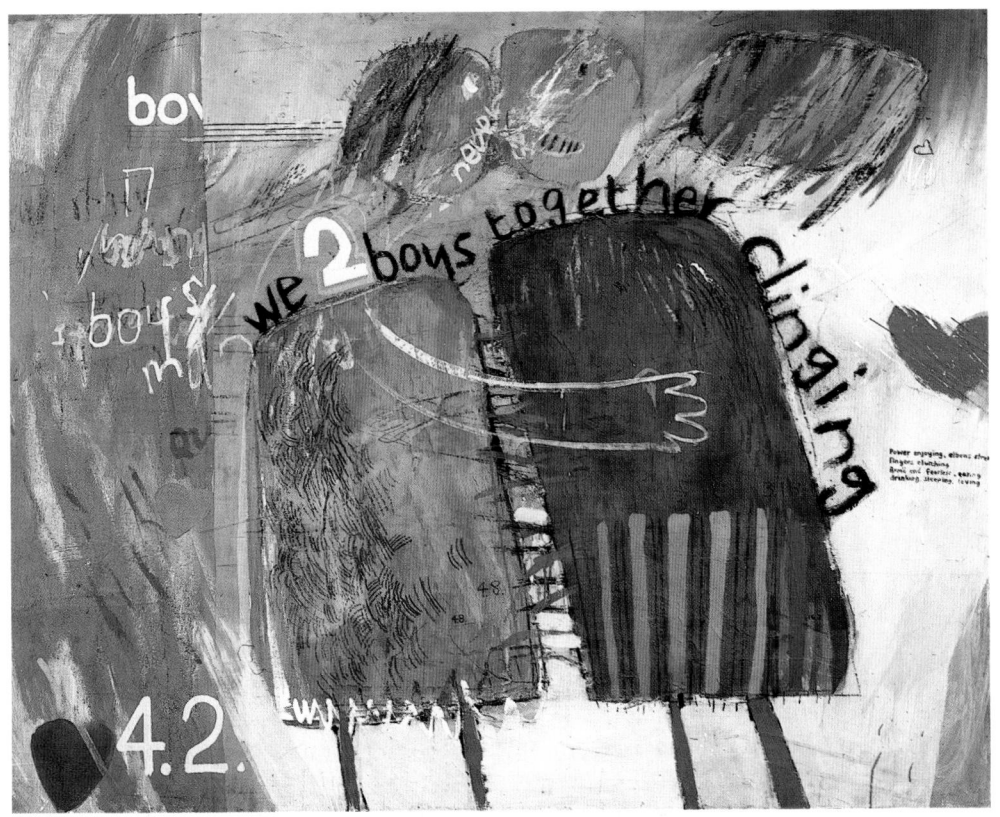

13 *We Two Boys Together Clinging*, 1961

As a student at the Royal College Hockney produced a vast amount of work, often investigating the possibility of variations on a theme. So it is that the image of two men embracing appears also in a drawing of about the same time, with a title used for another of his paintings, *The Most Beautiful Boy in the World*. This is one of a small group of drawings from 1961 in which Hockney tried watercolour for the first time, attempting to combat the apparent amorphousness of the medium by combining its veils of colour with a spiky linear underdrawing in ink in the manner of Paul Klee. The results did not satisfy him and he abandoned watercolour for the time being, returning to it in later years on several occasions only to dismiss it once again. *14*

In view of the extremely personal nature of the subject-matter with which Hockney was dealing, the often comic aspect of his deliberately crude style at the time provided a useful balance. Humour can be a weapon, as Hockney

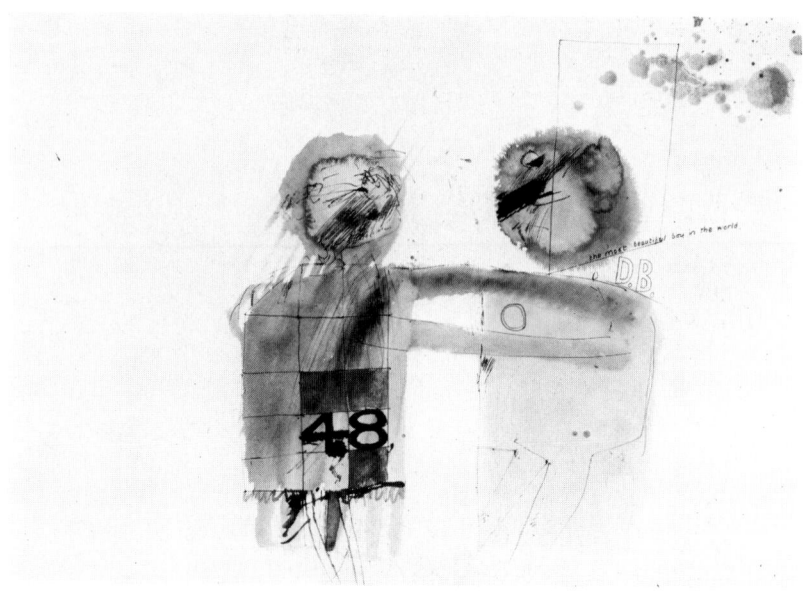

14 *The Most Beautiful Boy in the World*, 1961

realized in mocking the conventions of abstraction through the titles of his four Love Paintings of 1960–1, insisting through ironic contrast on the urgently human themes of his own work. By the time of *The Fourth Love Painting*, moreover, a softening had taken place of the blatantly propagandistic aims of the earlier pictures. It is not that Hockney had had a change of heart, but only that he had come to terms with his homosexuality and was able to take it for granted. Compared to the rather frantic repetition of the word 'queer' like some erotic mantra across the surface of *Going to be a Queen for Tonight*, painted in the previous year, Hockney's paintings of 1961 are altogether more at ease in their acceptance of homosexual love.

The Fourth Love Painting displays the relaxed and humorous attitude with which Hockney began now to treat themes of sex and love. Hockney took his cue for the line of type printed above the image ('I will love you at 8 pm next Wednesday') by paraphrasing W. H. Auden's *Homage to Clio*: ' "I will love You forever", swears the poet. I find this easy to swear to. *I will love You at 4.15 p.m. next Tuesday*; is that still as easy?' The title of the section from which this is quoted, 'Dichtung und Wahrheit (An Unwritten Poem)', is itself of significance, for Auden's concern with 'fact and fiction' is echoed in Hockney's picture. Love can take different forms, some more 'real' than

28

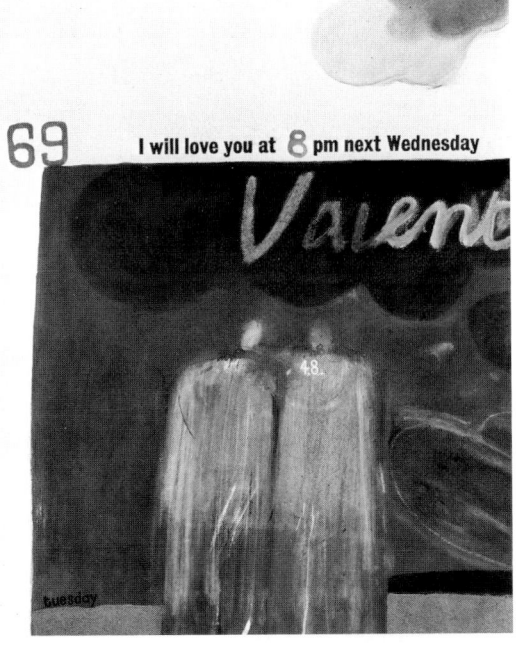

15 *The Fourth Love Painting*, 1961

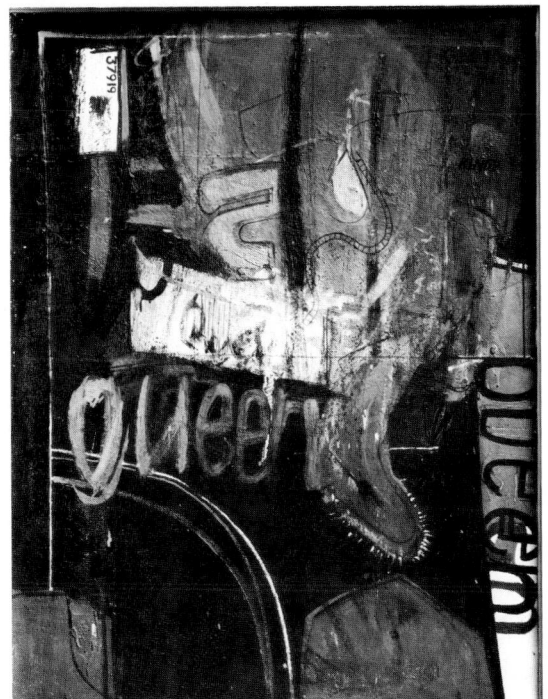

16 *Going to be a Queen for Tonight*, 1960

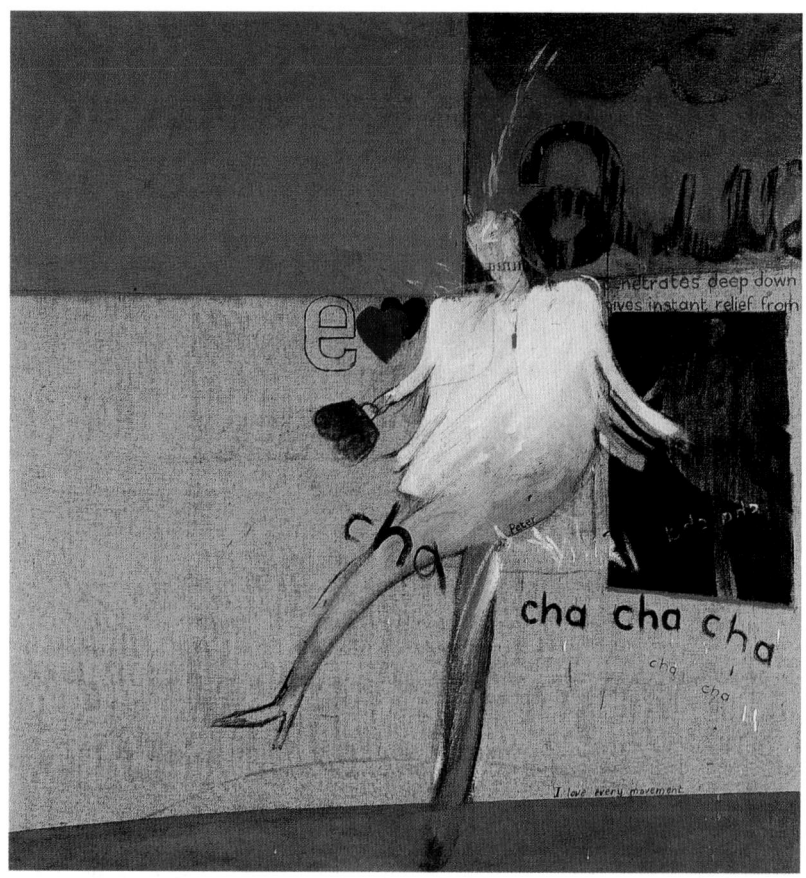

17 *The Cha-Cha that was Danced in the Early Hours of 24th March, 1961*

others. It can be romantic affection, as signified by the embracing figures and the Valentine message. It can be a crush on someone one has never met; *Valentine* was the name of a magazine aimed at teenage girls which specialized in photographs of current pop stars. Love, finally, can be the sexual act itself, as revealed in the sly allusion of '69' taking place at 8 p.m., which interprets the love of the message as a verb of action.

The transformation of sexual fantasy into reality is fêted in another painting, *The Cha-Cha that was Danced in the Early Hours of 24th March*, through reference to an actual event: a fellow student whom he hardly knew,

but who was aware that Hockney found him attractive, danced the cha–cha specially for his entertainment. A mirror in the background reflects the gyrating figure of the boy as well as the words 'cha cha', which themselves appear to be dancing across the surface. An etching that Hockney made in the same year, *Mirror, Mirror on the Wall*, includes a similar image along with a quotation from the last lines of the poem 'The Mirror in the Hall' by the Greek poet Constantine P. Cavafy (in John Mavrogordato's translation): 'The old mirror was . . . proud to have received upon itself/That entire beauty for a few minutes.' Hockney thus suggests that the artist, like the mirror, is able to celebrate beauty not merely by witnessing it but also by reflecting it back to the viewer for his contemplation. A visual idea drawn from poetry thus again finds form as a poetic image in paint. Lest we are tempted into an overly serious appraisal of eroticism as a disinterested admiration of beauty, Hockney reminds us of the joy and physical pleasures of sex by copying on to the canvas an unintentional *double entendre* from the slogan on a box of medicated ointment: 'penetrates deep down/gives instant relief from'.

The smudged treatment of the dancing figure to suggest movement, along with the exposure of large areas of bare canvas, reveal Hockney's interest at the time in the paintings of Francis Bacon. Given Hockney's return *18* to an overtly figurative idiom, his admiration of Bacon's work, which had impressed him in the one-man show held at London's Marlborough Gallery in the spring of 1960, now found an outlet not only in openly homosexual themes but also in purely painterly concerns. Bacon consistently declared his opposition to pure abstraction, which he regarded as mere decoration lacking in content, yet his desire to make paint work directly on the nervous system instead of achieving its effects solely through the imitation of surface appearances constituted a significant application of the principles of recent abstract painting. Only a year earlier Hockney had been painting informal abstractions, and he was thus quick to seize the implications of that approach in a figurative context. From this moment he began to make frequent use of Bacon's device of leaving bare large expanses of unprimed canvas, making evident that the image is formed in paint on a flat surface and thus destroying any illusion of depth. The painting is not to be a substitute for the world perceived through the senses but an equivalent to it, just as a poem creates a parallel to experience rather than its mere description.

The influence of Bacon's handling of paint is evident also in *The First Tea* *19* *Painting*, 1960, although here, for the first time in Hockney's work, another solution is proposed for the concern with the material substance of the picture: that of equating the painting with a real object. A number of Hockney's paintings of the early 1960s are based on commonplace objects which we know to be composed of flat printed surfaces. *The Fourth Love* *15*

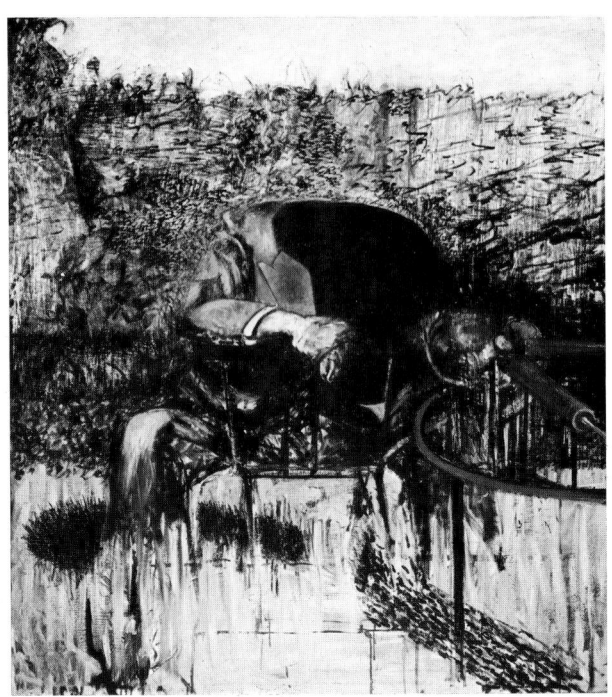

18 FRANCIS BACON *Figure in a Landscape*, 1945

Painting, for instance, mimics the format of a page in a calendar, carrying the reference so far as actually to print a caption on to the canvas surface. The notion of the painting as a real object was inherent already in Early Renaissance painting, for instance in shaped panels representing the Crucifixion, but it was enjoying a particular vogue about 1960 as a means of making figurative references while supporting the Modernist principle of the work of art as the thing-in-itself rather than as a pale reflection of reality. As early as 1955, for example in *Target with Plaster Casts*, the American Jasper Johns had influentially equated the canvas with the object it represented: an archery target, as in the case of this much reproduced work, or the American flag. Johns's example had a counterpart, closer to home, in the work of British painters such as Richard Smith and Hockney's fellow student Peter Phillips.

The First Tea Painting, executed shortly after *Adhesiveness* in the autumn of 1960, was one of Hockney's first tentative steps back into a fully representational idiom, and as such attention is concentrated on the making

20

19, 32

32

19 *The First Tea Painting*, 1960

of a legible sign rather than on the implications of the canvas as object. One senses a lingering Modernist prejudice about the act of depicting a three-dimensional object on a two–dimensional surface, a fear that the result will be a mere illustration. Hockney thus depicts only one side of the tea packet, reassembling a flat printed surface on to a flat painted surface, and taking care to leave ample evidence of the trail of the brush across the canvas. The rectangle of the tea packet, however, floats well within the boundaries of the canvas, creating a surface design which is essentially of the same nature as that of his abstract pictures from the beginning of the year.

The liberating influence of Picasso, the revelation that inspiration could be found anywhere, was by this time beginning to have an effect on Hockney, and the Tea Painting was soon followed by a series of pictures based on playing-cards. Intrigued by the reproductions in a book on the history of playing-cards which Mark Berger owned, Hockney began at first by making drawings from these illustrations. The image soon found its way on to canvas in paintings such as *Kingy B*. Here was an ideal subject for the

35

20 JASPER JOHNS *Target with Plaster Casts*, 1955

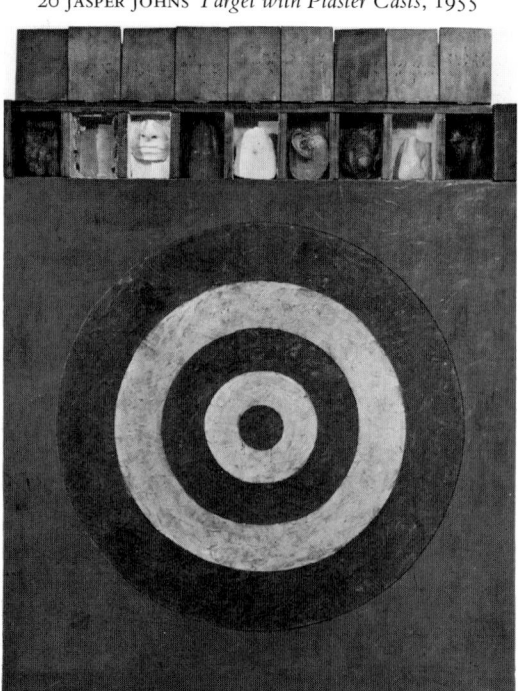

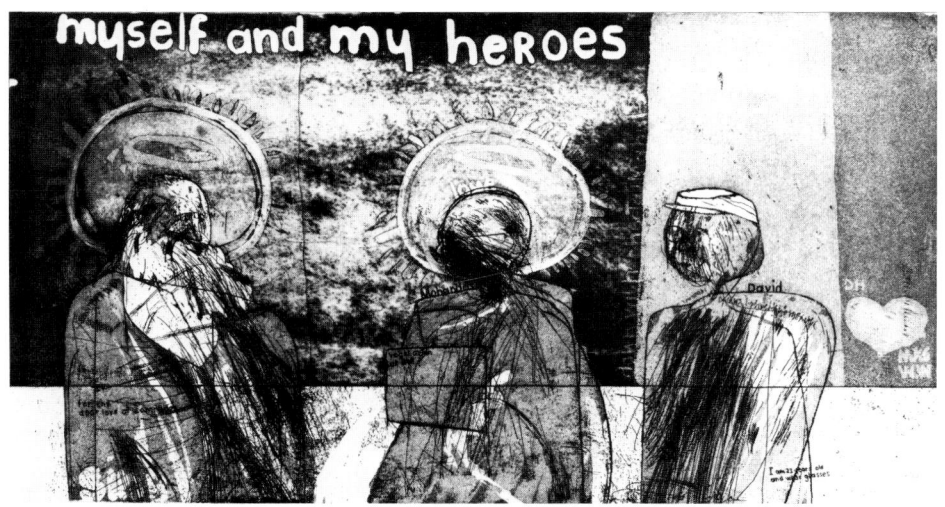

21 *Myself and My Heroes*, 1961

canvas as object equation, a printed artefact which itself was flat and which could be reconstituted in paint to the desired dimensions. The outline of the enlarged playing-card matches the boundaries of the canvas, freeing the artist to paint figures and even, if he so desires, to create sensations of space, in the full confidence that he is portraying these as pictorial conventions.

In contrast to the personal commitment characteristic of the imagery he was beginning to use in other works, there might appear to be something superficial and flippant about paintings of tea packets and playing-cards. To make this claim, however, would be to lose sight of the crucial fact that in the early 1960s Hockney was prepared to use anything in his work, and that it is this that gives his art at that time its sense of generosity and wide-eyed awe at what the world has to offer. It was in the same spirit that Hockney, having run out of painting materials and without the money to purchase more, decided early in 1961 to avail himself of the free plates offered by the graphic department in order to make his first etchings. At Bradford he had taken lithography as a subsidiary subject but he had never tried etching, and had it not been for circumstances beyond his control it might not have occurred to him to turn his attention to print-making now. It was simply a question of making the best of the situation.

Myself and My Heroes was conceived merely as a test plate, his first essay in etching, but it reveals a natural delight in the medium. In spite of its small size, it contains a number of the elements which he was to pursue in his subsequent prints – a combination of straightforward etched line, tiny scrawled messages, and several layers of aquatint for a full tonal range – as if,

in his impatience, he wanted to investigate at once the full potential of the medium. Hockney says that he is 'well aware that sometimes a medium turns me on', adding that 'often a medium can force you to work in a different way.'

The three figures in this first print by Hockney are set against three clearly differentiated panels, identifying the image as a rather wayward reflection of a traditional religious altarpiece. Hockney presents himself as a kind of donor figure standing in respectful admiration of two personal saints, each enshrined in a double nimbus: Walt Whitman and Mahatma Gandhi. Each man carries an identifying caption, Whitman speaking 'for the dear love of comrades', Gandhi promoting love and 'vegetarian as well', and Hockney himself, humbled by the achievements of his heroes, saying only 'I am 23 years old and wear glasses.' It is, however, an affectionate memento rather than a distant act of homage: the artist has drawn a heart and scratched his initials opposite those of his mentors.

Were it not for the spontaneity with which Hockney formulated his images at this time, one could almost say that there was a programmatic intention in these works of revealing his situation as a human being. Kitaj, with whom he had struck up a close friendship, was encouraging him to make pictures on themes about which he cared passionately, and it seems to have been Kitaj who disclosed to Hockney ways in which literature could be used as a legitimate source of imagery.

Kitaj often demonstrated a personal commitment to the content of his own pictures by taking literary and historical sources as his raw material; his proclamation in 1964 that 'Some books have pictures and some pictures have books' reflected a long-standing concern. Perhaps it was necessary that it be an American in self-imposed exile from his country, a man immersed in the writings of T. S. Eliot, Ezra Pound, Henry James and others, who saw in literature such potential for picture-making. In England, where there has been a long tradition of the literary in the visual arts, 'literary' characteristics have taken on a pejorative connotation. Reminded of the excesses of sentiment and theatricality of Victorian set-pieces, we are too easily led to the conclusion that inspiration from books constitutes a failure of nerve or a disappointing compromise, an inability to construct a picture through purely visual means.

Hockney appears to have found it difficult to indulge his taste for story-telling in paintings, perhaps because he was still conditioned by the Modernist prejudice against such an activity, but in his prints he was able at once to depict a sequence of events rather than limiting himself to the presentation of a static situation as in the paintings. This is manifest already in some of his first etchings, such as the multi-frame *Gretchen and the Snurl*,

1961, based on a fairy tale written by Mark Berger and which ends in an image of embracing figures similar to that of *We Two Boys Together* *13* *Clinging*. There are also two etchings of Rumpelstiltskin, dating from 1961 and 1962, which are the first evidence of Hockney's interest in the fairy tales of the Brothers Grimm, which he was to illustrate at the end of the decade in an elaborate book of etchings.

Hockney seems to have felt that there was a logic to telling a story in a print because of the similarity between the etched line and the printed word: 'All the early etchings deal with line, and somehow the line telling the story seemed appealing, whereas in the paintings you get involved with other things, the paint, the texture, and narrative is harder to deal with. I could do it now, but at the time it was easier to work out in etching.'

Hockney was aware, moreover, that there was a tradition for using prints to tell a moral, as testified by the work of William Hogarth. The importance of Hogarth's example is openly acknowledged in Hockney's first major series of prints, *A Rake's Progress*, 1961–3, in which the strong narrative *1, 22, 23* content was initially adapted directly from Hogarth's series of the same name, transformed through reference to Hockney's own time and experience. The idea for the series as well as much of its imagery arose from his first visit to New York City in the summer of 1961, a trip which was made possible with the first prize-money awarded to him at the 'Graven Image' exhibition held at the R.B.A. Galleries early in that year. Hockney's original intention, when he formulated plans for the set on his return to London in the autumn of 1961, was to make eight plates, the same number as in Hogarth's series and titled as in the eighteenth-century version. The Principal of the Royal College, Robin Darwin, encouraged him to increase the number so that it could be published also as a book by the College's Lion and Unicorn Press. The number of plates was raised to twenty-four but eventually a compromise of sixteen was reached.

Characteristically for Hockney's subsequent development, his first major work was thus created in a graphic medium, a medium often regarded by painters as of subsidiary importance to their main body of work. Such categories seem not to have worried Hockney, who was more concerned to find a medium suitable to the subject, but what did concern him was the enormous amount of work that would be called for without the help of an assistant. The sixteen plates were not finished until the summer of 1963, all of them having been made in London apart from Plates 7 and 7A, which were etched in 1963 on a return visit to New York. It was only on completion that Paul Cornwall-Jones of Editions Alecto approached him with a view to publishing the set commercially. The plates, however, were planned essentially in 1961. A few preparatory drawings were made as a means of

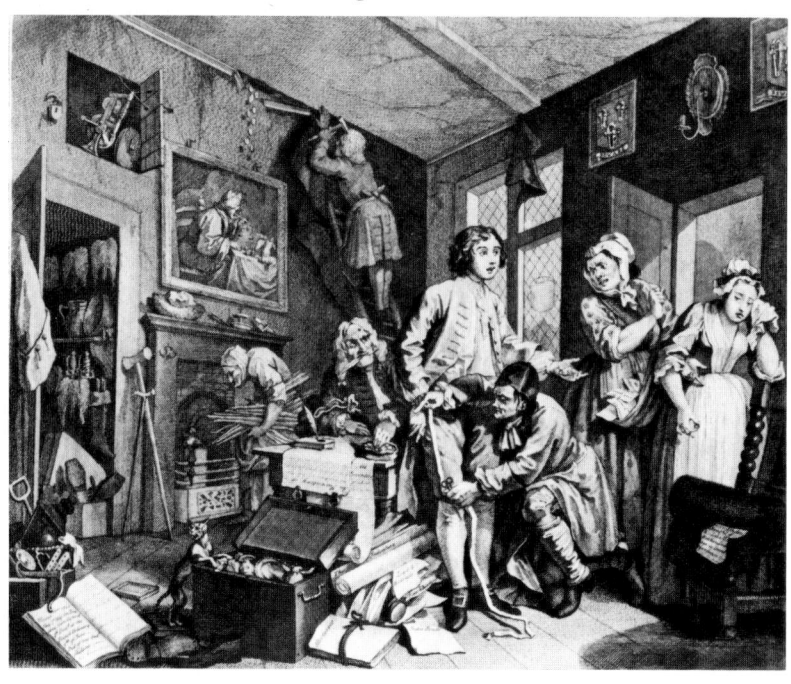

22 *A Rake's Progress: Receiving the Inheritance*, 1961–63

23 WILLIAM HOGARTH *The Rake's Progress*, Plate 1, 1735

planning out the sequence, but generally, since etching is itself a form of drawing, they were drawn directly on to the plates.

A Rake's Progress provides a visual account of the relationship between his life and personal interests and the work to which they give rise. The imagery is culled primarily from his visits to New York City, and the artist records private events such as visits to gay bars and the dyeing of his hair. Like Hogarth's series, it is a cautionary tale, a warning to himself as well as to others of the loss of identity which occurs when one bows to external pressures. The destruction of innocence and individuality, we are reminded, is not simply a matter of personal morality. Also at issue is the corruption and debasement of art. In Plate 1A, under the title *Receiving the Inheritance*, we witness the reduction of art to the status of a mere commodity, as the artist haggles with a collector over the price of his own etching *Myself and My Heroes*. The fact that this particular print is a statement of his own ethical stance makes the transaction all the more sordid and debasing. Elsewhere Hockney hints at the dilution of art in its transformation into the clichés of advertising, as in *The Start of the Spending Spree and the Door Opening for a Blonde*, where the artist admits to his seduction by the promises of eternal sunshine and carefree existence. Hockney is well aware of his own weaknesses: the swaying palm trees presented here as the product of his fantasy were later often to be depicted by him from direct observation.

There is a deliberate fragmentation of imagery and technique in these prints which makes sense only when interpreted thematically. References to advertisements jostle with film, with traditional religious iconography (as seen through a photograph by Cecil Beaton), and with images of monumental sculpture and twentieth-century architecture. The imagery printed in black from etching and aquatint is paired with textured surfaces printed in red from areas etched on to the plate using the sugar-lift technique. The dissolution of the rake is presented graphically in a number of the prints through his depiction as a limbless bust. In the last print of the series the rake is indistinguishable from the other robotic figures, all of them drawn in the same way and lined up like paper dolls with no facial features to indicate personality. Sealed off from human contact by the earphones of their transistor radios, this is Bedlam in modern guise.

Jarring juxtapositions of image and technique, as well as contrasts of spatial suggestions against the flatness of the support, are essential ingredients not only of the prints but also of the paintings executed by Hockney on his return from New York. This is particularly evident in the painting he began at the start of the autumn term, *A Grand Procession of Dignitaries in the Semi-Egyptian Style*, his largest canvas to date. Inspired by the poem 'Waiting for the Barbarians' by C. P. Cavafy, a resident of Alexandria, Hockney chose to

paint his picture in the style of Egyptian tomb paintings, an idiom as rigid as that of children's art but endowed with associations appropriate to the subject. The ironic tone of the poem appealed to Hockney as a wry comment on human nature: our tendency to inflate our self-image by contrasting ourselves with those we deem inferior, and the ease with which we can invent false motives for our actions and then delude ourselves into believing them. The clergyman, soldier and industrialist in Hockney's picture all hide within the trappings of their public persona, inside which they are really very small. The hieratic stiffness of the modified Egyptian style suits well the pomposity with which they carry themselves, the formality of their postures betraying the fact that they are putting on an act. Hockney recalls that he set out to make a highly theatrical picture, including even the tassels of a curtain along the upper edge, as a means of emphasizing the human situation with which he was dealing. This theatricality, and the curtain motif in particular, immediately acquired a fascination in itself and ever since has been a recurring feature of his work.

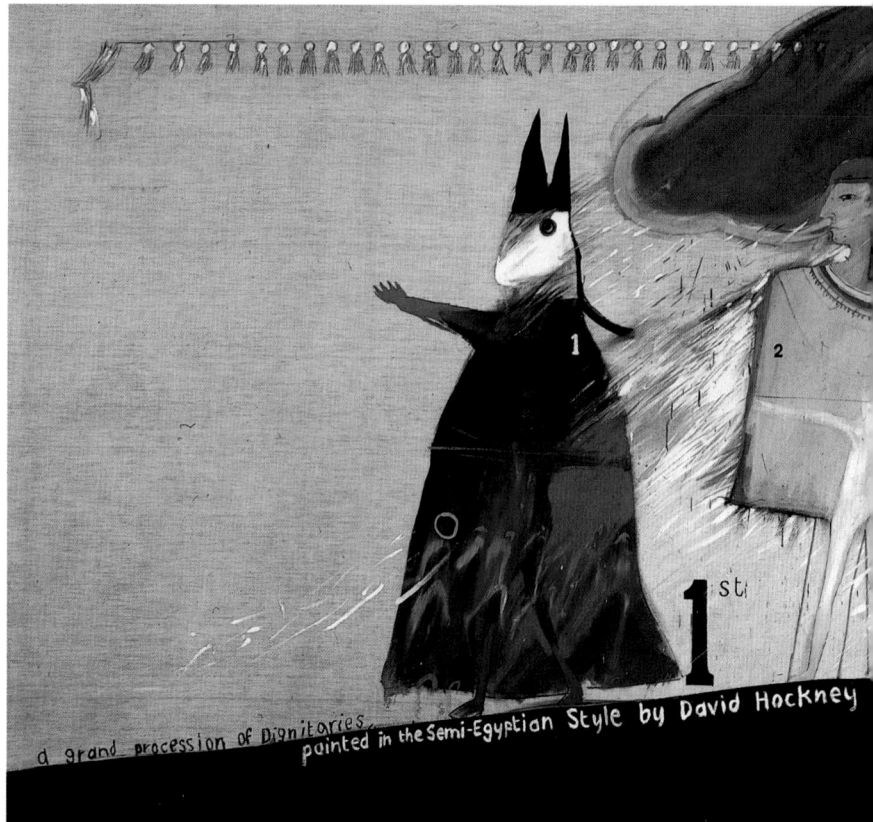

A Grand Procession was one of the four *Demonstrations of Versatility* which 24 Hockney exhibited at the 'Young Contemporaries' student show in February 1962. The others were *Tea Painting with Figure in the Illusionistic* 36 *Style, Swiss Landscape in a Scenic Style* and *Figure in a Flat Style*; the titles of 25 these have since been amended. The playfully confident attitude towards style as an element that can be chosen at will is revealed even in the selection of titles. In a conversation with the American painter Larry Rivers published in *Art and Literature 5* (summer 1965), Hockney later recalled: 'I deliberately set out to prove I could do four entirely different sorts of picture like Picasso. They all had a sub-title and each was in a different style, Egyptian, illusionistic, flat – but looking at them later I realized the attitude is basically the same and you come to see yourself there a bit.'

With an imaginative group of pictures already behind him, Hockney now felt sufficiently assured to take up the challenge of the Picasso exhibition he 11 had seen in 1960. Not only does he take up a succession of styles in different pictures, but within a single painting he moves freely from one mode to

24 *A Grand Procession of Dignitaries in the Semi-Egyptian Style*, 1961

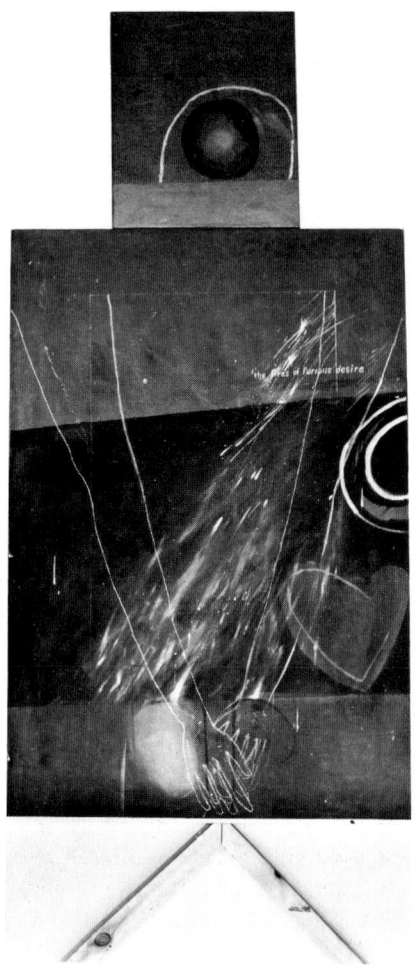

25 *Figure in a Flat Style*, 1961

another, from flatness to illusionism, from bare canvas or areas of unmodulated colour to gestural surfaces, from depictions of figures to written messages to painted marks that are so self-sufficient that in any other context they would be assumed to be abstract.

A self-conscious deployment of apparently contradictory styles is something that Hockney, along with other young painters with whom he was studying, had remarked also in the work of Kitaj. It is in this respect that one can detect a unity of purpose among a group of painters at the Royal

College for a short period in the early 1960s. Each was seeking refuge from the Abstract Expressionist concept of the canvas as an arena of self-expression, the notion of painting as existential autobiography formulated by the critic Harold Rosenberg to describe the aims of the generation of American artists then considered the epitome of the avant-garde. While not denigrating the achievements of painters such as Jackson Pollock or Willem de Kooning, Hockney and his colleagues were wary of such concepts of self-projection, which they believed could make the artist a slave rather than the master of his own means. Just as an image was selected rather than simply discovered in a haphazard manner, so a particular style could be quoted rather than adopted unthinkingly. In so doing the artist declared the pre-eminence of choice and control in the making of his picture.

Figure in a Flat Style relates to Hockney's homo-erotic pictures from 25
earlier in the year, but here he investigates the limits to which abstraction can be carried without sacrificing the legibility of the image as a figure. He achieves this through the form of the canvas itself, or more precisely through the relation of the three parts which make up the complete picture. A small square canvas functions as the head, a vertical rectangle as the torso, and the wooden supports of an easel are used as a sign for the legs. Thus even before the addition of the painted marks the shape of the picture as a whole identifies the subject. The head, represented within the square canvas as a grey circle within a white linear arch, is as severely schematized as the ungainly wooden legs. The arms and hands, by contrast, are clearly drawn in white across the central surface, bringing our attention to the urgency of the masturbatory gestures of the hands.

The sexual connotations of the image are alluded to in the alternative title of the picture, *The fires of furious desire*, written across the top of the main canvas. The awkward physique of the figure takes on strongly personal connotations when examined in the context of such lonely sexuality. The phrase is taken from a poem by William Blake, but the figure, built from the basic materials of the painter – canvas and easel – can be none other than Hockney's self-portrait. The very anonymity of the geometrical style provides, through contrast, a poignancy to this extremely personal image of vulnerability.

Hockney followed up the implications of *Figure in a Flat Style* in another of the *Demonstrations of Versatility, Tea Painting with Figure in the Illusionistic* 36
Style, in which he explored further the means by which the shape of the canvas alone could identify the subject of the picture or change our reading of the painted marks within. A preliminary drawing established the image of a figure trapped inside a box represented in isometric projection; when he came to make the painting, he decided to have the box-top open in order to

make the image more immediately recognizable as the rendering of a box. The equation of the canvas with a real object, an idea which he had used a year before in his playing-card and early tea paintings, here gives rise to the first work by any of the Royal College artists in which the shape of the stretcher departs from the traditional rectangle, so that even before any paint is applied the canvas is identified as a specific object. The containing shape alone establishes the subject, in this case a box in perspective, while maintaining the painting's literal reality as an object: canvas stretched flat over a wooden framework. Since the illusion is 'drawn' in the shape of the canvas itself, the painter is left to make whatever kind of mark he wishes across the canvas surface. The figure, no matter how flatly it is painted, still resides convincingly within the illusion of an enclosed space. Other artists, notably Allen Jones in his *Bus* paintings of 1962, seized on the idea of the shaped canvas, but Hockney himself did not pursue it for long. *The Second Marriage*, 1963, is the last picture of his to feature a shaped canvas, and this was stretched up long before it was painted. Hockney was interested more in other things, and felt the shaped canvas alone was too formal a device.

The last of the *Demonstrations of Versatility*, *Swiss Landscape in a Scenic Style*, followed soon after by a closely related larger canvas, *Flight into Italy – Swiss Landscape*, introduced another favourite habit, that of making reference to the work of other artists as a means of defining the characteristics of his own pictures and of making evident their relationship to other contemporary art. The bands of vivid colour in the latter picture, for instance, refer in the first place to the schematized depiction of mountains in geological maps, a wry comment on the fact that he failed to see the Swiss Alps from the back of the van in which he was driven to Italy (the momentary glimpse of a mountain peak rendered illusionistically was, in fact, culled from a colour postcard). The bands of colour, however, are also references to the abstract paintings by Harold Cohen, in which meandering lines direct the viewer's eye across the surface of the canvas. The subject of Hockney's picture, his rushed journey across Europe, is thus supported through this allusion to a pictorial device for movement.

In other paintings of this time Hockney borrows the technique of staining colour into the weave of the canvas – a method used by the American abstract painter Morris Louis as a means of evolving images directly through the process itself – only to negate the self-sufficiency of that image as a material fact by providing it with a representational meaning. The rivulets of colour on the surface of bare canvas in *Picture Emphasizing Stillness* paradoxically become the groundline supporting two figures, while the concentric rings in *The First Marriage*, a reference to the paintings of Kenneth Noland, are transformed into a sign for a tropical sun. The

44

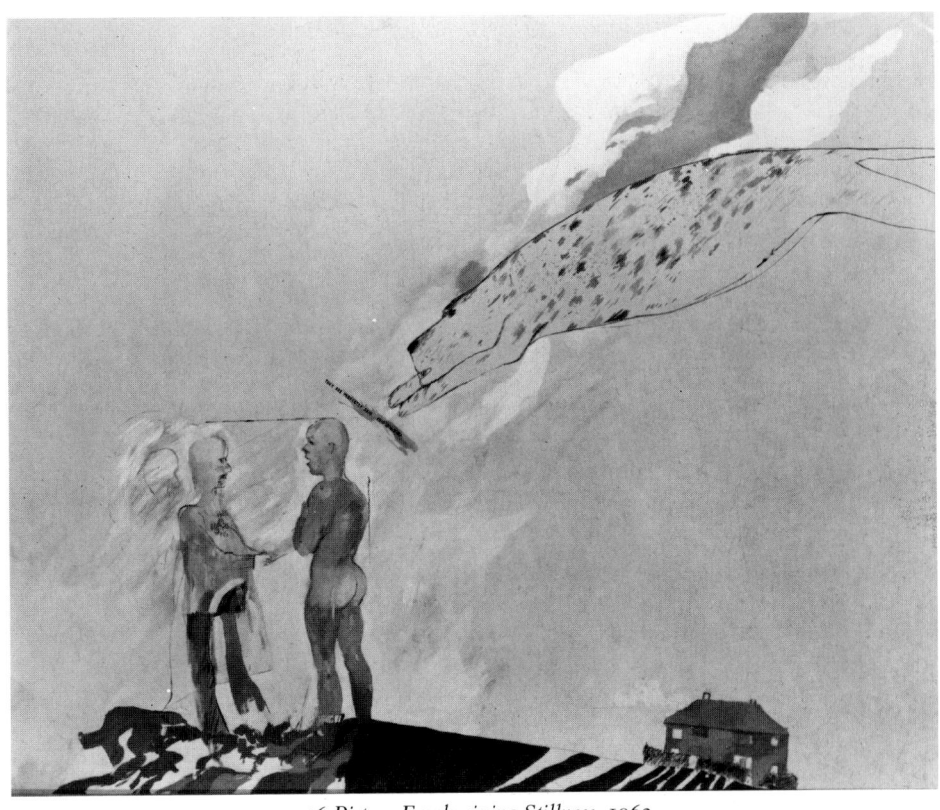

26 *Picture Emphasizing Stillness*, 1962

preoccupations of current abstract art are gently mocked, as in the 'animation' of the popular target motif into *Snake* in the 6 × 6 ft canvas of 1962. What Hockney is doing, in effect, is to assert the traditional concerns of figurative art, by which each mark functions both as an element within an enclosed formal system and as part of a recognizable image of something seen. The viewer's experience centres on the interaction of these two functions of paint-as-paint and paint as a sign for a reality outside the picture.

The ideas for *Picture Emphasizing Stillness* and *The First Marriage* both took form in drawings made by Hockney during his visit to Berlin with an American friend in August 1962. The former was suggested by a picture of a leopard which he saw in an East Berlin museum, and which made such an impression on him that he drew it as well as he could from memory on his return that evening to his hotel room. Using only this spontaneous ink sketch as a guide, he re-elaborated the image on canvas upon his return to London. The two men in the painting appear to be in imminent danger of

attack by the animal leaping through the air. It is only when we approach the canvas that we realize how foolish we have been to be taken in by this imaginary situation, for underneath the leopard is the self-evident message: 'They are perfectly safe. This is a still.' The messages written on Hockney's pictures, like the titles themselves, thus begin to have a different function, that of drawing our attention to the visual characteristics of the pictures rather than simply to their themes or literary sources. The message here is a serious one, that of relating the innate impossibility of presenting actual movement in the form of a static image, but Hockney manages to get it across by matching his detached attitude to style with a dead-pan literal-minded sense of humour.

39 The title of *The First Marriage (A Marriage of Styles)* also provides the key to its interpretation. The bridegroom and his wife are a most unlikely couple: the man, dressed in a conventional suit and tie, seems to be from our own society, but the stiffly formal woman with her exaggeratedly geometric breasts is not only not from our culture but not of flesh and blood either. The scene was, in fact, suggested by the sight of Hockney's American friend standing in profile next to a stylized Egyptian figurine at the end of a corridor in an East Berlin museum. The bride retains the unyielding hardness of the wooden model, but the man, too, although based on studies from life, has a rather caricatural air. The setting has been left deliberately vague, not only because Hockney had not made notes about this at the time of the original encounter, but also because the large area of bare canvas exposes the image undeniably as a fabrication in paint. Using only four elements – a groundline, a wedge form like the Gothic arch of a church, a palm tree and a schematized sun – Hockney establishes that a marriage is taking place in an exotic location without distracting us from the essential relationship of the two people.

 In spite of the high degree of stylization and the delight in contrasting idioms, *The First Marriage* is the first two-figure composition in which at least one figure can be said to have a specific identity. This quickly suggested the possibility of applying an even greater degree of particularity to the theme of intimate relationships which he had treated earlier in pictures such *13* as *We Two Boys Together Clinging*. Early in 1963, Hockney painted *The* *27* *Second Marriage*, placing the two figures within a defined domestic setting. Since the shape of the canvas itself identifies the box-like space of a room interior, very few elements are needed to convince us that this is a home: a sofa, a wallpapered wall, a small table with wine bottle and glasses (each marked with a numeral for the appropriate figure), and a patterned floor which is as much an ancient mosaic for the Amarna princess copied from a book as it is a modern carpet for the gentleman at her side.

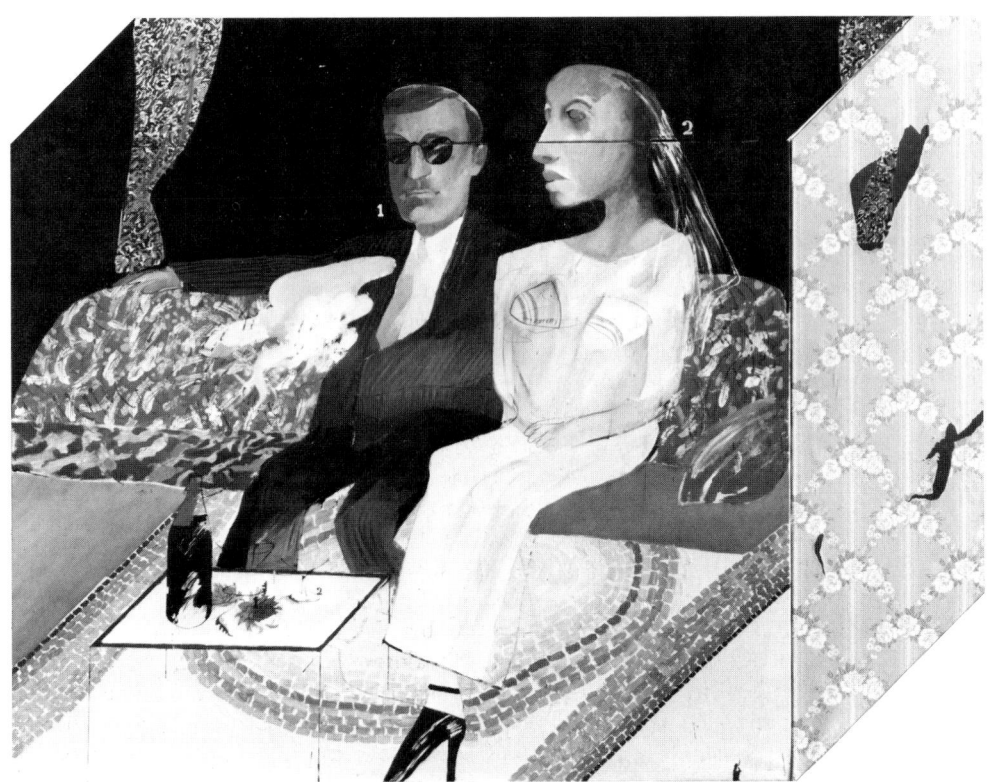

27 *The Second Marriage*, 1963

The Second Marriage could be described as a holding operation, a restatement of earlier themes and devices while the artist considered what to do next. Hockney had given some thought, in fact, to painting a rather different picture on this shaped canvas, which he had stretched up more than a year earlier. Prompted by memories of Duccio's shaped crucifixion in the Uffizi Gallery in Florence, which he had seen in 1961, Hockney's original intention was to paint a crucifixion in a box: 'But then I couldn't deal with a crucifixion at all. It's not that you have to be a believer, but I suddenly realized it was a genuinely "big" theme. It's about pain and suffering, which is something I chose to avoid, as I'm sure I avoided it a lot later, but I assume it will actually become a theme as you go on through life.'

Recoiling from the idea of a grand theme, Hockney decided instead to make a series of intimate pictures of people in their homes. The three Domestic Scenes which resulted are based both on observation and on imagination. The artist had recently moved into a flat in Powis Terrace in the

29, 30, 33

47

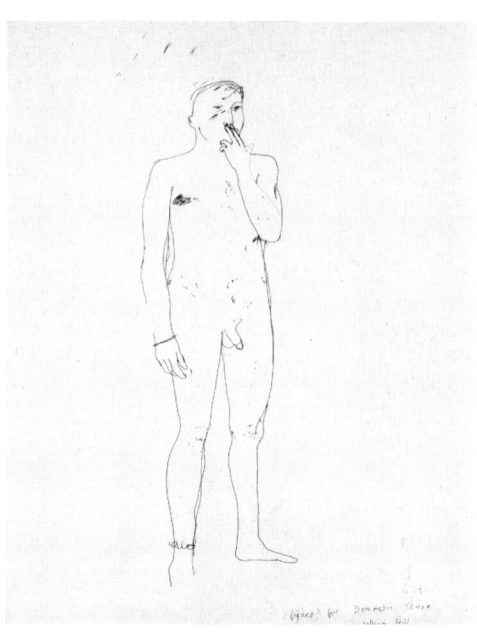

28 *Figure for Domestic Scene, Notting Hill*, 1963

29 *Domestic Scene, Notting Hill*, 1963

30 *Domestic Scene, Broadchalke, Wilts.*, 1963

Notting Hill district of London, and it is the objects in this interior which are recorded in *Domestic Scene, Notting Hill*. The two figures, like the objects, were painted from life, and although Hockney was not concerned with likeness, it was essential to the sense of relaxed social contact that both men were close friends of his and of each other. The seated figure is Ossie Clark, who had been a fashion student at the Royal College at the same time that Hockney was there, and the man standing in the nude is Mo McDermott, Hockney's model and assistant. The painting was preceded by two studies of Mo, one a sketchy rendering in crayon to test the colour and surface, the other a more detailed study from life which is one of Hockney's earliest line drawings in ink. The technique was suggested by the need to draw quickly from life, finding the essential contour, by his experience with a wiry descriptive line in etching, and by the work of other artists, including George Grosz, in which he had been interested for several years. (During his last year at the Royal College, Hockney had written an essay on Fauvism in which he called Matisse one of the 'master draughtsmen' of the twentieth century, praising his 'extremes of economy', but for many years he found Matisse's style of drawing too free for his own purposes.)

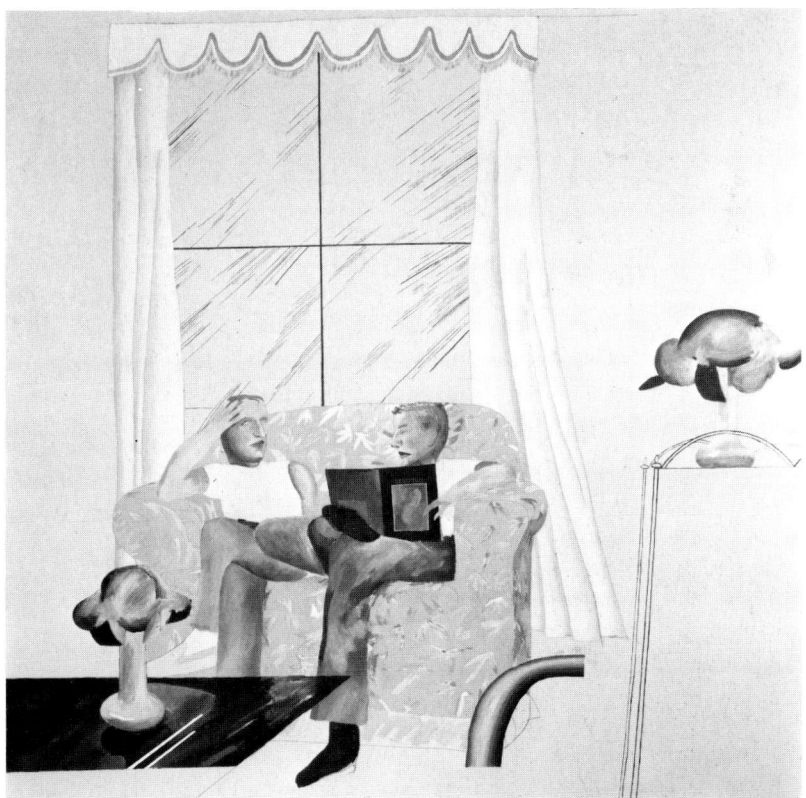

31 *Love*, 1960

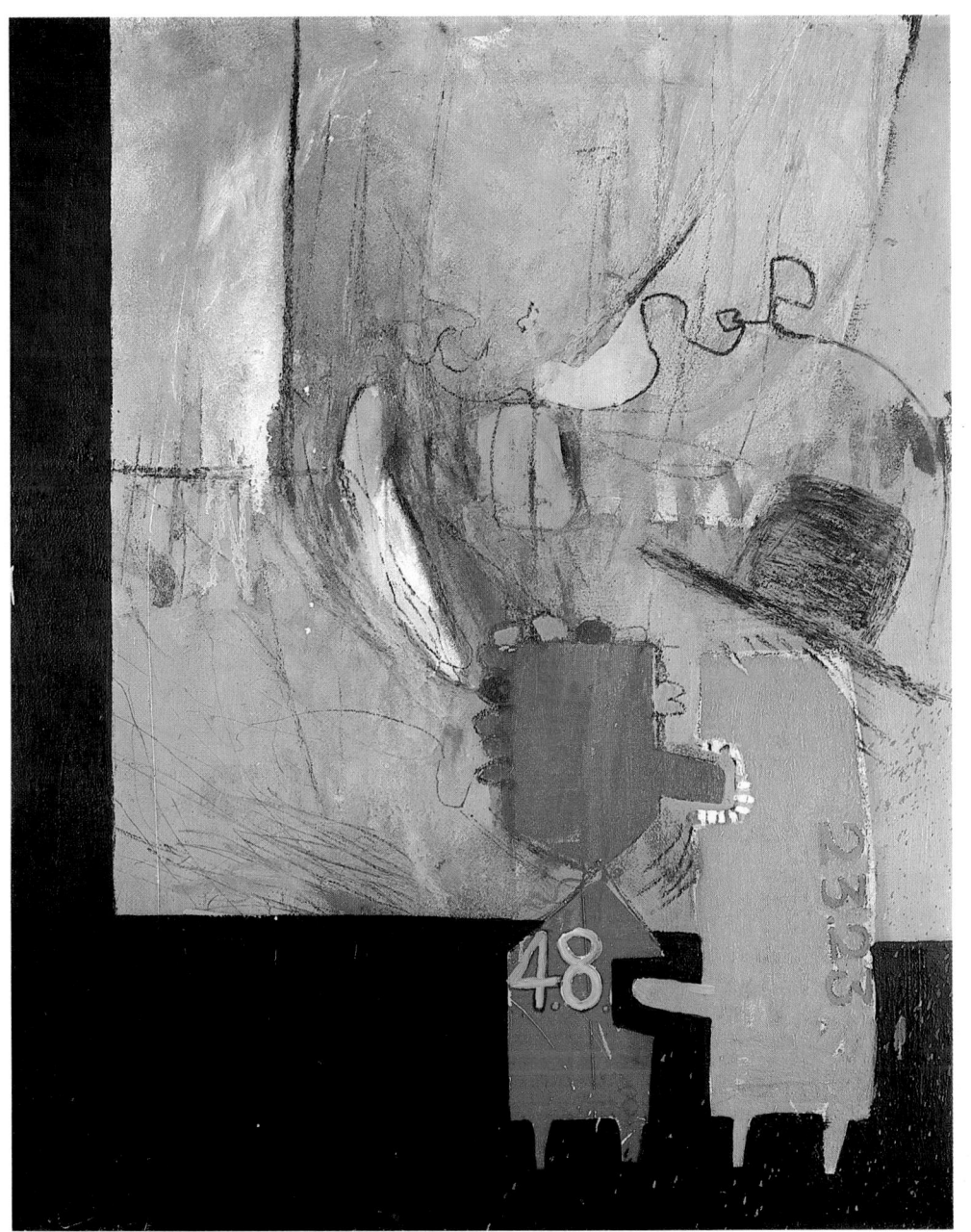

32 *Adhesiveness*, 1960

Hockney's use of a study in line for the figure of Mo reveals a change in his painting habits at this time. Rather than forming the images directly in paint on canvas, as he had done from 1960 to 1962, he would now draw in the outline first and then fill in this enclosed surface. This in turn directed a shift in the role and, therefore, the character of some of his drawings, which became tighter and more linear in these circumstances for ease of transfer. The figures in *Domestic Scene, Broadchalke, Wilts.* were painted entirely from drawings, but those of *Domestic Scene, Notting Hill* were done directly from life on to the canvas, using drawings only as a guide. Wishing to avoid the laborious appearance of an art school life painting, Hockney brushed the figures in quickly, worrying not about fidelity to natural appearance but only about the vitality of the painted marks.

There are no walls and no floor in Hockney's Notting Hill interior, which is re-created solely through a few eye-catching objects: a chair, a curtain, a lamp and a pot of plastic flowers. Hockney had observed, as he reiterated in 1979 in conversation with Charles Ingham, that 'Vision is like hearing, it is selective, *you* decide what's important, which means that other factors are

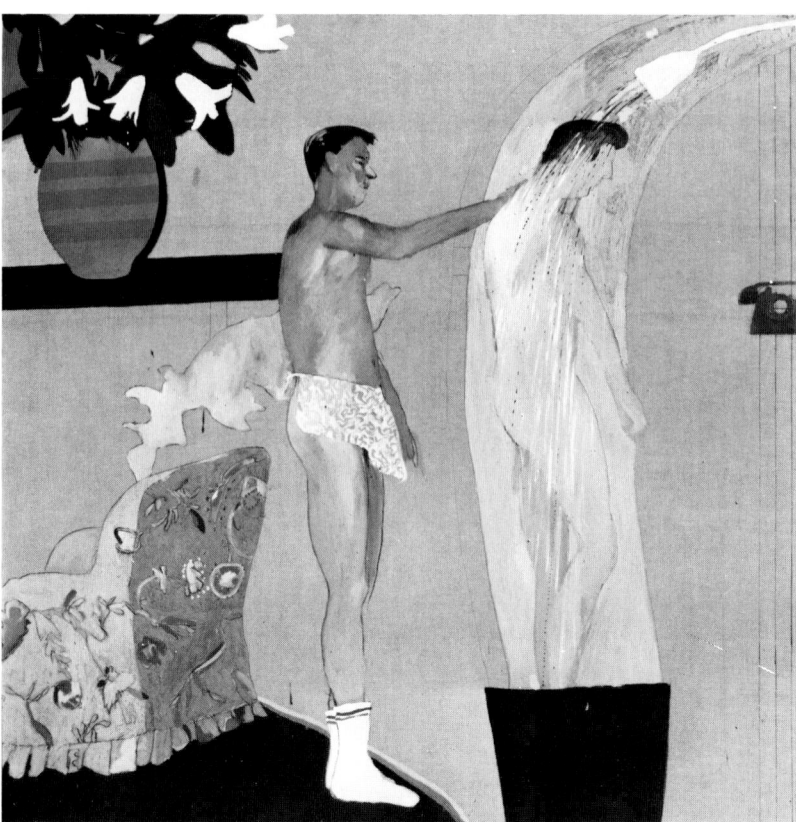

determining what you see as well. Mind you that's why painting is interesting, why in one way it's far more interesting than the photograph, because the selection is even better and more related to personal feelings.'

The same selectivity of vision marks the *Domestic Scene, Los Angeles*, painted early in 1963, many months before Hockney's first visit to California. It is a mixture of observed fact, fabrication and fantasy. The subject itself is one which he saw as a contemporary version of the traditional theme of the bather, which has precedents as far back as the Renaissance and in our own century most notably in the paintings of Cézanne. The elements of Hockney's picture, however, are wholly of his own time. The chair is the same one which had just appeared in *Notting Hill*, whisked into a new location simply through a change of context. The image of one man soaping another in the shower was borrowed from photographs in *Physique Pictorial*, a mildly homo-erotic magazine produced in Los Angeles; even the detail of the little apron coyly shielding one man's genitals was suggested by a picture in this source. Hockney has not copied the photographs directly, however, but used them only as a source of ideas. The picture is invented with the aid

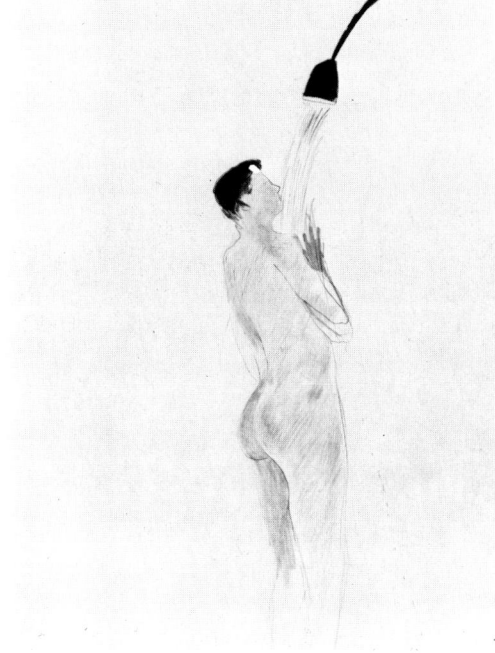

33 *Domestic Scene, Los Angeles,* 1963

34 *Boy Taking a Shower,* 1962

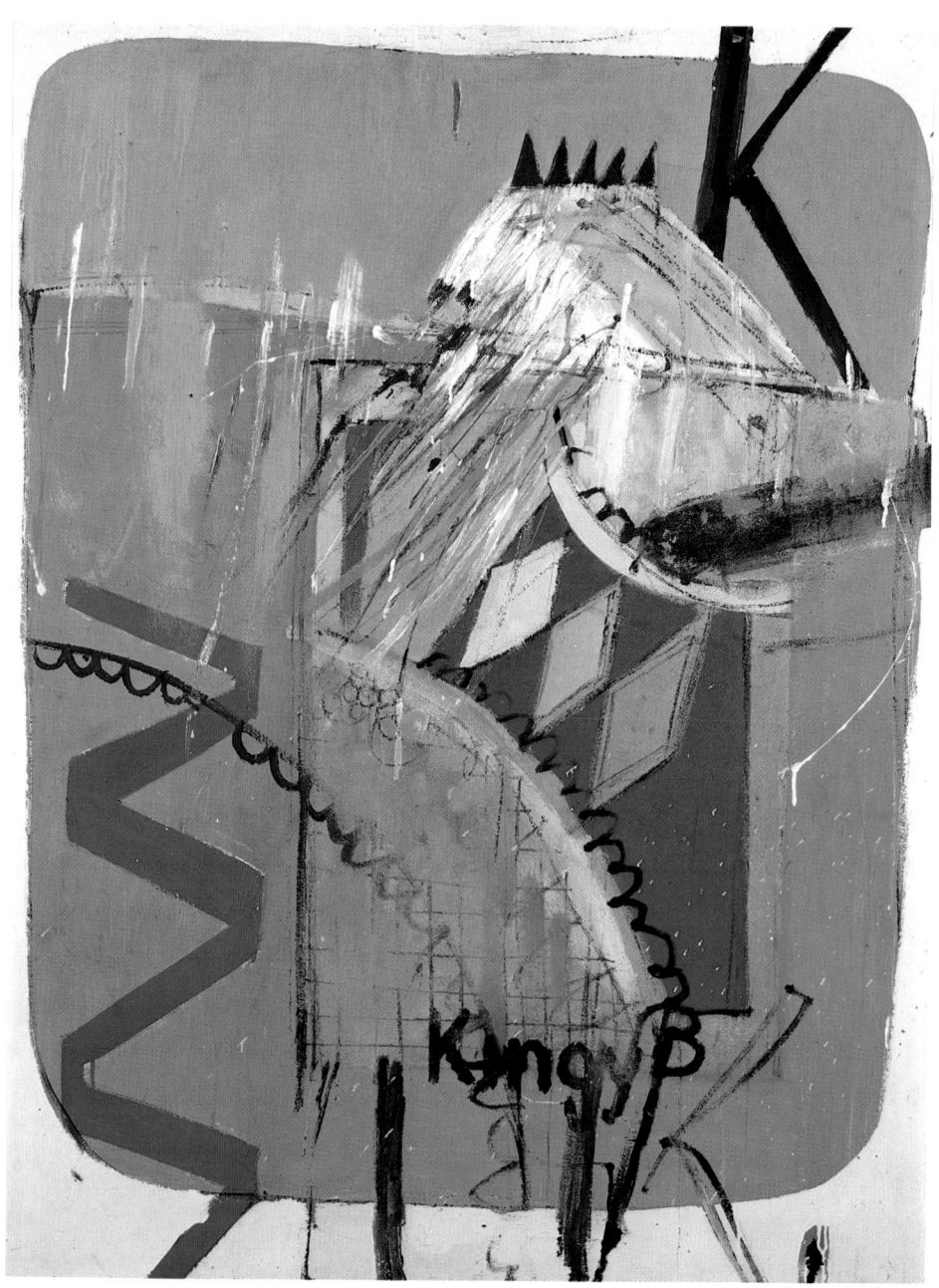

35 *Kingy B.*, 1960

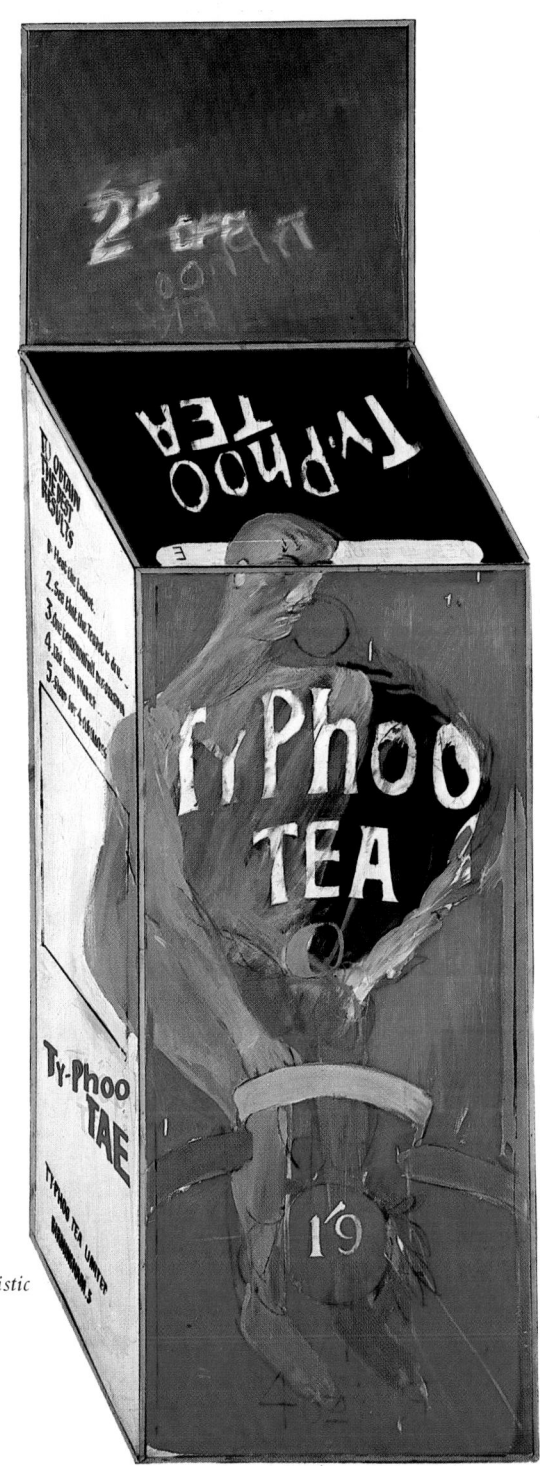

36 *Tea Painting in an Illusionistic Style*, 1961

of direct observation by re-creating the scene for himself. Hockney remarks that he has always found it difficult to paint something unless he has seen it at some time for himself. Memory can be as useful a tool as working from life, but there is no substitute for experience. It was for this reason that he installed a shower on moving into his flat in Powis Terrace in 1962, encouraged no doubt by the vision of California hedonism to which he had already been introduced. Without further hesitation, he began at once to draw people washing in it. *Boy Taking a Shower*, 1962, is one such drawing from life. The figure is depicted in an intentionally schematic manner, the legs trailing off into mere wisps of line and the anatomy brutally exaggerated, emphasizing the buttocks in particular, to intensify areas of erotic interest. Hockney's concern is not to reproduce objectively what he has witnessed but to relate to us his own experience of what he has seen.

34

In the painting of the imaginary Los Angeles interior a similar stylization marks the representation not only of the figures but also of the water flowing from the spout. In a sense Hockney continues here to use the language of children's art, depicting the falling water as a solid curve which is blatantly 'unreal' but which corresponds to the way in which we experience the motion of gravity. The image is thus strongly conceptual in its basis; it arises from what we think we know rather than simply from what we see. The same can be said of *Domestic Scene, Broadchalke, Wilts.*, in which the highly formalized treatment of the reflections on the window as a series of thin diagonal lines reads as a sign for light rather than as an illusionistic representation of it. These images of water and glass are but the first of a continuing series in which Hockney meets the challenge of finding different ways of depicting transparent and reflective materials.

In a well-publicized statement written for the catalogue of the 1964 'New Generation' exhibition, Hockney drew attention to the two extremes of his work, the concern with human dramas and the delight in technical devices, pointing out that the two approaches could sometimes be found within a single picture. The Domestic Scenes, although distinguished by Hockney's usual delight in opposing styles, place the main emphasis on the confrontation of two figures. The specific identities of the men are not of particular importance; they are not named and there is no attempt to make them recognizable as particular people. If the artist did not tell us, we would be hard pressed to know that the men in Notting Hill were Ossie and Mo or that the two seated figures at Broadchalke were the artists Joe Tilson and Peter Phillips, since they are as anonymous as the pictures of people he would never meet, such as the bathers in the Los Angeles painting. The essence of the theme is a general one of friendship in its different forms of companionship, emotional commitment and sexual involvement. The

homosexual milieu of Notting Hill is now presented as coolly as the meeting of artists in Wiltshire. Ossie and Mo are too involved in their lives even to take notice of the viewer; one sits in profile in contemplation, the other stands nonchalantly naked smoking a cigarette. The overtly propagandistic aspect of Hockney's treatment of homosexuality has by this time more or less disappeared, since in depicting a world in which homosexual relationships and feelings are taken for granted, there is no longer any need for proselytizing.

The figure trapped between a pane of glass and a painted curtain in *Play* 41 *within a Play* can easily be identified as Hockney's dealer John Kasmin. As the title makes clear, however, he is only an actor in a scene concocted by the artist, and for this reason we are unlikely to learn anything about him as an individual. The private joke of a dealer imprisoned by art does, however, deflect our attention on to the pictorial device from which the painting originated. The motif of the curtain as a picture within a picture, establishing a plane of illusion and a shallow pictorial space in which dramas could be enacted, was suggested by Domenichino's *Apollo Killing Cyclops*, an early seventeeth-century painting which had just been acquired by the National Gallery. Hockney presents us with various levels of unreality, going so far as

37 DOMENICHINO *Apollo Killing Cyclops*, 17th century

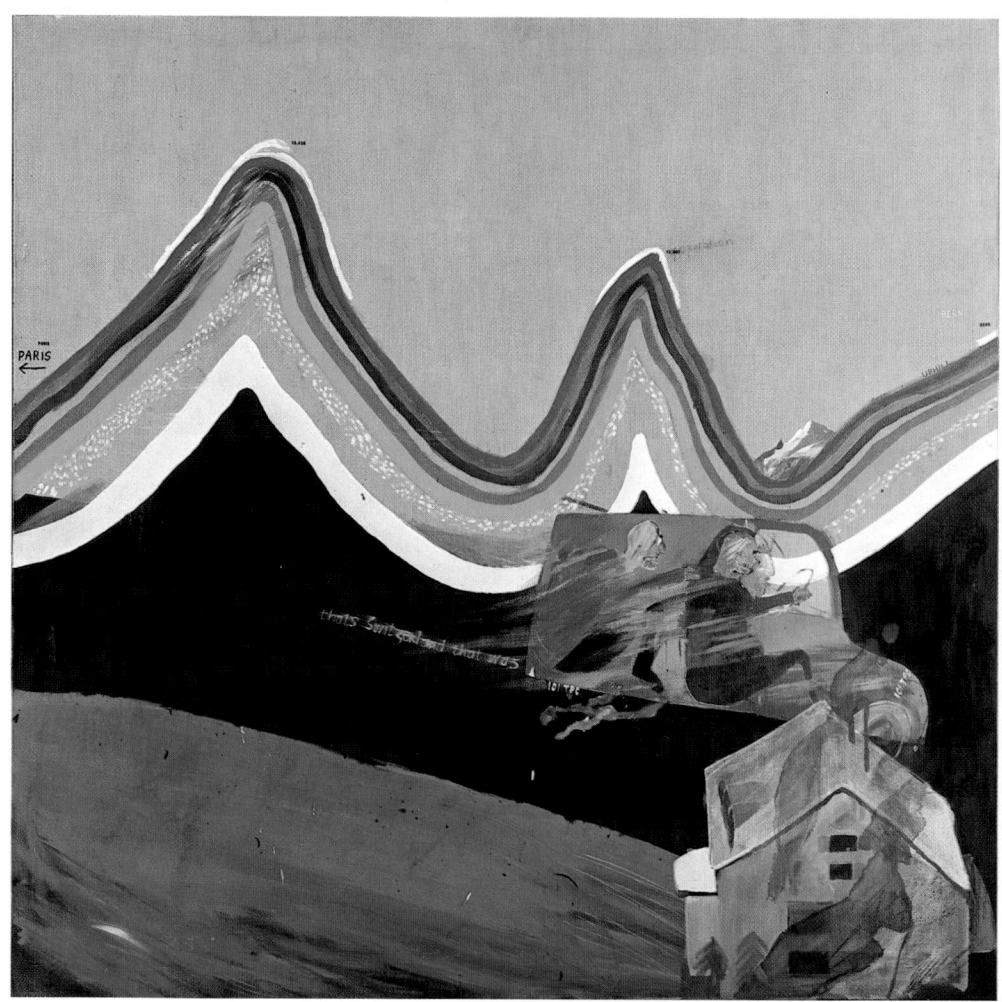

38 *Flight into Italy – Swiss Landscape*, 1962

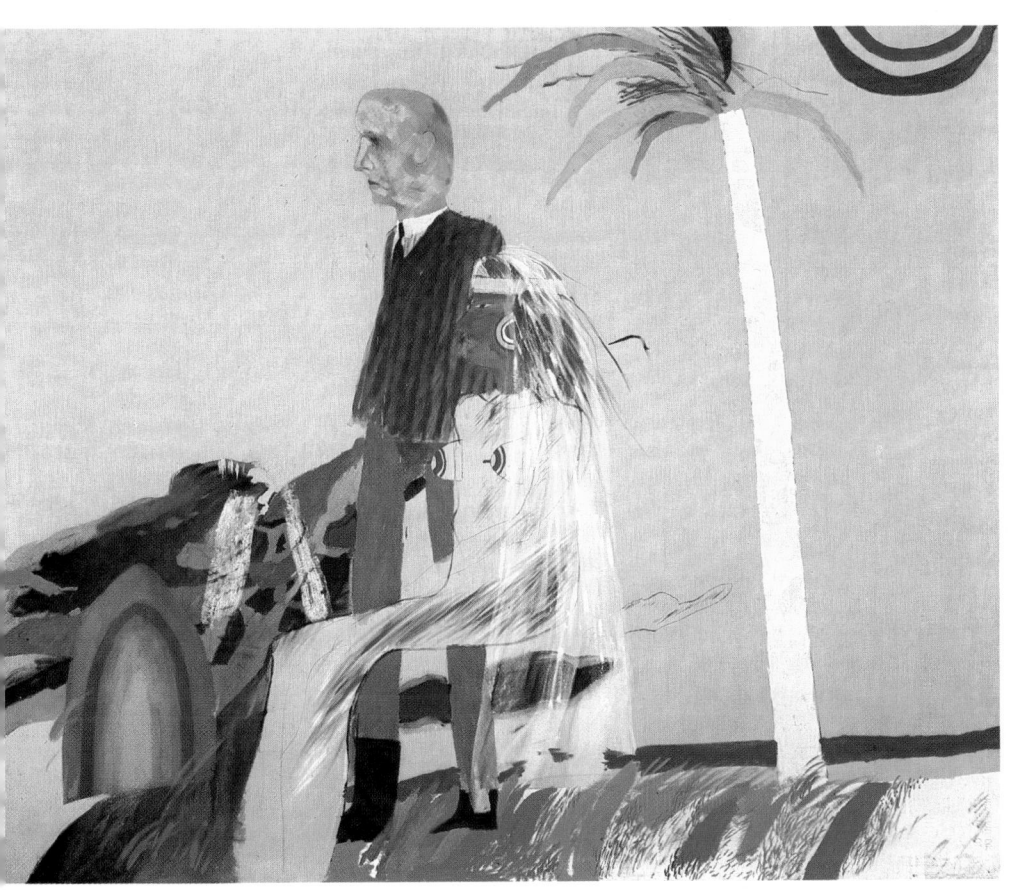

39 *The First Marriage (A Marriage of Styles)*, 1962

to depict the effect of Kasmin's face and hands pressed against the back of the *41* glass by adding painted marks to the *front* of the glass. The artist rests secure in the knowledge that the different levels of pictorial space will all meet, as they must do by definition, on the surface of the canvas, leaving him free to engage in illusions and to reveal dramatic human situations while maintaining the static quality of the image as an accumulation of painted marks. Hockney is thus able to maintain an allegiance to the tenets of Modernism while asserting the possibility of making pictures about anything he wishes.

Excited by the possibility of finding inspiration anywhere and at any time, Hockney quickly developed the habit of drawing constantly. The imagery of many of his paintings of the early 1960s was first proposed on paper, *36* sometimes, as in the sketch for the *Tea Painting in an Illusionistic Style*, as an invention towards a painting already in his mind. More commonly, however, it would appear that drawings were made in the first instance as independent works, and that of the many images thus produced only a certain number suggested possibilities for paintings.

Hockney continued during this period to draw from life, on occasion working from memory soon after an event or scene had been observed. This *40* is the case, for instance, in *Man Under Fiat Clock*, a depiction of a street scene in Viareggio as recalled at the end of the day in his hotel room. The selectivity of vision here can be accounted for by the method itself, since it was the contrast of the passer-by against the large clock and the distant building which attracted his eye and which remained in his mind hours later. The puzzling juxtapositions of scale, especially between the man and the clock, can be accounted for by the reversal of the lettering above the dial, revealing the image as a reflection in a window or mirror.

Given his delight in acute observation and the stimulation he has consistently found on his travel to new places, it is no surprise that Hockney accepted the invitation of the *Sunday Times* to travel to Egypt in September 1963 for the purpose of producing a series of drawings to be published in their colour supplement. (In the event, the *Magazine* did not print these because of the far greater urgency of political events including the assassination of President Kennedy.) This was the first occasion since his student days at Bradford on which Hockney drew consistently from life for a *42* prolonged period. Some of the Egyptian drawings, such as *Shell Garage, Luxor*, appear on first sight to be fanciful composite views along the lines of his earlier imaginary pictures. The surprising contrasts of scale in this picture, however, have a simple explanation, in that the huge disembodied bust of a man is, in fact, an enormous poster of Colonel Nasser pasted on to the side of a building. Hockney seems here to have relished the irony of producing what

40 *Man Under Fiat Clock, Viareggio*, August 1962

appears to be an image of pure fantasy but which in fact is based on direct observation. The double-take that we experience in looking at the drawing is equivalent to the shock of recognition which Hockney underwent on noticing the scene in the streets of Luxor.

Virtually all the Egyptian drawings were done in coloured crayons, a medium he had started to use in 1962 and which suited his painterly concerns at the time: a delight in textured surfaces, in clearly indicated boundaries and in decorative use of colour. In some of the drawings from this trip, however, such as *Man in Lobby, Hotel Cecil*, crayon is used not for rough textured surfaces but as an instrument for line drawing. Intent on noting down his observations with accuracy and detail, he began to change the function of the medium, emphasizing contour as a means of defining form in a succinct and expressive manner. This is also a practical consideration, since drawing from life requires a greater velocity if the essentials are to be captured. Filling in areas with colour can be too time-consuming when the valuable moments can be better spent in describing particular details. The linear drawing which results has an expressive beauty of its own which may obviate the need for any further elaboration with colour. Working intensely from life, moreover, made Hockney aware that his figures would be convincing as studies of real people only if they appeared to be endowed with volume.

43

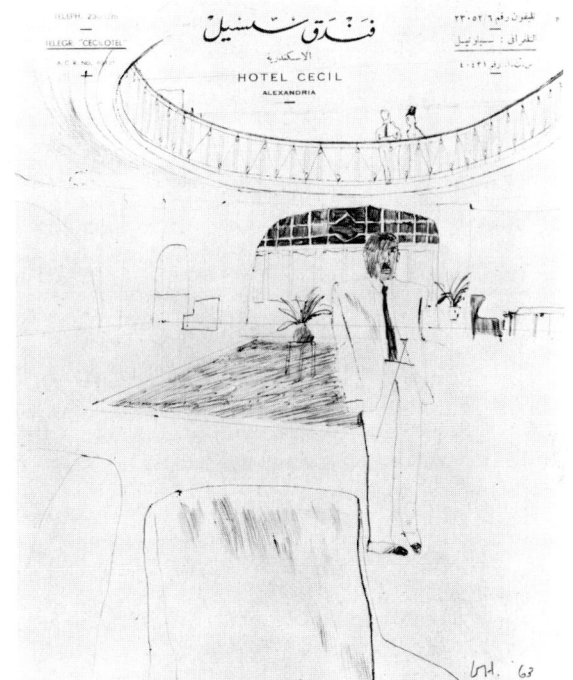

41 *Play within a Play*, 1963

42 *Shell Garage, Luxor*, 1963

43 *Man in Lobby, Hotel Cecil*, 1963

Through a few efficient lines, Hockney discloses that the man in *Man in Lobby* is standing in a three-quarter view with his torso slightly twisted to the left, and places him within a deep space established through the ellipse of the balcony overlooking him. The lines retain their identity as graphic marks not only because the imagery is still highly stylized, but also because of the way that the image encloses the printed heading of the hotel notepaper, establishing as in his earlier work a correspondence between the drawn line and the printed word. Many of the Egyptian drawings incorporate Arabic inscriptions as pictorial signs of particular beauty, making clear Hockney's continuing fascination with the look of words.

There is no immediate change in Hockney's drawing habits upon his move to California at the end of 1963 other than a confirmation of the opening out of possibilities. This becomes immediately apparent if one compares a group of four drawings of the human figure all made in 1964. *Square Figure Marching* is a pure invention, one of a number of figures he devised at this time from basic geometrical components, in this case a spherical head on a rectangular torso with arms in the form of elongated

44

44 *Square Figure Marching,* 1964

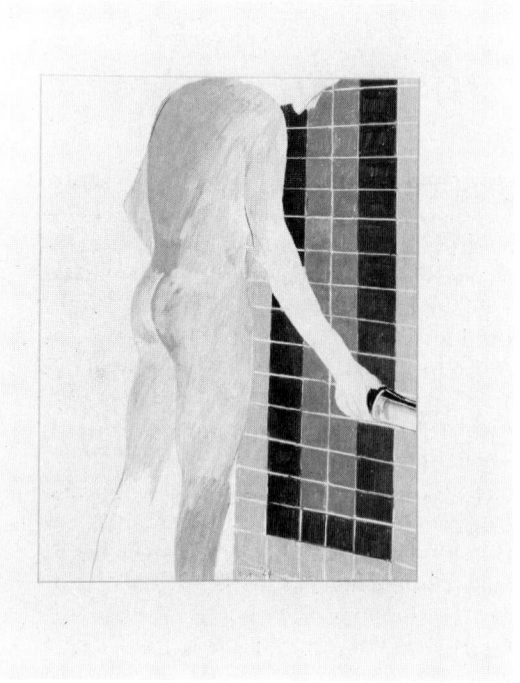

45 *Boy About to Take a Shower,* 1964

46 *Nude Boy, Los Angeles*, 1964

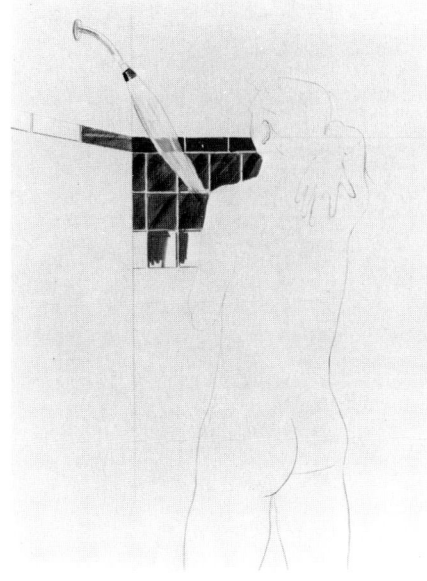

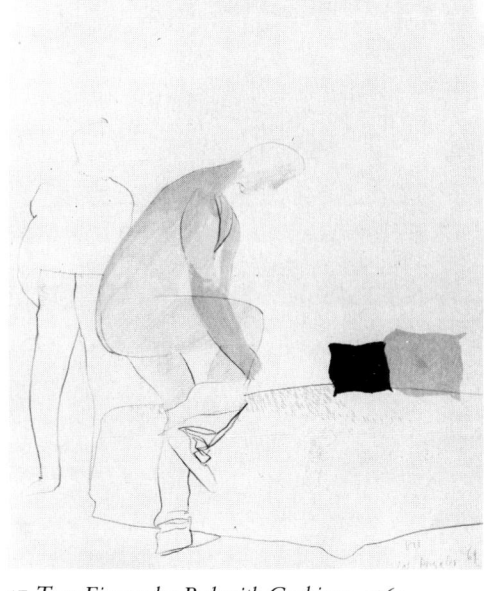

47 *Two Figures by Bed with Cushions*, 1964

ovoids. At the other extreme is the careful delineation and concern with tonal precision of the *Boy About to Take a Shower*, a highly finished study for the painting of the same name, which is drawn from the type of posed studio photograph to be found in *Physique Pictorial*, (Hockney had by this time visited the Los Angeles offices of the magazine to purchase further photographs for his own reference.) *Nude Boy, Los Angeles* is different again in its execution, relying on a continuous undulating contour to describe the flesh as sensuously and as economically as possible; this was drawn from life in the shower at Hockney's home on Pico Boulevard. *Two Figures by Bed with Cushions*, in contrast, was drawn quickly from memory soon after the event. The figures are faceless and exaggerated in form, disregarding all rules of anatomy, but their ritualistic movements are conveyed with a sense of pressing conviction that suggests the attentive scrutiny afforded by personal experience. It was drawn, Hockney recalls, during the only period in his life when he has been promiscuous; sometimes all he could remember after such encounters, after the memory of a casual sexual partner had disappeared, was the appearance of the bed.

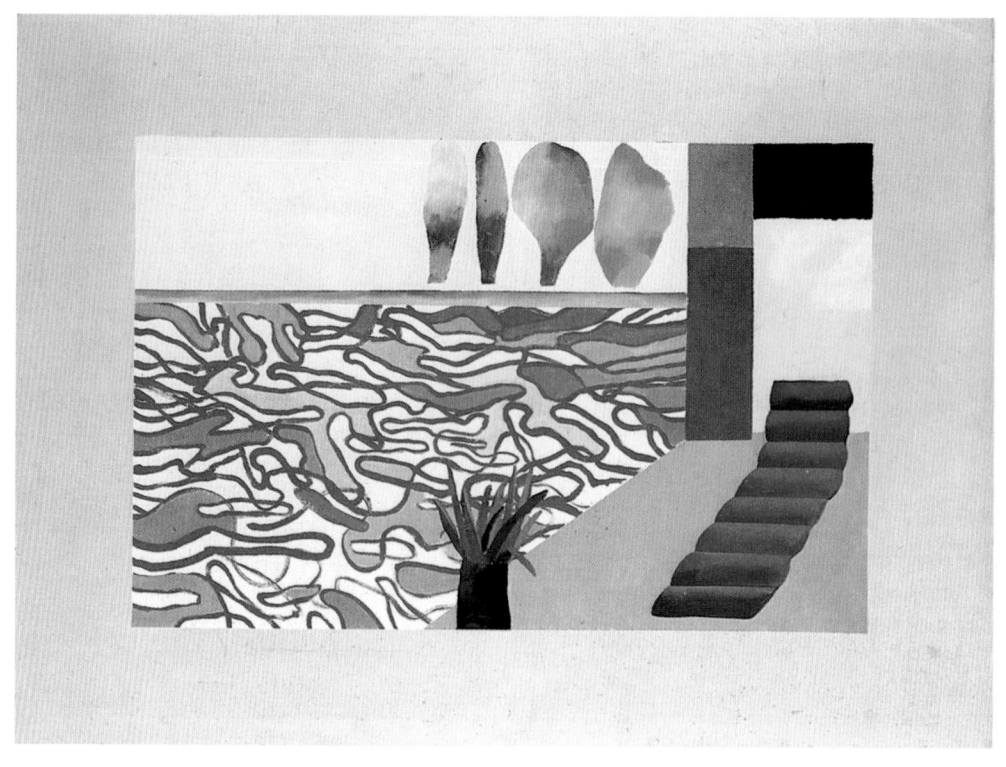

48 *Picture of a Hollywood Swimming Pool*, 1964

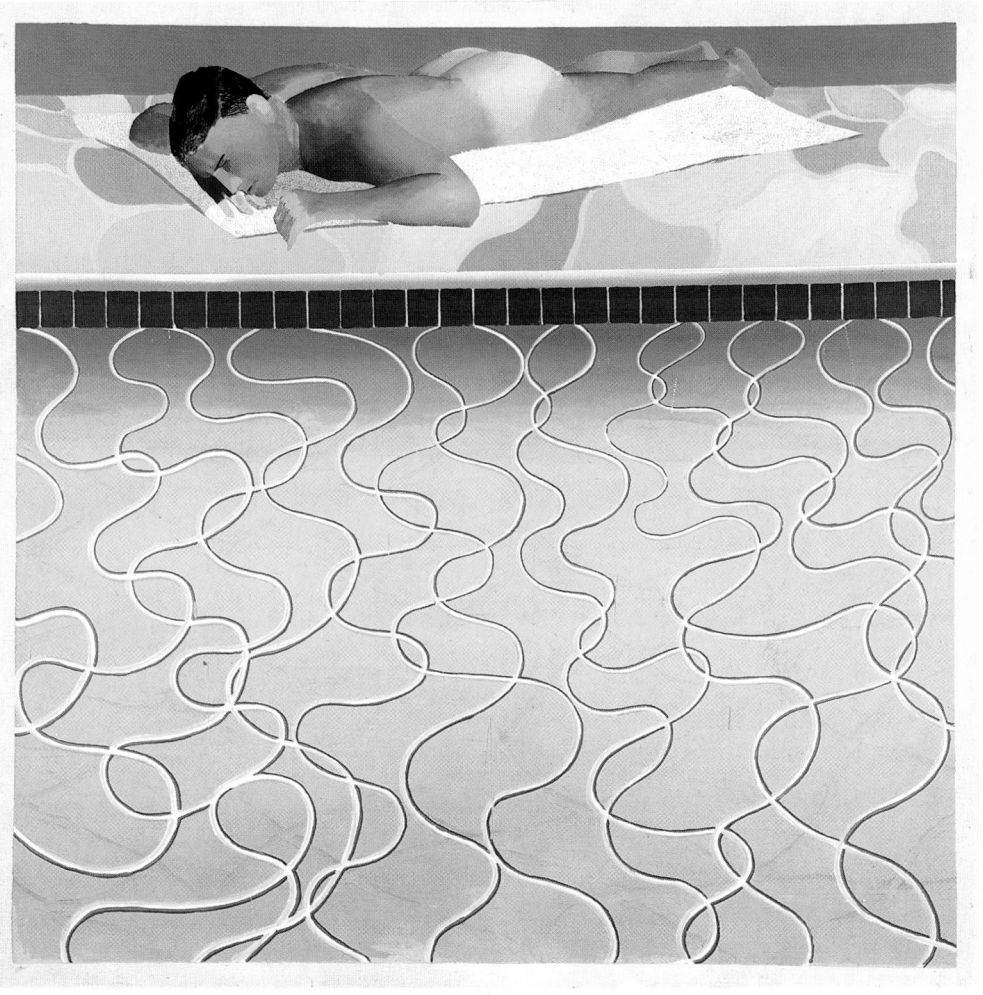

49 *Sunbather*, 1966

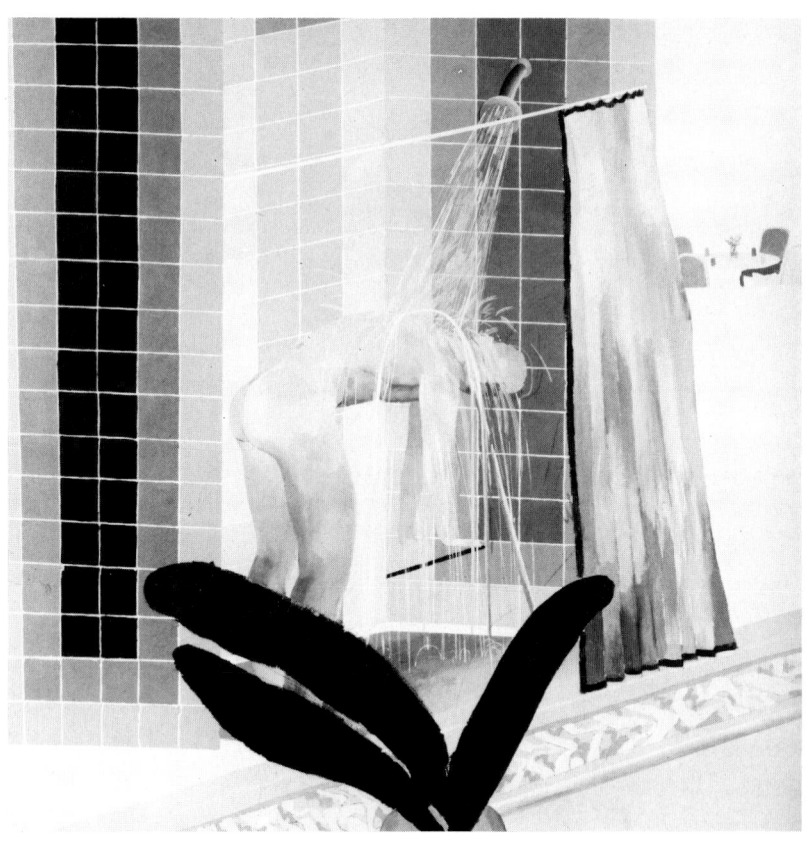

50 Man Taking a Shower in Beverly Hills, 1964

Just as Hockney's American drawings of 1964 carry on the spontaneity and varied approaches of his previous work on paper, so the imagery of his first Los Angeles paintings seems remarkably consistent with the invented *Domestic Scene, Los Angeles* painted before his first visit there. This can be attributed partly to the fact that even after his arrival in California he continued to refer to the photographic imagery on which his ideas of the place had been formed, a picture of life there as sensual, physical and uninhibited, a world of swimming pools and showers and athletic young men. The figure and tiled setting of *Man Taking a Shower in Beverly Hills*, for example, were painted from a photograph by the Athletic Model Guild; the painting was begun in Los Angeles and finished while Hockney was teaching in Colorado. Hockney went to California, moreover, in the hope of living

33

the kind of life he imagined to exist there, and found to his delight that the place matched his expectations: 'I think my notions *were* quite accurate in the sense that L.A. is a city where you can go and find whatever in a sense you want, and I found what I kind of expected. But what I expected was based on evidence from it, so it wasn't as though it was just a complete fantasy. It was based on what I had gleaned from little magazines and pictures and that sort of thing.'

Hockney has admitted that much of the attraction of Los Angeles for him was a sexual one, and that his image of the place was formed as much by John Rechy's homo-erotic novel *City of Night* (1963) as by the photographs and magazines he had seen. Indeed, the resonance of an otherwise bland image such as *Building, Pershing Square, Los Angeles* can only be understood if one knows that the location is the centre of the homosexual activity described in the section of Rechy's book that deals with Los Angeles. Hockney has depicted the Square, which is actually very drab and grey, as a virtual forest of palm trees in response to the poetic description found on the first page of Rechy's book: 'Remember Pershing Square and the apathetic palmtrees.'

51 *Building, Pershing Square, Los Angeles*, 1964

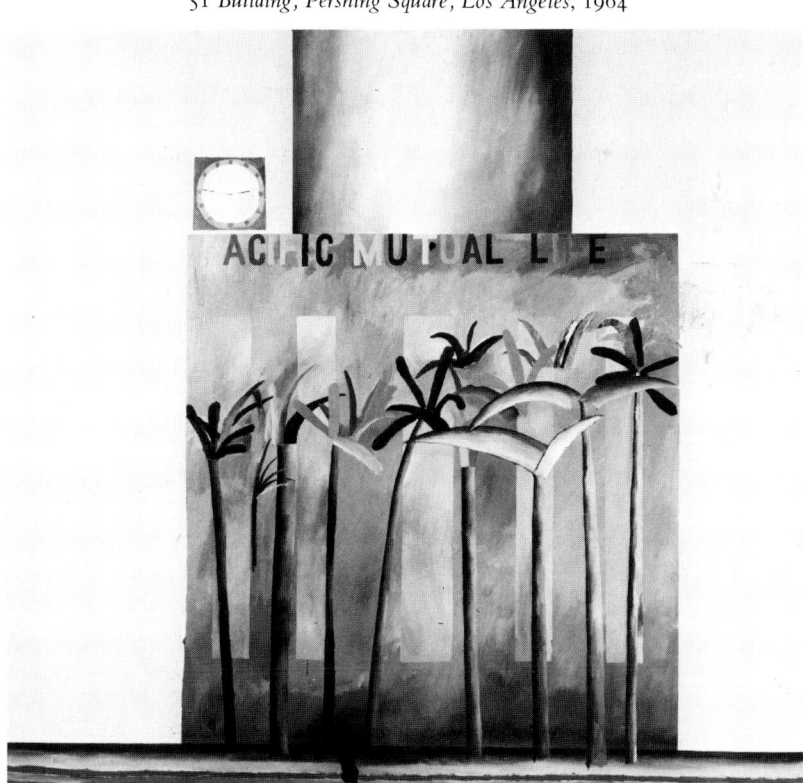

The particular beauty of southern California soon exerted its own fascination. 'It was the first time I'd ever painted a place,' recalled Hockney of Los Angeles in an interview many years later (*The Listener*, 22 May 1975). 'Egypt was almost the first place I'd ever *drawn*, as a real place. In London, I think I was put off by the ghost of Sickert, and I couldn't see it properly. In Los Angeles, there were no ghosts; there were no paintings of Los Angeles. People then didn't even know what it looked like. And when I was there, they were still finishing up some of the big freeways. I remember seeing, within the first week, a ramp of freeway going into the air, and I suddenly thought: "My God, this place needs its Piranesi; Los Angeles could have a Piranesi, so here I am!" '

53 In a series of pictures such as *Wilshire Boulevard, Los Angeles* Hockney represents the city as a sunny outdoor haven, characterized by curiously insubstantial architecture, omnipresent street signs and swaying palm trees. The economy of elements and of details, by which, for instance, the house is depicted as the conjunction of two flat geometric forms rather than by its attributes such as doors and windows, suggests that the image is a symbolic representation of a place rather than an objective recording of it. He is working from generalizations and from fragments of evidence, yet he presents these in highly specific form. The street sign and Letraset caption below provide the image with a factual identity, tying it to the observed scene on which the picture is based.

The urge to convey the appearance and atmosphere of a specific location is still held in check in these first Los Angeles pictures by fears, conditioned by Modernism, that simply 'copying' what one sees is a reactionary way to make a picture. Thus the more Hockney becomes involved with increasing the legibility of the image, the more aggressive he makes the pictorial devices as a means of compensation. The suggestions of space implicit in a depiction of people and buildings in an open urban setting are counteracted by a consistently frontal presentation and a highly formalized sense of design, with a consequent emphasis on surface pattern. The material composition of the image as paint on canvas, moreover, is drawn to our attention by the insistent border of bare canvas surrounding the image. Even the use of a caption printed on the surface with Letraset is a means of reminding the viewer that the picture is nothing more than an accumulation of marks of different kinds. Each element betrays the picture as an illusion, indeed to such an extent as to belabour the point.

The predominance of obtrusive devices reaches its peak in Hockney's work during 1964–5. Hockney seemed aware that his impulse to create convincing evocations of place was leading him back to a more traditional conception of painting. His first reaction, not surprising for an artist who had

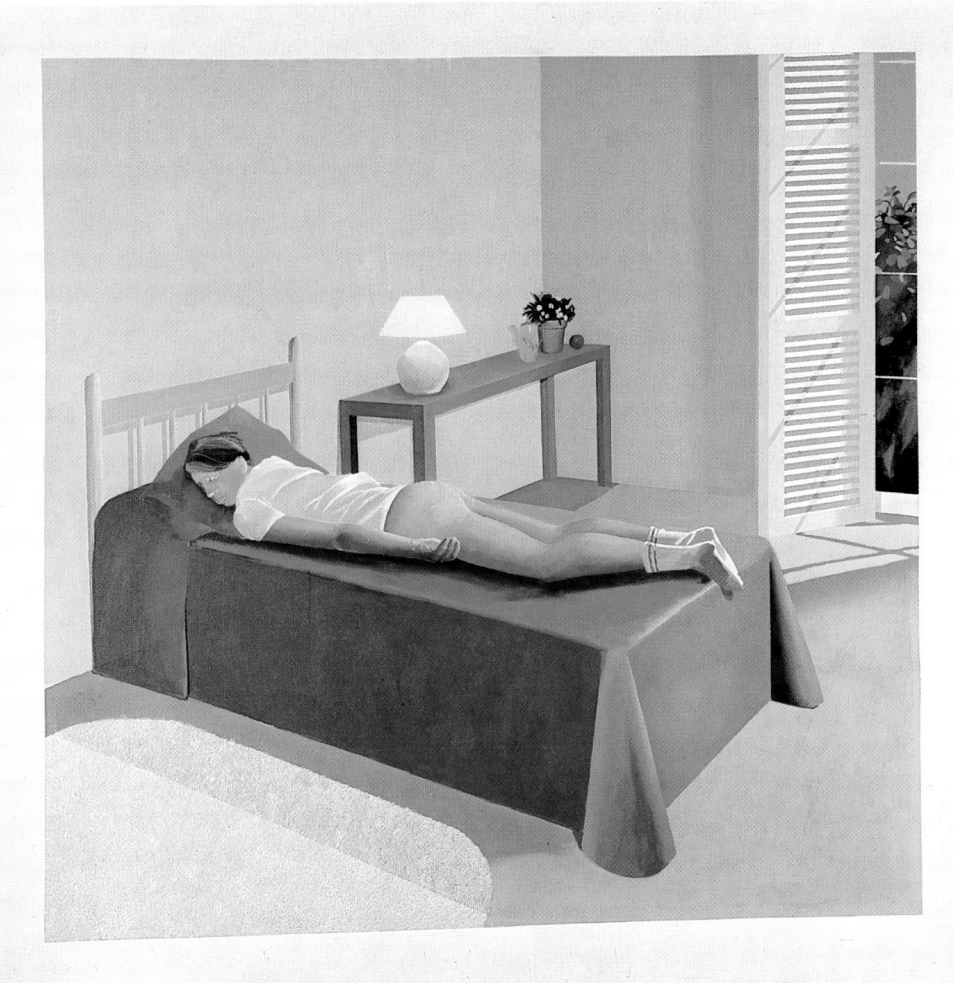

declared his modernity for the first time only four years earlier, was an anxiety to adhere to the principles of Modernism and to demonstrate the links between his work and that of other contemporary artists.

There are two important features which save Hockney's work from becoming too drily pedagogic in its demonstration of twentieth-century pictorial devices. One is the wit with which Hockney charges his stylistic references through a change of context. The curvilinear surface pattern of *Picture of a Hollywood Swimming Pool*, for instance, refers to Dubuffet's new *hourloupe* paintings, to abstracts by Bernard Cohen in which a looped line establishes a continuous movement across the picture, and to the arabesques of Art Nouveau (one of Cohen's own sources), but it succeeds despite the weight of reference because of the convincing way in which it evokes water in movement.

The other saving grace of these paintings is the interaction of decorative impact with succinctly stated imagery. On his arrival in Los Angeles, Hockney had begun to use American acrylic paints, the characteristics of which have much to do with the changes in his paintings at this time. More

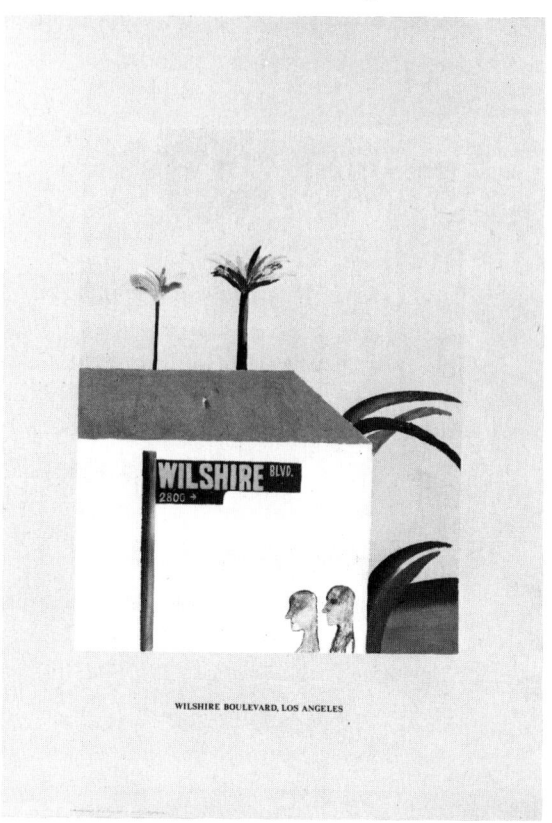

53 *Wilshire Boulevard, Los Angeles,* 1964

WILSHIRE BOULEVARD, LOS ANGELES

regular in consistency and much faster-drying than oil, this plastic-based paint could be applied thinly yet retain its full brilliance of colour. Hockney found that an assertive use of thick paint surfaces, such as characterized his own work of the early 1960s, was a feature of the art of the previous generation, including the paintings of Dubuffet as well as those of de Kooning and some of the other Abstract Expressionists. Like other painters at the time, he thought it would be interesting to use paint in an opposite way, applying it as a thin smooth surface in order to make the image more important than the paint.

The matt surface of acrylic paint in these pictures as a continuous skin or film of colour also calls to mind the flat, anonymous surfaces of photographs. It was, in fact, in this year that Hockney had acquired a Polaroid camera, with which he began to take snaps of friends, swimming pools and places he visited. Although he had no desire to give up his brushes in favour of the camera, preferring the painter's total control over the selection and placement of the images, the photograph may well have spurred him to a more neutral or depersonalized application of paint. He may also have been conditioned by certain currents in contemporary painting, including the Post-Painterly Abstraction of American artists such as Frank Stella and Kenneth Noland or the impulse to self-effacement and anonymity of surface in the work of Pop artists such as Andy Warhol, Roy Lichtenstein or Tom Wesselmann. A flat, unbroken and relatively unmodulated paint surface appears in retrospect to be a characteristic of much painting in the mid to late 1960s, including in different ways the work of other artists with whom Hockney had studied, such as Patrick Caulfield, Allen Jones, Peter Phillips and even R.B. Kitaj.

Often in Hockney's work a shift in approach can be traced to a change of medium, and in the mid 1960s it is not only his use of acrylic paints but also his growing interest in photography which must be taken into account. He had taken few photographs before, and on those occasions had worked in black and white because it was less expensive than colour. In 1964 he began using colour film, however, which he has consistently favoured ever since, not only because he found colour more interesting but 'also because every professional photographer tells you it's terrible.' The camera seems to have revealed the world to Hockney for the first time in terms of interlocking surfaces of colour, particularly vivid in the California light. There had been patches of brilliant colour in the early paintings, but these areas tended to be isolated from each other and often neutralized by expanses of bare canvas or murky colour. In contrast, colour becomes a major constructive element in the paintings of the mid 1960s. The vitality and decorative impact of broad expanses of intense hue are fully acknowledged.

It was to be some time yet, however, before Hockney felt prepared to use the full range of information provided by the photograph or to seek to rival its fidelity to natural appearances through his own observations. Hockney recalls that when he first used photographs, either taken by himself or found ready-made, it was simply for 'odd little details', and that he 'still relied on invention rather than using the photograph to tell you information.' This is the case, for instance, with *Man Taking a Shower in Beverly Hills*. The figure and tiles here are based on a photograph, but the image produced by the camera is used only as a guide rather than as a model to be slavishly copied. The images taken from the photo, moreover, are placed within an invented setting and the dramatized event is revealed by his favoured device of the curtain. Perhaps the most important factor of all is that the most memorable features are the stylized inventions: the animated silhouette of the plant superimposed over the figure to hide the difficulties he had experienced in painting the feet, and the trails of paint breaking off into short arcs which represent the spurts of water from the shower and the effect of drops bouncing off the figure or the floor.

Hockney's interest in transparent and reflective materials had manifested itself as early as the *Domestic Scene, Los Angeles*, 1963, but upon his arrival in California he began to increase his range of signs for glass and for water under different conditions. *Picture of a Hollywood Swimming Pool*, painted on his return visit to England at the end of 1964, was the first of many pictures on this theme, in each of which he has devised a slightly different solution to the challenge of painting water in motion. The effect here is still highly stylized, as much a representation of the idea of a gently rippling surface as an observed record of its appearance to the eye. The delight in devising abstracted signs and various techniques of paint application is even more marked in *Different Kinds of Water Pouring into a Swimming Pool, Santa Monica*, 1965. In perceptual terms, there is nothing very 'watery' about the imagery in this picture apart from the notions of flow rendered in static form. In a sense, water is not even the subject of this picture, but as he noted later in his autobiography, 'It offered an opportunity for abstraction – almost as much a recurring desire as painting a portrait.'

The flirtation with abstraction is nowhere more evident than in a series of paintings on a still life theme, all from 1965, starting with *A Realistic Still Life* and including also *A More Realistic Still Life* and *A Less Realistic Still Life*. In all these pictures and in related works such as *Portrait Surrounded by Artistic Devices* and *Blue Interior and Two Still Lifes*, Hockney takes as his premise a literal interpretation of Cézanne's famous remark about reducing everything to three basic elements: the cone, the cylinder and the sphere. At its most extreme in the 'less realistic' version, the result is a virtually abstract picture

54 *Different Kinds of Water Pouring into a Swimming Pool, Santa Monica*, 1965

that teeters dangerously close to vacuity in its presentation of slender formal devices outside their customary formal context.

Hockney may have been prompted to use geometric devices by the cubic qualities of modern American architecture, since California buildings, in particular, soon became material for paintings such as *Wilshire Boulevard, Los Angeles* and *Building, Pershing Square, Los Angeles*. In *Iowa*, painted in the summer of 1964 during a six-week visit to that state as a university lecturer, there is a deliberate interaction of pictorial depth with actual flatness, in that the massive floating clouds are self-evidently constructed from brush-strokes on the surface of the canvas. The still life paintings which followed a year later, however, carry the logical absurdity of this contrast to an intentionally ridiculous extreme. The cylinders in *Portrait Surrounded by Artistic Devices* are

53

51, 55

56

75

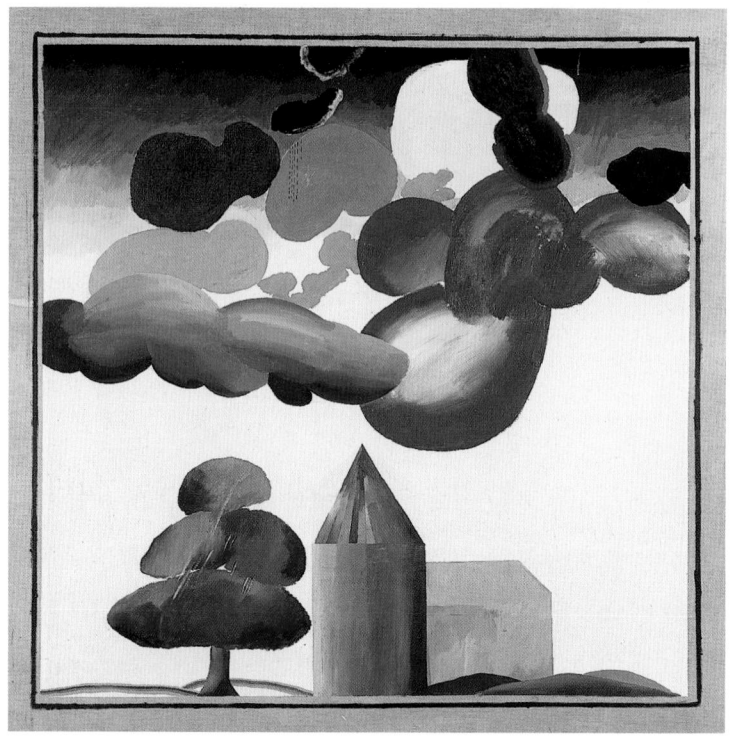

55 *Iowa*, 1964

piled up like so many useless and obsolete objects; stacked together in pyramid fashion, these so-called cylinders are revealed as nothing but patches of colour, existing only on the surface plane and incapable of projecting into real space. Close examination reveals the illusion to be even more of a trick than we might have suspected, for this entire stack of cylinders is painted on a sheet of paper which has been cut to the desired shape and collaged on to the canvas, thereby making its two-dimensionality an inescapable fact. Over the man's head, brush-strokes of different length and colour are placed next to each other as if stacked on a shelf, waiting to be removed into a new setting.

The superimposition of a mountain of devices over the portrait threatens to engulf the man and obscure him from view. One's suspicion that this is a cautionary image of formal devices run riot is confirmed by the knowledge that the man portrayed is Hockney's father; geometrical devices, Hockney implies, can be attractive in themselves, but they should not be allowed to replace an emotive involvement with the person whom the artist has taken as his subject. As Hockney recalled in his autobiography, '. . . the thing Cézanne says, about the figure being just a cone, a cylinder and a sphere:

56 *Portrait Surrounded by Artistic Devices*, 1965

57 *Blue Interior and Two Still Lifes*, 1965

well, it isn't. His remark meant something at the time, but we know a figure is really more than that, and more will be read into it. . . . You cannot escape sentimental – in the best sense of the term – feelings and associations from the figure, from the picture, it's inescapable. Because Cézanne's remark is famous – it was thought of as a key attitude in modern art – you've got to face it and answer it. My answer is, of course, that the remark is not true.'

56 If *Portrait Surrounded by Artistic Devices* provides both an examination and a rejection of Cézanne's concept of pictorial geometry as the dominant 57 element of painting, in other pictures such as *Blue Interior and Two Still Lifes* Hockney is at pains to find a way out of the empty formalism into which he had been tempted over the previous year. The technique of staining rivulets of colour into the canvas, borrowed from the work of Morris Louis and Kenneth Noland, is here reduced to the role of decorative frame. In so doing, Hockney recognizes the decorative qualities of such methods, but refuses to consider them as anything more than good design. The doubts that he casts on the rules of Modernism do not stop here. He treats each image within the coloured borders in an illusionistic manner, going so far as to have the formal devices cast shadows. Areas of canvas are still left bare, but the perspective and positioning of the furniture establish a cohesive internal space which suggests that Hockney is now willing to consider working within a more traditional frame of reference.

 Stylistic conceits in Hockney's Royal College work had been a means of declaring his freedom of movement. For a short time during 1964–5 there was a danger that their function would become a more circumscribed one, that of establishing his credibility as an artist aware of current trends and of the issues of the avant-garde during the twentieth century. As Hockney recalled in his autobiography, 'I have never thought my painting advanced but in 1964 I still consciously wanted to be involved, if only peripherally, with Modernism.'

 Hockney's anxiety about whether his work was suitably contemporary seems to have been shaken off by the time he came to produce the series of 58 lithographs *A Hollywood Collection* in 1965. The very title of the set, which was envisaged as an 'instant art collection' for a Hollywood starlet, was chosen for its connotations of fashion, which Hockney implies is an issue with which the artist should not be concerned. The pictures present traditionalism alongside the self-proclaimed avant-garde as opposing trends which can be chosen to taste. The titles of the separate prints, like the elaborately drawn frames which form part of the image, distance the artist from the styles contained within, thus making a claim for diminished responsibility. A landscape, a cityscape, a still life and a portrait all compete for our attention. *Picture of a Simply Framed Traditional Nude Drawing* jostles

58 A Hollywood Collection: Picture of a Pointless Abstraction Framed Under Glass, 1965

with *Picture of a Pointless Abstraction Framed Under Glass*. We have been trained to expect that a 'traditional nude' has been drawn from life, yet the extreme stylization of the figure here is as much an invention as the pattern of colours in the 'pointless abstraction'. Hockney reserves for himself the right to examine any or all of these areas, to experiment with any style or technique, to reject them all if he so wishes or to take from them those elements that interest him. The insistent presence of the frames makes it clear that the artist's ultimate concern is not with any one subject or form of representation, but rather with the act of picturing itself.

A Hollywood Collection reaffirmed many of Hockney's concerns from the previous five years: the notion of a picture within a picture, the free range of style and theme, the assertion of the artist's control over his chosen subjects, materials and techniques. Hockney was not allowing himself to be deflected by the considerable success which he had already experienced commercially and in terms of critical acclaim. He retained all his original ambitions and self-confidence and continued to present to his public demonstrations of his fertile imagination and versatility. There seemed little to indicate that his apprenticeship as a modern artist was drawing to a close and that a shift in direction was on its way.

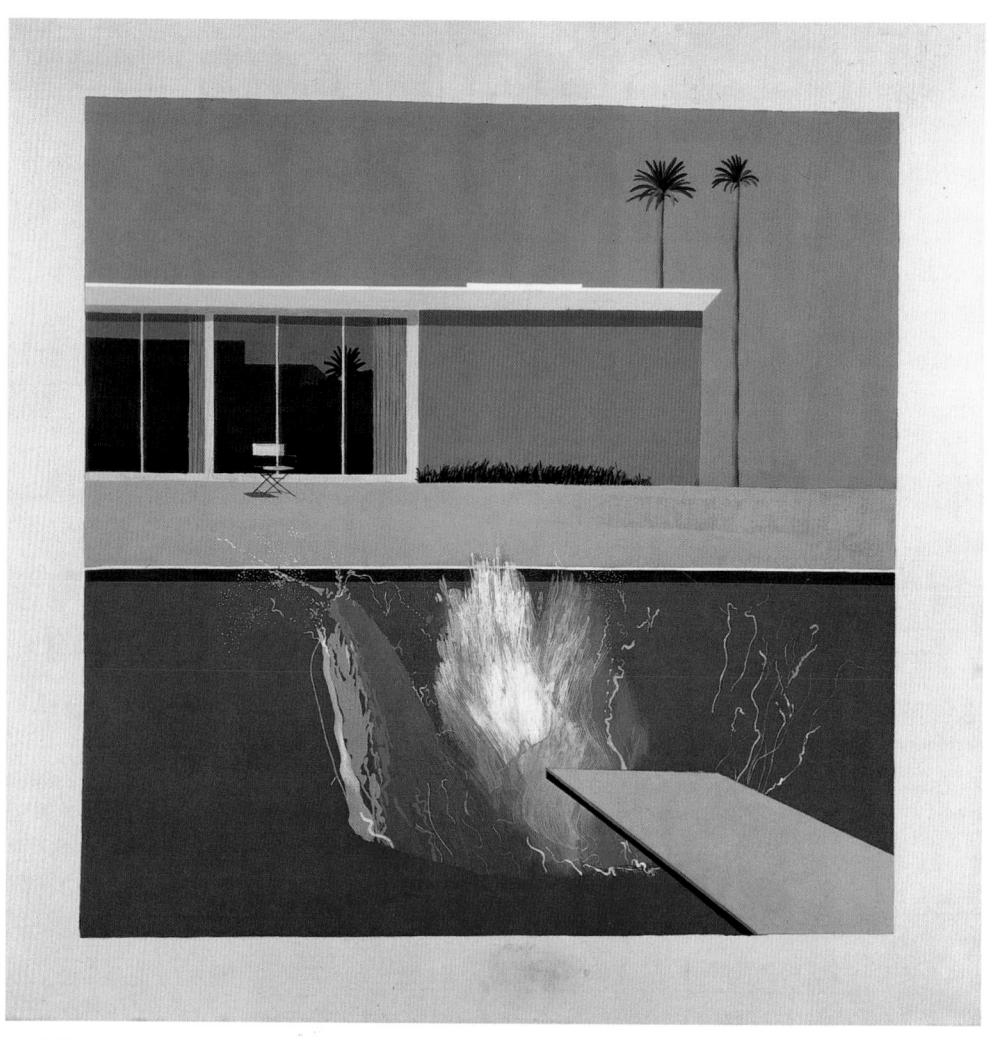

59 *A Bigger Splash*, 1967

2 Essays in Naturalism

Hockney's delight in artifice emerged in its most extreme form in the still-life paintings of 1965. At the time it might have seemed that he was once again on the verge of eliminating figurative references, as he had done for a short time during his initial year at the Royal College, but this was not to be the case. The still-life paintings are not quasi-abstractions but pictures about abstraction. In form they are deceptively empty, consisting of nothing but artistic devices, but Hockney has drawn attention to these devices as his subject, thus providing the pictures with a content that was lacking in his non-representational paintings of early 1960. Hindsight allows us to see these pictures as the culmination of one line of development within his work, as his purest statements concerning style as subject. 56, 57

It may at first seem surprising that at the same time that he was making pictures about abstraction, Hockney in his drawings was beginning to transcribe 'natural' appearances in a way that had not greatly concerned him since his departure from Bradford College of Art in 1957. Working in contradictory modes, however, was entirely consistent with his view of style as an element to be chosen and used at will. It was a question simply of exchanging one set of pictorial conventions for another.

Since his arrival at the Royal College in 1959, Hockney had painted sporadically, but not consistently, from life. During this time he was involved with the 'look of things' mainly through the filter of a stylistic device. In California, on the other hand, he became much more interested in the specific appearance of objects and places. He began to use drawing as a medium for noting down what he saw as directly as possible, seeking to retain his sensations of the moment by tying them immediately to the page rather than attempting to hold them in the mind as vague memories.

Hockney's use of drawing as a visual diary was an important factor in the emphasis on descriptive exactness in the paintings that followed in 1966, for it directed his attention to the characteristics that differentiate one object from another rather than to the general types or categories to which these objects belong. Without losing sight of the fact that there is no such thing as a 'styleless' style, that any form of representation makes use of a set of conventions, there nevertheless occurs a shift away from self-conscious style in favour of depiction. Devices continue to be in evidence, but they are now

placed at the service of the image rather than brought to our notice as the primary subject of the picture.

Major changes were effected in Hockney's drawing methods between 1965 and 1966. Many of the drawings of the early 1960s were in coloured crayons, with the emphasis on the surface texture as in the paintings of the same period. The style of execution was deliberately loose, the figure style consciously disjointed or schematized, and there was a tendency to organize a composition through the relation of fragments. Even when drawing from direct observation, as he did in Egypt in 1963, the strong element of exaggeration and stylization distanced the scene portrayed from reality.

60 The shift in function of drawing as a tool for observation can be seen as early as *Bob, 'France'*, drawn aboard ship on his return to England towards the end of 1965. It is self-evidently drawn from life, not only because of the convincing treatment of anatomy and the avoidance of stylization but also because of the way that the pencil lines and areas of pink crayon suggest the softness of the flesh and rounded mass of the figure. Amassing evidence in the most economical and expressive manner possible, contour rather than surface is the essential feature, since the enclosing line alone serves to define the form. The pencil line both describes the form and expresses the inner forces of the figure, while the selective use of pink crayon across the buttocks and the pose itself emphasize the man's sexual desirability, taking for granted the homo-eroticism which less than five years earlier Hockney had promoted as a subject for strident propaganda. The sense of heaviness of the figure sprawled out on the bed, along with the carefully chosen details such as the guardrail by the edge of the bed and the sheets gathered over the man's feet, convince us that the scene was witnessed rather than invented. Hockney ensures, however, that we experience the figure sensually, and not only in terms of its beauty, by concentrating our attention through line as well as colour; the right buttock trails off into nothing, leaving the figure with only one visible leg, and the pinkness of the flesh is presented in those areas that Hockney finds especially appealing.

61 A similar combination of selectiveness with attention to observed detail can be found in *Michael and Ann (Upton)*, a crayon drawing from December 1965. This heralds a new use of the medium of coloured crayons in Hockney's work. The concern for surface textures found in his earlier crayon drawings persists, but it is now subservient to a more tightly descriptive form and to the decorative impact of colour and *mise-en-page*. The medium continues to serve as an equivalent on a reduced scale for his paintings, but where he once would have emphasized the invented quality of the images and their physical presence as a deposit of colour on the surface, he now draws our attention to the subject as an observed reality and to the

60 *Bob, 'France'*, 1965
61 *Michael and Ann (Upton)*, December 1965

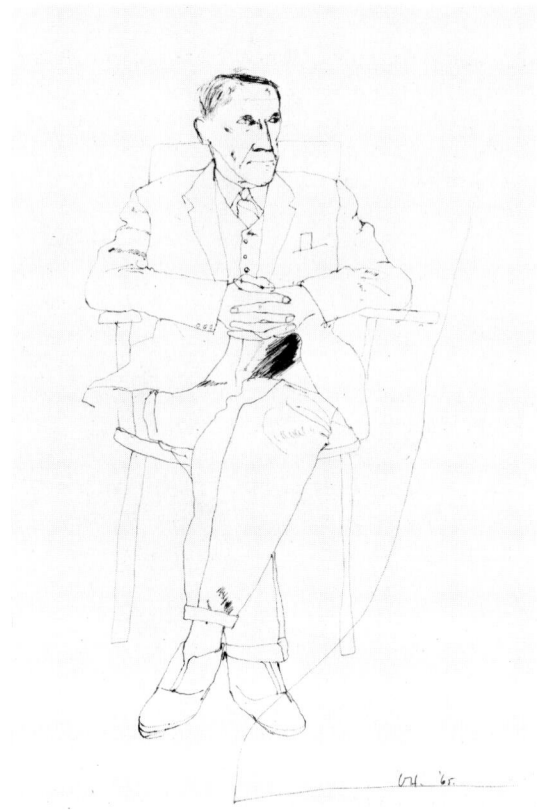

62 *Kenneth Hockney*, 1965

fabrication of the image as a direct response to what he sees. The sitters in this, as in many of Hockney's later drawings, are close friends. Because he knows them well, there is no need to insist on achieving a likeness; it is assumed that this will emerge naturally and that it can be caught as much in the pose and facial expressions as in the person's features. Essentially these drawings arise from an urge to make or deepen contact with other people, and as such their role is a far more intimate one on the whole than that of the paintings. 'I did learn quickly,' Hockney recalls, 'not to bother what the reaction of the sitter was. It's not much to do with them, really. I'm not making the drawings for them, I'm making them for myself.'

Kenneth Hockney, a portrait of the artist's father drawn in 1965, was one of his first line drawings in ink, and it is evident from the rather awkward result that he was still struggling with the medium. There are particular difficulties with the head, parts of which have been redrawn twice in an attempt to find

the right contour, and the rather arbitrary marks on the sleeves and trouser legs reveal that the problem of depicting folded cloth through line alone proved equally troublesome. Hockney acknowledges that he has not captured the character of the sitter, but adds that 'if you're going to experiment, you must expect failure.' The idea of making line drawings of the figure attracted him because of the very difficulty of the enterprise, a challenge which appealed to him even more because of the fact that so few twentieth-century artists had attempted them. There are still resemblances, almost certainly as a result of habit rather than intention, between the drawing of his father and the rather caricatural drawings he had made in the early part of the decade under the influence of George Grosz. Stylization in this case appears to be the result simply of inexperience. Hockney's solution was to improve his technique by giving himself an intensive course in drawing from life. It is difficult not to agree with his own estimate that his line drawings are among his greatest achievements and that they have consistently improved over the years, with the line itself becoming more beautiful as well as more economical in transmitting information.

The expressive potential of line suggested by the new drawings was vividly realized in the *Illustrations for Fourteen Poems from C.P. Cavafy*, 1966, Hockney's first major series of etchings since *A Rake's Progress*. Hockney had made occasional reference to Cavafy's writing in earlier prints and in *A Grand Procession of Dignitaries* of 1961, but it was only with this book of etchings that he was able at last to produce a major statement inspired by the poet. The idea for the series was Hockney's own, but his original intention of illustrating a far more ambitious range of poems proved impracticable and it was decided only to include those on the subject of homosexual love. Plans to use John Mavrogordato's translations were also rejected because of copyright problems, so it was decided to produce a new translation. Stephen Spender, who had earlier purchased etchings from Hockney, introduced him to Nikos Stangos, and together the two poets devised the texts that were published with the etchings in 1967.

Hockney went to Beirut at the beginning of 1966 to draw, as a way of researching imagery for the prints. Beirut seemed to him to be the contemporary equivalent of Cavafy's Alexandria, in that it had now replaced Alexandria as the most cosmopolitan city of the Middle East. The trip provided Hockney with architectural settings of suitably Arabian character for three of the prints, but what he most wanted was simply to get the flavour of the place and its way of life. The poems, however, have a far more general application as reveries on human relationships, and Hockney thus felt free to take inspiration from his own experience and environment. *Boys in Bed, Beirut*, an ink drawing which (unusually for Hockney) was

63, 65

1, 22

24

64

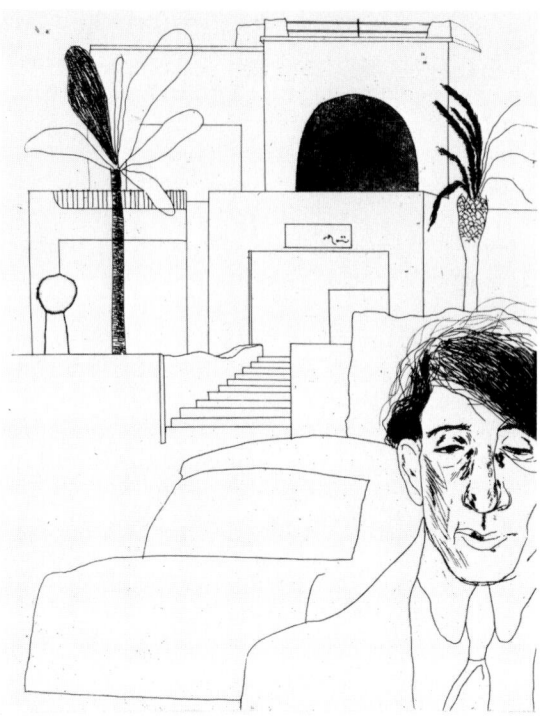

63 *Illustrations for Fourteen Poems from C.P. Cavafy: Portrait of Cavafy II*, 1966

copied on to the plate for one of the prints, *According to the Prescriptions of Ancient Magicians*, was actually drawn in London using two of his friends as models. The demands of the project forced Hockney to break some of his own habits, since if he had planned this as a self-sufficient drawing it would not have occurred to him to pose the boys in the middle of an action in this way. Some alterations were made in redrawing the image on to the plate: the figure in bed has been cropped by the framing edge, and the entire image has been shifted further up the page; the vertical line defining the corner of the room has been eliminated; and details such as the hand of the standing figure, which is badly defined in the drawing, have been redrawn, though judging from the still awkward result it is questionable whether this was done from direct observation.

Photographs were also used as reference material, especially for the prints which Hockney describes as 'very posed', such as *In an Old Book* and *The Beginning*, as well as for the portraits of Cavafy, where he had no choice. It is a solution, however, which he finds far from satisfactory: 'Things like weight and volume are very hard to get from a photograph. You don't get the

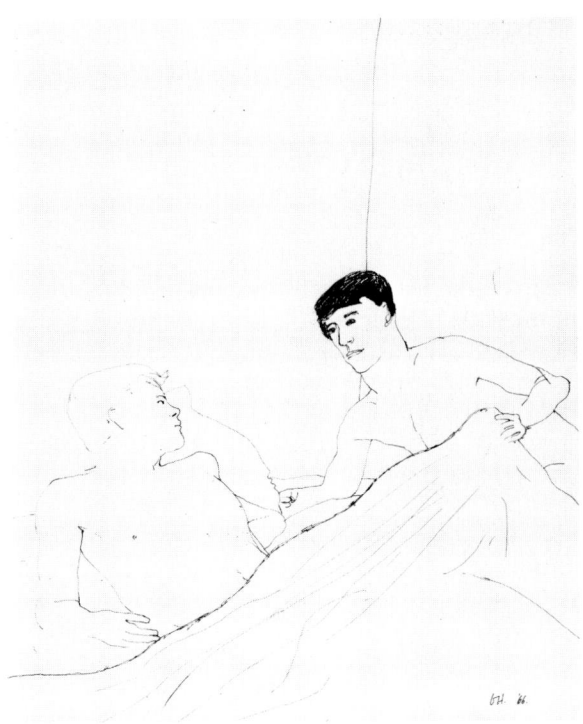

64 *Boys in Bed, Beirut*, 1966

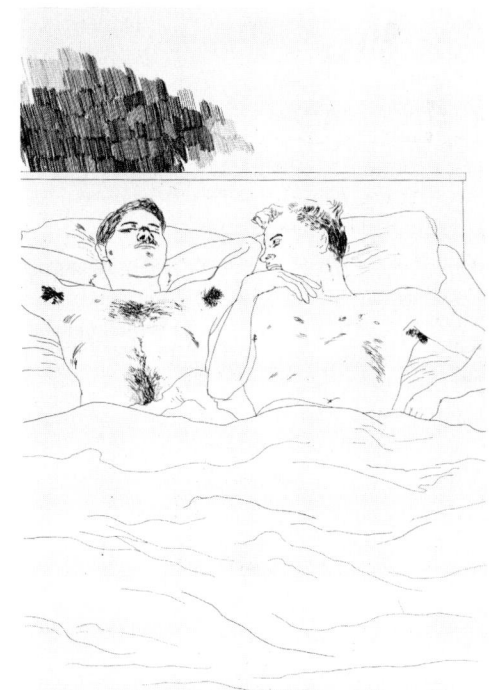

65 *Illustrations for Fourteen Poems from C.P. Cavafy: In the Dull Village*, 1966

information you need to be able to do the line. You could draw in another way from a photograph or you could draw it imaginatively, you could really interpret it, but if I was trying to draw you now I would find it a lot better to have you there rather than for me to take a photograph. I can often tell when drawings are done from photographs, because you can tell what they miss out, what the camera misses out: usually weight and volume, there's a flatness to them.'

63 *Portrait of Cavafy II* depicts the poet in front of an architectural setting copied from a drawing made by Hockney of a police station in Beirut. Although the *mise-en-page* has been altered and the entire image has been reversed in printing, the drawing has otherwise been transcribed faithfully, retaining even the modern car in the foreground. Hockney seems unworried about any such anachronisms, for if modern Beirut has the flavour of Cavafy's Alexandria, then it follows that it is more important for him to be faithful to his observations than to attempt an accurate historical reconstruction. The images, like the English texts which they accompany, are conceived as a translation into a language in current use.

The appeal of Cavafy's lines for Hockney lies not so much in particular images as in the atmosphere they generate: the sense of wistful nostalgia for events in the past, for fleeting experiences, for people with whom one has had brief but memorable contact; the conviction that history is not only continuous in a linear fashion, but that the past remains alive because human nature is essentially constant; and the sense of being torn between a deep interest in other people and the ultimate need to remain aloof, a spectator of other people's lives. These attitudes are strongly present in Hockney's own work. By nature they are rather intangible qualities, and it is difficult to say whether Cavafy has influenced Hockney's way of thinking or whether Cavafy's writing could be assimilated by the painter because he already 'thought like a poet'. One thing that is clear is that the accuracy with which Hockney presents these encounters has much to do with the fact that he has observed and participated in similar situations himself. His own memories of

47 experiences such as that depicted in the 1964 drawing *Two Figures by Bed with Cushions* inevitably will have coloured his conception of the prints, and it is this capacity to draw on personal insights which provides this series with its sense of authenticity.

Only a small number of the Cavafy etchings (*He Enquired After the Quality, The Shop Window of a Tobacco Store*) depict a particular place or scene as described in the poem. The prints demand, instead, to be appreciated as a group of recollections or visions which in their totality provide an experience similar to that suggested by the poems. This is attested to by the fact that Hockney did not have the poems by his side while he was working

and did not conceive of each image as an illustration of a particular poem; the reverse is, in fact, the case, for instead of choosing the poems first, he and Nikos Stangos assigned poems to the etchings only after the prints were done. Five etchings planned for the series were rejected at this stage, either because Hockney did not consider them good enough or because they disrupted the continuity of the set. If Hockney can be said to resort to illustration in many of his paintings, it is paradoxical that when he does come to illustrate literary texts his approach is not that of the conventional illustrator. The Cavafy prints are not literal depictions of the subject-matter of each poem but a visual equivalent to the mood and theme of all Cavafy's homo-erotic poetry, just as the later Grimm etchings are evocations of a particular world rather than illustrations of events described in the narrative. The Cavafy images create an almost musical sequence in their variations on the theme of two men, the deliberate repetition of the pairings conveying the sense of ritualized action at which the poet hints: the endless pick-ups in anonymous settings, the urgent need to relate to another human being. The delight in physical sensation is transmitted not only by the imagery of lithe nude bodies but also by the formal sparsity of the compositions and by the emphasis on tactility effected by the contrast of the wiry etched lines against the smooth surfaces of white paper.

The Cavafy etchings are conceived almost entirely in terms of line, unlike Hockney's earlier prints in the medium, which relied to a great degree on aquatint, on gestural scribbles and on variations of tone and surface. Two years had passed since he had made any etchings, and when he now returned to them it was with the intention of putting to use what he had learned from drawing the figure in pen and ink. The Cavafy prints are, in effect, the most accomplished line drawings that Hockney had yet made.

Hockney has consistently favoured etching over other print-making media; he appreciates its flexibility and the fact that he can retain full technical control over its production. The equipment and technical expertise required for lithography, for instance, is more complicated, and it was for this reason that Hockney, having made three lithographs at art school in 1954, did not return to the medium until invited to do so ten years later by the Atelier Matthieu in Zürich. He experimented only once with screen-printing, probably the most popular and certainly the most influential graphic medium of the 1960s, at the instigation of the Institute of Contemporary Arts. The result, *Cleanliness is Next to Godliness*, he regards as *66* his worst print; he allowed it to be published only because it was part of a commission involving other artists. This was the only occasion on which Hockney used a camera-produced image in a print, rather uncomfortably masking a photograph culled from a physique magazine with a hand-cut

66 *Cleanliness is Next to Godliness*, 1964

stencil representing a shower curtain. It is a disjointed and incoherent image; the pool of water, for instance, is a fragment of a Harold Cohen screenprint, a witty reference but an unsatisfactory visual solution. What Hockney most disliked about screenprinting, however, was the mechanical nature of the process, the fact that it does not depend on the autographic mark. Curiously, the flat areas of colour in Hockney's paintings of the mid 1960s have much in common with the formal qualities of screenprints produced with the aid of hand-cut stencils, implying that his sensibility may have been affected by the work of other artists in this graphic medium. Hockney agrees that some of the imagery he was using in his work at that time, above all the swimming pools, might have lent itself to screenprinting, but says that in California there was no screenprinter with whom he could have worked who was comparable to Chris Prater of the Kelpra Studios in London. In any case, his dissatisfaction with the one print he did produce with Prater caused him to reject the possibility of working again in this medium.

One of Hockney's strengths has been his willingness to extend his work, even at the risk of failure, into a new medium or context. It is this enthusiasm for experiment that led him to accept a commission from the Royal Court theatre to design a production of the Alfred Jarry play *Ubu Roi* in 1966. Even though his own preoccupations in recent months had been with devising a

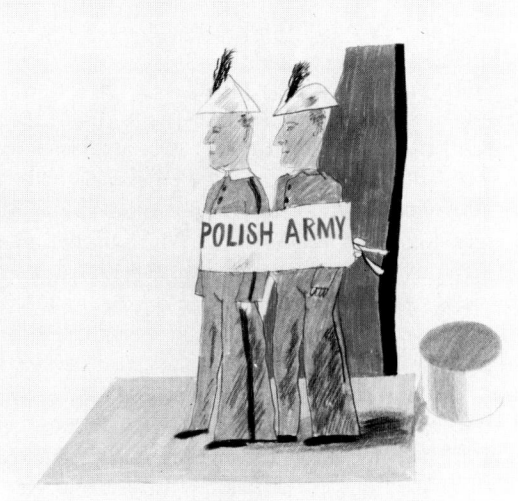

67 *Polish Army, Ubu Roi,* 1966
68 *The Polish Royal Family, Ubu Roi,* 1966

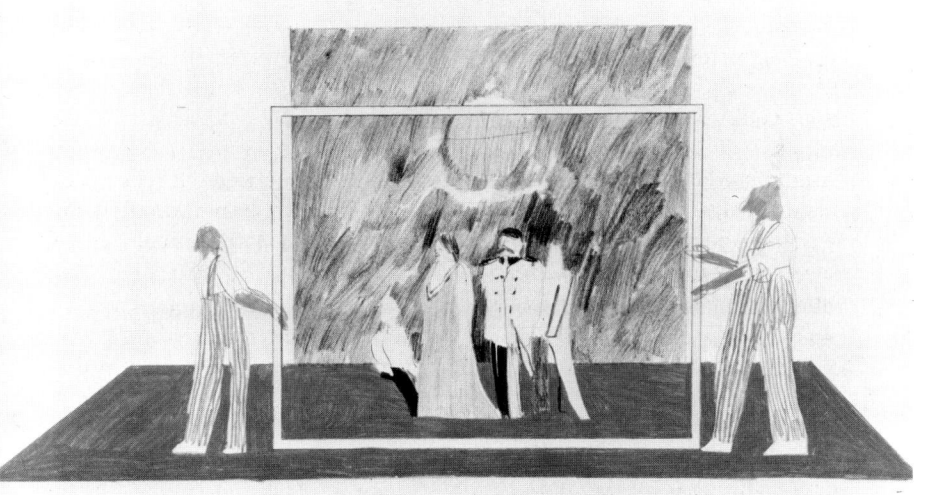

more naturalistic rendering of the human figure in his life drawings and the Cavafy prints, the challenge of working from the imagination for the stage greatly appealed to him. He was afraid at first that the theatrical devices he had used in his earlier paintings would simply disappear if transferred again to the stage, but he was encouraged by the knockabout humour of the play, its rapid scene changes and the author's written instructions to keep the designs simple rather than bothering with traditional scenery. Hockney followed the spirit of the advice very closely and presented the play, first performed in 1896, as a series of conceptual tableaux. Much of the fun lies in establishing a simple visual equivalent for the often riotous action of the play.

67 The entire Polish Army consists of two uniformed men with an identifying banner wrapped round them, while the parade ground is established simply by placing on stage a series of letters which spell out the location. Most of the scenes were done as small backdrops measuring eight by twelve feet, so they are presented in effect as a series of static visual images which define a specific space for the human participants. Hockney's favoured framing device is used

68 for the arrival of the Polish royal family, describing the scene as a picture within a picture by mimicking the conventions of official group portraiture.

The *Ubu* designs come at the end of Hockney's period of involvement with the notion of versatility of style. Both the requirements of the play and Hockney's delight in the artificial led him to an exaggerated and anti-naturalistic treatment that was at odds with the development of the rest of his work at that time. It is doubtful, however, that naturalism would ever have appealed to him in the theatre in the way that it did in his paintings. He did

139–40 not work for the stage again until he designed *The Rake's Progress* nine years later, simply because no one asked him, but his delight in contradiction leads one to suspect that he would always have favoured a more stylized idiom in this context. The fact that real people are making real actions appears to encourage him to provide a blatantly artificial setting for their activities, so that their metaphorical content can be better perceived. The audience should remain conscious that what they witness is a parallel to, or analysis of, life rather than its imitation. Hockney recognizes that there is a danger, too, in over-simplification, for if the sets are too minimal they can be distracting and obtrusive. What matters fundamentally is that it all be of a piece: 'In the theatre you must believe. And you can believe many things, so long as they have a unity!'

The backdrops which Hockney used in the *Ubu* plays may well have clarified his ideas for the more naturalistic paintings which followed on his return to California in the summer of 1966. The notion of the rectangle of the canvas as a setting for human activity exists in seminal form in earlier works, but usually in terms of a generalized stage, as in *The Hypnotist*, 1963,

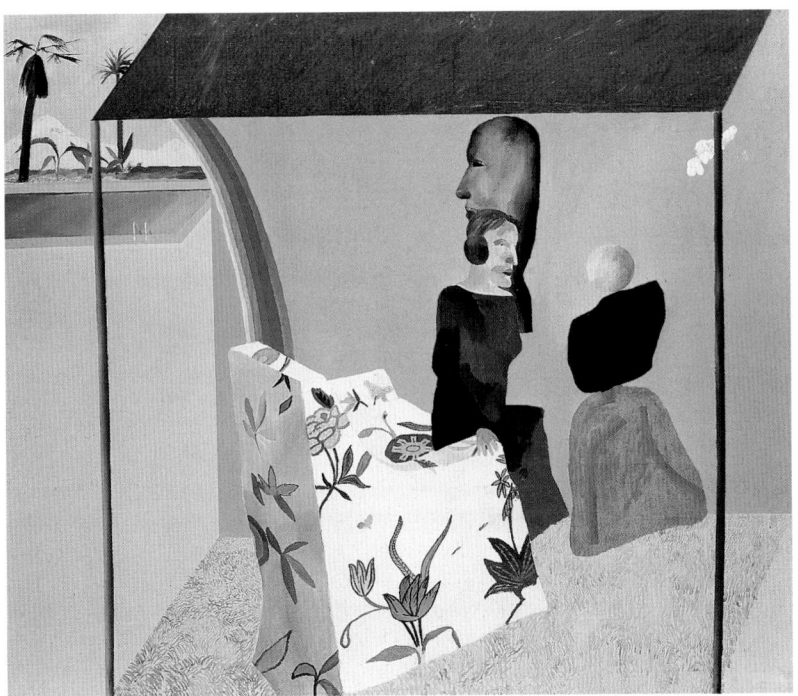

69 *California Art Collector*, 1964

or in terms of scattered objects and props within the neutral setting of the canvas, as in the Domestic Scenes of 1963. In 1964 he had begun to devote much more attention to the architectural settings, in the shower paintings as well as in *California Art Collector*, but it was only in the second half of 1966 that he began to place real people within identifiable settings.

29, 30, 33

A comparison between *Beverly Hills Housewife*, the first painting that he began on his return to California, with his treatment of a similar subject in *California Art Collector*, 1964, displays the enormous shift which had occurred in Hockney's work over this two-year period. The earlier picture is, in his own words, 'a complete invention', although details such as the primitive head, the William Turnbull sculpture and the fluffy carpets are drawn from his observations of typical homes of well-to-do collectors in Los Angeles. The figure, however, is not a portrait, and the house is only a notional one, borrowed from the simplified settings characteristic of Early Renaissance paintings (see, for example, the figure beneath a loggia in the scene of the Annunciation to St Anne by Giotto in the Scrovegni Chapel, Padua). The swimming pool in the background was copied from a newspaper

70

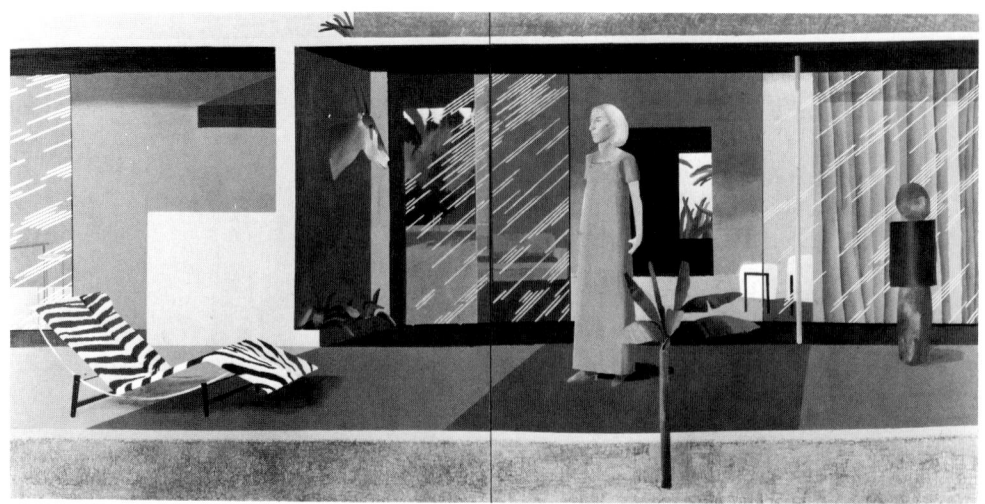

70 *Beverly Hills Housewife*, 1966

71 PIERO DELLA FRANCESCA *The Flagellation of Christ*, 1455

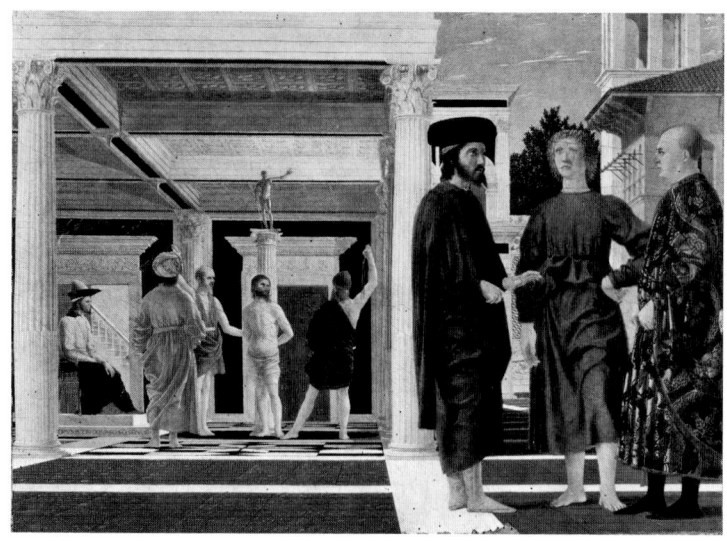

advertisement, although Hockney insists that the photograph is not the real source material but only a visual reference that happens to be in a convenient and accessible form. He had observed that swimming pools were a common feature of Los Angeles homes, and decided to put one in his painting; only now did he set about looking for a picture of a pool as a 'memory-jogger'.

72 Betty Freeman, Beverly Hills, 1966

Beverly Hills Housewife, measuring six by twelve feet, was Hockney's largest and most ambitious picture for some time. The relationship of the figure to its architectural setting continues to refer to Early Renaissance prototypes such as Piero della Francesca's *Flagellation of Christ*, in which the figures are depicted as if performing on a platform, but Hockney has based the details of his painting on a small group of grainy, badly lit black and white photographs of Betty Freeman standing on the porch outside her home. Hockney had purchased his first camera, a Polaroid, in 1964, and he used it at first only for 'odd little details', still relying on invention rather than using the photograph as a source of information for the picture as a whole. The close-up of Betty Freeman is so small and lacking in definition as to provide only the most meagre assistance in building up the stance and features of the figure. Hockney has used other elements visible in the photographs, such as the curtained window and the Turnbull sculpture, but has taken enormous liberties in interpreting these images in paint. The position of the pole which holds up the balcony has, for example, been moved back to avoid a sense of clutter in the foreground, and the spiky plant which occupies a central position in the right-hand panel has been added as a kind of companion for the woman.

In spite of Hockney's rather casual attitude to photography at this time, its introduction as an integral part of his working methods had a great impact in changing the orientation of his work. The use of photographs as an adjunct to drawings corresponds to a highly traditional system of organizing a composition with its subsidiary details, a procedure which inevitably places a

70

71

72

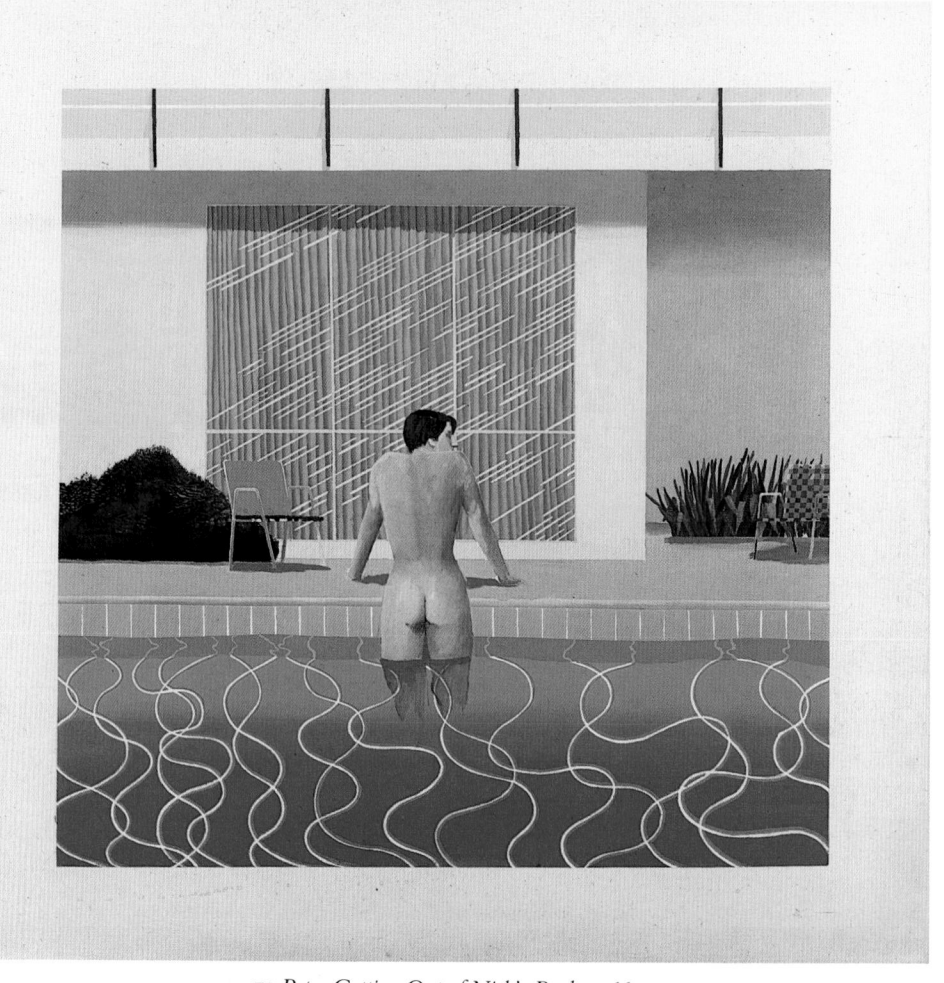

73 *Peter Getting Out of Nick's Pool*, 1966

premium on depiction and leads to an increasing clarification of image. The process of making a picture began to take longer, also as a result of the characteristics of acrylic paint, which he had begun to use in 1964; because acrylic dries quickly and cannot be scraped off the canvas, it demands a greater degree of pre-planning than oil. Hockney's naturalistic paintings, conceived one step at a time and painted with great deliberation, by definition cannot have the apparent spontaneity of image and fluidity of paint of the earlier work. The emphasis on intuition and immediacy was bound to give way to a more rigid and calculated conception and technique.

Hockney did not simply chance upon the camera and then allow it to exert its influence. It is clear, rather, that he became interested in the camera at this time because he surmised that it would be a useful tool in making pictures which communicated his pleasure in the specific qualities of the environment in which he was now living. Paintings such as *Beverly Hills* 70 *Housewife* and *Peter Getting Out of Nick's Pool* are, in the first instance, 73 evocations of southern California as a land of sunshine, leisure and affluence. If in certain works, such as *Sunbather*, 1966, there is more than a hint of the 49

74 Photograph taken for painting *Peter Getting Out of Nick's Pool*, 1966

language of the travel brochure, this is not inappropriate, for Hockney's idyllic vision of carefree life in Los Angeles is unashamedly that of a foreigner. The dozing figure in this painting is, in fact, based on an illustration in a magazine.

'I think that buying the camera', Hockney recalls, 'coincided with an interest in making pictures that were depicting a place and people in a particular place. Certainly in California in '65/'66 when I had begun to do that, using only rather poor Polaroid photographs to jog my memory – the paintings on the whole still invented – I'd never taken that much interest in photography at all. I still go hot and cold now.'

It was only in 1967 that Hockney collected his photographs together, many of which had in fact been taken by other people, and began to mount them in large leather-bound albums. To date he has filled more than sixty. The first album, however, covers a period of six years, July 1961 – August 1967, whereas subsequent albums cover a period of months or even days. This testifies to the casual attitude which he took to photography at first:

'When I first took photographs I just took them rather like anybody takes snaps. The more you travelled, the more you took photographs. They were

mostly just of friends. I didn't bother composing photographs, the compositions weren't that important. It took me a while to realize you could compose with a camera in a certain way, simply because I didn't take it very seriously. It was just a record, like anybody would keep a record of photographs of friends. Then I started photographing things that I thought I might use, architectural details of things as you travelled. I've fluctuated over the years with the camera, sometimes using it a lot, sometimes not.'

74
73
Polaroid photographs were referred to in painting both the figure and architecture of *Peter Getting Out of Nick's Pool*. The intermediate role of the camera is made evident in the format of a square image within a plain canvas border, which immediately calls to mind a photographic print. In a sense it is a snapshot souvenir of his experience of America, and specifically of the homosexual subculture of Los Angeles; Peter Schlesinger was his new boy-friend, an art student whom he had met while teaching at U.C.L.A., and the owner of the pool, Nick Wilder, was a dealer specializing in contemporary art with whom Hockney had lived earlier in the year. Making the canvas look like a grossly enlarged snapshot also provides an updating of the canvas as object-equation which had interested him in the Tea Paintings and related works of five years earlier. Since the viewer knows that a photograph is flat, the artist is free to imply spatial depth while maintaining the literal reality of the image as paint on a flat surface.

This painting is not a mere transcription of a single photograph. Peter was leaning against a car, not pulling himself out of a swimming pool, when Hockney snapped the shutter, and the play of shadows across his back in the Polaroid is disregarded. The reflections on the window here and in *Beverly*
70
Hills Housewife were not set down from direct observation outdoors nor even based on the evidence of the photographs; the regular diagonal lines are copied from the type of illustrations found in mail-order catalogues, where they function as a kind of visual shorthand signifying light on a hard reflective surface. The interlaced curved lines in the pool are not exactly as Hockney would have perceived the patterns on the tiled floor through moving water; they are abstracted signs of flowing movement that are knowingly borrowed from the sinuous forms of Art Nouveau. What might have appeared at first sight as a straightforward naturalistic description thus emerges as a composite view. Each element, carefully studied and (in the best sense) highly contrived, has passed through a filtering process of simplification and stylization. Through the combination of references, Hockney insists on the role of long-established pictorial devices allied to direct observation in the formulation of the painted image.

54
As late as 1965, Hockney's fascination with pictorial devices was presented within formats which deliberately scattered the viewer's attention across the

surface, drawing attention to these devices only to deny their apparent function. In his new paintings such self-evident devices would have jarred and become intrusive to the point of obliterating the subject, breaking the spell of the ideal vision he was transmitting. His attention thus shifted to the formalized structure of the composition in support of the picture's theme. For the sake of convenience, this could be labelled a 'classical' impetus in his work of this period, in the sense, for instance, of Seurat's involvement with linear directions and with rigid geometrical frameworks as aids to the communication of feeling or of the urge to seek order in the visible world.

A firm vertical/horizontal structure, often accounted for by settings of severe rectilinearity, is a characteristic feature of Hockney's paintings of this period. The architecture in a picture such as *Portrait of Nick Wilder* provides a *75* metaphor for the construction of the composition. The rectilinear grid, moreover, establishes a strong consciousness of the surface on which the image rests, while at the same time suggesting real space through the identification of this grid with a three-dimensional setting. The urge to assert the primacy of the picture plane, the most-discussed feature of Modernist painting at the time, is particularly noticeable in Hockney's paintings from 1966 in spite of his wish to provide his figures with a convincing solidity of mass. In many of these pictures a continuous horizontal band extends across the whole of the image area as a visual echo of the framing edge, as with the band of blue tiles in *Sunbather*, reminding the viewer that the only space *49* contained by a painting is the distance across its surface. Hockney had recently met Frank Stella, whose work he already knew through exhibitions with his London dealer Kasmin, and it seems likely that the American's early paintings of horizontal bands directed Hockney to relate the image to the external form of the canvas in this fashion. At the very least one can say that the overt formalization of structure, notwithstanding its antecedents in the art of Poussin and other 'classical' painters, is the product of a mid-twentieth-century sensibility.

The crispness and descriptive clarity of *Portrait of Nick Wilder* would be unthinkable without the experience provided by Hockney's recent, more exacting line drawings, just as the devotion to a more homogeneous space and to the observation of the fall of light within a particular setting owes much to the lessons learned from photography. This is, moreover, Hockney's first fully explicit portrait in a painting since that of his father eleven years earlier, since even *Beverly Hills Housewife* does not make a *70* particular point of the identity of the sitter. In contrast to the first swimming pool pictures of 1964–5, paintings still deliberately crudely worked and full of spatial distortions and inconsistencies, the *Portrait of Nick Wilder* and related works reveal an urge to depict the world perceived through the eyes

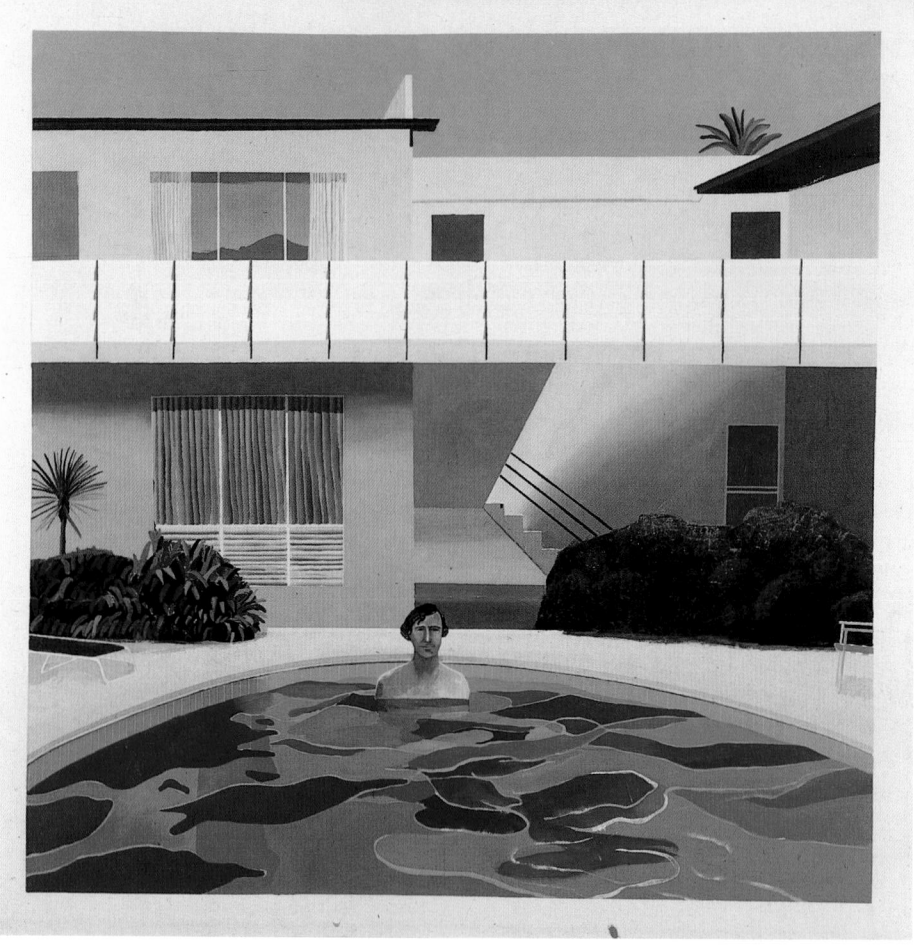

75 *Portrait of Nick Wilder*, 1966

with as great a specificity as possible. The very title of the picture suggests that Hockney realized at once that it was something of a breakthrough to depict someone so that he could be recognized, after years of making pictures about people without dealing fully with their individuality.

'Painting portraits took quite a while to come to. I think I always wanted to do portraits, but you were so tied to those boring old Royal Academy ideas. The portraits, after all, of Picasso and Matisse were not the ones that were being thrust at you, they're not even now. Now I have come to the conclusion that painted portraits are infinitely more interesting than

photographic portraits. Painting has completely abdicated to the camera in portraiture, which is a pity; I'm sure it will come back. The painting of people is too deep in us, everybody is interested in faces. To tell you about another person is a very deep thing in people, and it's going to come out in some way or other.'

In planning the *Portrait of Nick Wilder* Hockney referred to photographs taken in the pool by the painter Mark Lancaster under his directions, but his excitement at painting a portrait led him at the same time to draw portraits from life with greater determination than ever. Single-figure studies are rare in Hockney's paintings, probably because the larger scale and the technical requirements of the medium demand a degree of formality and detachment, whereas drawings of one person are much more frequent, since they can be made anywhere in one sitting as an intimate and essentially private confrontation. With the move towards naturalism drawing becomes for Hockney not only a way of learning how to look, but also a means of getting to know a person through intense concentration. He thus tends to return incessantly to the same models, finding out about the different facets of their appearance as clues to the complexity of their personality and of their relationship to the artist.

76 Nick Wilder, 1966

77 *Peter, La Plaza Motel, Santa Cruz*, 1966

Peter Schlesinger, whom Hockney had met and become sexually and romantically involved with on his return to California that summer, became his preferred model almost at once. A group of line drawings made in the last months of 1966 were the first to capitalize on the economy of outline first evident in the Cavafy etchings, with a similar sense of the tactile sensual appeal of the blank paper itself and a handling of a continuous contour as a physical caress of the forms described. One such drawing, *Peter in Santa Cruz*, is especially revealing of the increased authority of Hockney's line because of the similarity in subject to some of the Cavafy prints. More is achieved with fewer lines; each line now seems absolutely necessary to the description of form as well as to the elegance of the surface design. Some critics have criticized Hockney's drawings as lacking in passion, saying for

102

78 Peter (with head in hands), 1967

instance that Peter is drawn with the same detachment as any object which happens to catch his eye. The reticence is deceptive, however, for in the choice of subject alone Hockney has already declared an emotional attachment. In a drawing such as *Peter (with head in hands)*, 1967, everything is pared away save for the young man, who is described with a tautness and sensitivity of line that strongly avows a tenderness of feeling and intensity of involvement.

Hockney's drawings of Peter reveal a remarkable advance in his assurance. The delicacy of *Dream Inn, Santa Cruz*, October 1966, is in full contrast to the boldness, sense of urgency and even roughness of much of his earlier work. The figure is drawn entirely in pencil, its fragility emphasized by the crayoned areas of deep blue at the right and the balancing strips of yellow and orange at the left. It is an image imbued with silence, particularly undeclamatory when compared with the more robustly decorative quality of Hockney's other crayon drawings of this period. The tranquillity and gentleness of this picture evidently has much to do with the peace of mind that Hockney had within the relationship, just as his delight in his friend's physical beauty encouraged him to depict him with an acuteness of vision free of distortions and stylistic conceits. Peter was himself training as an artist and seemed to Hockney to have everything he sought in another human being: 'It was incredible to me to meet in California a young, very sexy, attractive boy who was also curious and intelligent. In California you can meet curious and intelligent people, but generally they're not the sexy boy of your fantasy as well. To me this was incredible; it was more real. The fantasy part disappeared because it was the real person you could talk to.'

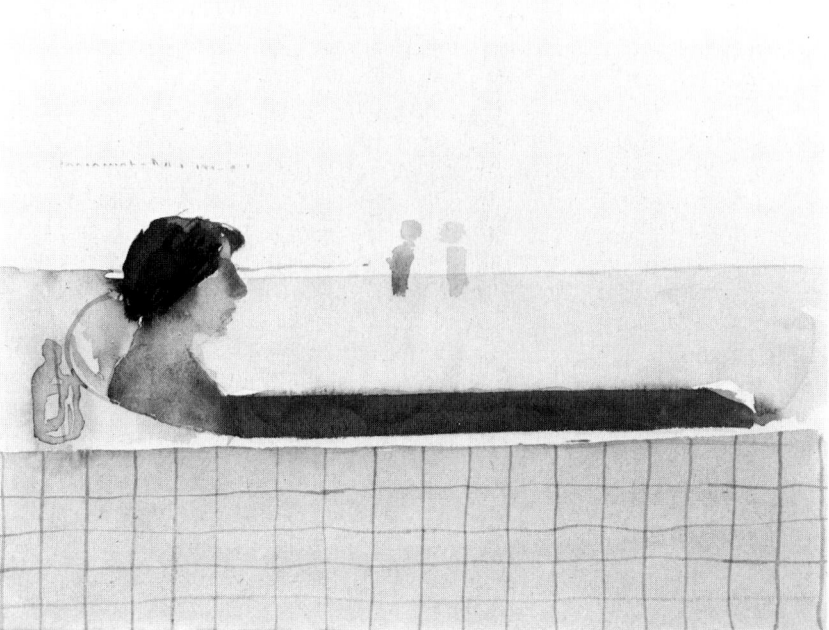

79 *Dream Inn, Santa Cruz*, October 1966
80 *Peter Having a Bath in Chartres*, 1967

Thanks to his intimacy with the artist, Peter is often caught in informal moments, less posed than is the case with other sitters. There are practical reasons for drawing people when they are asleep or otherwise unaware that they are being drawn: they will not become impatient or restless and with luck they will not even move. Moreover, they will be more relaxed and there will be no opportunity for them to 'put on a face' for the sake of a drawing. The picture will thus relate more successfully the artist's view of that person rather than the sitter's self-image.

No amount of intimacy, affection or informality, however, can save Hockney's excursions into watercolour from outright failure or awkwardness at best. Having tried the medium in 1961 and again in Egypt two years later, Hockney returned to it on his tour of Italy and France with Peter and fellow-painter Patrick Procktor in 1967. *Peter Having a Bath in* 80 *Chartres* is one of the more successful watercolours, but even here he seems unable to control its flow properly or to give substance to the portrayal of mass without the assistance of a clearly defining line. Now that his handling of paint had changed to a thin application of colour contained within tightly drawn boundaries, the formlessness of watercolour must have been even less sympathetic to him. After this trip, he has returned to the medium only on isolated occasions. Similarly, Hockney made a series of ink drawings of Peter in a very loose idiom reminiscent of his more subjective, almost caricatural drawings of the early 1960s. Hockney has kept these simply because he can see no reason, other than the exigencies of the art market, to throw them away, but he would not consider selling them or making them public because he regards them as failures. He has continued to this day to experiment with different styles and techniques in the full knowledge that many of the results will be unsatisfactory. It is a risk he is prepared to accept if he is to extend his range.

Following *Peter Getting Out of Nick's Pool*, Hockney did not use his friend 73 again as the protagonist of a painting until the next year, for *The Room,* 52 *Tarzana*. The example of Boucher's painting *Reclining Girl (Mademoiselle* 81 *O'Murphy)* has often been cited as a reference for the positioning of the figure, but the erotic charge of Hockney's painting is equally the result of the contrast between the deliberately provocative pose and the otherwise antiseptic and impersonal interior. (The room was copied from a colour photograph of furniture which Hockney found in a local newspaper, an advertisement for Macy's, which appealed to him for its formal simplicity and almost sculptural sense of volume.) The white socks and shirt emphasize the vulnerable nudity of the young man, while the cool blue atmosphere and dreamlike stillness complete the impression that a fantasy has been frozen in memory. If one is to speak here of Hockney's relationship to other artists, the

81 FRANÇOIS BOUCHER *Reclining Girl*
(Mademoiselle O'Murphy), 1751

82 EDWARD HOPPER *Evening Wind*, 1921

83 *The Room, Manchester Street*, 1967

borrowing of a pose from Boucher is of minor significance by comparison with the example of painters who had systematically explored the psychological and emotional implications of a figure within an enclosed architectural setting. Vermeer, Balthus and Edward Hopper, though isolated in time and style from each other, all share this basic concern. Hopper's etching *Evening Wind*, 1921, provides a particular point of contact with its sensual image of a female nude in a room bathed in a strong unifying light. Now that Hockney was working in a naturalistic idiom and dealing with a more traditional conception of spatial continuity, he began to study the work of these painters with great interest in order to achieve in his own work a similar integration of figure with environment.

82

The Room, Tarzana was accompanied in the same year by *The Room,* 52
Manchester Street, a portrait of the artist Patrick Procktor in his London 83
studio. Each depicts a close friend in an appropriate indoor setting, an
enclosed space which defines the entire ambiance of the place and of its way
of life. *The Room, Manchester Street* is one of Hockney's rare pictures of
London; England in general has provided little stimulus to his imagination.
The light that emanates through the venetian blinds of the two windows, a
contre-jour effect to which Hockney returned on several occasions in later
years, has a cool silvery quality appropriate to the greyness of England. The
light in *The Room, Tarzana*, on the other hand, is clear and intense, casting
crisply defined shadows across the interior.

The titles of these two pictures tell us nothing more than the location of the scene, real in one case and contrived in the other. Other captions at this time tell us the obvious, drily identifying an image which is already self-evident: *A Table, A Lawn Being Sprinkled, A Bigger Splash*. Even in the explicit portraits such as *American Collectors (Fred and Marcia Weisman)* we are given only the names of the people and occasionally a brief description of who they are, but what we wish to know about the complexities of their relationships must be deduced from the pictures themselves. It is right that the words should now emphasize the importance of choice in interpreting the visible world, since this is a fundamental theme of the paintings and perhaps the most vital influence on their construction.

Hockney recalls that the image of *A Table*, with its strong sculptural presence, was suggested by the similar emphasis on mass in *The Room, Tarzana*. The frozen quality of the image, its dry dead-pan humour, the foreboding silence and the playfulness with which the illusion is revealed all suggest, however, that Hockney was beginning to look at the work of the Belgian Surrealist painter René Magritte. It recalls particularly Magritte's pictures of tables and still lifes made of stone, such as *Souvenir de Voyage III*, 1951, in which the disturbing quality of the image is called to our notice through the very blandness with which it is depicted. The objects on Hockney's table, for all their simplicity, also seem charged with mystery, if only because they are isolated and presented to our gaze for contemplation. It is the very act of looking with such unaccustomed intensity that turns a prosaic scene into something like an apparition.

The immediate decorative impact of colour and design in Hockney's work at this time belies the undercurrent of emptiness and silence that becomes more compulsive the longer one looks. There is something jarring about the apparent depopulation of Los Angeles, in which the only signs of movement come from mechanical objects such as lawn-sprinklers. Even *A Bigger Splash* into the swimming pool betrays no sign of the diver. Unconsciously, perhaps, a sense of isolation emerges, not so much the sombre melancholia of Giorgio de Chirico's metaphysical paintings as a feeling of aloneness as induced by Edward Hopper's pictures of deserted American city streets.

There are many elements that contribute to the forcefulness of pictures such as *A Lawn Being Sprinkled* and *A Bigger Splash*: the wit in devising new signs for representing water, the strong sense of design and boldness of colour, and the playful way in which an observed scene has been used to construct an almost abstract painting. Yet it is the stillness of the images that lingers longest in the mind. Earlier painters, Vermeer being the most notable example, had occasionally contrived pictures which appeared to deny the

84 *A Table*, 1967

85 RENÉ MAGRITTE *Souvenir de Voyage, III*, 1951

86 *A Lawn Being Sprinkled*, 1967

passage of time. The advent of the photograph, particularly with the introduction of the high-speed camera, made it possible literally to capture an instant. The situation seized by a photographer is thus removed from our customary experience, which consists of a succession of events in relation to each other. Twentieth-century artists are in the position of being able to use the evidence provided by photography at the service of the slow and deliberate process of painting, in which a far greater degree of control is possible in selecting or exaggerating particular effects. While availing

himself of the camera, Hockney takes advantage of the contrast between the mechanically produced and the hand-drawn image, playing on the precision of form and smoothness of surface that can be achieved with acrylic paints. As Hockney himself has pointed out, the congealed gesture of *A Bigger Splash* arouses our interest because of the way in which an image captured instantaneously with the camera has been laboriously translated into paint. There are two time scales, that of the initial action and that of its restatement on canvas, and it is the interplay of the two that creates the peculiar intensity of the picture.

Pictures such as *A Bigger Splash* are among the last in which Hockney continued to use a framing device round the image. He had begun to wonder whether the border was not merely a sign of timidity, a redundant element, and from 1968 he consistently investigated whether there was really any need to continue admonishing the viewer that what he is looking at is merely an artificial reconstruction of reality on a two-dimensional surface. As the framing device disappears, there emerges a greater attention to the portrayal of an illusionistic space through traditional perspective. There is no question of misleading the viewer, as everything is clearly calculated. The figures are shown in formal hieratic poses, with a preference for straight frontal and profile views, as in the paintings of Piero della Francesca, which he was studying closely. The architecture as well as the objects within it are disposed on perspective grids as highly defined as those of another fifteenth-century Italian painter, Paolo Uccello. We are left in no doubt about the artist's control in composing the picture.

Hockney's first purchase of a 'good camera' in 1967, a 35 mm Pentax, made a great impact on the shift of his interests during that year. The Polaroids he had used previously were casual snapshots, helpful as *aide-mémoires* but ultimately rather limited and inflexible. The 35 mm camera allowed him greater subtlety of lighting, focus and format, and he now began to take photographs much more seriously, sometimes taking dozens of shots in planning a particular picture. The camera also renewed his interest in traditional pictorial devices for the representation of space, with the result that his pictures begin to open out and to deal as much with the illusion of depth as with the surface of the canvas. Hockney recalls that he realized that to paint convincing figures, he had to deal with volume, and this led him to reject Modernism's insistence on flatness. His own lingering fears that he might be retreating from the art of his own time still find reassurance in Picasso's apparent about-face from Cubism to a personal form of Neo-Classicism in the 1920s:

'You know perfectly well that wonderful art has been made within these old conventions. When conventions are old, there's quite a good reason, it's

not arbitrary. So Picasso discovered *that*, as it were, and I'm sure that for him that was probably almost as exciting as discovering Cubism, rediscovering conventions of ordinary appearance, one-point perspective or something. The purists think you're going backwards, but I know you'd go forward. Future art that is based on appearances won't look like the art that's gone before. Even revivals of a period are not the same. The Renaissance is not the same as ancient Greece; the Gothic Revival is not the same as Gothic. It might look like that at first, but you can tell it's not. The way we see things is constantly changing. At the moment the way we see things has been left a lot to the camera. That shouldn't necessarily be.'

99, 102

The theme of intimate relationships between people is one that had concerned Hockney since the early 1960s, but it was only now that he had devised a more naturalistic framework for his pictures that he was able to treat the subject in terms of the subtleties of particular friendships. *American Collectors (Fred and Marcia Weisman)* and *Christopher Isherwood and Don Bachardy*, both painted in 1968, initiated a series of double portraits that was to occupy Hockney for the next seven years, and which still survives as a subject in his current work in a modified form. Only on one occasion, for the *Portrait of Sir David Webster*, 1971, has Hockney allowed himself to be persuaded to paint a portrait on commission. The double portraits are all of close friends of the artist, and they are invariably emotionally attached to each other as friends, lovers and married couples. Each picture in the series measures seven by ten feet, a size which corresponds to that of a wall in a small room. This establishes an immediacy of contact between the spectator and the people portrayed, since the continuity of our space and scale into the picture invites us to be participants as well as witnesses to an essentially private event. Each scene is set in the home of the people depicted, and the objects and environment that surround them are as much a part of the portrait as the capturing of their likenesses. They are 'domestic scenes' in a much fuller sense than the canvases for which that phrase was devised in 1963.

87–90
98

Photographic studies taken by Hockney were used heavily for reference for all the major double portraits, although in most cases the camera was used primarily as a guide in setting up the composition, and details, particularly of the figures, were painted directly from life. The portrait of the Weismans, however, was painted entirely in the studio with the aid of a group of colour and black and white photographs. One such colour photo established the basic format – it is not by accident that the proportions of these double portraits are approximately the same as those of photographs produced with a 35 mm camera – as well as a number of the details and even the colour scheme for the painting. Further details of objects such as the totem-pole

provide more information, and the faces are painted from two black and white close-ups of the collector and his wife. Although Hockney has felt free to stylize the representation of certain areas, such as the light glancing off the windows, and to effect changes in the placement of the objects, he has otherwise imposed himself little on the scene as described by the camera.

An even larger number of photographs was shot for the portrait of the writer Christopher Isherwood, a close friend of Hockney's since 1964, and his companion, the artist Don Bachardy. Hockney amassed as much information as he could in preparing the picture because it was his intention 'to depict them, the way they lived and everything', but as much as possible of the actual painting was done from life in Isherwood's own living-room. Before setting to work on the canvas he also made at least one watercolour study and two pencil drawings to work out the composition and determine the most effective poses. In the final picture Isherwood is seen shooting a 102

87 Christopher Isherwood, March 1968

88 Santa Monica, 1968

89 Henry Geldzahler, 1968

90 Christopher Scott, 1968

piercing glance across to Bachardy, who in turn looks straight out at the spectator, establishing a triangular relationship. Through this orchestration of pose and expression, as well as by means of the bilateral division of the canvas round a vertical axis, Hockney alludes to the bonds uniting the two men as well as to their separateness, their need for a degree of independence.

In each of the double portraits the sitters are conscious of each other's presence, yet they are also apart. Mr and Mrs Weisman, for instance, look resolutely in different directions, each enclosed in his or her own thoughts. 105 The picture of *Henry Geldzahler and Christopher Scott* has been compared to traditional Annunciation scenes, in which the peace of one person is suddenly interrupted by the intrusion of another. The sense of struggle between the impulse to connect with another human being and the need to remain separate, already implicit in the Cavafy illustrations, is now treated with greater directness. These observations of human nature are achieved through purely pictorial means, both through the gestures of the participants and by means of the formal division of the architectural settings into compartments or separate spaces.

The Geldzahler and Scott picture is divided into three vertical panels of approximately equal width which provide separate enclosures for the two figures. The triptych format is a characteristic of the traditional altarpiece, strengthening the analogy to the Annunciation and leading one to view the frontally seated man as a transformation of the standard icon of the Madonna enthroned. This might be an over-interpretation of Hockney's thoughts at the time, but he is willing to accept such overtones because 'slightly unconsciously, there are many things you think about when you're making a

114

91 JACQUES-LOUIS DAVID *Madame Récamier*, 1800

picture.' On one level, this is after all a private devotional picture, an image of the commitment of two men to each other. Geldzahler also has a public role, however, as an influential museum curator and a leading figure in the American art world, and the picture thus also relates to the tradition of the society portrait. There are echoes, in fact, of a particularly famous precedent, the early nineteenth-century portrait of Madame Récamier by Jacques-Louis 91 David. It may be that Hockney was not mindful of the connection when he selected the sofa and the elegant lamp as the essential props, but this does not affect the resonance which the picture holds as a transformation of a familiar image of an earlier taste-maker. Geldzahler's sense of purpose as a promoter of contemporary art takes on an almost aggressive air if we contrast his unflinching gaze and forthright frontal posture with the reticence of Madame Récamier's reclining pose. We know from Geldzahler's own account that even though the picture seems perfectly plausible as the record of a particular place at a precise moment, the artist has in fact added objects that were not originally there and substituted another view through the window. The painting is indeed a composite, but as a self-sufficient image it needs no justification.

An unpublished pencil drawing, depicting Peter sitting cross-legged on a sofa with Hockney walking towards him in profile from the right, appears to be the only extant evidence of a self-portrait with his boy friend contemplated by Hockney but never brought to fruition. Hockney says simply that, as with many of his other plans, he 'never got "round to it",' but he acknowledges that the scarcity of self-portraits in his work as a whole may be due to a reluctance to examine himself too closely. 'I admit I avoid some

92 Swimming Pool, Le Nid du Duc, October 1968

things about myself, as I avoid some things about life,' he says, adding however, 'I think my work develops slowly. It takes me a long time to find out things, and of course I do believe my work will get better, richer. I also assume that in the end I'll deal with things that I avoided when I was younger, partly because you will face them more anyway. . . . I'm assuming I will come to self-portraits. Partly I'm aware that in the past there was a certain innocence of vision and is there still at times, but I'm also aware that perhaps it can't go on, might not go on. It's not going to change quickly. If you don't know how to deal with it, you put it aside, and anyway it will force itself in the end. I think if I looked at myself carefully, it would probably be the end of that innocent vision. Maybe therefore I should do it.'

Hockney filled five large photograph albums between September 1967, when he first started using his new camera, and February 1969. Of the thousand or so images that these contain, only a few suggested possibilities for paintings. Certain photographs, such as Swimming Pool, Le Nid du Duc and others of the same series taken in October 1968, seemed complete in themselves without the need for further elaboration. His growing experience with the medium was changing his appreciation of it and directing him to emphasize the formal qualities of the images as seen through the lens. This photo and others of equally bold and simple design satisfied Hockney's persistent urge towards abstraction, and in a sense left him free to emphasize the central role of depiction in his paintings.

Fascinated by the technical possibilities offered by the camera, Hockney did allow himself for a moment to be seduced by what he discovered with it.

92

93 *L'Arbois, Sainte-Maxime*, 1968–69

94 Hotel l'Arbois, Sainte-Maxime, October 1968

Two paintings executed over the winter of 1968–9 transfer with little alteration photographs he had taken at Sainte-Maxime in October 1968. One of these canvases, *L'Arbois, Sainte-Maxime*, simplifies to a great degree the information provided by the squared-up photograph, eliminating certain details such as the wording on the signs and the car on the street, but otherwise transfers the image intact in a way that was not true in his earlier

96 *Illustrations for Six Fairy Tales from the Brothers Grimm: The Enchantress with the Baby Rapunzel*, 1969

97 *Illustrations for Six Fairy Tales from the Brothers Grimm: The Sexton Disguised as a Ghost Stood Still as Stone*, 1969

Hockney chose to illustrate the stories not in the usual terms of dramatic narrative but rather as a succession of memorable static images. To achieve this end, he has freely borrowed from the work of other artists. In order to depict the sexton standing perfectly still in front of 'The boy who left home *97* to learn fear', he plays humorously on a literal interpretation of the phrase 'stood still as a stone'. Taking his cue from Magritte's paintings of objects *85* made of rock-like surfaces, Hockney has devised a striking image in the form of a visual pun. He has recourse to Magritte also for the story of Rumpelstiltschen, conveying the enormity of the task demanded of the miller's daughter by adapting the unnerving dislocations of scale from certain paintings by the Surrealist to the picture of *A Room Full of Straw*.

The imagery in other prints from the set draws on the work of artists such as Leonardo da Vinci, Paolo Uccello and Carpaccio, but it is in terms of technique, as well, that Hockney has recourse to previous solutions. He recognizes that the range of marks that can be made within a particular medium forms a kind of visual language, and that each artist who has conceived or perfected a particular technique can be said to have enriched the vocabulary and extended the range of expression of that language. Hockney borrows from other artists not because he is lacking in imagination or because he wishes to impress us with his knowledge, but as a means of controlling the 'emotional' content by expressing it in the most vivid and economical form possible. How better to project a sense of the irrational than through Goya's dense and dramatic aquatint, or to achieve a contemplative stillness than by way of Morandi's restrained and delicate cross-hatchings? By seizing in this way any technique that he deems suitable to his purposes, Hockney pays tribute to all his predecessors who have made a contribution to the medium.

In view of the length of time alone that he spent on the Grimm etchings, Hockney is right to consider them one of his major works. Certainly the series contains some of his most memorable and poetic inventions, and as a contemporary illustrated book it is virtually without rival. Ironically, though, it is the very elements which provide much of the aesthetic and intellectual pleasure of the prints, the insistence on beauty and the constant references to the work of other artists, which also make one conscious of the artist's limitations. There is no real sense of unbridled horror. Hockney's characteristic detachment furnishes considerable humour and insight into the underlying themes of the stories, but fails to convey their more tragic or morbid aspect. Like 'The boy who left home to learn fear' in one of the lesser-known tales chosen for illustration, Hockney seems fundamentally incapable of producing a genuine shudder.

98 Fred and Marcia Weisman, Beverly Hills, 1968

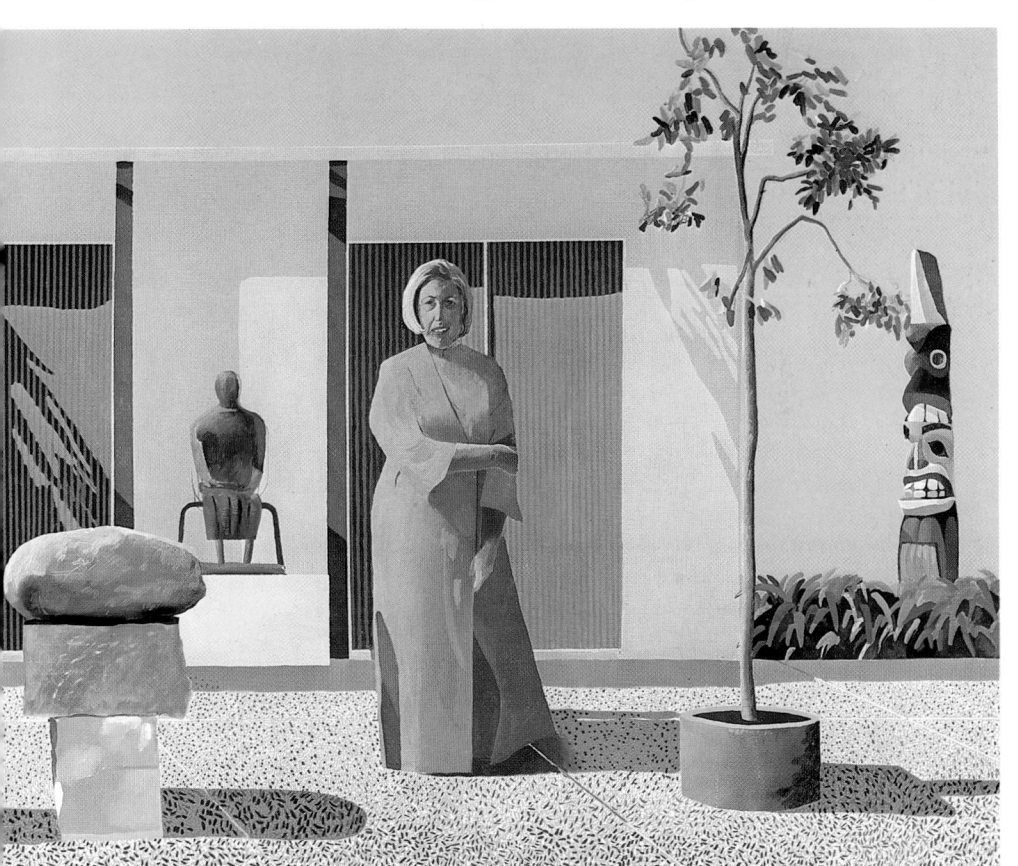

100 *Illustrations for Six Fairy Tales from the Brothers Grimm: The Pot Boiling*, 1969

A number of the fairy tales stress the magical qualities of objects in themselves, a notion which Hockney demonstrates in the prints by presenting isolated articles detached from their surroundings: the rose, the

100
101 tower and the pot in 'Fundevogel', the lathe in 'The boy who left home to learn fear', the piles of straw and gold in 'Rumpelstiltschen'. *Armchair*, 1969, one of the few precise line drawings made in preparation for the series, carries the symbolic function even further. Copied on to the first plate for 'The boy who left home to learn fear', where it is titled *Home*, it represents the departure of the younger son from the security of his own environment. The chair is explicitly a stand-in for the figure: the image is presented in the guise of a formal portrait, and the dented cushions reveal that it is only moments

111, 112 since the chair has been vacated. The motif of the chair was soon to become a favourite human metaphor in Hockney's work, but in the context of the Grimm illustrations each of the separate images claims our attention with equal force as we read through the text and thus takes on a powerful

124

talismanic quality. The implication is that the real source of magic in figurative art lies not within the object but as the result of the act of picturing itself.

Just as naturalism ceased to be an issue in the Grimm illustrations, so in the prints that followed Hockney was able to avoid the problems of excessive fidelity to appearances that plagued his paintings at this time. *Peter*, a three-foot-high etching of a complete figure, uses a high vantage point and two sets of perspective, one for the lower half of the body and the other to describe the figure from the waist up. Seen from above, the legs appear truncated by the effects of foreshortening. The torso, on the other hand, is viewed at a lesser angle and the head is seen from straight across.

103

101 *Armchair*, 1969

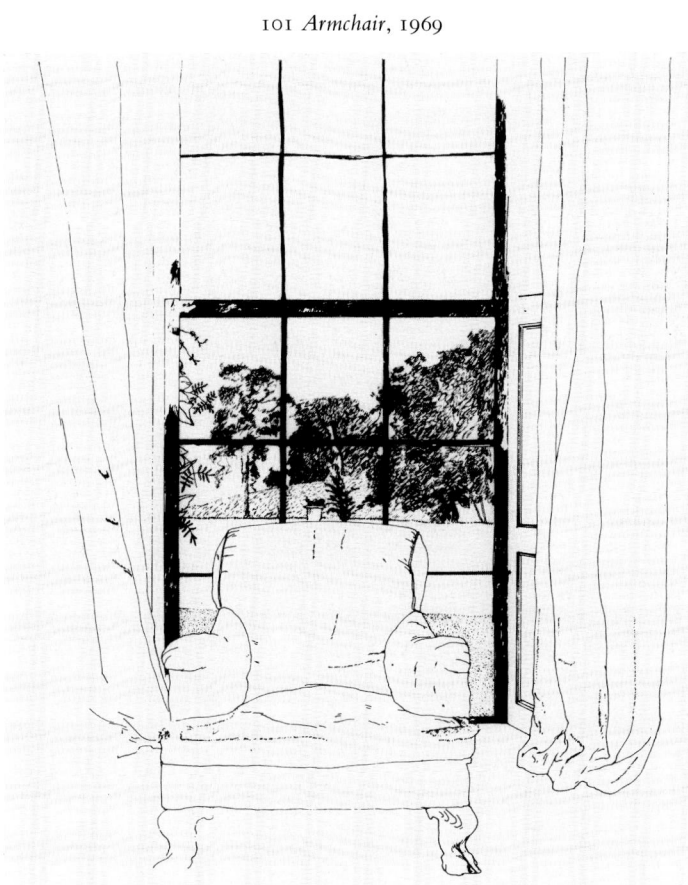

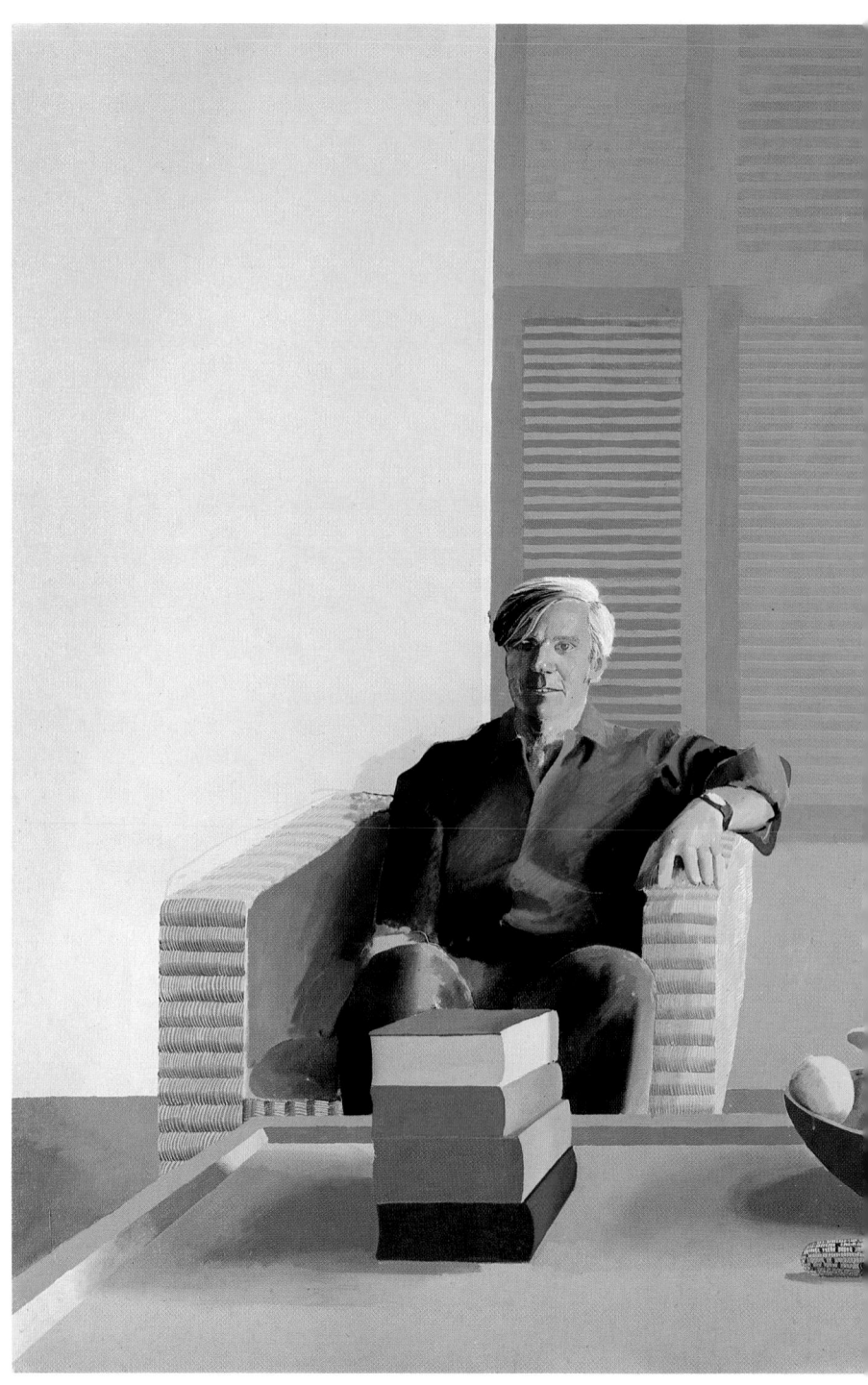

102 *Christopher Isherwood and Don Bachardy*, 1968

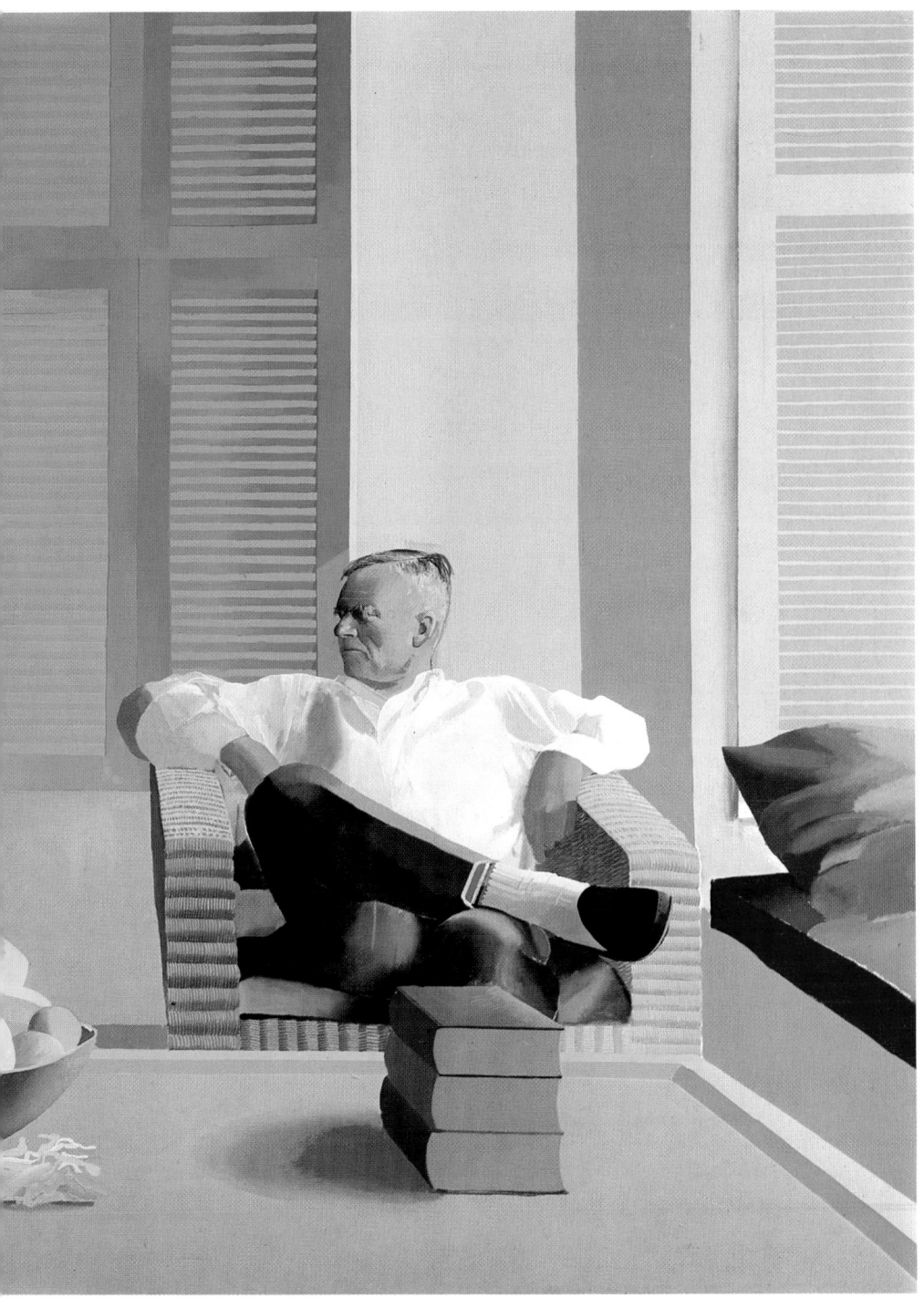

The proportions of the figure, though somewhat startling if interpreted in naturalistic terms, correspond to our experience of looking at someone standing near us, as if we had started by looking at the ground and then slowly turned our gaze upwards towards the man's face. The picture is thus analogue and metaphor of the artist's act of scrutinizing another human being.

104 *Flowers Made of Paper and Black Ink*, a companion to *Coloured Flowers Made of Paper and Ink* which is printed from the same set of ten lithographic plates, acknowledges with a similar sense of purpose the artifice by which the image is composed. The title and the image both allude to the process of constructing the picture. The pencils on the table are not only his drawing tools but also the key to the superimposition of ten printings; this is especially obvious in the colour version, in which the image is colour-coded to the

103 *Peter*, 1969

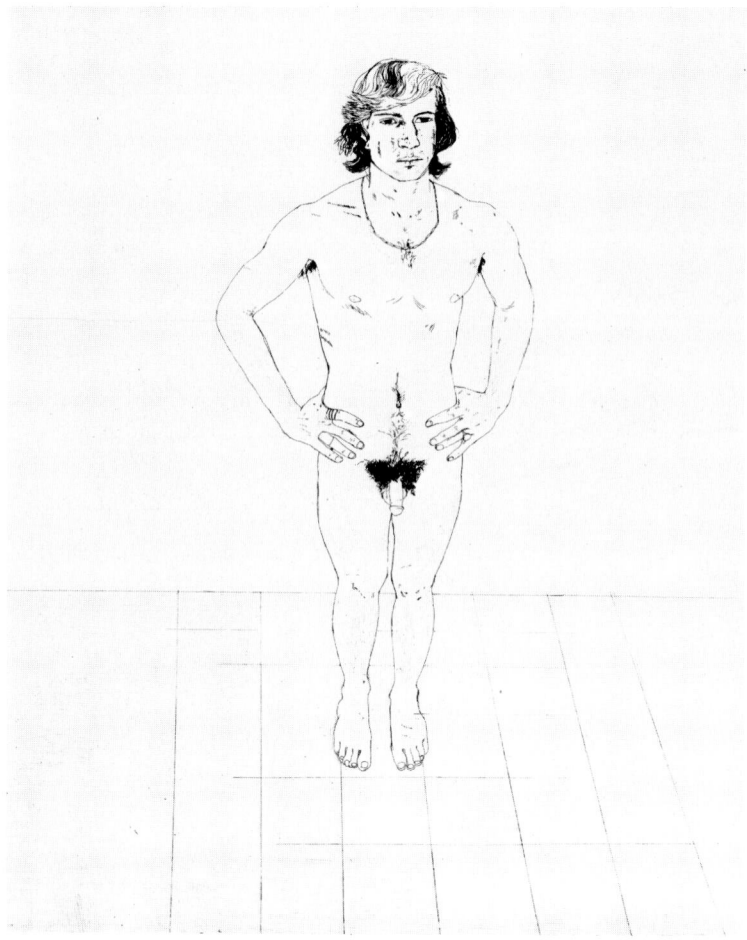

104 *Flowers Made of Paper and Black Ink*, 1971

pencils. In laying out these drawing instruments in the immediate foreground, cropped by the edge of the picture, Hockney symbolically sets his tools before us, implying that in studying the picture we become surrogate artists ourselves. For the background he has used the cross-hatching technique that he had favoured in the Grimm etchings, transposing it to a medium where it is redundant as a means of shading. Hockney clearly enjoys the decorative pattern of lines for its own sake, regardless of its necessity for technical reasons. His delight in ornamental beauty and in the old-fashioned theme of simple still life is almost in conscious defiance of current practice. In an era which has prized rigorousness, austerity and grandness of intention, Hockney has not been afraid to court accusations that his work is lightweight. One lithograph of 1969 is actually titled *Pretty Tulips*, not in irony but as a simple celebration of beauty.

105 *Henry Geldzahler and Christopher Scott*, 1969

106 *Le Parc des sources, Vichy*, 1970

107 *Mr. and Mrs. Clark and Percy*, 1970–71

108 *Still Life with TV*, 1969

Still Life with TV, one of a very small number of paintings completed in 1969, treats the still life theme in terms of wholly contemporary imagery. The heightened presence of the objects in this and the paintings that followed, a strong consciousness of the human use and connotations of inanimate things, seems to owe much to the experience of the Grimm etchings. Equally important, however, is his concern with the specific *84* delineation of each detail, by comparison for instance with *A Table* painted only two years earlier. A photograph of the objects arranged on the furniture, taken by Hockney simply as a record rather than as a working aid, reveals the extent to which he has simplified and altered the evidence, ignoring a framed print on the wall and reducing the complicated play of shadows so that they gain in force. Implicit in the imagery itself is an assertion of drawing, an emphasis on the artist's hand, over mechanically produced images; the television screen here, as in the 1968 crayon drawing *Sony TV*, is blank, and all the imagery is created round it.

Hockney recalled in an interview with Charles Ingham in 1979 that all the objects in *Still Life with TV* were 'food for thought' while working: 'I used to watch TV sometimes making paintings. . . . And there's the paper here waiting to be drawn on. And there's food to keep you going, this little sausage is literally food, and there's some other food here for the mind, a

dictionary, full of words.' He acknowledges, however, that within the cool presentation there is an emotionally charged atmosphere, and that the painting might carry further meanings of which he was not conscious at the time. The inexpressively uniform surface of acrylic paint by its very blandness intensifies the unease caused by the violent foreshortening, an exaggerated perspective which is anchored to the picture plane by means of a device, favoured by Cézanne as well as by the Cubists, of a drawer placed frontally along the lower edge of the picture.

Where Hockney in his earlier work had used devices as subjects in themselves, he uses such mechanisms in his naturalistic pictures to support the theme and construction of the image. *Le Parc des sources, Vichy*, 1970, for *106* instance, is not simply concerned with the false perspective which so intrigued him at this French spa, in which two rows of trees are planted in the form of a triangle to increase the impression of distance. Certainly it was direct observation that triggered him off, and he made much use, for the colour as well as for the composition, of a series of photographs he took on site in September 1969. He was struck, however, by the sense of the landscape as a picture within the picture, a favourite theme which he now realized he could deal with in the context of naturalism simply by finding the right subject. The seated figures, Ossie Clark and Peter Schlesinger, witness the view as a theatrical or cinematic spectacle, while the artist has vacated the third chair so as to contemplate the entire scene and produce his picture of it.

Merely by depicting what is there, choosing his vantage point but inventing nothing, Hockney has created a picture about illusion which by his own admission has 'strong surrealist overtones'. It could almost be described as a 'found' Magritte. The implications of the picture's form, however, could be taken even further, for if it is a construction of triangles it concerns also a romantic triangle in which Hockney and his two friends are the participants. Although he was only vaguely aware of it then, the first strains in his relationship with Peter were beginning to show, and this emotional tension, teamed with the false perspective, produces a sense of unease and insecurity.

A further variation on the theme of the picture within a picture occurs in *Three Chairs with a Section of a Picasso Mural*, 1970, which is based on *111* photographs taken in March of that year at the Château de Castille, the home of the art historian Douglas Cooper. Hockney has remained faithful to one particular photograph of the mural, which is painted on the wall of a covered outdoor patio, but he has removed part of the foreground as well as the crazy-paving pattern of the floor. More important, he has transferred the date '1.11.62' from another photograph of a separate part of the mural, tampering with the evidence provided by the camera in order to call attention to the fact that this is a re-creation of a picture by someone else.

110 *Rubber Ring Floating in a Swimming Pool*, 1971

III Three Chairs with a Section of a Picasso Mural, 1970

Picasso was beginning to interest Hockney much more again. The mural in Hockney's picture is an example of the fluency and dexterity of the drawing technique for which Picasso was renowned. The apparent ease of Hockney's transcription makes it a particularly cheeky form of homage.

In the spring of 1970 Hockney began work on a painting he had been planning since the previous year, a double portrait of the recently married fashion designers Ossie Clark and Celia Birtwell. In addition to making some drawings as early as 1969, he took more photographs for this painting than for any of his previous works, both in colour and in black and white. The figures were painted largely from life, but the large size of the canvas made it necessary to do this work in his studio rather than in the home of the sitters. The photographs thus occupy a particularly important role here in providing information, not only in terms of the architectural setting but more significantly for the colour scheme. Along with *The Room, Manchester Street*, 1967, this is the only explicit picture of London that Hockney has painted, and it was thus of the utmost importance to capture the muted,

136

veiled quality of the light streaming in through the window. Hockney's own description of the genesis of this picture makes it clear that it was precisely this problem of light, in particular the *contre-jour* effect from the centre, which was his main concern. So dominant is this aspect, in fact, that it is only on closer inspection that one realizes how little he actually concerns himself with detail other than in the description of the figures and a small number of objects. Large areas, notably of the walls and the carpet, are treated simply as abstract surfaces and patterns of colour. *Mr. and Mrs. Clark and Percy* is not, *107* therefore, the slave to naturalism that it might appear; not only has Hockney put the picture together from different sources, but he has also felt free to move these elements around and even to invent large sections of the surface in order to ensure the aesthetic self-sufficiency of the picture.

Hockney struggled with this double portrait for nearly a year, constantly reworking it and finishing it only in February 1971. He was aware already of the tensions within the marriage which was to end eventually in divorce, and reveals to the spectator that it is not an ordinary marriage by reversing the usual convention by which the man is shown standing and the woman seated. It was not, however, psychological pressures which made his work difficult; it is, after all, the very perceptiveness of the image which gives the picture its strong sense of presence. The problem, rather, was that the demands of naturalism were beginning to be a burden. The figures, particularly that of Ossie, were heavily repainted, and the surface, especially when covered with a thick uneven application of varnish, is murky and uninviting.

Much of Hockney's work of the early 1970s is disappointing in execution, since the image and overall decorative impact are all too often emphasized at the expense of the handling of the paint. The surfaces can be surprisingly lifeless and coarse, a far cry from the technical perfection one is led to expect from reproductions of these pictures. The very fact that his work by that time was so widely illustrated may have been a contributing factor, since he seemed to be painting as much with a view to reproduction as to a direct confrontation of the spectator with the canvas itself. The pressures of his enormous and rapid public success, which had culminated in 1970 with a large retrospective exhibition, unheard of at the age of thirty-two, were compounded by the adulation of an audience that was, and continues to be, frequently indifferent to the technical subtleties of the work. It is to be applauded that Hockney's naturalistic pictures can be enjoyed without a profound knowledge of art history or of current aesthetic issues. It is dangerous for the artist, however, if the appeal lies primarily in the subject-matter rather than in the formal clarity, wit and technical skill towards which he was also striving.

112 *Chair and Shirt*, 1972

113 *Mt Fuji and Flowers*, 1972

114 Hotel de la Mamounia, Marrakesh, March 1971

The great strides which Hockney was making with the camera, at first such a help to him, now also seemed to be turning into a source of confusion. The photographs were now composed to such a degree that the paintings were in danger of becoming redundant. *Rubber Ring Floating in a Swimming Pool*, 1971, is a virtual reproduction of a colour photograph, but here at least Hockney has chosen one of his most minimal, formalized, photographs as his source, giving the painting great formal simplicity as a wry comment on abstraction. *Sur la terrasse*, 1971, on the other hand, cannot truthfully be said to qualify as a great improvement on the small colour photograph taken at

110

the Hotel de la Mamounia, Marrakesh, in March of that year, even though it was based also on a crayon drawing he had made on the same occasion. Hockney never worked like a Photo-Realist, transferring a photographic image by projecting it directly on to the canvas, but he had come to allow his vision to be influenced to an extreme degree by the camera. His paintings of the early 1970s, as attractive as they might be in terms of image, suffer from emotional shallowness and from a lack of engagement with the material properties of paint. He was relinquishing too much control to the camera.

Hockney's most successful paintings during this time are those in which photographic sources are less in evidence or at least less slavishly adhered to. *Portrait of an Artist (Pool with Two Figures)*, 1972, perhaps the most *118* impressive painting from this period, is a case in point. The image was suggested by the accidental juxtaposition of two photographs, one, taken in Hollywood in 1966, of a boy swimming under water, the other of another boy gazing at the ground. Seeing them placed together, Hockney realized that he had a subject for a two-figure composition with a greater than usual dramatic charge. The first version of the picture was begun in September 1971, along with several other paintings, shortly after the break-up of his relationship with Peter Schlesinger. Jack Hazan's film about Hockney, *A Bigger Splash* (begun in the summer of 1971 but not released until the autumn of 1974), suggests that this initial picture failed because of the artist's emotional problems in depicting Peter, who is posed at the edge of the pool. Hockney, however, says that the picture failed because he had the perspective of the swimming pool wrong, and in April 1972 he took a series of approximately two hundred colour photographs in preparation for the second version of the painting, which had to be finished for his one-man show in New York the following month.

The new series of photographs was shot at Le Nid du Duc, house of film *109* director Tony Richardson in the south of France, using Mo McDermott as a stand-in for Peter and another friend, John St Clair, as the underwater swimmer. Hockney was now using a new Pentax camera with automatic exposure, which he says 'meant you could shoot quicker, which meant you actually shot some things that you wouldn't have bothered with before because it took you too long. It's much simpler to use, and therefore when you're travelling, technically you get much better pictures. The exposure is always going to be better, so the colour will be better, richer.' These swimming pool photographs, evenly lit, perfectly in focus and full of dazzling patterns, are among Hockney's most beautiful to date. Laid out in rows, they evidently spurred his imagination, though the very wealth of evidence they provided encouraged him to devise a solution appropriate to painting rather than simply copying the patterns from a single photograph.

115 *The Weather Series: Sun*, 1973

116 *Contre-jour in the French Style – Against the Day dans le style français*, 1974

117 Peter, Kensington Gardens, April 1972

'The point about the patterns you see in water in swimming pools is that they're moving, they don't stay still. And if the water is moving violently and there's a lot going on, the photograph, which is only capturing a fraction of a second, is in a way quite unrealistic, whereas you can paint it closer to the experience of seeing it.'

Hockney painted the figure of Peter from photographs taken later in the same month in London's Kensington Gardens, referring in particular to one

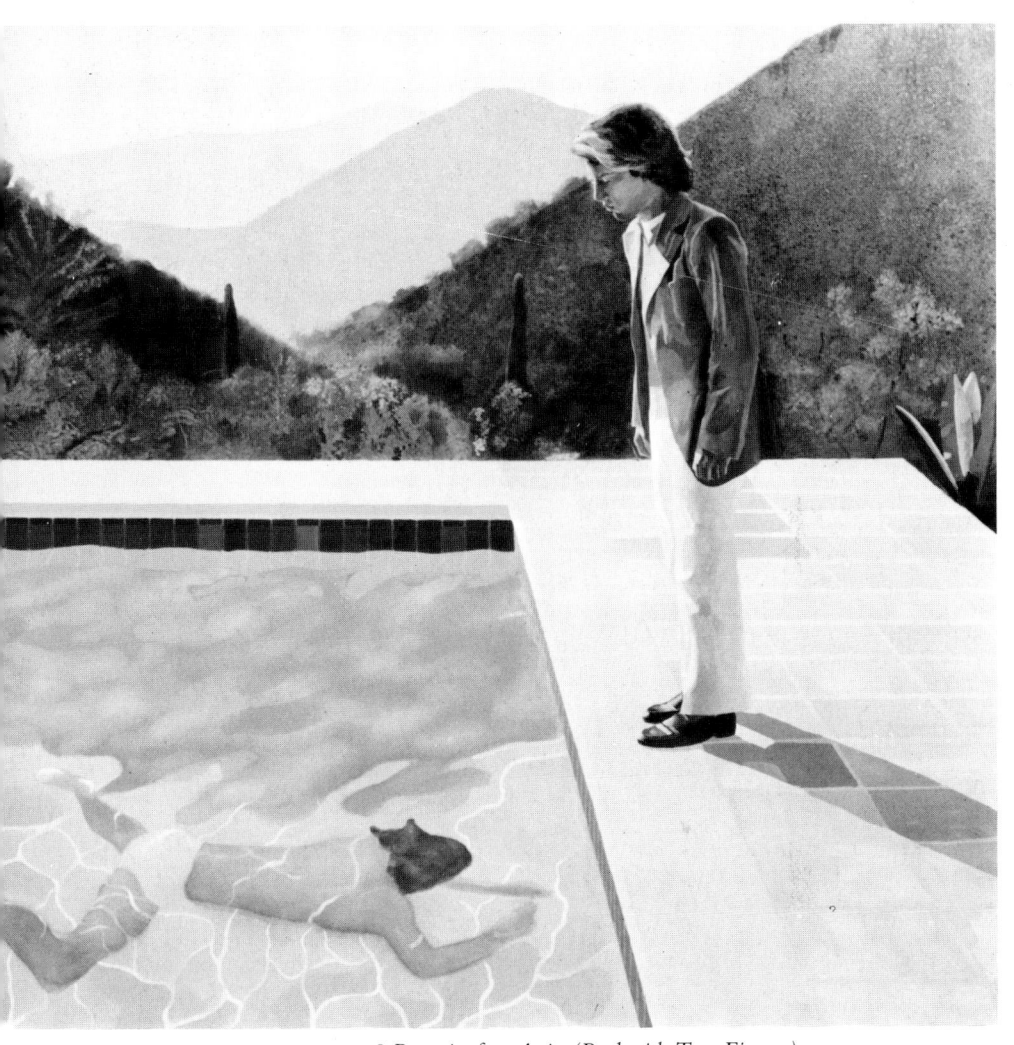

118 *Portrait of an Artist (Pool with Two Figures)*, 1972

large image made up of five separate sections pieced together, since a composite photograph of this sort provides more detailed information than could be obtained from an enlargement of a single negative. Composite photographs had begun to appear in his work as early as 1970, often as a way of dealing with architectural subjects on his travels. 'I did try using a wide-angle lens but I didn't like it much. Its distortions were extremely unnatural, I think. I thought "Why don't you just take many and glue them together?"

It would be more like the real thing than a wide-angle lens which makes the verticals go this way and that way. There's too much distortion in it, for me, and I don't like distortion in photography.'

Technical solutions thus helped in bringing *Portrait of an Artist* to completion. The traumatic effect of the ending of Hockney's relationship with Peter, however, is one that must be considered, for several of his most important paintings from 1971 to 1972 make particular reference to the absence of his friend. Plunged in a deep depression for the first time in his life, Hockney sought refuge in his work, producing his largest group of paintings in some years. 'It was only when Peter left in 1971, I think that was the first time in my life I had been really unhappy, and felt it, which then made you

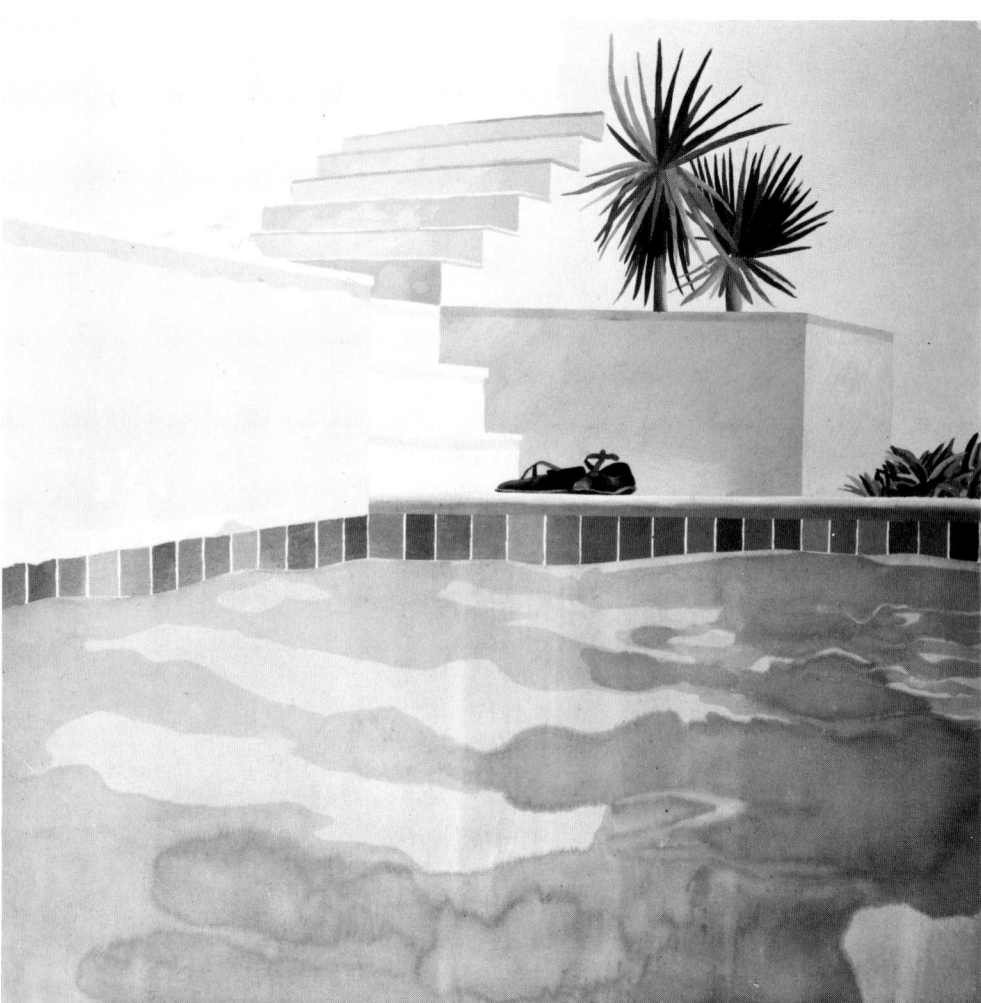

realize how happy you'd been. . . . For a few years afterwards I didn't want to see Peter. He wanted to see me and I said, "Please try and go out of my life, it's better." It was quite a long time before we could become reasonable friends. It took me two years, anyway, to get over it. Sometimes I'd almost break down. I felt terrible.'

In the paintings that followed there is an obsession, perhaps unconscious in some cases, with objects associated with Peter as symbols of his absence. The sandals in *Pool and Steps, Le Nid du Duc*, 1971, belong to Peter, but Hockney recalls that the picture was commenced while they were still living together and he is, therefore, reluctant to have too much meaning read into it. It is, after all, based very closely on a two-part colour photograph dated 'May 23rd/24th 1971' and can be viewed simply as a technical exercise in transcribing the image into paint. The water is depicted by recourse to a technique used by American abstract artists such as Helen Frankenthaler, Morris Louis and Kenneth Noland, in which acrylic paint mixed with water and detergent is stained into the weave of the canvas. In its selection of a 'watery' technique to represent a watery subject, it anticipates the even more successful solution of the *Paper Pools* seven years later.

154

Still Life on a Glass Table, 1971–2, also began as a formal exercise, this time exploring the theme of transparency through the representation of glass objects on a glass surface. Such a subject had been proposed in an ink drawing as early as 1967, and a rather schematized glass table appears in the 1969 double portrait of Henry Geldzahler and Christopher Scott, so there is a long time span leading up to the isolation of the image in a painting. The ink drawing, however, merely presents the subject as an idea; the perspective is wilfully exaggerated and the contours are awkward and naïve, so that the objects appear malformed and lacking in corporeality. The 1972 painting, on the other hand, demonstrates not only a far greater complexity but also a new-found ability to deal with the technical problems through direct observation. It is a virtuoso display of Hockney's recently acquired perceptual conviction in dealing with the refraction of light through glass, the reflections off it and the modifications of surface through it; yet through all this transparency he manages to endow the objects with a credible sense of weight and mass.

120
121
105

Even when setting himself a purely formal exercise such as this, however, Hockney seems still to return to sentiment, even if this happens unconsciously, through the selection of imagery. It was pointed out to him on finishing the picture that the objects on the table belonged mostly to Peter, and that the shadow beneath the table looked like that of a man with his limbs outstretched. The isolation of objects against a bare background, combined with an unnerving silence and a nagging sense that there should be

119 *Pool and Steps, Le Nid du Duc*, 1971

someone there to use all these things, creates a profound impression of loneliness and sadness rare in Hockney's work but understandable under the circumstances. It is an emotive reading which Hockney is prepared to accept not only for this painting but for other pictures as well, quoting in support the views of his own family: 'My sister thinks a great number of my paintings are full of loneliness. She doesn't know much about art but she did tell me that when she went through the book.'

If *Pool and Steps, Le Nid du Duc* and *Still Life on a Glass Table* both appear to reflect unconsciously the break-up of Hockney's relationship with Peter, *Chair and Shirt*, 1972, deals much more directly with Hockney's feelings of isolation and with his longing to be reunited with his friend. Hockney had gone to Japan in November 1971 with the artist Mark Lancaster to try to forget his personal problems, but he soon found himself thinking of Peter; stopping over in Hawaii on his way there, he awoke one morning in his hotel to find Lancaster's shirt draped over a chair, and suddenly realized that it was exactly like the shirt that Peter had once worn when he had drawn him. He took a photograph and made a drawing of the shirt as he found it on the chair, and drew the shirt again during his stay in Japan, using all this material to compose the painting on his return to England. The image thus constitutes a reminder of a particular person and of the circumstances which triggered memories of their friendship, even though it can also be viewed simply as a naturalistic representation of an observed scene.

The single unoccupied chair, placed in the centre of the picture as if posing for a portrait, is a favoured image of Hockney's work of the 1970s as an evocation of human presence. One is reminded particularly of Van Gogh's paintings of empty chairs as poignant reminders of particular people. Hockney believes that his own fascination with the image 'was more intuition than plotting', but acknowledges that the Dutchman's work has come to mean more and more to him: 'I've always had quite a passion for Van Gogh, but certainly from the early '70s it grew a lot, and it's still growing. I became more aware of how wonderful they really were. Somehow they seemed to become more real to me.' He regrets coming to Van Gogh so late, saying that 'it is only recently that they've really *lived* for me', but adds that Van Gogh now means more to him than Cézanne, even if it is sacrilege to say so. The great lesson of Van Gogh's work, in Hockney's view, is that one should not worry so much about innovations if it is possible to deal so directly with experience.

120 *Still Life on a Glass Table*, 1971–72

121 *A Glass Table with Glass Objects*, December 1967

Hockney's trip to Japan in November 1971 lasted only two weeks, but resulted in several paintings. One of these, *The Island*, 1971, was actually painted before he went there from a tinted postcard of the Japanese inland sea given to him by his dealer, Kasmin. Hockney recalls that his intention was to test whether his ideas about the place were accurate, as he had done in 1963 in painting *Domestic Scene, Los Angeles* shortly before his first trip to California. *33* Hockney thinks it is impossible not to impose to some extent your preconceptions on to a place even after you have visited it: 'You take yourself around everywhere you go, don't you? If you go to a fresh place, a place you've never been before, you can clear your mind for a while, and then you can't clear it and other things come back. Then you see it in a slightly different way and you find familiar things from what you thought was unfamiliar.'

The Island and its companion *Inland Sea (Japan)*, 1971, are both self-consciously picturesque in a way that had not been true of Hockney's work

122 Royal Hawaiian Hotel, Honolulu, 11 November 1971

123 VINCENT VAN GOGH *The Chair and the Pipe*, 1888–89

124 *The Island*, 1971

125 *Mark, Suginoi Hotel, Beppu,* 1971

95 since *Early Morning, Sainte-Maxime* of 1968–9. The homage to Impressionism, and particularly to Monet's paintings of the cliffs at Etretat, is as obvious as the striving for romantic effect; one is reminded of the stark silhouettes against a clear horizon in the work of Caspar David Friedrich, of which Hockney had by then become a great admirer. These paintings have a certain freshness from the free manner in which the marks have been applied, but there is something heavy-handed about the deliberate striving for prettiness and for a respectable pedigree. They are dangerously empty, intellectually and emotionally.

Mt. Fuji and Flowers, 1972, painted on his return to England, is crisply *113* executed and strong in decorative impact, but one cannot help feeling that the image is too much of a cliché and that the artist is playing along with this triteness rather than using it for his own ends. Hockney admits to having been disappointed with the country, finding it shockingly ugly at the time, and this may explain why he resorted to the standard conception of beautiful Japanese landscape as depicted in nineteenth-century woodcuts by artists such as Hokusai. Hockney, in fact, had hardly seen Mount Fuji and had made no drawings of it, working instead from a colour postcard and from his knowledge of the same motif in earlier Japanese art.

That Hockney was studying Japanese colour woodcuts is implicit in the strong rectilinear design of a crayon drawing such as *Mark, Suginoi Hotel,* *125* *Beppu*, 1971. It bears a particular resemblance to the prints of Kuniyoshi, in which a single figure is often framed by the thrusting diagonals of a simplified architectural setting and in which mood is frequently evoked through gesture and facial expression. Hockney made best use of the qualities of Japanese woodcuts, however, in *The Weather Series*, a set of *115, 126* colour lithographs drawn and printed in Los Angeles in the spring of 1973. These were consciously intended as a tribute to Japan and particularly to the skill and poetry with which the Japanese have depicted the weather, stylizing it in a way that Hockney thinks has never been the case in English art. Hockney made a few trial runs, such as *Ten Palm Trees in the Mist* and two studies of lightning, and then set to work on the six prints which form the set: *Sun, Rain, Mist, Lightning, Snow,* and *Wind. (Rainbow* and *Frost,* also planned, were not executed.)

The Weather Series codifies to some extent the experience of Hockney's naturalistic work, to the degree even of producing variants of two of the prints (*Dark Mist* and *Snow without Colour*) to suggest the Impressionist practice of working from the motif under different conditions of light. The information provided by photographs is still referred to for certain details such as the blue shutters in *Sun*, which was drawn from camera studies made *115* by Hockney at Christopher Isherwood's home. The naturalistic elements, however, are now subordinated to the decorative impact of the design. The light in *Sun* is treated in a highly conventionalized manner; it is a sign for light which recalls the devices Hockney had favoured in his paintings of the mid 1960s. *Rain* is depicted in an equivalently abstract manner, with a perfect *126* congruence of the fluid medium of tusche – a dilution of the lithographic ink brushed on to the plate – with the wetness of the subject it depicts. It is a memorable image because of the way in which an observed experience has been translated into visual terms: we are made far more conscious here than in the paintings of the material composition of the image. Hockney's

genuine pleasure in making prints, his concern for the quality of the printed mark, once again saved him from the excesses of naturalism, as had been the case with the Grimm etchings four years earlier.

Hockney thinks now that *The Weather Series* was a mixed success, perhaps because it was too conscious a move away from naturalism. Indeed in his other work at that time he was exploring how far naturalism could be taken by pushing to the limit his sharpness of observation and virtuosity of execution. This is particularly evident in the drawings and prints of Celia Birtwell, which are on a larger scale than any of his previous drawn portraits and which exhibit effects of textural subtlety and delicacy more impressive than anything he had yet achieved in this idiom. Hockney had got to know

126 *The Weather Series: Rain*, 1973

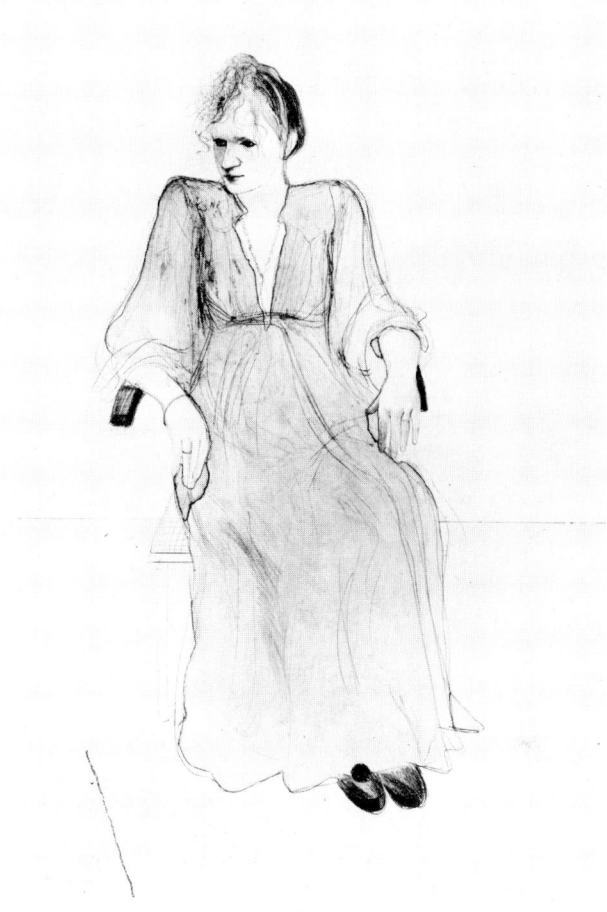

127 *Celia*, 1973

Celia well on his return to England in September 1968 through Peter, who was studying painting at the Slade, and he started drawing her almost at once. Using her as a subject in 1969, he produced one of his most refined line drawings to date as well as his first large-scale printed portrait, a somewhat clumsy etching which is, nevertheless, important as a prefiguration of the series of large lithographic portraits of the 1970s.

Following the break-up of his relationship with Peter in 1971, Hockney drew even closer to Celia, partly, he admits, because she was like a link between them. This is not to deny that he was attracted to her for her own

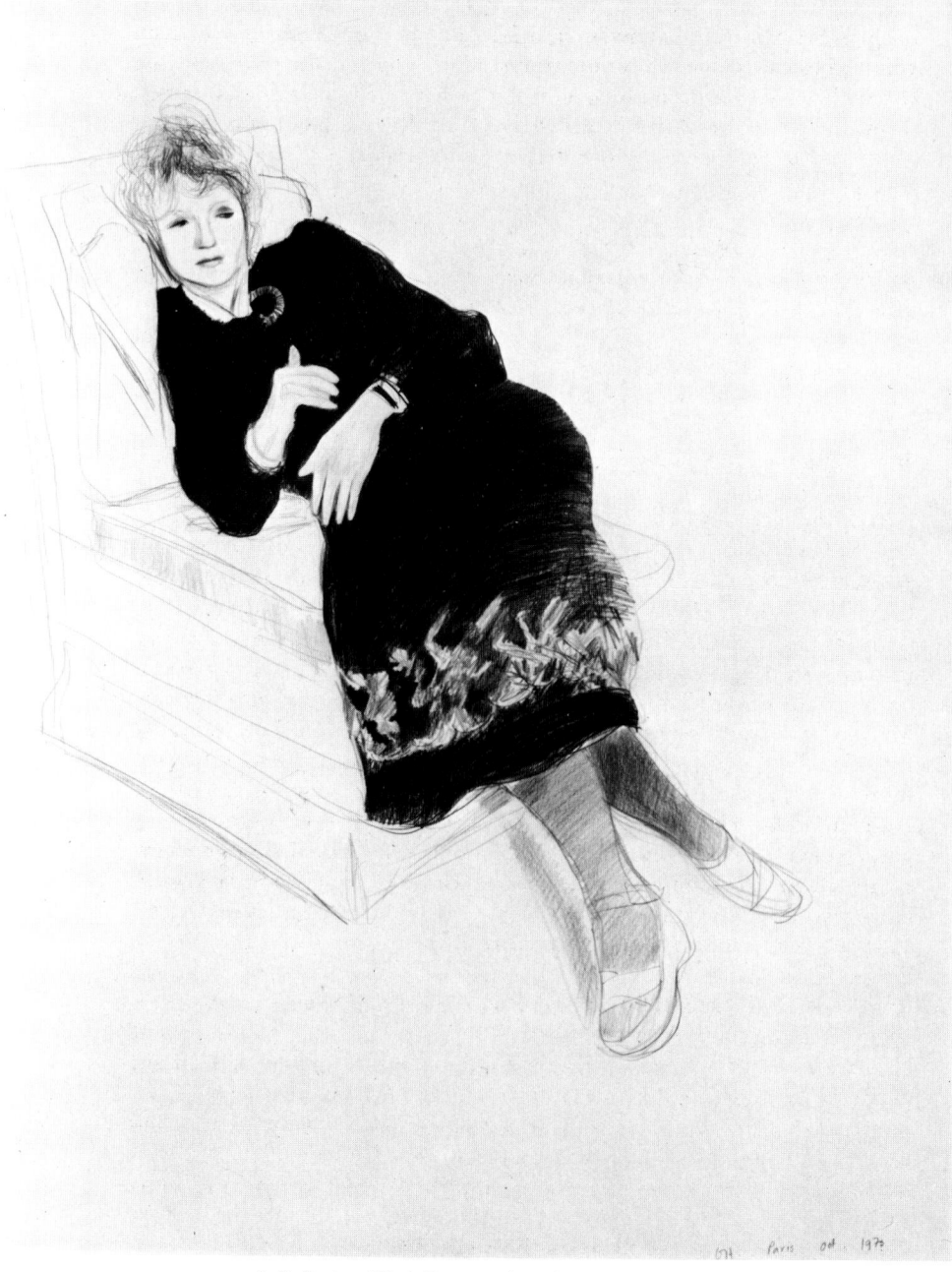

128 *Celia in a Black Dress with Red Stockings*, 1973

qualities as a companion, however; to this date, she is one of the few women whom he has come to know intimately. The drawings reveal the consolidation of this friendship and the growing trust and closeness between them; the rather wary and detached mood of the first pictures of her has given way by 1973 to a much more relaxed understanding. The tenderness of these pictures makes it possible to speak of them almost as the consummation of the relationship between them. By trusting his responses, Hockney had already effected a surprising transformation of the treatment of the male figure in art, picturing men as objects of erotic desire rather than as symbols of aggression or power as had been the case in most earlier art. His pictures of Celia, similarly, would be difficult to imagine as the work of a heterosexual male artist, for his appreciation of her beauty lies in his responses to her as an individual rather than as a sexual object. Hockney sees her as 'a very feminine woman, a very sweet-natured, gentle person', and it is these qualities that are emphasized in crayon drawings such as *Celia in a Black Dress with Coloured Border*, 1973, and in the lithographic portraits of the same year. For these pictures he has devised a more sensitive approach to colour as well as a wispier line and more delicate, sensual effects of surface than he had yet achieved. At their most conservative, Hockney's portraits sometimes suffer from the vacuous and ostentatious display of fashion that one associates with artists such as Paul Helleu and John Singer Sargent, and have a similarly irritating air of self-congratulation about them. We should not be blind, however, to the great beauty and finesse which they can also achieve. Modernism has made us too suspicious of conventional notions of beauty and of hedonistic pleasure. Hockney accepts the risk of being old-fashioned for the sake of communicating a delight in the senses.

128, 127

Many of the drawings of Celia were done in Paris, where Hockney had gone to live in 1973. Knowing that he needed the stimulation of a new environment and wishing for once to have a change from California, as well, Hockney moved to the heart of the Latin Quarter, where he rented a studio and flat that had formerly been occupied by the painter Balthus. He recalls that he 'hadn't the least idea' what to paint on his arrival there, and in the end completed only three major canvases before leaving Paris for the last time in 1975. (He was never, in fact, an official resident in France but spent much of his time commuting to England.) He produced another double portrait, *Gregory Masurovsky and Shirley Goldfarb*, which was rather smaller and much more stilted than the previous works in the series, as well as two large paintings of windows in the Louvre: *Contre-jour in the French Style – Against the Day dans le style français* and *Two Vases in the Louvre*. All are dated 1974.

116

Part of Hockney's difficulties with his paintings at this time can be attributed to technical problems, for he had decided on his move to Paris to

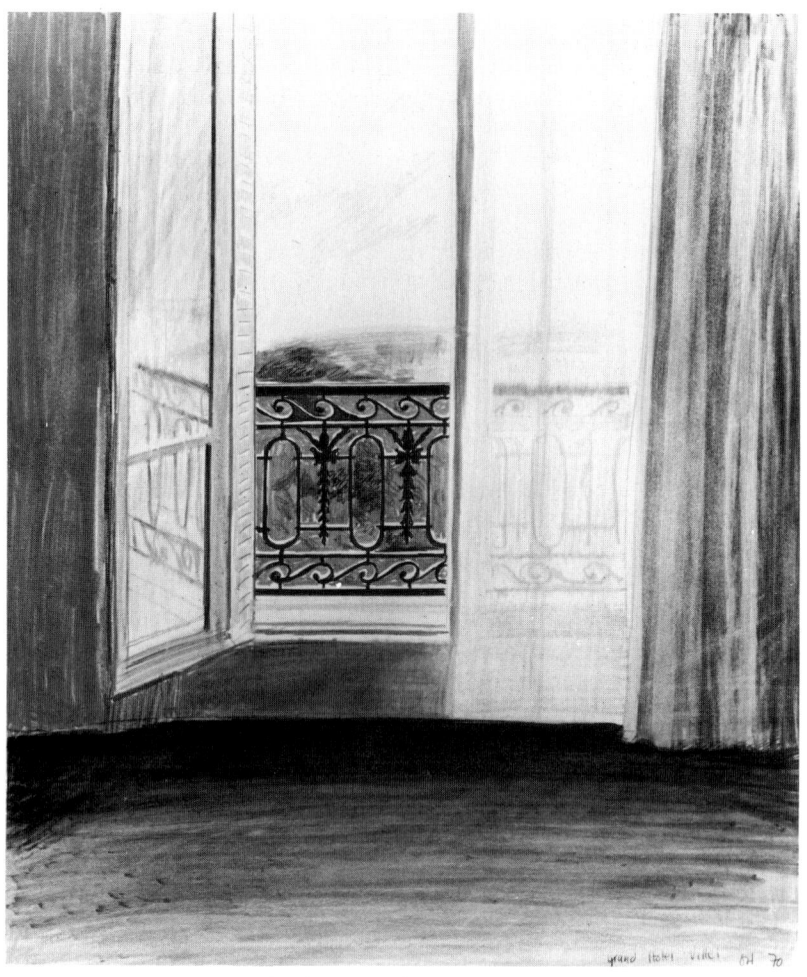

129 *Window, Grand Hotel, Vittel*, 1970

abandon acrylic paints, which he now regarded as too limiting, and to take up oils again. He found that after nearly a decade of using a plastic-based medium, he had to teach himself to handle oil paint as if he had never tried it before. The problem went further than this, however, for it was naturalism itself which he now realized was becoming a dead-end.

Contre-jour in the French Style, the most accomplished of his Paris paintings, in fact returns to an image that he had treated as early as 1970 in drawings such as *Window, Grand Hotel, Vittel*, and in prints such as the 1971 etching, *Rue de Seine*. The French tradition is recalled particularly in the

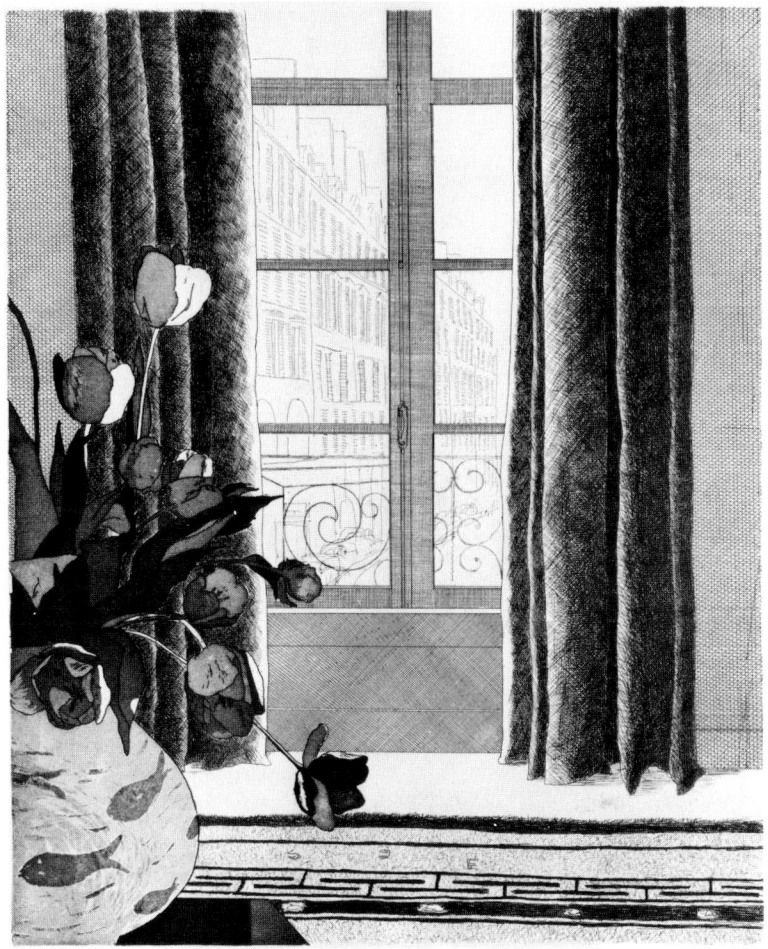

130 *Rue de Seine*, 1971

latter in its treatment of the view through the window, a variation on the theme of the picture within a picture such as one would find in the work of Matisse; the goldfish bowl in the foreground can be interpreted as a direct homage to particular paintings by that twentieth-century master. The Vittel coloured drawing, on the other hand, anticipates by four years not only the *contre-jour* effect — which was, after all, an important feature also of the double portrait of Ossie Clark and Celia Birtwell begun in the same year — but even the technical problem of depicting the passage of light through a film of translucent material. Hockney says, however, that he had forgotten

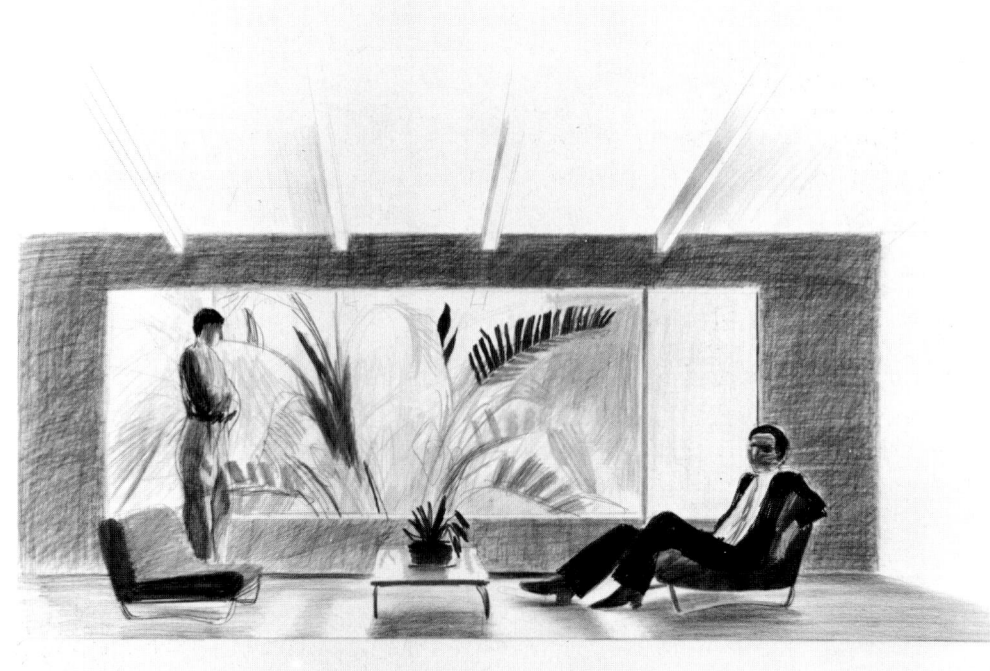

131 *Sketch for Portrait of Nick Wilder and Gregory*, 1974

these earlier images, and that he was attracted subconsciously to the subject for the same reasons that occasioned the previous pictures on a similar theme.

Various aspects of French artistic traditions are combined in the two Louvre paintings. The view through the window recalls not only Matisse but also the work of other Parisian artists such as Degas, who was particularly adept at *contre-jour* effects. The strict symmetry, rigid architectural format and the image of formal gardens all relate to the traditions of Classicism in French painting and design. The stippled paint application is a modified version of the pointillist technique of Neo-Impressionism, one which allowed Hockney to begin loosening his brushwork again and to distribute colours in small patches across the surface. Even the slow-drying and supple nature of oil paint seemed appropriate to the challenge of French painting and to the demands of subtlety of surface and of effects of light. Photographs were used as an *aide-mémoire*, particularly for painting the gardens, but entire surfaces once again are invented, self-sufficient as luminous patterns of

colour. Naturalism, even in this painting about light, is no longer assumed to be the only goal worth pursuing.

Naturalism was beginning to appear to Hockney as an increasingly restrictive idiom by the time that he returned to England in 1975. The seven by ten-foot double portrait *George Lawson and Wayne Sleep* on which he had spent six months in 1972 was still unfinished, and his dissatisfaction with acrylic and particularly with the rather dead, overworked surface of this painting led him finally to abandon it. Another large double portrait planned of Nick Wilder and Gregory Evans, set in Wilder's Hollywood home, was proposed in a coloured crayon drawing, but the painting was never begun. Hockney was attracted to the challenge of depicting the light streaming in through the huge picture window, but the prospect of laboriously executing another large painting of this type seems finally to have dissuaded him. He realized that he had reached a state of crisis in his work and that what was needed was a complete change of direction.

131

132 *George Lawson and Wayne Sleep* (unfinished), 1972–75

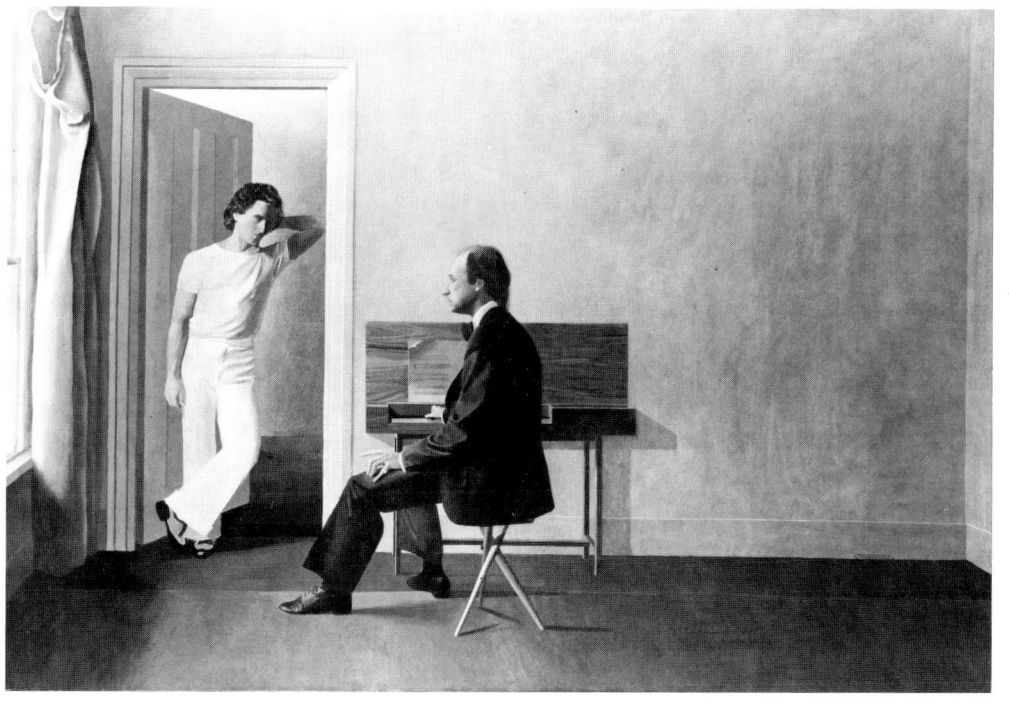

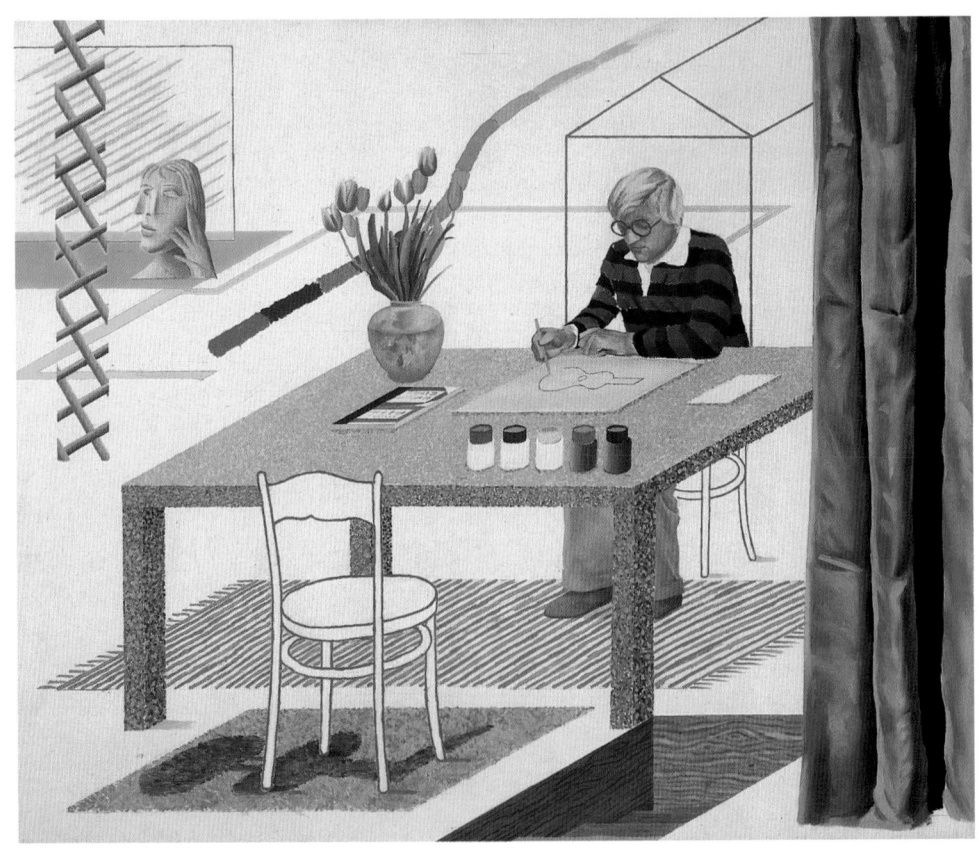

133 *Self-Portrait with Blue Guitar*, 1977

3 Inventions and Artifice

In the early 1970s Hockney slowly became aware that for the first time in more than a decade he was in danger of becoming set in his ways, trapped by naturalism as well as by his commercial success and popularity. His growing impatience with the self-imposed limitations of picturing the world in one way only was compounded by a sense that he had lost the freedom of movement that he had known when he was younger. As early as 1973 in *The Weather Series* he began to move away from naturalism, yet his efforts to disembarrass himself of the style, in spite of the firm intentions voiced in the autobiography taped in the summer of 1975, were to preoccupy him at least as late as 1977.

115, 126

'I was, I think, going on the wrong path, but it took me a long time to completely realize it and a longer time to get out of it. In a sense it took a few years to get out of it again, it's amazing, partly because of timidity, I think.' Hockney suggests that like other artists in mid-career he was afraid to make a drastic change that might appear to negate his own earlier production. 'I think your past work sometimes becomes a burden, I think it is for a lot of artists around today. In a way they're burdened with what they see as commitment, but might not be truly commitment anyway, and it might be severely limiting what really expressive qualities they wish to deal with. I think that happens when you're older and I think it causes a kind of crisis. All artists can go through that and if you come out of it the other side, you come out richer, the art comes out richer and wider and better.'

The first sign of Hockney's urge to work again directly from the imagination occurs in a group of drawings and prints made in 1973 under the inspiration of Picasso, who had died on 8 April of that year. Hockney was one of a group of artists commissioned by a Berlin publisher, the Propyläen Verlag, to produce a print for a portfolio, *Homage to Picasso*, to be published in the following year. Hockney left California to work on this etching in Paris with Aldo Crommelynck, the master printer who had worked closely with Picasso for twenty years. The contact was decisive: Crommelynck not only showed Hockney sugar lift and colour etching techniques which he had perfected for Picasso, but also spoke with great affection of the Spanish master, telling Hockney how well the two of them would have got on with each other. Hockney's regret at never having met him seems to have

136

renewed his long-standing admiration for his work, which had exerted such a powerful influence on him as early as 1960, and intensified his desire to meet the challenge of Picasso's art through a close examination of favoured themes. Hockney recalls also that it was only with Picasso's death that one could begin to see the consistency of his life's work, making sense of the apparent stylistic breaks as the result of a unified attitude towards style and content. In Hockney's view, only now will Picasso's real influence begin to emerge, for it will be based on an appreciation of his expansive approach rather than on the mere imitation of the superficial characteristics of one of the many styles he devised. The problem of so much contemporary art lies not in its relative degree of academic, reactionary or avant-garde qualities but in its self-imposed narrowness, which to Hockney seems like a meanness of spirit. The authority and weight of Picasso's work, on the other hand, is the result of the sheer breadth and generosity of his vision, allied to a steadfast insistence on connecting his pictures to his own life, surroundings and interests.

Hockney eventually produced two etchings which transform one of Picasso's favoured themes, that of the artist and his model, into a personal act of homage. The first of these, *The Student: Homage to Picasso*, 1973, was the print produced for the Berlin portfolio. Hockney depicts himself in this etching in the humble role of student, carrying under his arm a portfolio of his work for the scrutiny of his hero Picasso, who is represented as a youthful sculptured head on a columnar pedestal. The image carries deliberate echoes of Picasso's series of etchings *L'Atelier du sculpteur*, executed in 1933 as part of the Vollard suite, in which the artist presents himself in the act of contemplating his own creation, reflecting on the sources of his inspiration and awed into silence by the impossibility of fully achieving his own ambitions. Hockney evidently looked closely at this series of prints by Picasso and made at least one ink drawing as a reasonably accurate copy of the figures in one of them. His imagination may have been further stimulated by an article, 'The Artist and his Model', by Michel Leiris, published in 1973 in the volume of essays edited by Roland Penrose and John Golding, *Picasso 1881/1973*, which discusses the transformations of the subject in Picasso's work over a period of four decades.

The Student: Homage to Picasso, interesting though it may be in terms of theme, is treated, however, in a rather uninspired illustrative manner. Far
134 more successful is a second etching, *Artist and Model*, which was begun in 1973, nearly abandoned, but reworked and published in the following year by Petersburg Press. Hockney here has devised an affectionate and far wittier response to the theme, again incorporating, for the first time in his work
21 since the 1961 etching *Myself and My Heroes*, an explicit self-portrait.

164

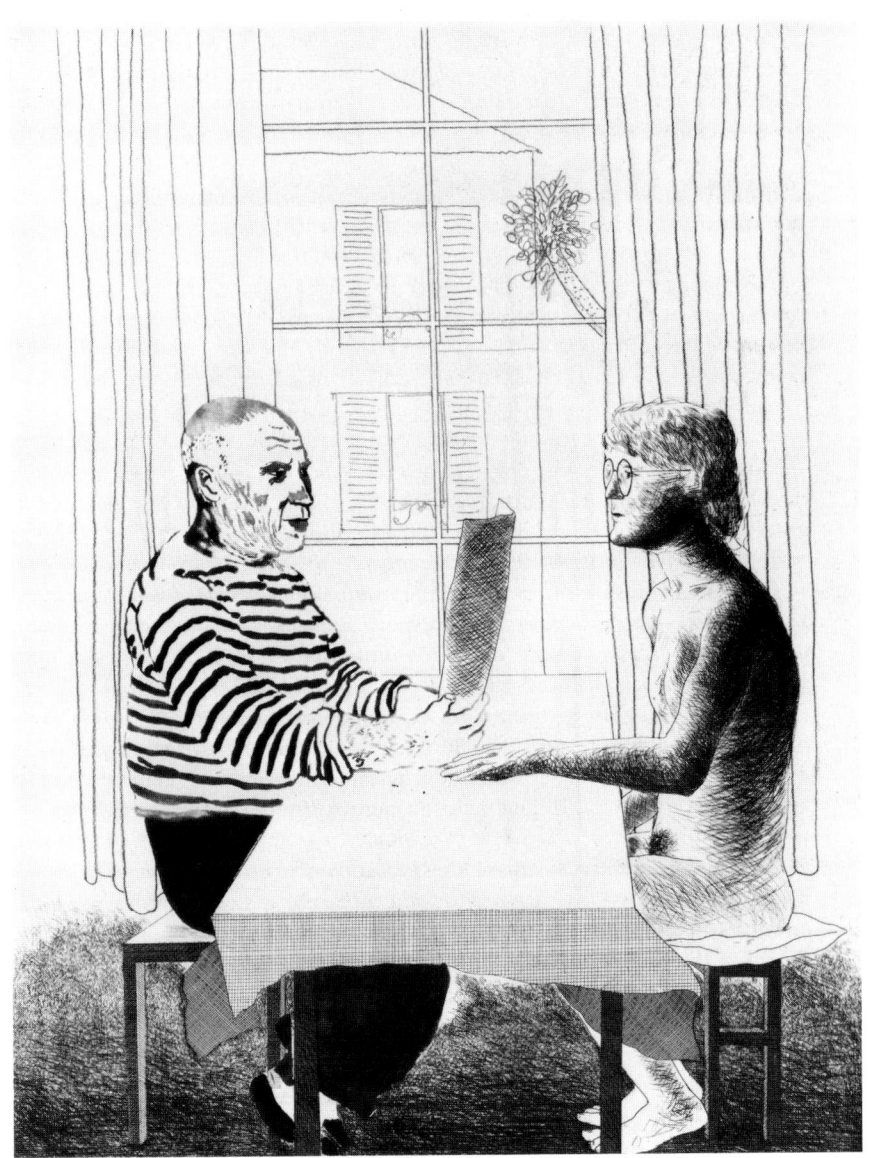

134 *Artist and Model*, 1973–74

Hockney and Picasso are shown gazing intently at each other, just as the artist and his model often do in images by Picasso, of which Leiris writes: 'Confrontations, meetings, mutual discoveries are the basic themes of many compositions involving two or more characters between whom nothing is happening, except that they are looking at each other.' In depicting himself naked, however, Hockney humbly places himself in the role of model rather than artist, reversing the iconographical custom so as to declare once again his admiration and debt to an artist whose greatness he would not pretend to rival.

In his work of the early 1960s Hockney had found it useful to play with both form and style as a means of doing away with arbitrary restrictions. The freedom of movement which he now wished to reclaim, as he readily avowed in the interview published in the catalogue of his 1974 Paris retrospective, took its inspiration directly from Picasso. Just as the elder master often contrasted different styles within the same picture, drawing attention to the elusive task of devising a visual form for the reality he perceives, so Hockney in *Artist and Model* contrasts various ways of drawing and three different techniques: hard-ground, soft-ground and sugar aquatint.

In the same year that he began this print, Hockney made several drawings based closely on Picasso's most stylized sculptures, particularly on those with self-portrait connotations. Three of the heads in *Cubistic Studies, Paris* derive from the cut-out and folded metal sculptures which Picasso began making in 1953. These sculptures made actual the interpenetration of planes characteristic of Picasso's Late Cubist paintings, adapting the methods of two-dimensional representation to a three-dimensional object opened out into space. If Picasso had found a way of making the implicit pictorial volume explicit by fabricating the images out of sheets of metal, Hockney here reverses the process by drawing the sculptures back on to paper, transforming the volumes into a surface design of insistent flatness. There is a gently ironic humour at work here, but also a poignant sense of the struggle facing the artist. In 1971 Hockney had produced two paintings, *Gonzalez and Shadow* and *Cubistic Sculpture with Shadow*, both based on photographs he had taken at the Musée d'Art Moderne in Paris, which demonstrate how circumstances can contrive to undermine the illusions so carefully sought by the artist. There is something slightly pathetic as well as funny about the fact that Cubistic sculptures, theoretically the most vivid expression yet devised of volume and mass in space, cast shadows just as flat pictorially as those produced by any other object, thus apparently denying their whole purpose. This reminder that reality can never be fully seized in pictorial form must have been slightly painful to Hockney at a time when he was doubting more and more the efficacy of naturalism as a neutral container for depicting the

world. If any form of depiction is but a convention requiring the viewer's 'suspension of disbelief', there can be no justification in placing a special premium on naturalism.

As if to test how far a highly conventionalized treatment can still transmit the artist's perceptions and sense of humanity, Hockney shifted his attention to the extremes of geometric stylization in Picasso's work in a playful return to the theme of Cézanne's cube, cylinder and sphere which had preoccupied him in 1965. The head in the lower right of *Cubistic Studies, Paris*, which

135 *Cubistic Sculpture with Shadow*, 1971

136 *Cubistic Studies*, Paris, 1973

appears three times in a companion drawing of the same year, refers to Picasso sculptures such as *Head*, 1958, fashioned in wood and then cast in bronze. In these a sophisticated, knowing 'primitivism' prevails, an urge to discover the ability of the viewer as well as of the artist to transform the barest of pictorial signals into a convincing evocation of human presence. Still taking his cue from Picasso sculptures as well as from the sketchiest of Picasso's post-war paintings, Hockney took this one step further by creating a head solely from geometric elements: the head as a sphere surmounted by a rectangular face on which are drawn the simplest possible indications of eyes, nose and mouth. A group of four such heads constructed from standard geometric forms fills the entire sheet of *Simplified Faces*, 1973, a crayon

168

137 *Showing Maurice the Sugar Lift*, 1974

138 FRA ANGELICO *The Dream of the Deacon Justinian*, 15th century

drawing which was used as the model for two coloured etchings in the following year.

During 1973–4 Hockney was still immersed in the stilted naturalism of
132 the double portraits of *Gregory Masurovsky and Shirley Goldfarb* and *George Lawson and Wayne Sleep* and in the delicate if rather academic drawings of
137 Celia. *Showing Maurice the Sugar Lift*, 1974, although originally intended only as a demonstration piece for Hockney's printer, Maurice Payne, in retrospect can be seen as a signpost for Hockney's subsequent return to the bewildering variety which characterized his work in the early 1960s. The etching technique used here was that devised by Crommelynck for Picasso, but the selection of contrasting idioms is Hockney's own, recalling his *Rake's Progress* etchings of 1961–3. The geometric figure in the upper-right of the
160 print reappears in the *Invented Man Revealing Still Life*, a small canvas of early 1975. This is the first painting in more than a decade in which Hockney avoids naturalism completely, and it is not, therefore, surprising that he voices his new-found freedom in a language that has much in common with his work of the first half of the 1960s. Particularly prominent is the device of

the curtain, seized this time from Fra Angelico's *The Dream of the Deacon* 138
Justinian (Museo di San Marco, Florence), as an indication of a shallow
theatrical space and as a means of disclosing the scene as a painted event
witnessed by the spectator. The brushwork once again is more varied, there
are jarring contrasts of idiom from the flattened geometry of the figure to the
illusionism of the vase of flowers, and the combination of conflicting
perspectives and areas of bare canvas breaks any possible spatial illusions,
once more proclaiming a discontinuity of space rather than a continuous
single view. Even the figure, though derived from Hockney's recent study
of Picasso's work, is endowed with a schematization and anonymity that
recall equivalent qualities of the childlike and semi-Egyptian figures of
Hockney's paintings of the early 1960s. Like the trickles of colour that flow
from the upper edge of the canvas, the figure is presented as a pure invention,
a fabrication in paint, rather than as a substitute for reality.

The blatant artifice and theatricality of *Invented Man Revealing Still Life*,
in spite of its sources in Hockney's own earlier work and in his recent
drawings and prints, owe much to the fact that it was worked on at the same
time that he was producing his first designs for an opera. He had worked for
the stage only once before, in 1966 when he designed the Royal Court
production of *Ubu Roi*, and when producer John Cox approached him in the 67–8
summer of 1974 to design a new production of Stravinsky's opera *The Rake's*
Progress for Glyndebourne, he was tempted simply to turn down the offer 139–40
out of fear that he did not know enough about the technical problems
involved. He agreed, however, to return to England from Paris to discuss the
project with Cox, who convinced him that he would be able to adapt his
procedures to the requirements of the theatre. The opera was to be staged the
following summer, and Hockney was given until Christmas 1974 to produce
the designs. Hockney could not resist the challenge, particularly since he
enjoyed the music so much, and consented to take on the project. In October
he left for Hollywood to work on the designs, partly to be able to
concentrate without the social pressures of London or Paris but also because
Stravinsky had composed the music there between 1947 and 1951. By
Christmas, Hockney had completed 70 per cent of the work and knew how
he was going to approach the rest.

There were a number of factors which prompted Hockney to accept the
commission. He had been a lover of opera since about the age of twelve,
when he was taken by his father to see a production of *La Bohème* at the
Bradford Alhambra, and since his arrival in London in 1959 he had been an
avid opera-goer. *The Rake's Progress* was bound to interest him, of course, 23
for the story alone, since it was based on the same group of pictures by
Hogarth that had inspired Hockney's own series of that title in 1961; it was, 1, 22

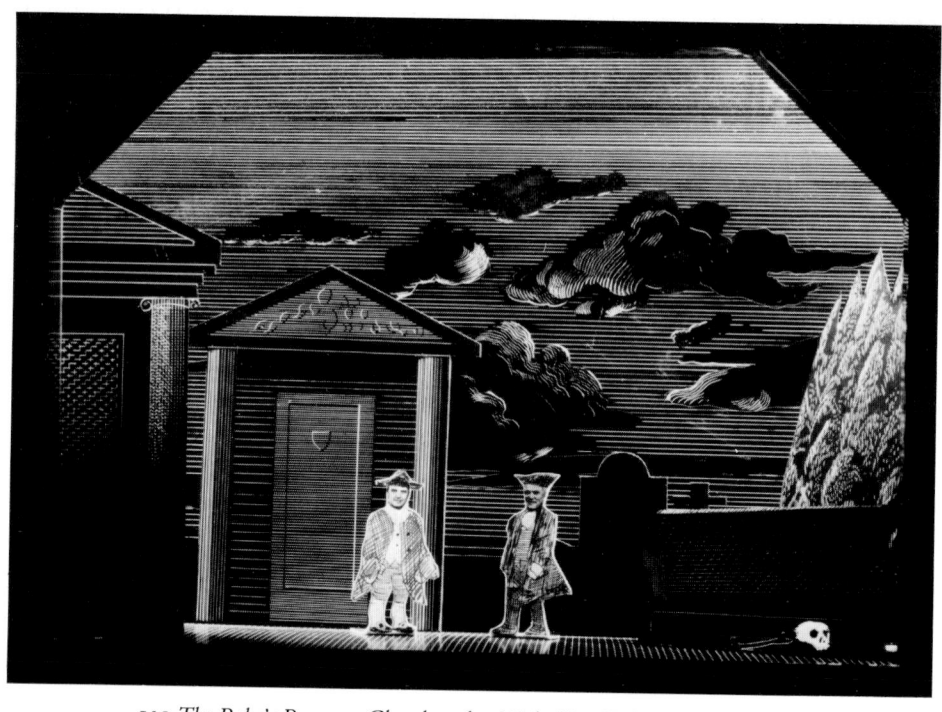

139 *The Rake's Progress: Churchyard at Night* (Act III Scene 2), 1974–75

indeed, because of this link that John Cox thought of contacting Hockney in the first place, although Hockney immediately made it clear that he wished to keep the action in the eighteenth century rather than updating it as he had in his set of prints. Hockney had met the co-authors of the libretto, W.H. Auden and Chester Kallman, on several occasions, although he had not had occasion to speak to either of them about the opera. The music itself, written in what Stravinsky called the 'Italian-Mozartian' style, appealed to Hockney, and he realized that this essential element would provide additional inspiration that he would not find in designing a straight play. Following Wagner, whose views have greatly shaped his own, Hockney considers opera to be 'heightened reality'. He points out that if poetry can say more than prose, then music combined with poetry can achieve still greater profundity.

Hockney's painting, in any case, was causing him problems, and he sensed that the challenge of a new medium could inject a new enthusiasm into his work. 'When you're working suddenly in another field, you are much less

140 *The Rake's Progress: Bedlam* (Act III Scene 3), 1974–75

afraid of failure. You kind of half expect it, so therefore you take more risks, which makes it more exciting.' Had he been asked to do work for the theatre earlier, while he was still engrossed in naturalism, he thinks that he would have turned the offer down, since he cannot conceive of working in a naturalistic vein in this context. Coming when it did, Glyndebourne's offer seemed a possible way to help him out of the clutches of naturalism through a return to the theatrical devices which had exerted such a fascination on him in the early 1960s. His experience with *Ubu Roi* had already taught him that he need not worry about reintroducing theatrical devices to the stage, because that is what they are intended for. It is merely a question of using them in context rather than out of context.

67–8

Hockney had seen only one production of *The Rake's Progress*, at Sadler's Wells in 1962, before setting to work on his own, but that single experience had proved so visually uninteresting to him that he had to be reminded by a friend that he had actually seen it. He carried out all possible research into previous productions and did a considerable amount of reading about the

imagery he had to achieve his effects principally through the choice of colour and image. The garden of Trulove's cottage, seen first in the afternoon (Act I Scene 1) and then at night (Act I Scene 3), is based on a single design but reveals the changes in light through the use of different backdrops: a brightly lit landscape for the first, followed by a pitch-black sky etched with the white outlines of clouds. A similar black sky is used for the 'starless night' of the churchyard scene. The designer's constant ingenuity is required to surmount the necessary limitations of painted scenery:

139

'The trouble with painted scenery is all the effects have to be created in the painting. You light it mainly one way, dim or light. But if you put two cubes on an empty stage, there are so many ways you can light it; using the shadows, you can create a lot of effects. If you put two pictures of cubes on the stage, your lighting is a lot more limited; you can have light and dark, but you can't help the space or flatten it, it's always going to be the same. Whereas with the 3-dimensional cubes you can have them flat or you can make it suggest a bigger space, there's a lot of things you can do with it. I wouldn't do that. That's why there are operas that at one time I thought I might not do that I might do, that you could deal with in different ways.'

Hockney thinks of his sets as large pictures, but as three-dimensional rather than as two-dimensional pictures. The rooms in *The Rake's Progress* are viewed from an angle rather than straight on. This ensures that each member of the audience, depending on his position, will get a different perspective on the wealth of detail afforded by certain scenes. Hockney remains faithful to the simple instructions provided in the libretto, but elaborates the designs with a complexity of imaginative detail in excess of anything he had produced in his paintings in recent years. For the Bedlam scene, the last in the opera, Hockney suggests the disordered states of mind of the inmates by providing them with grotesque masks reminiscent of the *commedia dell'arte* and by covering the walls with a multitude of nervous scribbles, doodles and graffiti. (On one wall are written the initials 'W.H.' in an elegant script, an homage both to Auden and to Hogarth.) The inmates are housed in a grid of wooden stalls, a symbol both of their physical imprisonment and of their psychological isolation from each other.

140

The Rake's Progress was the most demanding project which Hockney had undertaken since the Grimm illustrations five years earlier. Every visual detail had to be carefully considered. For the costumes, for instance, Hockney made a few drawings and provided references to figures in Hogarth engravings which he wanted to be used as a guide. The fabrics from which the clothes were made were printed up in cross-hatched patterns in different colours under Hockney's supervision. In this way, the figures partook of the same characteristics as their surroundings. The triumph over

141 Drawing for the design for Roland Petit's ballet *Septentrion*, 1975

naturalism was now complete, for even when dealing with real people he had now found a way of avoiding the prosaic description which had been plaguing him in his paintings.

Soon after Glyndebourne had approached Hockney, Roland Petit of the Ballet de Marseille asked him to produce a simple backdrop for a new ballet, *Septentrion*, which was staged in 1975 shortly before the première of *The Rake's Progress*. Hockney was asked for a scene in the south of France with a swimming pool; he produced two preliminary sketches and a finished crayon drawing which was then painted to scale by scene painters in Paris. Although the pool is borrowed from *Portrait of an Artist (Pool with Two Figures)*, 1972, and the house is reminiscent of the façade in another 1972 painting, *Two Deckchairs, Calvi*, this backdrop is not simply a retrospective image. Deliberately French in tone, it looks forward to the Mediterranean backdrop designed in 1980 for the Poulenc opera *Les Mamelles de Tirésias*.

As Hockney had hoped, the theatre proved to be the liberating influence that he needed. A renewed sense of purpose becomes evident in all his work following the staging of the opera in the summer of 1975. He was excited to see the results of the collaborative effort, and his confidence was further boosted on the opening night when John Cox asked him if he would next design Mozart's opera *The Magic Flute*, to be staged three years later. Even though he did not actually begin working on the latter until mid 1977, the

<div align="right">

141

118

166

152–3
163

</div>

theatre has thus been a constant and dominant presence in Hockney's work since 1974, providing a clear focal point for his energies and an alternative to naturalism.

Hockney's research for *The Rake's Progress* led him to examine editions of Hogarth's complete engraved work. In the process he discovered an amusing design by Hogarth, engraved by Luke Sullivan, which was used as the frontispiece to *Dr. Brook Taylor's Method of Perspective made easy* (1754) by Hogarth's friend Joshua Kirby. The print was intended as a satirical illustration of the disastrous effects resulting from neglect of the rules of perspective, but Hockney enjoyed the playful element of Hogarth's engraving and decided to transcribe it on to canvas, adapting the technique that he was using at the same time for the stage sets. *Kerby* tests the hypothesis that a painting observes its own laws and not those of the natural world. In an interview in *Art Monthly* published in November 1977, Hockney remarked that with this painting he finally 'abandoned the idea of superficial consistency', realizing that underneath the differences 'there is consistency in the search, in the attempt to find it.' *Kerby*'s concept outstrips its presence as a painting, since Hockney was escaping one form of illustration only to engage in another, but it is of the utmost significance as a clarification of his ideas concerning the role of painting.

While working on *Kerby* in the spring of 1975, Hockney began work on *My Parents and Myself*, a subject which he conceived when his mother was in hospital in the early 1970s to undergo an operation. 'My father could go to the hospital every day for a few hours, but he wasn't used to sitting and talking to her for a few hours every day at home. He'd be doing something, my mother would be doing something else. It was then I noticed that people communicate in other ways, it's not always just talking, especially people who know each other well. They'd been married forty-five years, and if you've been living with somebody forty-five years, you know a lot about the face, the little actions, what they mean, you know how to interpret them. I think it was then I decided there was a subject there I somehow wanted to try and deal with.' As in Hockney's previous double portraits, the figures are still treated volumetrically, which he evidently considered necessary as a means of endowing them with a convincing presence. This picture marks a departure, however, in the minimal note that is taken of the setting, which is not so much a room as a neutral background for the figures. The function of the bare canvas here is to concentrate attention on the people portrayed, just as the new square format, six foot by six foot, makes the figures appear compressed and more monumental. It is a picture very much about Hockney's relationship with his parents and about their dealings with each other. His self-portrait appears in the small mirror, and a red triangle behind

142

143

142 *Kerby (After Hogarth) Useful Knowledge*, 1975

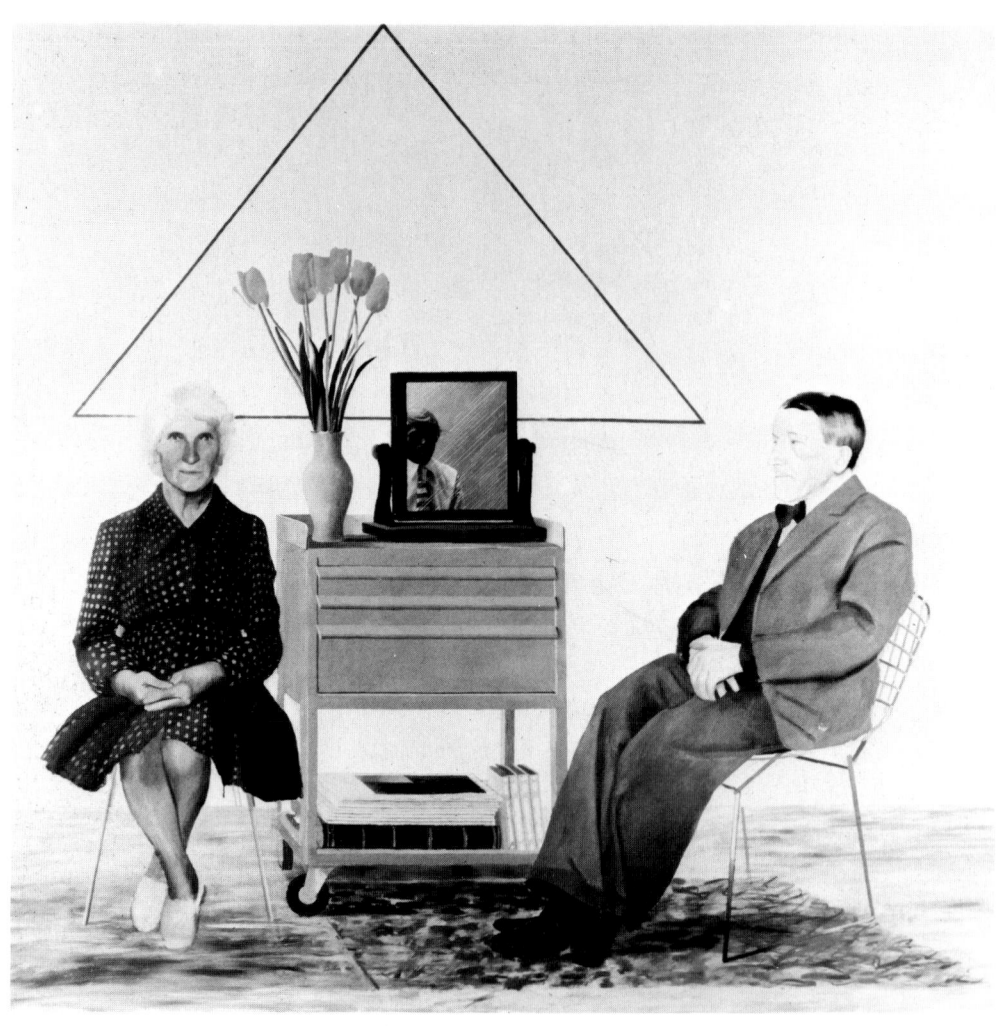

143 *My Parents and Myself*, 1975

the figures, the bottom line of which indicates the heads of the three people, functions both as a formal device uniting them and as a visual metaphor of their mutual dependence. Hockney recognized, however, that this triangle was a superficial response to a profound emotional relationship, and it was partly for this reason that he later decided to paint a second version of the subject.

143 The figures in *My Parents and Myself* were painted from life, but the composition was first established in line drawings in ink (one of them drawn

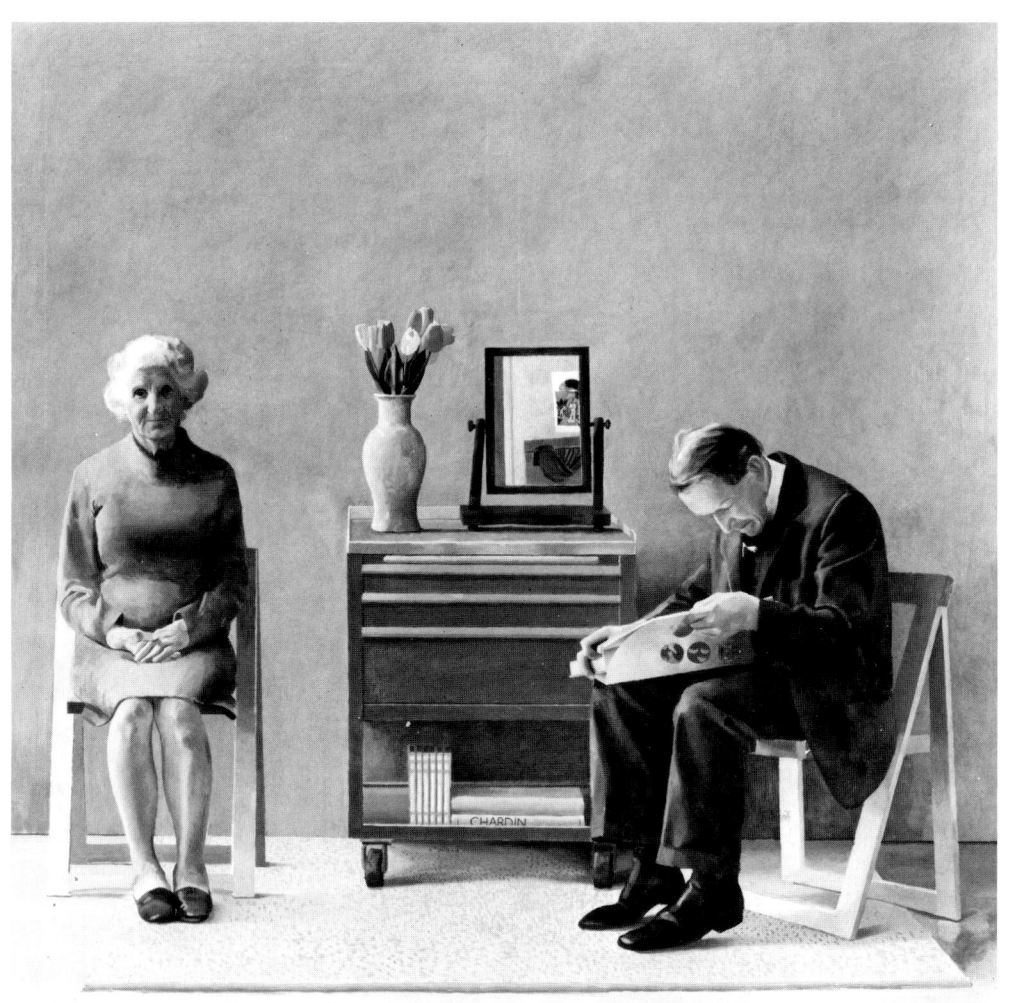

144 *My Parents*, 1977

very rapidly as a means of working out the format) and in a rather crude crayon drawing. The painting should have been a fairly routine matter once he had decided what to do, but he decided to paint the picture slowly, perhaps because he was still out of practice with oils, and reworked it to such an extent that it began to lose its freshness. It was eventually abandoned. In 1977 he began work on a second version, again measuring six foot by six *144* foot, but this time painted quickly. This pleased him more even though he could not find a way 'to put myself successfully in the picture'. The

145 Mother, *c.* 1976–77

composition and the most significant details remain the same, such as the set of paperbacks of Marcel Proust's *Remembrance of Things Past*, which he had recently re-read and which he evidently considered an apposite reference in a picture concerned with personal memory and with the process of ageing. A comparison of the two versions, however, makes it clear that the awkwardness of the earlier picture was due to various factors: the difficulties in handling the paint, the stiffness of the poses, and the uncomfortable contrast of volumetric figures set within a flat background. In the new picture Hockney makes something of a return to naturalism, devising a coherent internal space in which the floor meets the painted surface of a wall rather than bare canvas, and allowing the sitters to adopt a more characteristic posture. Hockney's father, impatient with the business of sitting still for long sessions, has picked up a copy of Aaron Scharf's *Art and*

Photography and has shifted his attention to the book. This results in a far more revealing study of the behaviour of the two people, the father drifting into himself while the mother patiently gives her son her undivided attention.

The two portraits of his parents may appear to be a reactionary move back into naturalism, all the more curious after the liberating moves he had made in his work in 1974–5, but Hockney never lost faith in the validity of depiction. One must recall, moreover, that it was a project formulated essentially in the early 1970s but which he felt the need to complete for personal reasons out of respect for his parents, who were approaching their eighties. In the first picture he seemed intent on getting away from his old habits, but was unable to find a radically new way of treating an old subject. By the time he came to start work on the second version, he felt secure enough in his capacity for invention to return to a more naturalistic conception when the occasion seemed to demand it. He had again availed himself of the camera, taking more than five dozen colour photographs to *145* establish the composition and as studies for the individual figures. It was in these photographs that he discovered a more appropriate attitude in which to depict his father, although the figures were still painted from life, and it was the camera also which supplied the evidence for the greater colouristic brilliance of the picture. The camera, however, is no longer to be obeyed in a servile manner. Next to the Proust paperbacks, Hockney has inserted a book on the eighteenth-century painter Chardin as a clue to the frame of reference in which he would like the picture to be seen. Like the paintings for which Chardin is best known, this is an intimate and contemplative domestic interior and one in which a sensuousness of response is invoked through the technique of superimposing transparent glazes of colour to describe the fall of light on the surface of the wall.

The difficulties Hockney experienced with the portraits of his parents attest to a far more serious problem, the fact that from about 1974 to 1978 he was suffering from the longest and most severe painting 'block' he had yet encountered. Apart from working on designs for the two operas staged in 1975 and 1978, he occupied much of his time with photography and with academic drawing exercises which reiterate earlier concerns sometimes to great effect, but without arriving at new solutions of any great significance.

There is a confusion in Hockney's work at this time which suggests that he was not sure what he should do. He still wished to move away from naturalism, but through his increasingly close association with fellow painter R.B. Kitaj he was now having to consider also the possibility of abandoning Modernism. He had admired Kitaj since their student days together at the Royal College, had renewed the friendship in 1968 when Kitaj was teaching

at the University of California at Berkeley, and since moving to Paris in 1973 had made him one of his best-loved and most intimate friends. Together Hockney and Kitaj began in 1976 to make a unified public stand in favour of the traditional virtues of drawing from the human figure, in direct opposition to what they considered the peripheral concerns of the more extreme forms of Late Modernism. A double interview between Kitaj and Hockney published in the January/February 1977 issue of *The new review* provides the clearest expression of their views. Given their fighting tone, it is not surprising that the case they were putting forward was grossly misinterpreted both by their reputed supporters and by their detractors. The latter labelled them reactionary, while the former used them as symbolic leaders of a 'return to the figurative', and both parties tended to regard them as agents for the destruction of Modernism. It was not Modernism they were attacking, however, but Modernist academicism. They felt much recent art to be hopelessly compromised by its downgrading of the humanist concerns so strongly evident in the early stages of Modernism in the work of great artists such as Picasso and Matisse.

For a short time Hockney seems to have suffered from a loss of nerve as a result of thinking constantly about the issues raised by these discussions, as if through fear that what he produced was going to be used in evidence against him. Rather than make a big statement, he retreated to the relative security and privacy of drawing and print-making. He spent some time in Los Angeles in 1976 producing a series of large-scale lithographic *Portraits of* 146 *Friends* such as *Joe McDonald*. Taking up where he had left off in 1973 with the similar sized lithographs of Celia, he produced what are in effect a series of academic demonstration pieces, evenly worked, painstakingly drawn and ultimately rather dull. In retrospect he thinks the small book produced by Gemini G.E.L. to accompany the publication of the prints is more successful than the full lithographs, since each page reproduces a detail of the head, 'the most interesting part'. Granted that these prints lack the wit of most of Hockney's work in the medium, Hockney nevertheless felt that it was necessary for him to produce such prints and academic drawings simply as another bout of self-training.

'I've always liked the idea of doing academic drawings at times, and I will still do it, I'm sure, in the future. It's something that's reasonably necessary to do if you want to draw at all, I think. If you want to make depictions of anything, it's just something as old-fashioned as training your eye to look and observe again. They're done really as exercises, you're not that interested in what it's going to look like when you've done. It's the doing of it that's the exercise. Every period I've done it, I've always thought then immediately afterwards all the drawings are better, whatever you draw. The line

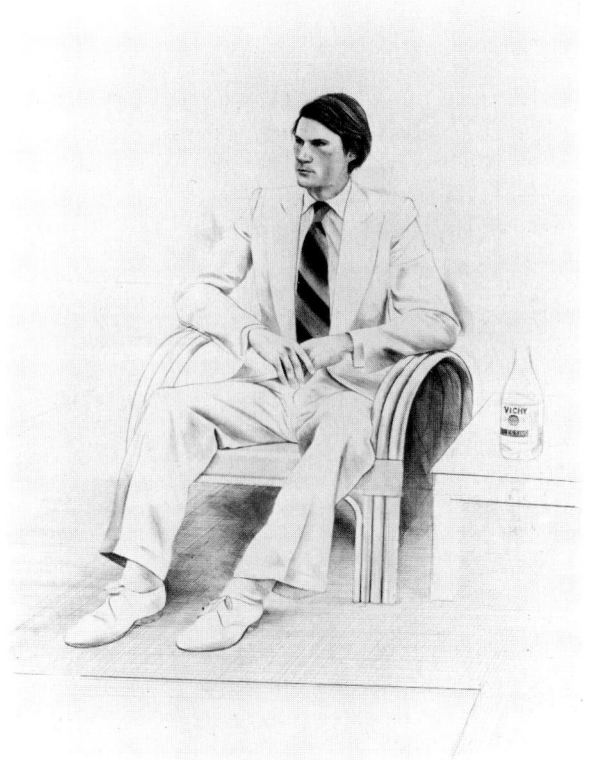

146 *Joe McDonald,*
1976

drawings are better: the line can tell you more of what's there after doing this. . . . Before he did all those lovely line drawings, Matisse would make really detailed charcoal drawings and tear them up. He wouldn't leave them about, he thought of them as working drawings. I understand what he was doing: discovering what's there. And then when you come to use line, if you know what you're looking at, it's much easier to make the line meaningful, to find a linear solution to what you want to depict.'

The evidence of Hockney's claims is provided by the prints he produced immediately after the hard linear portraits of 1976. Lithographs such as *Henry with Cigar* and *Gregory with Gym Socks* are among the freest and most daring excursions Hockney has yet made in the medium. The picture of Gregory is notable for the nervous energy of the contours which describe the volume of the body without recourse to shading except on one side of the face. The fact that one arm and one side of the body have been redrawn serves only to increase the sense of urgency, revealing the broad sweep of the artist's arm in making the mark. The small lithograph of Henry Geldzahler,

147, 148

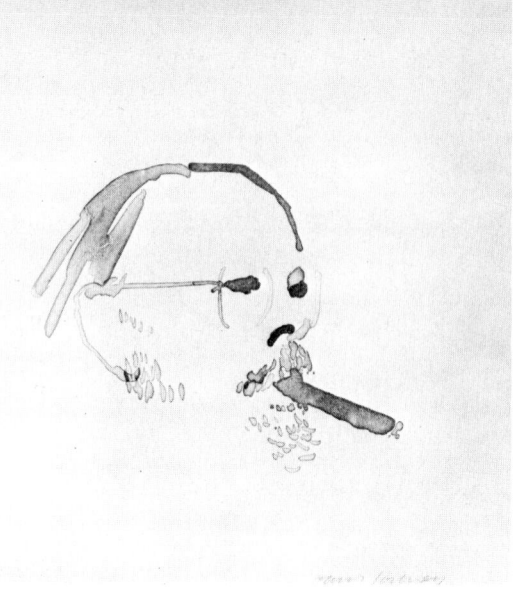

147 *Henry with Cigar*, 1976
148 *Gregory with Gym
Socks*, 1976

186

drawn with a diluted form of lithographic ink known as tusche, achieves an extreme of simplicity which recalls the Oriental brush drawings which Hockney had recently admired in an exhibition at the British Museum. What astonished him most of all was the beauty and economy of means by which a few marks described the gesture of the artist's hand while at the same time producing an immediately recognizable depiction of something seen. It is an almost alchemical process of transformation which could be described as a visual equivalent to poetry.

While staying on Fire Island, just outside New York City, during the summer of 1976, Hockney read for the first time the long poem by Wallace Stevens titled 'The Man with the Blue Guitar'. This was at the instigation of Henry Geldzahler, who has consistently influenced Hockney's literary interests over the years. Hockney was immediately stimulated by the poem, which concerns the role of the imagination in interpreting reality and which uses as its primary reference the Blue Period Picasso painting of 1903 called *The Old Guitarist*. With nothing more than paper, coloured inks and crayons with which to work, Hockney immediately began a set of drawings inspired by the poem, producing ten in all. For the moment the drawings were an end in themselves, a means of bringing together his admiration for Picasso with his new-found freedom of technique, united by reference to the poem. He investigated the possibility of transferring this imagery on to a few small canvases, but these paintings were abandoned. In the autumn he decided instead to produce a set of coloured etchings in which, appropriately, he could make his first concerted group of prints using the method devised by Aldo Crommelynck for Picasso. Producing as many as three or four etchings 149 from a single drawing and researching into Picasso's *œuvre* for additional images, he completed a set of twenty etchings which was published as a portfolio and also as a book in an edition of 20,000. Printed in the spring of 1977, this was Hockney's most important series of prints since the Grimm illustrations of 1969.

The full title of *The Blue Guitar* gives a forewarning of the double and triple takes which lie in wait: *Etchings by David Hockney who was inspired by Wallace Stevens who was inspired by Pablo Picasso*. These are pictures based on words based on pictures, pictures of pictures, and pictures about techniques. What holds them together is the constant reference to Picasso's example. The method of colour etching itself was chosen not simply as the most appropriate for translating the linear coloured drawings on to a plate for printing; there was also a poignancy about using a technique which had been invented for Picasso but which the master had not had a chance to use before his death. The imagery is derived largely from Picasso's work, with references to particular paintings and prints, to different modes of drawing

and stylistic phases associated with him, to standard themes such as the artist and his model, and to recurring geometrical forms and motifs such as the guitar, symbol of the artist's most important instrument, his imagination.

Hockney made *The Blue Guitar* at a time when he and Kitaj were most actively involved in discussions concerning the central importance of the human figure in the history of art; Kitaj remarked in several interviews that it was no accident that the two great artists of the twentieth century, Picasso and Matisse, received a training based on drawing of the human figure. Hockney's etchings suggest a variety of ways of reinventing the human form, from the most basic geometrical armature to outline drawings of great elegance and delicacy. Naturalism is not rejected altogether; rather it is one possibility among many. The clear implication is that art resides in the search for equivalents, rather than in a particular style, and that the imagination is the vital tool for transforming the prosaic into the poetic.

Intelligent as it is in its treatment of a poetic theme, *The Blue Guitar* series can only be judged a qualified success; the imagery tends to be disparate, and the colour schemes of red, blue and green, used so effectively for *The Rake's Progress* sets, do not always balance. Hockney's exhilaration by the themes proposed in the poem, however, did not wane, and early in 1977 he began work on two canvases in which he examines the theme of painting as the subject of painting. The first of these, *Self-Portrait with Blue Guitar*, was begun spontaneously with no real plan, simply taking imagery from his recent work. The title and subject of the picture can be interpreted in two ways. Taken literally, it is a representation of the artist at work on the *Blue Guitar* drawings. Suspended in the air as a materialization of his thoughts are images used in the etchings: the two-coloured path in perspective from the print titled *It Picks its Way* next to the 1937 female head by Picasso depicted in *What is this Picasso?*, the last print of the series. Coloured inks, a table and chair in conflicting perspectives, curtains and other devices lie in wait for him like the brushmarks and false geometries in the *Portrait Surrounded by Artistic Devices* of 1965.

Construed metaphorically in the terms established in the series of etchings, however, this is a self-portrait of the artist as one who creates through his imagination. The similarity of the props and setting to those of *Invented Man Revealing Still Life*, painted in 1975 before he had come across the Wallace Stevens poem, is a conscious one that celebrates the central role of the imagination already indicated in Hockney's work before the morale-boosting discovery of 'The Man with the Blue Guitar'. The juxtaposition of the Blue Guitar imagery with Hockney's first-ever self-portrait on canvas proclaims a personal involvement with these themes which belies the sense of ironical detachment in the prints. The echoes of other past works by

149

133

56

160

188

149 *The Blue Guitar: Tick it, Tock it, Turn it True,* 1976–77

Hockney such as the 1974 Louvre paintings (in the modified pointillist 116
technique used for the table) and the 1971 Gonzalez paintings (in the spiky 135
shadow cast by the chair and in the Cubist-inspired illusionistic painting of
wood grain) suggest that Hockney recognized at once that in *The Blue Guitar*
he had drawn together many of the threads from his previous work. Inspired
as he was by the example of Picasso, the apparent discontinuities and

189

contradictions evident in his own development no longer seemed to pose such a threat to his integrity. He was free once more to do what he wished, confident in the knowledge that the consistency of his attitude would emerge no matter what style he chose to work in. In contrast to the rather innocent freedom of movement declared in his early work, however, his attitude has by this time become highly self-conscious.

161 The second of the two paintings, *Model with Unfinished Self-Portrait*, was planned with greater deliberation. The title warns us that what appears at first glance to be a continuous interior space in fact consists of a portrait from *133* life placed in front of another canvas, the *Self-Portrait with Blue Guitar*, a finished reproduction in paint of a work in an incomplete state. The lower half is painted in a naturalistic style that contrasts with the blatant artifice of the upper register, drawing attention to the fact that reference is being made to two orders of reality and that the two figures do not occupy the same space. The double takes and sense of play are carried still further in a series of colour photographs which Hockney took of the model and props in the studio in front of these paintings, suggesting that the resounding of visual echoes is potentially limitless. As always in Hockney's work, however, these witty games have a serious purpose, that of reminding the viewer that he must question all the information with which he is presented.

Model with Unfinished Self-Portrait carries one step further the first painting's implication that aesthetic concerns continue for Hockney to be *131, 148* closely bound to personal matters. The sleeping figure is Gregory Evans, Hockney's companion and model who appears in many of his drawings and prints of this period (including *The Blue Guitar* print *Etching is the Subject*), and whose close relationship with him provides an immediate instance of the artist and model theme which occurs repeatedly in *The Blue Guitar*. To complicate matters, Peter Schlesinger was used as a substitute model in Gregory's absence and was photographed by Hockney in this role. Hockney's insistence on personal emotional motivation was a direct rebuff to what he considered the refusal of much Modernist art to deal with sentiment. As he said to Kitaj in the conversation published in the January/February 1977 issue of *The new review*: 'And remember this: it is always figures that look at pictures. It's nothing else. There's always a little mirror there. On every canvas there's a little bit of mirror somewhere. You don't get "Red and Blue Number Three" looking at "Blue and Brown Number Four".'

Looking at Pictures on a Screen, one of the last two canvases he painted in London before leaving for New York in the summer of 1977, takes account more directly than ever before of our role as spectators. Henry Geldzahler engages in the same activity as we, that of looking at pictures. Celebrating art as a shared human experience, Hockney brings to our attention

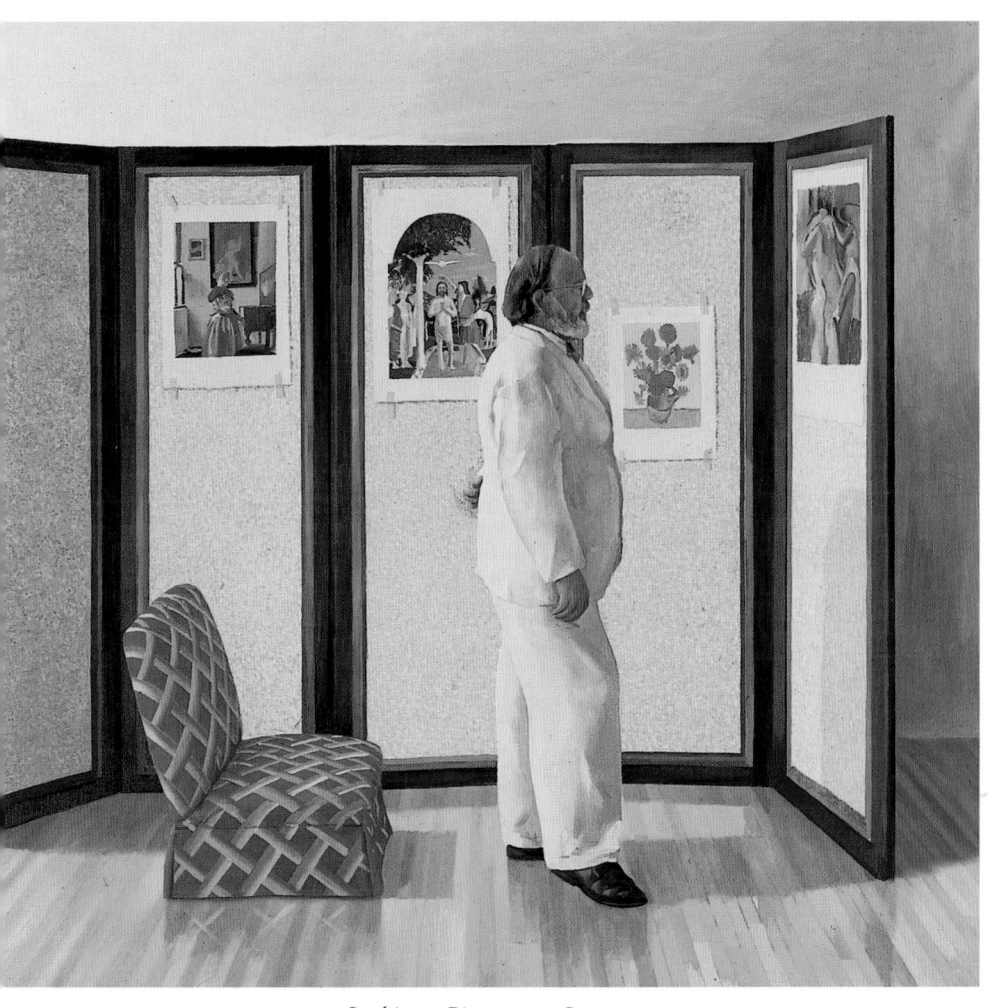

150 *Looking at Pictures on a Screen*, 1977

reproductions of favourite pictures from the National Gallery as an act of homage to four masters of the human figure, Vermeer, Piero della Francesca, Van Gogh and Degas. Hockney declares his own alliance with the tradition represented by these artists by taking as the focal point of his own picture a figure which is endowed with an impressive monumentality in spite of the fact that it is under life-size.

Hockney's interest in Van Gogh led him early in 1978 to experiment with new techniques of line drawing. Using a reddish-brown ink and reed pens of

Bradford. 19th Feb 79

151 *Mother, Bradford*, 18 February 1978

the same type as those which Van Gogh had taken up in Arles in emulation of the Japanese, Hockney began to produce drawings marked by a spontaneity and boldness of execution which strongly betray the influence of Van Gogh's essays in the same medium. Given that this looseness of technique and delight in surface pattern are new in Hockney's drawings and owe much to his adoption of instruments closely associated with one artist, there inevitably is an element of pastiche in these first excursions, a sense that he is imitating a style rather than using it to his own ends. When the subject itself makes a strong impression on him, however, Hockney rises to the occasion and uses the medium to transmit an emotional content all the more poignant for its apparent awkwardness. This is the case, for instance, with *Mother, Bradford*, 18 February 1978, which was drawn on the day before his father's *151* funeral and which captures the vulnerability and sadness of a person contemplating the future without the company of a lifelong partner. It was drawn quickly because she had already put on her hat and coat to go out, and Hockney was aware that she was not feeling well. Although it might seem callous to ask her to pose at such a moment, the reverse is the case, for in drawing his mother Hockney was communicating his own sense of loss at a time when words would have been superfluous. 'When my father died, it was the first person who was very close, *very* close, who had died. Death was not something I had dealt with.' The adoption of a technique from Van Gogh, an artist particularly adept at translating emotions into pictorial form, is thus not a question here of making a knowing artistic reference but of manipulating a technique for an essentially private purpose.

The direct acknowledgment of the spectator's presence alluded to in *Looking at Pictures on a Screen*, though attributable to Hockney's views on the *150* role of the human figure in painting, may also be due to the fact that he was about to begin his next project for the stage, a context in which the audience must be borne constantly in mind. He had accepted John Cox's commission to design a new production of Mozart's *The Magic Flute*, to be staged at Glyndebourne in May 1978, and in the summer of 1977 he left for the comparative anonymity of New York City to begin work on his models.

The Magic Flute is one of the most frequently staged of all operas, popular with public and with designers alike not only because of the beauty and clarity of the music but also because of the immense scope for pictorial invention provided by Emanuel Schikaneder's libretto. Hockney is not the only painter to have responded to the challenge; in 1967 Marc Chagall designed a famous production for New York's Metropolitan Opera which is still being used. The demands on the designer, however, are enormous. Hockney produced designs for thirteen separate sets, more than twice his *152–3* annual production of paintings at that time, and had to find a way of *163*

139–40 changing scenes in the space of a few seconds so as not to interrupt the flow of the music. He had found in designing *The Rake's Progress* three years earlier that moving objects on and off stage took too long, and decided that on this occasion he would have to use painted drops as the most efficient method of dealing with the problem. He knew early on, therefore, that his designs would take the form of enormous pictures rather than fully three-dimensional settings as he had used for the Stravinsky. Only two of the final scenes, however, employ ordinary illusionism on a single flat surface, since in most cases a sensation of space is created by the placing of two or even three drops parallel to each other, establishing a continuous perspective which must be filled in by the spectator's imagination. Hockney eventually used all the drops available to him on the relatively small Glyndebourne stage, thirty-six in all, and was disappointed that there were not additional drops with which to put into action the aerial car he had devised for the three boys who appear at intervals with messages for the protagonists.

Hockney had seen about ten different productions of *The Magic Flute*, 'none of them totally memorable, nor that clear', and did a lot of research on previous designs and on the meaning of the opera itself before starting work. He was aware from his own experience as a spectator that the designer could ruin the production by making it visually dull or by taking too long to effect the transformation scenes. The pictures, he thought, should be crisp and clear like the music, and he explained in an interview published in the Glyndebourne programme that he decided for that reason to keep the designs 'in focus, no haze, not too many shadows, reduce chiaroscuro.' He played different recordings of the opera constantly while working, an enormous advantage to designers in recent years, particularly to those who, like Hockney, cannot read music. Other designers of this opera have married their sets to the music by setting them in the eighteenth century, a solution which Hockney firmly resisted as lazy and as a misrepresentation of the action, which is set in ancient Egypt. He wished to follow the original libretto as closely as possible, obeying the instructions for the imagery required but devising an equivalent to the mood of the music through colour and formal design.

Hockney's sets are unmistakably situated in ancient Egypt, filled as they are with images of pyramids, palm trees, deserts, obelisks, monumental stone heads and massive interior spaces. He had recourse both to his own early Egyptian drawings and paintings, such as *Great Pyramid at Giza with Broken Head from Thebes*, 1963, as well as to the photographs and drawings he made on a return visit to that country at the beginning of 1978. Unlike the work he did for *The Rake's Progress*, however, this time he could not rely on one source alone for all his material. He was aware that the libretto of the opera

itself drew on a bewilderingly diverse range of sources such as Masonic symbolism (both Mozart and Schikaneder were Masons); a treatise by Abbé Terrasson called *Sethos* (1731), now known to be a fabrication, concerning the mysteries of Isis and Osiris; a collection of pseudo-Oriental fairy tales titled *Dschninnistan*, which was published in 1786 and which provided plots for a number of other *Singspiele* written in Vienna at the time; and elements from the *commedia dell'arte* and from Viennese popular theatre. Hockney likewise took ideas for his designs from a number of unrelated sources, reinterpreting written as well as visual material in a stylized pictorial form to ensure a sense of unity. A satisfactory flow was also aided by Hockney's decision to make all the models in the order in which they would appear dramatically. The models were painted on a scale of 1 to 12 in gouache, so that the proportions and colour relationships could be envisaged accurately from the beginning. The scale Hockney used is said to be twice that normally favoured by professional designers, suggesting that he was anxious both to think on the expanded scale required and to maintain complete control over every detail to be painted.

Italian paintings of the Quattrocento, which have the kind of linear clarity and evenness of light which Hockney required, supplied ideas for the opening scene of Act I, which is described in Schikaneder's libretto as 'A *152* rocky scene dotted with a few trees. In the centre stands a temple, to which steep paths lead from either side.' Not wishing to overcrowd the scene, Hockney has disregarded the temple, which is not absolutely necessary for the sense of the action, putting in its place a hollow mountain which will shortly burst open for the spectacular entry of the Queen of the Night. The mountainous landscape is based on Benozzo Gozzoli's fresco painting of *The Journey of the Magi*, painted 1456–60 in the Chapel of the Medici in the Palazzo Riccardi, Florence. Hockney has not copied Gozzoli's complexly detailed painting in a slavish manner, keeping the stylized treatment of the rocky terrain and foliage but greatly simplifying the scene for impact. In order to preserve the homogeneity of the scene, Hockney has chosen to clothe the protagonist, Tamino, in garments drawn from other Italian paintings of the same period rather than in the exotic Japanese costume stated in the libretto. By the same token, the serpent which pursues Tamino is presented in the guise of the monstrous beast from Uccello's *Saint George and the Dragon* (National Gallery, London), completing the tableau.

The violent contrasts of mood characteristic of *The Magic Flute* demanded, in Hockney's view, equally dramatic visual shifts and clearly differentiated scenes so as to complement the music and to make the action easy to follow. 'In *The Magic Flute* you have contrasts between comic, bawdy entertainment like a pantomime and then rather solemn almost

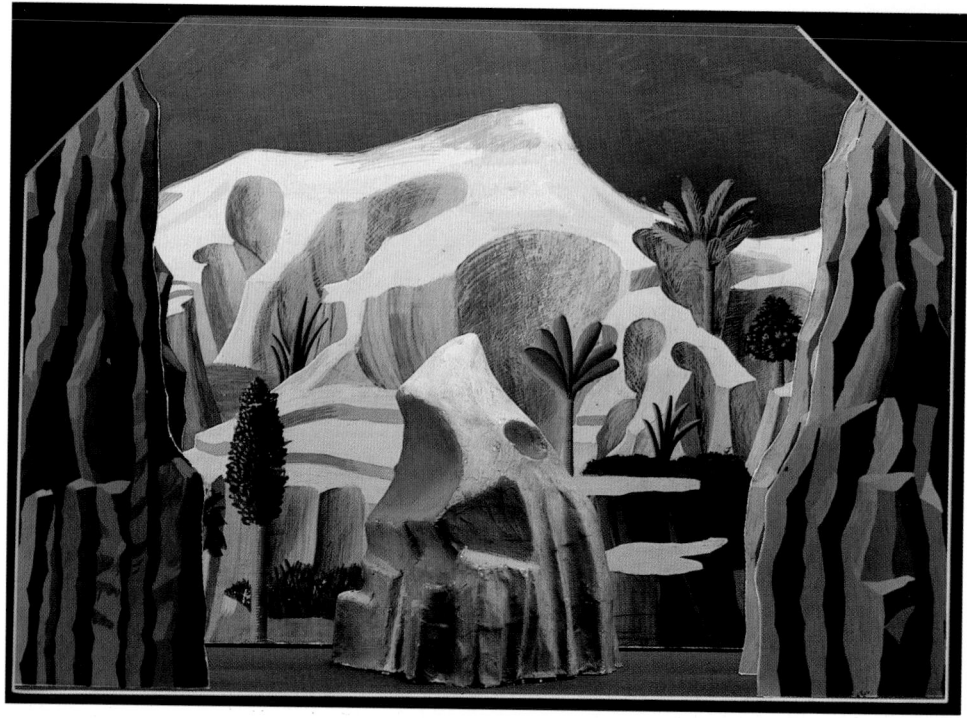

152 *The Magic Flute: A Rocky Landscape* (Act I Scene I), 1977–78

church-like music when of course you wouldn't want a comic setting behind it. That's the difficult part of doing it, you have to be able to combine these two things which you don't usually come across in a play. So I used the mood of the music for the scenes; depending on what was going on, you'd then decide to make something jolly or something solemn.'

The wide range of reference of Hockney's designs thus has a specific function in devising a series of starkly differentiated visual solutions, each of which is appropriate to the events taking place and to the emotional dimension of the music at that moment. The crescendo and clap of thunder which announce the awesome appearance of the Queen of the Night, a personification of the forces of darkness, necessitates an equally breathtaking visual transformation. The stage lights are extinguished and Hockney's mountain parts in the centre, following the instructions in the libretto, revealing the Queen of the Night in front of a black sky studded with a swirling pattern of stars, lit in such a way as to make invisible the gauze back-drop on which the mountain landscape is painted. Hockney's design of this scene bears sufficient resemblance to that devised by Karl Friedrich Schinkel

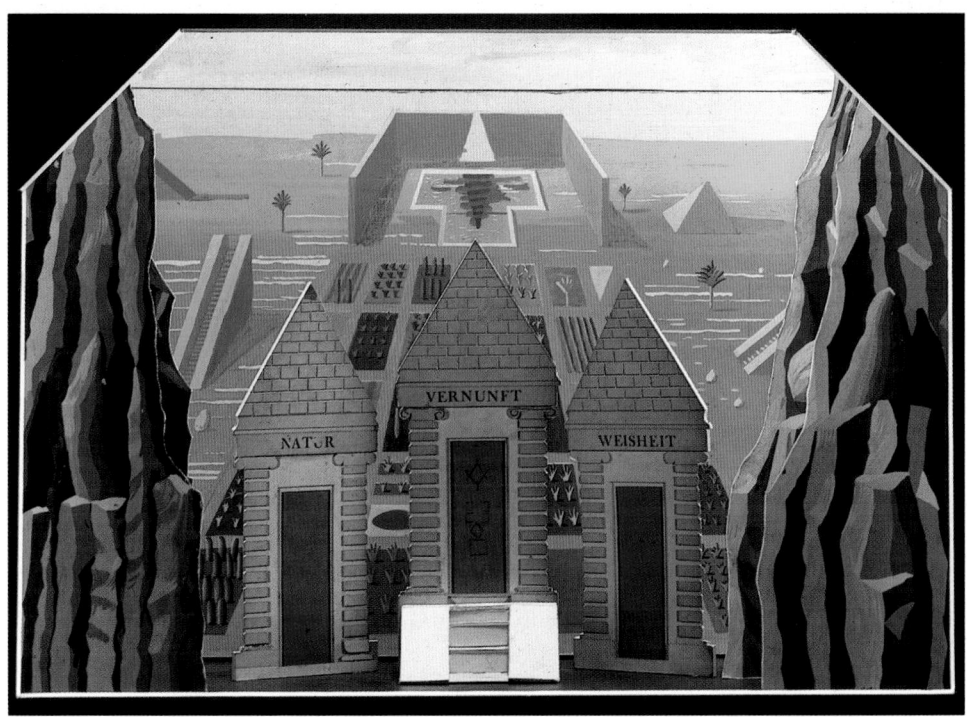

153 *Grove with Three Temples* from *The Magic Flute* (Act 1, Scene 3), 1977–78

for the 1816 Berlin production to suggest in this case a direct inspiration. In the few instances where Hockney's sets recall other designs for the opera, reference invariably is to very early productions, which like his own were conceived as painted drops and which follow Schikaneder's instructions more closely than has generally been the case in this century. The distribution of the three temples in Act I Scene 3, for instance, is based on Schikaneder's own staging of the opera (first performed in 1791) as known through coloured sketches by Josef and Peter Schaffer published in 1794 in the *Allgemein-Europäisches Journal*. Impressively, Hockney has outdone even Schikaneder by including all the elements outlined in the stage instructions: 'The scene changes to a sacred grove. Right at the back is a beautiful temple with the inscription: "Temple of Wisdom". Two other temples are joined to this temple by colonnades: the one on the right is inscribed "Temple of Reason"; the one on the left, "Temple of Nature".' While the original production indicated the grove simply by surrounding the temple fronts with foliage, Hockney has introduced a vast grove complete with sacred pool on a separate backdrop behind the three cut-out façades.

The awesomeness of the setting in this closing scene of the first act is suggested through the high horizon and plunging perspective, one of many such pictorial illusions by means of which Hockney greatly extends the impression of scale. The monumental interiors in Act II, for instance, employ the perspective trick of two vanishing-points to make the stage look larger than it really is, with the foreground elements as if seen from above and those in the background as if viewed from below. Such solutions were worked out intuitively through trial and error, although Hockney has also made use of his own observations of architecture. The huge flight of steps used as the dominant element of one of the great halls, for instance, was suggested by the main staircase of the Metropolitan Museum in New York, where Hockney had spent much time researching Egyptian art.

163 The opening scene of Act II, which represents the domain of the High Priest Sarastro, is largely of Hockney's own invention, although the palm trees have been transplanted from the Uffizi *Baptism of Christ* by Andrea del Verrocchio and Leonardo da Vinci, as an illustration of the landscape envisaged in the libretto. In spite of the considerable research which he undertook on Masonic symbolism, Hockney decided to represent the progress from the darkness of superstition to the blazing light of enlightened wisdom not through a symbolic use of colour but by a literal rendering of the stage instructions. Scenes 2 through 7 of the second act are all set at night, as in Schikaneder's libretto, and it is only at the end of the opera, after Tamino and Pamina have undergone their trials that 'man's dark world is filled with light'. The sun makes its reappearance as a rigidly geometrical pattern that paraphrases certain paintings by Frank Stella; on Hockney's own admission, it is perhaps the least successful of his backdrops for the opera.

Hockney's work on *The Magic Flute* confirmed him in the belief that inspiration can be found anywhere. He did much research, for instance, for the brief trial by water scene, reading books about water and even purchasing a book on waterfalls. The blue-green waterfall which he eventually devised for the backdrop, however, was borrowed from a colour advertisement for menthol cigarettes which he discovered in a magazine. The advantage of using such a cliché is that its very familiarity saves valuable time in identifying a scene which lasts only a matter of seconds. The moonlit garden of Act II Scene 3, on the other hand, takes its cue from two of Hockney's earlier designs for *The Rake's Progress*, those used for the garden 139 of Trulove's country cottage and for the churchyard at night.

The vast range of sources compiled by Hockney was reassembled in a form so traditional as to be almost archaic in terms of modern theatre practice. It is not simply that the designs take the form of painted backdrops, but also that depth is suggested by means of coulisses, or wings, one of the

oldest devices known to the stage. Some critics expressed fears that Hockney's sets, as impressive as they might be as paintings, could turn out to be distracting when placed in their dramatic context. These worries proved unfounded, for the clarity of Hockney's designs, and the splendid scene changes of the second act in particular, focus the viewer's attention on the action and themes of the opera to an unusually successful degree. The achievement is recognized by the fact that this production is now commonly known as 'Hockney's *Flute*', a rare instance in which a version has come to be associated with the designer rather than with the producer or the conductor.

Hockney's own reservations about his designs for *The Magic Flute* centre on the costumes, which he found more difficult to do than for *The Rake's* *139–40* *Progress*. Papageno's bird costume, based on engravings which depict Schikaneder himself in the original role, was a simple enough matter. Hockney wanted the other costumes, however, to fit in with the colours of the sets he had already designed, but by this time he had sent the models to Glyndebourne and thus had difficulty in matching them as he planned. Since he did not know enough about 'building' clothes to produce accurate measured drawings, he simply brought with him coloured sketches as a guide for the wardrobe department. The clothes were made in the month prior to the première, with the designs altered in the process of making them until a satisfactory solution was achieved.

Hockney's absorption in *The Magic Flute* dominated his attention for nearly a year, and he produced no paintings at all during this period. He explains that it was not only that his time was taken up but also that he was suffering from a painting 'block', one which he blames in part on his distaste for his newly modernized studio at Powis Terrace, where he felt enclosed and cut off from the life outside. He decided to sell the studio, along with the rest of the house where he had lived for sixteen years, and return to Los Angeles, for him always a more receptive environment for painting.

In view of the enormous amount of work which he had produced for the opera, however, one should take with a grain of salt Hockney's complaints about his unproductiveness. He recognizes that the theatre once again had acted as 'a liberating influence', and it is evident from the work he made immediately afterwards that his enthusiasm had been renewed not only by the optimistic message of *The Magic Flute* itself but also by the warm reception accorded to his designs and by the new boldness of colour and form which he had achieved. It was the first occasion on which he had worked extensively in gouache, a medium which he has continued to use because of the intensity and range of its colours and because of its fluid texture, which has helped him considerably in loosening his technique. Responding to the qualities of the medium as on past occasions, he began to

explore the possibilities of placing one colour over another to achieve effects unprecedented in his earlier pictures, finding a way to create images 'more spontaneously, relying more on the paint than on outline'.

The boldness and expansiveness of scale characteristic of the *Magic Flute* designs dictated a major shift in Hockney's subsequent work. The change in his sensibility is apparent in the first pictures he made on his departure from England in the summer of 1978. Hockney had intended to stop off in New York for a few days *en route* to California, but decided to extend his stay after visiting Ken Tyler's graphic workshop at Bedford Village, a short drive outside New York City. Tyler was determined to interest Hockney in a technique he was using with other artists, one which combined painting with print-making, and showed him works in this medium by Ellsworth Kelly and Kenneth Noland. Hockney responded immediately to the beauty and tactile qualities of these pressed colour paper pulp pictures and decided to try the medium for himself. Liquid colour pulp is poured into metal moulds directly on to a surface of wet paper; more coloured pulp and liquid dyes can then be applied freehand, and the whole pressed between felts in a high-pressure hydraulic press. Once it has dried, the coloured image is part of the actual fabric of the paper.

After making a few trials himself, including a series of Sunflowers which indicate that Van Gogh was still very much on his mind, Hockney decided to use this 'watery' medium for a more appropriate subject, and started making photographs and drawings of Tyler's swimming pool. In the interview recorded only three years earlier for his autobiography, Hockney had stated that 'doing variations on a theme doesn't interest me; I think it's too easy.... The idea of doing a whole exhibition of swimming pools, for instance, wouldn't appeal to me at all, even though you could do them very differently.' Now he found himself doing precisely that, completing in a six-week period a series of twenty-nine *Paper Pools*, all dating from August to October 1978. His enthusiasm for the medium, and the challenge it provided both to his technical abilities and to his powers of perception, made him forget his former qualms about working in series.

It was the technique itself, with its brilliance of colour and its sensuously tactile quality, which attracted Hockney. Never before had he demonstrated such a direct physical involvement with the materials, actually kneading the surface, for instance to fuse the pinks of the underwater swimmer's flesh, in order to achieve particular effects. The very nature of the medium allowed Hockney to integrate the activities of drawing and painting in a way that had hitherto proved difficult for him, since in these works the flat areas of colour and the (necessarily crude) figurative images alike are produced by the same method. The separation of line and colour evident in his former work can no

154, 167

200

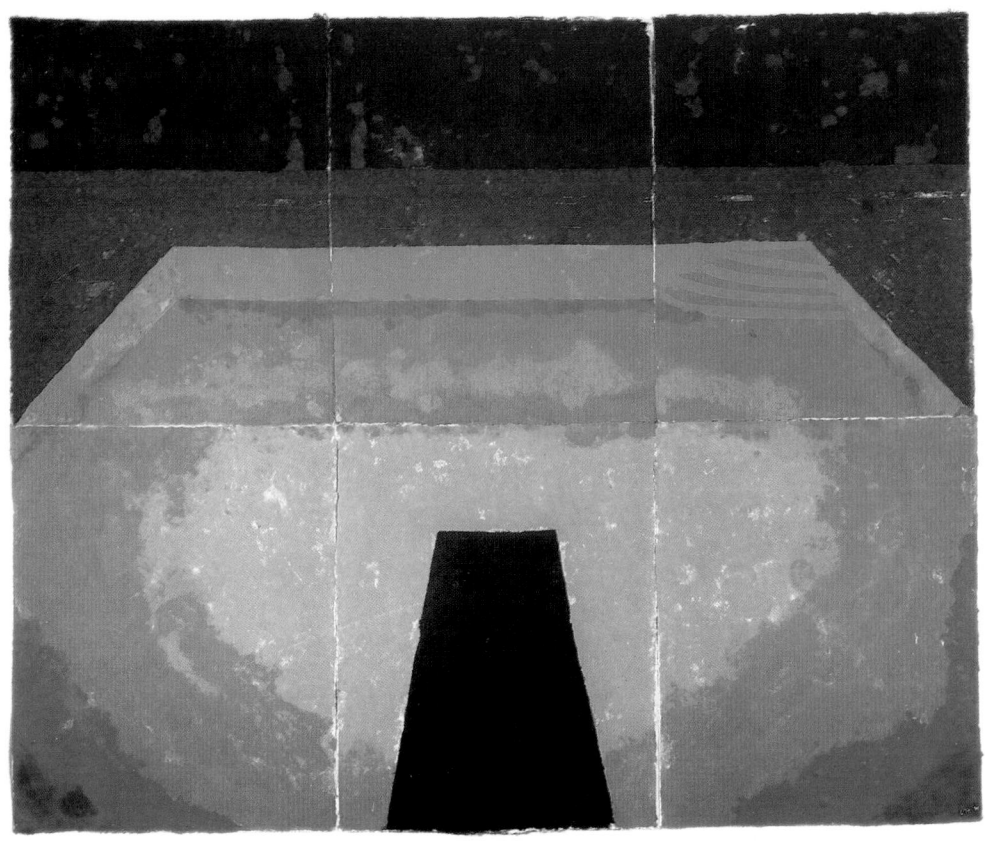

154 *Midnight Pool (Paper Pool 10)*, 1978

longer be perceived in these works in, rather than on, paper, since line is defined by the boundaries of coloured forms and colour is the basic constructive substance rather than merely an additional source of decorative pleasure.

The *Paper Pools* take the swimming pool motif as a convenient reference point for the exploration of his long-standing interest in water, light and pattern, but these pictures are by no means mere spin-offs of the California pool paintings of the mid 1960s. These new works are based on direct observation, and the fact that the swimming pools this time are in New York State rather than on the Pacific coast determines fundamental changes in colour and in imagery: the vegetation is different (no palm trees, but greener grass) and the colours are cooler, evidence of a more muted type

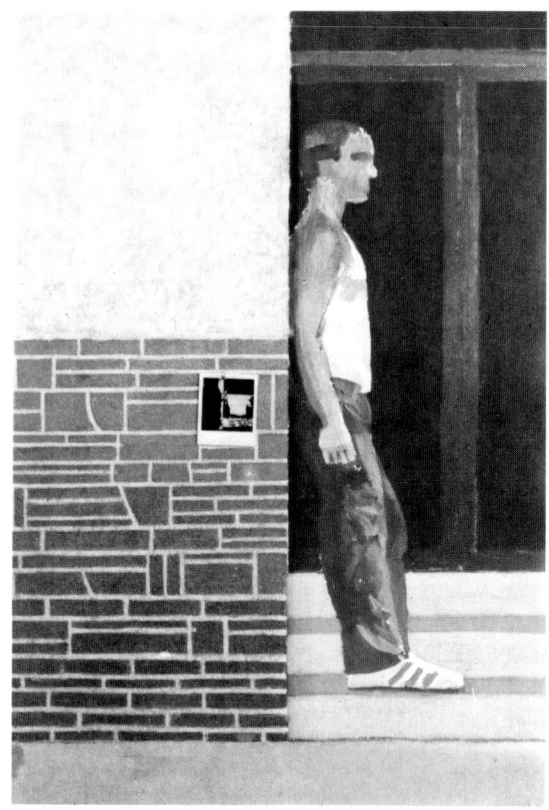

155 *Santa Monica Boulevard* (detail of work in progress), 1978–80

of light. The echoes of Monet's Giverny paintings are appropriate in view of Hockney's adoption of the Impressionist practice of producing a number of views of the same scene under different weather conditions or at different times of day, something he had already tried with the alternative painting of some of *The Weather Series* lithographs in 1973. This time the changes of colour and surface occur within a scene which remains literally the same, since a single set of moulds is used to produce a series of variations. The static man-made object thus becomes a container for the artist's perceptions, a contemporary reformulation of a late nineteenth-century concept. Hockney tests to the full the acuteness of his observations, studying the effects of transparency, reflection and refraction of light under constantly changing circumstances. Among these *Pools* are his first direct studies of nocturnal effects. These may have been prompted not only, as he says, by the mysterious appearance of the pool at night, but also by his recent experience *163* of designing seven night scenes for *The Magic Flute*.

Challenged by the medium itself, Hockney devised new methods for representing the interaction of light and water, taking full advantage of the fact that images are created with coloured matter in a fluid state. Like Matisse's late paper cut-outs, to which the *Paper Pools* have been compared, these pictures are at once fully representational and virtually abstract in the simplicity and daring of their formal designs. Hockney's sense of pattern is given free rein in the interplay of the rectilinear structure of the over-all image with the format of separate sheets of paper of identical size. One sheet on its own might read as an abstract image, one that recalls work in the same medium by artists such as Kelly, Noland and Frank Stella, but the relationship of the various parts provides a figurative context which modifies the interpretation of the marks. This division of the image was a practical necessity, since there was a limit to the sheet size which could be accommodated by the hydraulic press, but Hockney has used it to his own advantage as an opportunity to continue making sly reference to abstraction.

A comparison of the swimming pool pictures of the mid 1960s with the *Paper Pools* reveals the extent to which Hockney has persisted in devising new responses to constant preoccupations. The spectator of the earlier pool *48, 49, 59* paintings seemed to be placed outside the experience of the painting; the highly schematized arrangement across the surface, the abstracted symbols *73, 75* for light and transparency, and the mediation of the photographic process all conspired to distance the viewer from the subject. The *Paper Pools* have an equal emphasis on the surface, actually fusing the image with the material, yet as spectators we now seem actually to be immersed in the space created by the boundaries of the image. We are placed directly at the pool's edge and encouraged to examine the changing patterns on and through the water. There is a subtle subjectivity of intention here which establishes an emotional response beyond the expected involvement with perception and with the material processes of painting or drawing. The bold surface geometries and rich colour range, along with the clear evidence of direct study from nature, create an air of silent contemplation, a remarkable shift of mood from the extroversion of the earlier pool pictures.

Hockney's recent experience in the theatre and sense of environmental enclosure of the *Paper Pools* paved the way for the twenty-foot-wide figure painting, *Santa Monica Boulevard*, which he began on his arrival in Los *155* Angeles in the autumn of 1978. He worked on this canvas, his first multi-figure composition, for two years before finally abandoning it. He was satisfied with only two fragments: a male hitch-hiker and a female shopper, spied walking casually down the street rather than formally posed, as had been Hockney's earlier custom. The architectural background which

was the dominant element in the painting seemed hopelessly stilted, but in the figures at least there was evidence of a new conception of the human form based not just on physiognomy but on the patterns of ordinary behaviour and social interaction.

If *Santa Monica Boulevard* was the last gasp of Hockney's old method of piecing together a composition from photographs, it did signal a startling change in his use of colour. The picture was executed in a new kind of acrylic paint which he found in California and which excited him at once for the vividness of its hues; it is finely ground and dense in pigment. Hockney's delight in the medium, as on previous occasions, was immediately incorporated into his work. Also significant was the huge scale of this canvas, which in one sense was a contemporary version of the *Grandes Machines* painted for the Salon in the previous century but which was also a response to the vast enclosures of American Abstract art since the Second World War.

Within two weeks of his arrival in California, Hockney had begun work on a canvas that was eventually to be known as *Canyon Painting*. Initially this was not conceived as a painting at all but only as a technical experiment, a means of testing the new acrylic paints he was using and of exploring combinations of colour. 'French marks' such as one would find in Dufy's work are dangled suggestively over flames of colour reminiscent of Kandinsky's pre-First World War Improvisations. In the centre is a grid of red and blue strokes which calls to mind Mondrian's so-called 'Plus and Minus' paintings of about 1914, seminal works of abstraction still rooted in an appreciation of landscape. 'Until I finished it,' Hockney recalled in December 1980, 'I didn't treat it seriously. Then I made it into a picture. Then it took nearly a year before I did the next thing from it, partly because I was working on other things. Meanwhile I kept going back to the *Santa Monica Boulevard* painting, working in a way that I'd already broken, actually, and not realizing it.'

Hockney's policy since his arrival in California in 1978 has been to keep his paintings in the studio for as long as possible so that he can learn from them, since his income from prints and drawings alone is now such that he does not need to worry about selling the canvases. In this case, prolonged study changed his interpretation of his own picture. What he had originally conceived simply as a testing ground now appeared to him as a kind of landscape, with the central void as an equivalent to the canyons running near his home in the Hollywood Hills. The Mondrian reference now took on another meaning. Excited by the discovery through intuitive means of an image literally 'close to home', he immediately set to work on an explicitly representational landscape of Nichols Canyon, a road down which he drove every day from his home to his studio.

Nichols Canyon takes its cue from Hockney's stylized landscapes of the mid 172
1960s such as *Iowa*, 1964, or *Rocky Mountains and Tired Indians* of the 55
following year. The boldness of design now creates a continuous surface pattern, however, and the saturated colour has a lushness unprecendented in his work. Hockney has at last found a way of dealing directly with experience without resorting to the imitation of appearances as captured by the camera. The extraordinary range of orange, yellow, blue, red, green and violet in this painting is not an arbitrary one nor simply a response to the challenge of incorporating the entire spectrum on one canvas; the conjunction of colours, rather, is an accurate if grossly exaggerated reflection of the spectacular sunsets which can be viewed over the Holly wood Hills. In form, too, Hockney has conceived an equivalent to actual experience, for the serpentine line which rushes through the picture conveys the disorienting effect of driving down a constantly curving road. The landscape is schematized, as if glimpsed briefly and recalled in memory; its only specific features, such as the red-roofed house in the centre, are the landmarks which identify each bend in the road.

Hockney's return to California was marked by feverish activity. Plainly exhilarated by his own discoveries and anxious to loosen his technique, during 1979 and the early months of 1980 he began no less than twelve medium-sized canvases as well as an equal number of small paintings measuring no more than about two feet in height or width. All are painted in acrylic and most have been worked on sporadically and then put aside in order to concentrate on other projects, such as the designs commissioned for a triple bill of opera and ballet premièred at the Metropolitan Opera in February 1981. At the same time, Hockney was effecting changes in his way of drawing, conscious of his need to develop greater spontaneity first in this medium in order to translate his discoveries into paintings.

In the summer of 1979 Hockney produced a series of ten lithographs known collectively as *Celia and Ann*, large in scale and demonstrating a 156
boldness of contour strongly reminiscent of Matisse's lithographs, in which the single female figure is the most characteristic subject. Like Matisse's prints, described and illustrated in Susan Lambert's 1972 catalogue for the Victoria and Albert Museum, Hockney's lithographs of his friends Celia Birtwell and Ann Upton were done in the presence of the model but with the imagination as an equally important element. Also as in Matisse's prints, a sense of languid self-absorption is linked to the subject of women engaged in daily activites, dreaming or sunk in thought. On occasion Hockney's awareness of the historical lineage of these images in late nineteenth-century Intimism becomes obtrusive, as in *Ann Putting on Lipstick*, a tall vertical print with reminiscences of Bonnard and Toulouse-Lautrec. One senses the

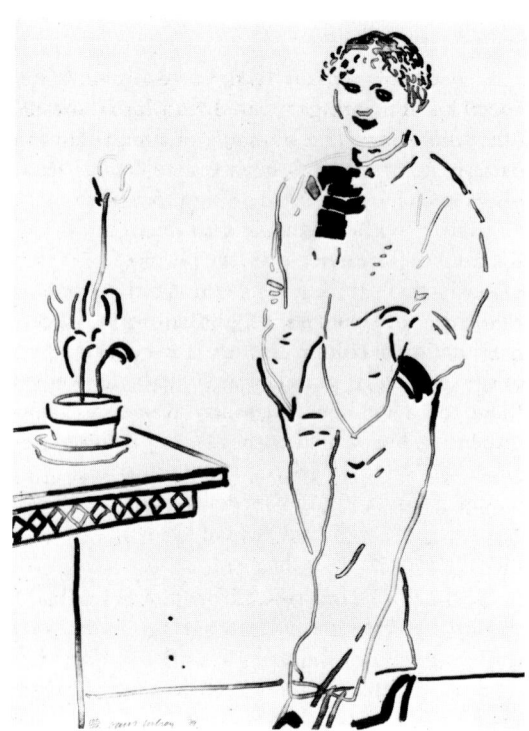

156 *Celia Amused,* 1979

presence also of the calligraphic marks of Albert Marquet, whose work Hockney had grown to admire while living in Paris, and particularly of Raoul Dufy, the freshness and exuberance of whose work Hockney only now was beginning to appreciate. The vitality of early twentieth-century French painting, which Hockney was studying for inspiration for his Metropolitan Opera designs, was making a great impression on him. In preparation for the project he made a series of watercolours which consist of nothing but 'French marks' derived largely from the paintings of Dufy. The lightness of touch and animated strokes of Hockney's recent work owe much to this source.

Although Hockney was still, in his own words, 'groping around' for a new pictorial structure for his paintings, he recognized at once that colour was fulfilling a more important constructive role than ever before. Freed of the restrictions of naturalism, he had begun to apply colours in a much more forceful manner, using them at full saturation, with very little white mixed in, and combining them in surprising ways. 'A lot of the early paintings have quite strong colour. I suppose it was the naturalism that muted it. As you

move away from naturalism, you do get more involved with colour. I did an awful lot of paintings where I wasn't that interested in colour, they're about other things, but I think that lately, in the last two years certainly, the colour has been a lot stronger. In the *Paper Pools* there's more colour, and the Ravel opera I'm working on is about colour.' *154, 167*

In *Santa Monica Boulevard* colours that were new to Hockney's palette *155* were daringly juxtaposed, a shrill lemon-yellow abutting the red of the brick wall, which in turn was contrasted with flat areas of orange and blue-green. Hockney remarks that 'California has an effect on colour, you do see brighter colours than you do in England', and the new pitch of hue in his work would certainly be unthinkable without the experience of this strong light. The boldness of colour in new paintings such as *Nichols Canyon*, *165* however, far exceeds in expressive potential the bright but essentially local colour of Hockney's earlier California paintings. Van Gogh's influence, apparent already in the 1977 oils *My Parents* and *Looking at Pictures on a* *144, 150* *Screen*, with its talismanic reproduction of Van Gogh's *Sunflowers*, now was fully realized. Hockney was drawing also from Matisse's work, sometimes to the extent of specific references, as in the translation of *La danse*, 1909, into *169* the nocturnal garden of his Ravel opera designs. By examining the work of both artists, Hockney began to explore ways in which colour could be used to create moods, and he also became more acutely sensitive to the properties of colour in particular environments, which he realized could be made an expressive feature through exaggeration. Intuition was playing an ever more important role. 'The more you use less naturalistic colour, less local colour, the more you discover it in the painting itself as you're doing it.'

Van Gogh and Matisse are constant presences in Hockney's work of the early 1980s, which is characterized by an appreciation of colour at full strength, an activation of the entire surface of the canvas by means of patterns and bold brushmarks, and a fusion of drawing with painting achieved through the conjunction of flat areas of colour. Hockney was searching for a way to paint ·more spontaneously, more freely, in order to endow his paintings with the kind of freshness and immediacy of impact that he had often found easier to achieve in his work on paper. In an interview with Charles Ingham in February 1979, Hockney spoke of his wish to paint more quickly. 'I now realize sometimes I've been labouring over things, therefore not being expressive enough. The drawings rarely get laboured because they're done with some speed. And I think they're fresher, aren't they, than the paintings? Although it's harder to paint. Now, what I always longed to do was to be able to paint like I can draw, most artists would tell you that, they would all like to paint like they can draw. But in California I'm beginning to find the way.'

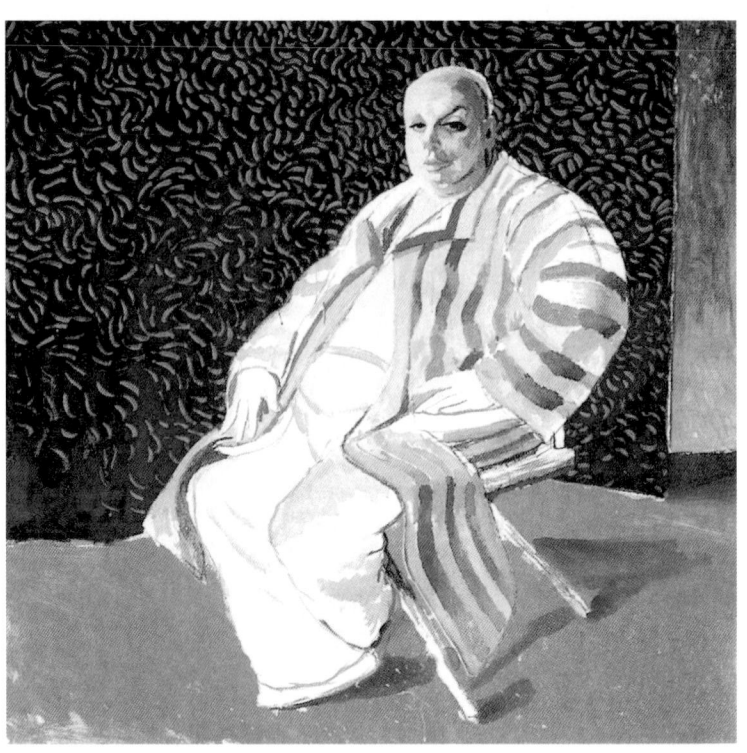

157 *Divine*, 1979

157 The portrait of drag artist Divine, star of outrageously vulgar American underground films such as *Pink Flamingos* and *Female Trouble*, was perhaps the most successful of Hockney's new figure paintings, the one in which he most convincingly translated the spontaneity of his drawing style into paint. A great measure of its success, Hockney later realized, was due to the fact that the head was repainted after the sitter's departure, using small photographs only to prompt his recall and otherwise relying completely on memory. As 172 in *Nichols Canyon*, this freedom from the motif allowed him to invent the image in an apparently unpremeditated and effortless fashion. The massive presence of the figure is contained within an aggressively patterned setting, so that the entire image is locked into a surface design of brilliant colour. It bears particular comparison to Matisse single-figure paintings of the 1920s, such as *Figure décorative sur fond ornamental*, 1927, and *Nu assis au tambourin*, 1926. Hockney here uses pattern and colour for just the purpose that Lawrence Gowing detects in the paintings of Matisse: 'The all-over pattern makes an enveloping symbolic reality which is "conclusively present" just as the colour is.'

208

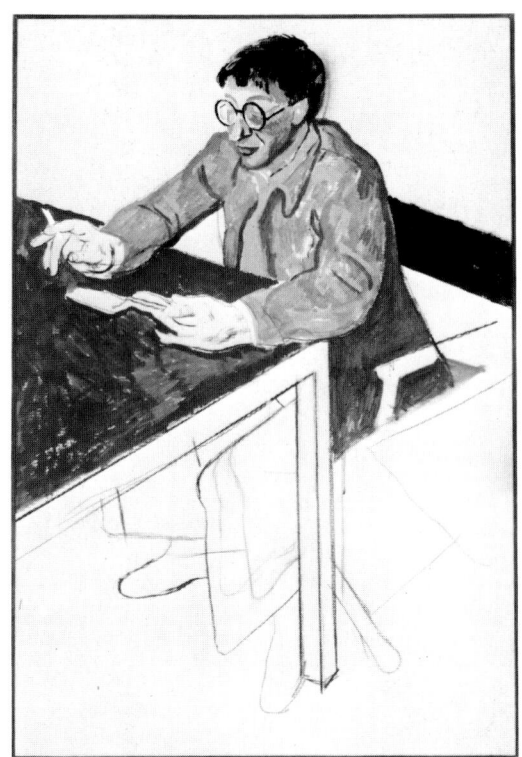

158 *Kas Reading "Professor Seagull"*, 1979–80 159 R.B. KITAJ *Moresque*, 1975–76

An opposite approach, but one also based on fluency of drawing and vividness of colour, is demonstrated in *Kas Reading "Professor Seagull"*, the first of a small group of paintings executed on large sheets of acid-free cardboard intended for the packing of works of art. It was Kasmin himself who suggested to Hockney that he try painting on board as a way of translating the directness of response he was achieving in his drawings; Hockney agreed that he was sometimes intimidated by the canvas, whereas when he worked on paper he felt much freer, secure in the knowledge that he could always throw the results away if they failed to satisfy him. The image, painted from life, is drawn in first with bold charcoal lines, and then over-painted with colours straight from the tube. The charcoal lines are used as a guide, but colour now is not simply an afterthought filling the contours, as had been the case in Hockney's work from 1963 through to the middle of the following decade. The surfaces of colour, freely brushed and assertive in hue, proclaim their presence as independent forms vital to the impact of the

158

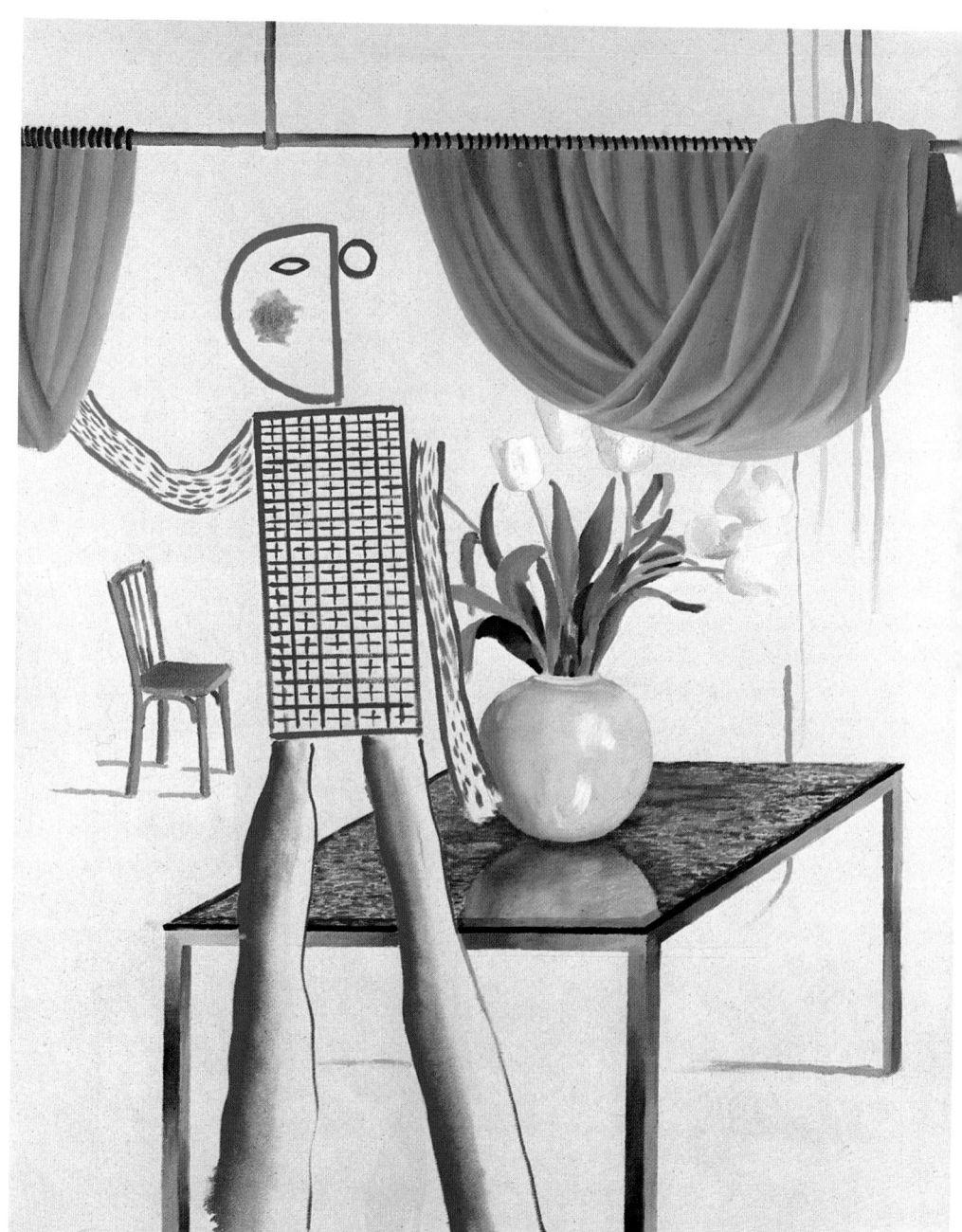

160 *Invented Man Revealing Still Life*, 1975

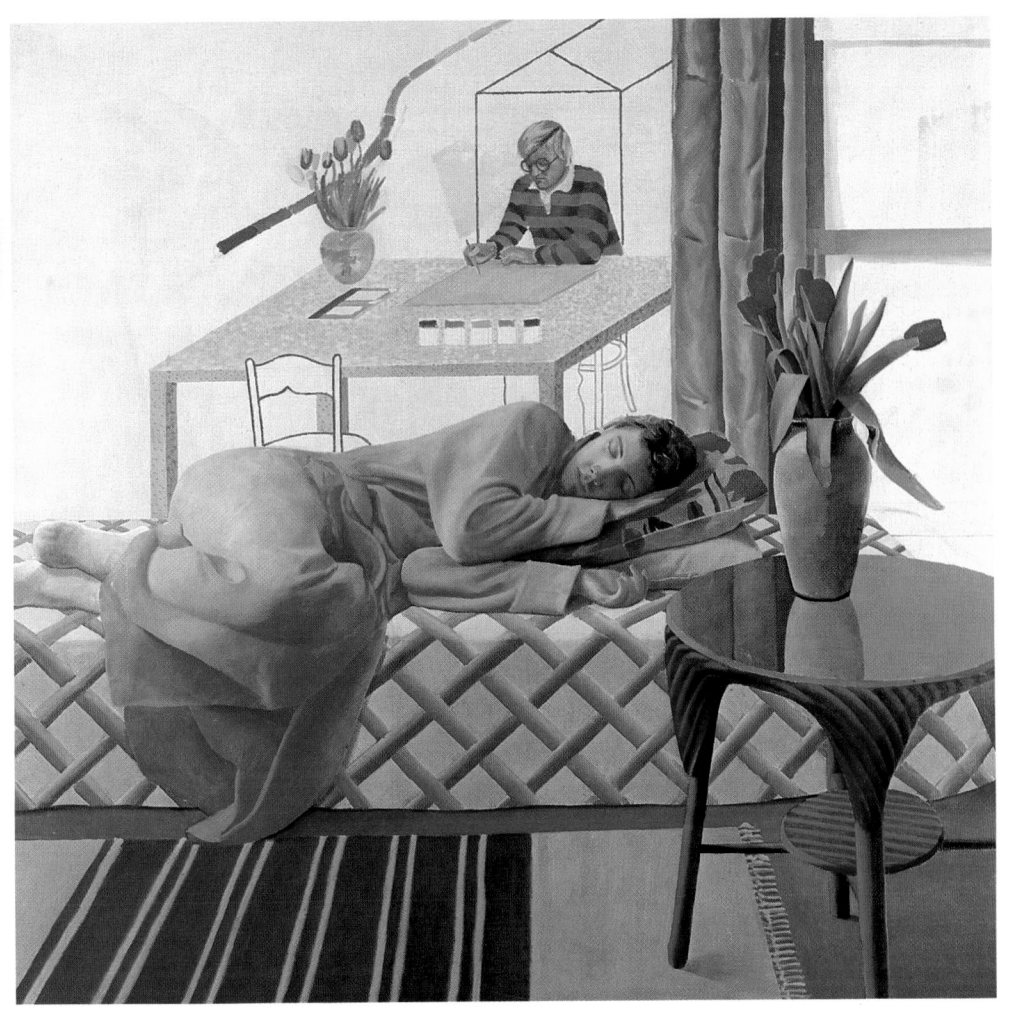

161 *Model with Unfinished Self-Portrait*, 1977

composition as a whole. So concentrated is the image and so forceful is the presence of the figure compressed within the four borders that Hockney decided to leave the painting in what he had first regarded to be an unfinished state; the original intention was to paint the legs as well, but Kasmin had to return to England from California before this had been done. As it is, everything in the image is geared to immediacy of impact and to a concentrated attention on the figure. There are echoes of Kitaj's impressive single-figure panels such as *Moresque*, 1975–6, both in the composition and in *159*

the device of the table viewed at an angle as a spatial lead-in to the figure, but Hockney has peeled away the layers of reference and sophistication in order to transmit at full intensity his impression of the man seated before him. For all its roughness, this figure has a physical impact which exceeds the more fussy concern with surface appearance and likeness of the naturalistic portraits of the previous years.

Hockney's two-figure compositions of this period seek a similar physical force, but attention is necessarily dissipated to some degree by the human situation depicted. In paintings such as *The Conversation*, a portrait of Henry Geldzahler and his friend Raymond Foye, Hockney has deliberately concentrated attention on the figures by placing them within the neutral setting of the studio. Gone for the moment are the explicitly domestic environments of the double portraits of the late 1960s and early 1970s, which used architectural devices and details of particular locations to inform the viewer of different aspects of the relationships portrayed. Now it is through pose and gesture alone that the nature of the relationship is communicated, as in the 1975 and 1977 portraits of Hockney's parents.

The screen behind Henry and Raymond is a single surface of bright yellow paint, unavoidably evocative of Van Gogh, applied unevenly over a black ground so as to vary its luminosity and strength of hue. It is a technique of superimposing colour which Hockney has evolved through his experiments with gouache in his stage designs. Colour is used in broad areas for decorative impact, but it also serves to create volume in the figures, a development which surprised even Hockney. 'It's reasonably loose, but it's rather tight in its volumes; you feel them, and that's because of colour actually. I'm discovering that, what you can actually do with it. That's a new discovery, for me, I mean, not for anybody else, but for me that's a new discovery which is quite exciting.'

During the latter half of 1979 and through much of 1980, Hockney's attention turned once again to the stage, this time to design a triple bill for the Metropolitan Opera which consists of Erik Satie's short ballet *Parade* and two operas lasting less than an hour each: *Les Mamelles de Tirésias* by Francis Poulenc and *L'Enfant et les sortilèges* by Maurice Ravel. Director John Dexter encouraged Hockney to consider the three pieces as a unity linked in period and theme. The First World War and its aftermath in France supply the background against which the action is set; the coils of barbed wire punctuated with Tri-colours which are the sole objects on the stage at the beginning of the performance remain a half-seen presence behind the sets which follow, disappearing only during the Ravel opera with which the evening closes. The world of the circus and street fairs, explicitly introduced in *Parade*, also underlies Poulenc's opera and can be extended into the

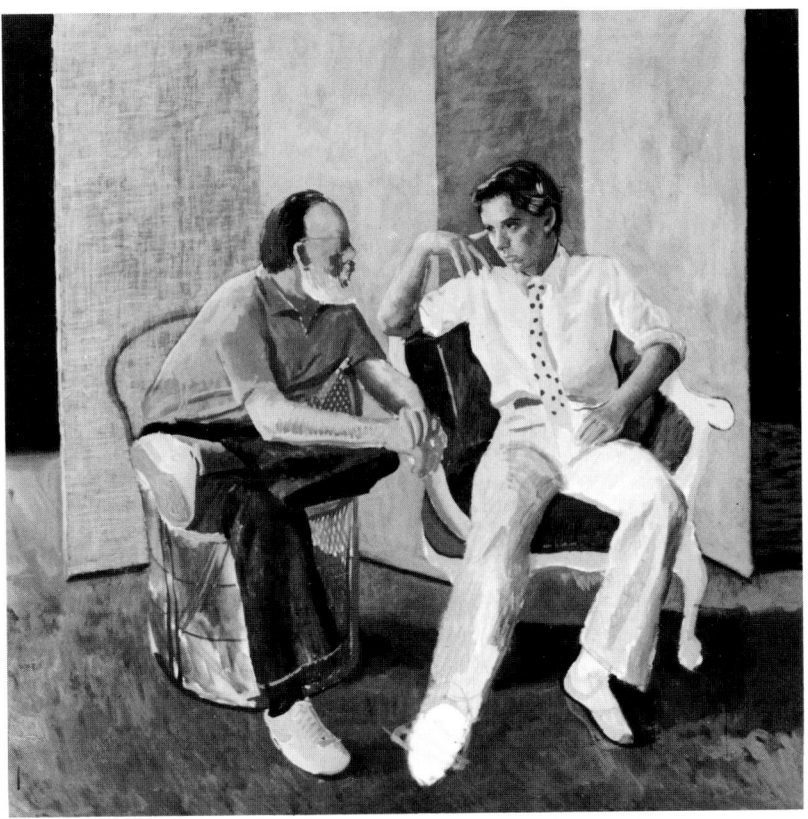

162 *The Conversation,* 1980

children's fantasy world of the Ravel; as a result, Pulcinella and other figures from the *commedia dell'arte* appear in all three parts, with the entire chorus in the Ravel opera clothed in such costumes. For these costumes Hockney has made reference in particular to a group of Pulchinello drawings by Domenico Tiepolo which were exhibited at the Stanford University Museum of Art at the end of 1979.

In a letter to Hockney (8 February 1980), John Dexter expressed his hope that the evening would present a gentle reminder 'of how wildly and weirdly the arts survived in a time of world chaos.' *Parade,* a short ballet which takes as its premise the beckoning of the audience from the street into the theatre, is used as a prologue to the evening's entertainment and as an indication of Dexter's 'personal philosophy of possible alternatives in musical theatre'. As Dexter explained, 'Perhaps I am trying to lure a new audience into a different tent to discover whether there are not still ways of

163 *Outside the Temple* from *The Magic Flute* (Act II, Scene 7), 1977–78

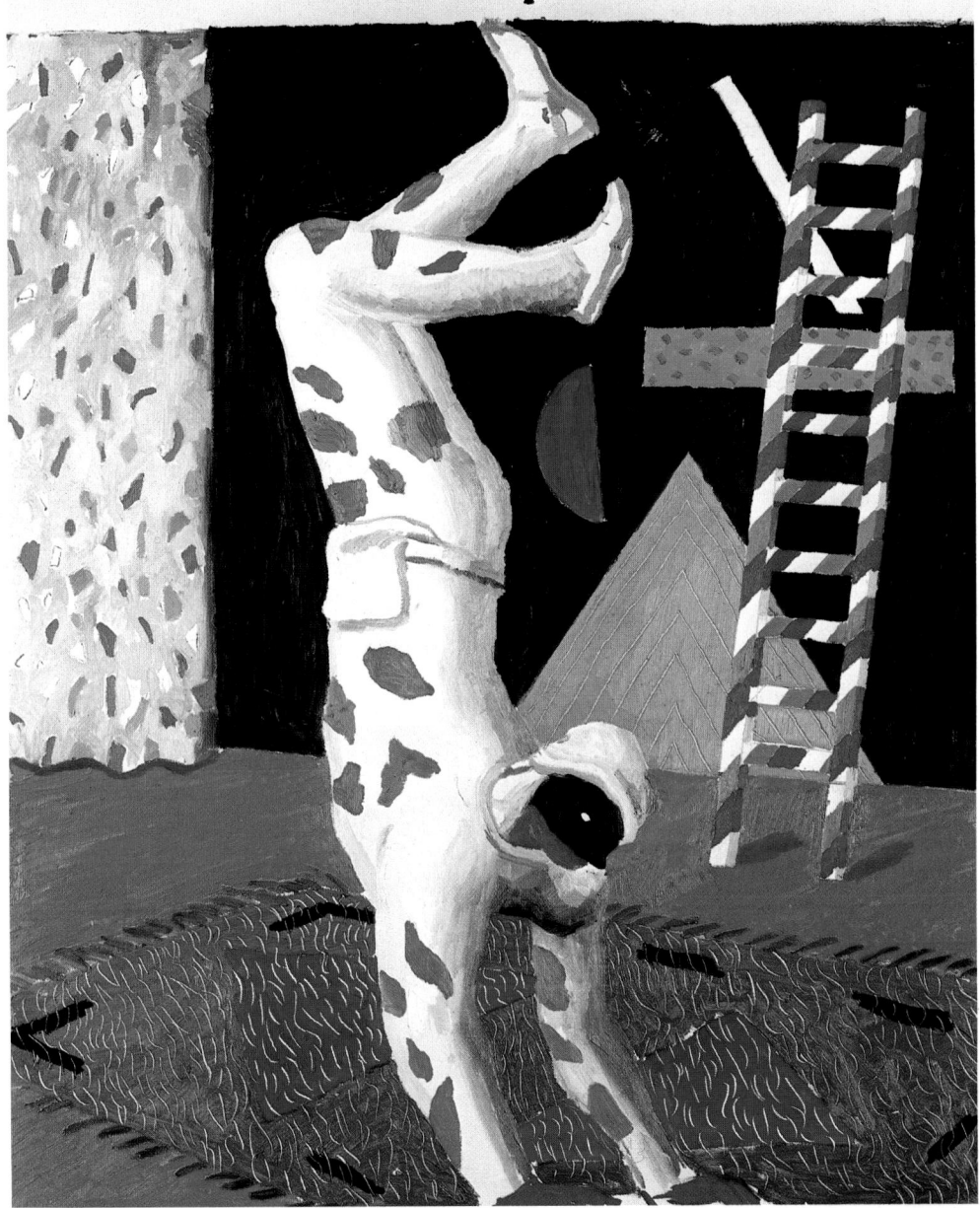

165 *Harlequin*, 1980

164 *Ravel's Garden with Night Glow*, 1980

making evenings of theatrical excitement in an opera house which are restricted neither by the disappearing breed of star international singers or by the weight and expensiveness of the décor.'

Hockney's designs make constant reference to the heroic days of Modernism in France in the second and third decades of this century, in recognition of the themes set by Dexter and of the historical connections with the music. *Parade* is one of the most famous theatrical collaborations of this century, largely because of the extremely influential designs by Picasso which dominated its first production in 1917, but also because of the involvement of other figures: Satie wrote the music, Jean Cocteau devised the story, Massine was choreographer and Diaghilev producer, and the poet Guillaume Apollinaire, who died in the last week of the war, wrote the programme note. Poulenc's music for *Les Mamelles de Tirésias* was written in 1944 and first performed in 1947, but it is based on a play written by Apollinaire for the most part in 1903 and staged in 1917 as a 'Surrealist drama in two acts and a prologue.' (It was this caption and in the programme note for *Parade* that Apollinaire first used the term 'surrealism', appropriate to the farcically illogical events of his play.) *L'Enfant et les sortilèges*, based on a poem written by Colette during the First World War, 'Ballet pour ma fille', was composed by Ravel between 1920 and 1925, when it was first staged. Set in 'the present', no direct allusion is made to the war. The story of the child who is isolated through his misbehaviour but redeemed by his compassion can, however, be interpreted symbolically as a triumph of love over violence, a theme with evident anti-war implications.

Hockney's designs for *The Rake's Progress* and *The Magic Flute* were made largely in the form of scale models, with few preliminary drawings. For the triple bill, however, which underwent numerous modifications before reaching its final form, ideas were formulated in a large number of sketches in gouache during late 1979 and the first half of 1980. Other aspects of these set designs, in particular the costumes and the movement of the figures in and around the backdrops, were explored in more than half of the sixteen small canvases which Hockney painted during his stay in London from early June to mid August 1980.

The concept of *Parade* was changed several times. It was first conceived as an entr'acte to be staged between the Poulenc and Ravel operas, but it was later decided that it would be more logical to stage it first as an invitation into the world of the theatre, which is presented as a reflection of life on the street. The final design, established in one of Hockney's last London paintings from that summer, shows the stage strewn with fragments of the designs that the audience will see later in the evening, conveying the impression that the scenery has been improvised quickly from the material at hand.

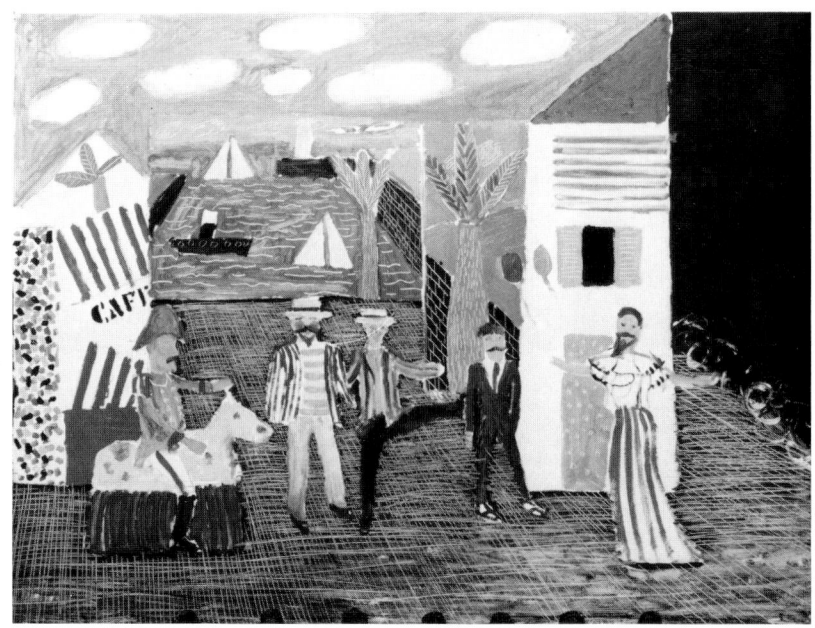

166 *Les Mamelles de Tirésias*, 1980

Les Mamelles de Tirésias (The Breasts of Tiresias), an *opéra bouffe* in two acts and a prologue, was the most straightforward of the three pieces to design. It opens with a prologue in which the theatre manager, standing in front of the curtain, explains that the entertainment to follow will be light and amusing but that it has a serious message, that of repopulating the nation after the ravages of war. The only indication of the farcical action to follow, the frantic illogicality of which has been compared to Jarry's *Ubu Roi*, comes in the form of Hockney's stylized backdrop representing a curtain, a variation of that used in two 1963 paintings, *Still Life with Figure and Curtain* and *Seated Woman Drinking Tea, Being Served by Standing Companion*. The curtain is then lifted to reveal the single set as a 'stage within the stage'. Poulenc's note for the staging of the opera removes the action from the country of Zanzibar used by Apollinaire and places it instead in an imaginary town on the French Riviera, somewhere between Monte Carlo and Nice, about 1910. In Poulenc's view, exoticism did not accord with the patriotic overtones of the theme, and he insisted that on no account should the designs emphasize this aspect. The change of scene to the Riviera was predicated largely on the fact that Apollinaire grew up in that part of the country.

Hockney's set for Poulenc's opera, which because of its short length is performed without an interval, is an exact rendering of all the elements

160

217

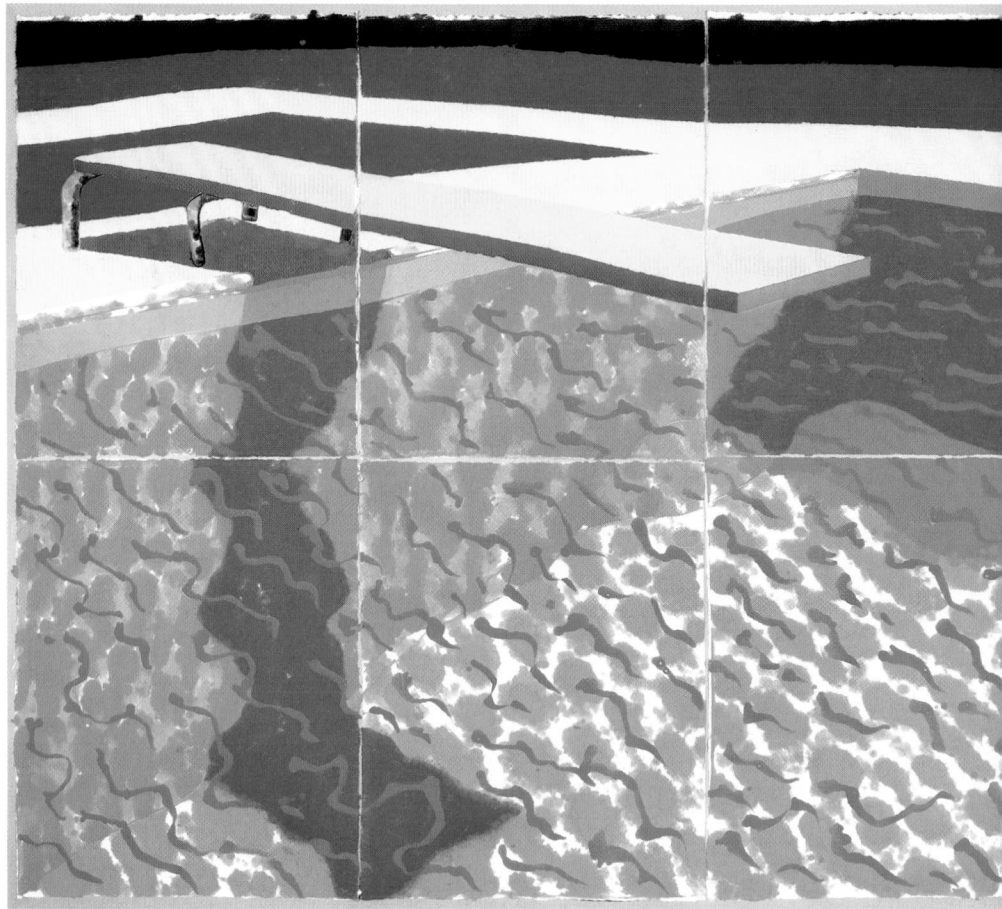

detailed in the libretto's instructions. It represents the main square of the Mediterranean town. On one side is a café with an awning, on the other a building in the style typical of the south of France, with a window open on the first floor and a 'Bar–Tabac' on the ground floor. In the centre is a view through to the port. Hockney has gone for inspiration primarily to Dufy's harbour scenes of the 1930s appropriately witty and buoyant in tone and sufficiently familiar as an identifiable artistic reference to provide a visual parallel to the elements of stylistic parody which characterize Poulenc's music.

Hockney lavished his greatest attention, however, on Ravel's opera not only because of his love of the music but also because of the challenges presented to the designer by its forty minutes of complicated transformation

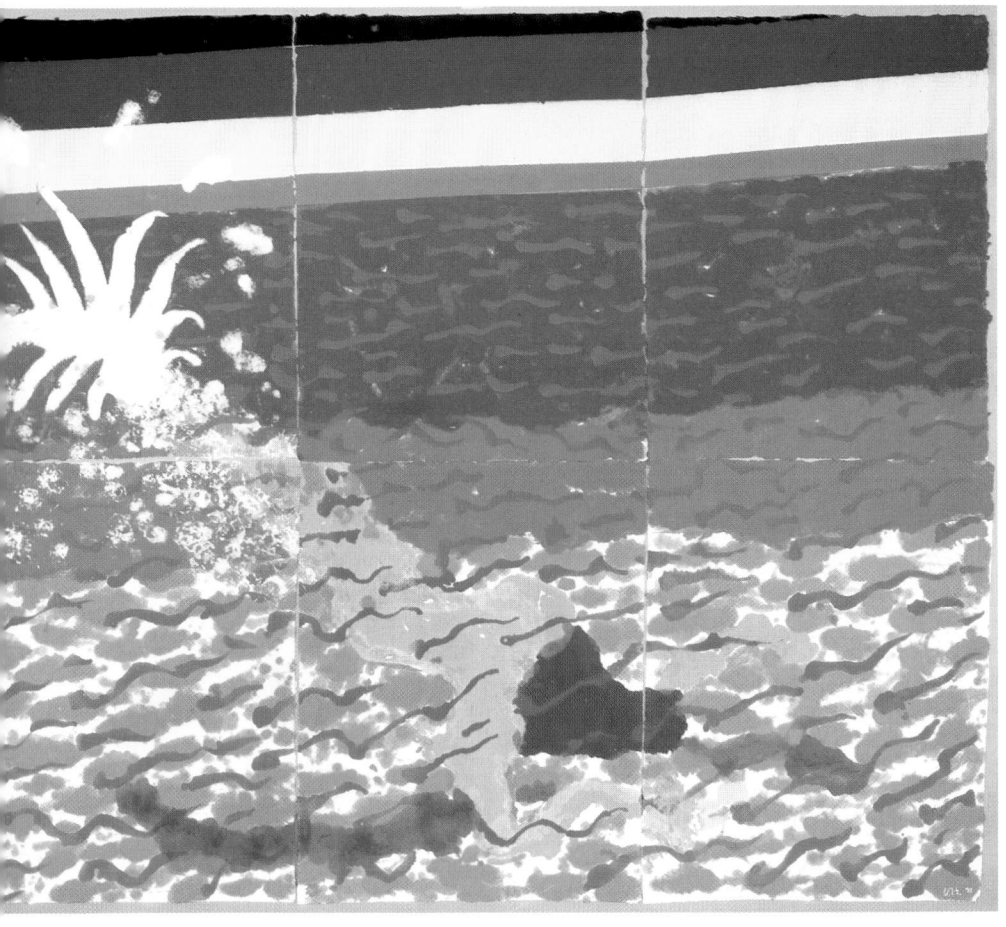

167 *Le Plongeur*, 1978

scenes. In the first part alone, set in the child's room, chairs dance, a Wedgwood teapot and a Chinese cup perform a foxtrot, flames jump from the hearth to menace the child, the shepherds torn off the wallpaper sing and dance before making their departure, and the princess from the child's favourite book, torn by him in anger, emerges from the severed page to come to life. Hockney's ingenious solution to this constant metamorphosis was to make a stylized representation of each of these objects on the faces of oversized building blocks, which were turned in different directions and reassembled by stage hands dressed as Pulcinellas. Through this simple device of a child's toy we as spectators are placed in the role of children, filled

with wonder at the imaginative power through which fantasies can be turned into actuality.

A plunging perspective worked out intuitively in a series of at least six designs transforms the enormous stage of the Metropolitan Opera into an intimate room seen from a child's point of view. More remarkable than this spatial sensation, however, is Hockney's daring use of colour, a startling scheme of green, red and blue, through which he creates a parallel to the mood of the music. The music begins slowly and quietly, simply setting the mood, which Hockney interprets as that of 'the child in the room looking at everything, in the way a child is excited by everything, a corner of the room, the shadows.' It was thus decided to have no action accompanying those opening bars. 'You're just looking. The music is evoking the room, that's all.'

The equivalence of music and colour is even more impressively achieved in the second part of the opera, when the walls of the room suddenly disappear and the child finds himself in the garden at night, lit only by the *164* moon and by the lingering pink of sunset. Hockney's garden diorama is dominated by a large central tree, an image inspired by a black and white photograph of *Joe McDonald and Peter Schlesinger on the Banks of the Nile* taken at the beginning of 1978. Once more, however, it is the environment of rich colour that creates the fullest impact. The scene is itself a transformation, for the brilliant red trunks and vast expanse of blue foliage, balanced by a vivid green ground, are based directly on the colour scheme *169* and formal economy of Matisse's great canvas of 1909, *La danse*. The reference here is made not for the sake of cleverness or even as an act of homage, but out of an urge to find the most compelling visual form in which to clothe the mood of the music. Matisse's painting, which not only proposed a correlation between music and colour but also sought, in the artist's words, to 'inspire the most direct emotion possible by the simplest means', is here re-enacted in a new context. The graceful flowing curves of the dancers' arms suggesting continuous movement, are translated into the swaying branches of the trees, which become animated when wounded by the child's knife. Matisse's painting is well served by this remarkable revitalization of colour on a huge scale. Once again the inspiration of opera has led Hockney to transcend his sources and to create some of his most memorable inventions.

In a great burst of energy unprecedented in his work for more than a *164, 165* decade, Hockney produced a series of sixteen canvases on themes of music *166, 168* and dance during his two-month stay in London during the summer of 1980. In these paintings, many of them based on his designs for the Metropolitan Opera triple bill, he brought together his recent experience with the stage with his ever-growing enthusiasm for the work of Picasso, which he studied

at some length earlier that summer in the mammoth retrospective held at the Museum of Modern Art in New York. More than ever it was Picasso's attitude to his art, rather than the superficial appearance of particular works or styles created by him, that Hockney wished to emulate: the ability to take inspiration from anywhere at any time, to discard methods when they cease to provide an adequate container for his ideas, to work quickly and spontaneously, trusting to impulse, to return to earlier subjects in the light of new experience, to channel his energies so as to produce a wealth of imaginative ideas rather than to squander all his effort on constantly reworking a single picture, and above all to unify his art and his life.

'The Picasso exhibition made me realize', recalled Hockney in December 1980, 'that sometimes just getting it down quickly, what you get down is

168 *Two Dancers*, 1980

169 HENRI MATISSE
La danse, 1909

170 *Mulholland Drive:*
The Road to the Studio, 1980

171 *Canyon Painting*, 1978

172 *Nichols Canyon*, 1980

often more your thinking than when you coldly plan it. Henry used to say to me, "The real bit of puritanism you have left is that you think if you've spent three months on a painting it's forced to be good, and if you've spent two days on a painting, it's nothing." He said, "Often when you just spent two days on it something came out that doesn't come out in the others." I realized there was a lot of truth in that. All the paintings I've spent a real long time on, like the portrait of George Lawson and Wayne Sleep, I've eventually abandoned. Sometimes I play down spontaneity, whereas you never do it in drawings. In painting, somehow or other, blocks occur, you don't treat the canvas like the paper; you *should*.' Hockney agrees that a great deal of the vitality of his work in the early 1960s, when he rarely spent longer than two or three weeks on a picture, arose from its sense of urgency, and it is this which he wishes to recapture now. 'If you deal with subjects quickly, you actually get more in, because you put more into it.'

132

Hockney has not set himself up in competition with Picasso; rather, Picasso's example has made him conscious of how important it is to continue relating his own experience in his own voice. The success of many contemporary artists in constantly refining a single idea has come to seem to him a rather hollow one, since it eliminates such a wide range of experience. Hockney recognizes that in following Picasso's approach he is likely to produce some failures as well as some work which might seem trivial, but what his art could gain in terms of its humanity is immeasurable. He has come to the conclusion that the artist should fear nothing, that he should not worry even about imitating other artists or about producing work which seems old-fashioned, for if he deals honestly with his own experience the work by definition will be of his own time.

The paintings Hockney made in London during the summer of 1980 and those that have followed in subsequent years are exuberantly varied, yet there is no doubt that they are all by his hand. There is a playful sense of experiment and a willingness to engage in games of style and technique that recall the liberating eclecticism of his work of the early 1960s, creating an air of constant surprise and discovery. The new paintings seem logical successors to his Royal College work, a fact that pleases him greatly and that has led him to the view that it is the naturalistic pictures of the late 1960s and early 1970s that in time will come to seem the aberration in his development.

None of Hockney's London canvases took more than a few days to paint. In general they are very freely drawn in bold colours and simple forms. The first of the paintings, a highly schematized image of two dancers, was rapidly improvised from a drawing made three years earlier for a drop-curtain used in Wayne Sleep's one-man show at London's Adelphi Theatre in November

161

1977. The portrayal of movement through line and colour alone is carried even further on another small canvas, *Waltz*, which proposes a nearly abstract equivalent for the music of Ravel's 1919 ballet *La Valse*. Hockney has flirted with abstraction before, but never quite in this way. Instead of making an ironical gesture towards abstraction, as in the 1971 *Rubber Ring* 110 *Floating in a Swimming Pool* or the earlier *Portrait Surrounded by Artistic* 56 *Devices*, he now feels sufficiently confident about his ability to translate his experience into paint that he is able to simplify an image to the point of near-illegibility. He has come to see that abstract art has more to offer him than its decorative appeal, that it can provide the means to concentrate on essences, but he feels more strongly than ever that an art which severs its links with perceived experience is bound to be vacuous. 'The trouble with some abstract art', explained Hockney in December 1980, 'is that it doesn't come from anywhere. That is the point Kitaj keeps trying to make, that there is a difference, actually, between an art that depicts and an art that does not. . . . Very few people are interested in the activity of moving one's arm around making marks, but people *are* interested in making something of experience, because everybody does that. The only difference is that the artist makes something of it.'

Hockney returned to Los Angeles in the autumn of 1980 in a buoyant mood, anxious to apply the spontaneity of the new London pictures to a more ambitious project. *Santa Monica Boulevard*, which was still pinned on to 155 the wall of his studio, now seemed to him beyond saving. Hockney instructed one of his assistants, Jerry Sohn, to destroy the painting and to keep only the two fragments that satisfied him; only after more than a decade had passed did he discover that Sohn had taken it upon himself to roll the canvas up instead. Pleasantly surprised by the rediscovery of the work, which seemed to him much better than he had remembered, he agreed that it be shown at last in the context of an exhibition, 'Hockney in California', that toured Japan in 1994. His intention had been to make the eye move across the painting as if one was walking down the street, employing to this end a very wide format and a composition which deliberately dispersed attention among a number of separate images. He stopped work on the painting, however, when he decided that the result was static because it was too tightly drawn and the images were too fragmented, too separate, to create a continuous flow. *Nichols Canyon*, which was painted much more freely and 172 with recourse to memory, seemed to him a far more satisfactory solution because of the way it conveyed sensation rather than literal appearance. With this in mind, Hockney tacked up another eight by twenty-foot canvas over the *Santa Monica Boulevard* and in the space of three weeks in November produced another Los Angeles landscape, this time *Mulholland Drive: The* 170

Road to the Studio, a diagrammatic view of an undulating route through the Hollywood Hills also painted from memory.

Hockney worked daily on *Mulholland Drive*, completing it in time for it to be shown at the Royal Academy's survey exhibition, 'Painting: A New Spirit', the following January. The road which he chose as his subject is the main thoroughfare down which he was driving daily on the way to his studio from his home in the Hollywood Hills. The winding route is depicted prominently at the top of the hill. Beyond this can be seen, to the left and right, the suburbs of Studio City and Burbank in the San Fernando Valley, copied on to the canvas from road maps. Like his forays into landscape in the mid 1960s, and more recently in *Nichols Canyon*, this view of the Hollywood Hills is presented in a strongly diagrammatic fashion. It was painted quickly and entirely from memory, concentrating on the sensation of curving movement and on salient details spotted while driving: the roofs of houses, various hills, different kinds of vegetation, and to the left some tennis courts and a swimming pool. By means of a robust serpentine line, orchestrated accents of colour and scattered points of interest, the viewer's eye is made to wander in a jagged path across the surface of the painting, emulating the movement of an automobile through a landscape.

'You drive around the painting, or your eye does,' explained Hockney a few weeks after completing his picture, 'and the speed it goes at is about the speed of the car going along the road. That's the way you experience it.' The enormous width of the canvas is appropriate to the subject, allowing a panoramic view of the extended landscape and filling the viewer's field of vision with sensations of colour and texture. Hockney has used a wide range of marks, a lexicon of his new pictorial vocabulary: broadly brushed images, decoratively patterned areas, outlines incised into the paint, and surfaces filled with bustling brushmarks of intense hue. It was painted in acrylic because the enormous scale made oil impractical, as Hockney knew that the painting would have to be ready quickly to be rolled for shipment. He has made much use of thin glazes of colour applied one over the other on a white ground, a method that creates unusual and rich hues and guarantees maximum intensity and luminosity. Elsewhere the contrasts are often of an elementary kind – red against blue or green, blue against orange – but varied from section to section and kept at a constant pitch. The result is a tumultuous blaze of colour.

While Hockney had no intention at that time of reinventing himself as a landscape painter, it was clear that he no longer believed in a hierarchy of subject matter. The whole world around him, not just the human figure, could legitimately capture his attention. Having opened up his options in this way, anything was now possible.

4 Remaking Appearances

With *Mulholland Drive* and related paintings Hockney sensed that his goal no longer lay in verisimilitude but in *remaking* appearances in a way that revealed their essence. Such an ambition, he realized, had its roots in the discoveries of Van Gogh, Matisse and Picasso, who nearly a century earlier had taken a similar course following the example of Japanese and other non-western art. Always one to make his own opportunities, Hockney directed much of his energy in the early 1980s to a personal reinterpretation of oriental art, not only in his designs for a triple bill of works by Stravinsky, premièred at the Metropolitan Opera House on 3 December 1981, but also in a three-week visit to China at the instigation of his publishers, Thames and Hudson, in May of that year.

The Stravinksy programme posed a rather different challenge from Hockney's previous work for the theatre, comprising as it did three works of unequal length that were distinct musically, dramatically and in mood. In *Hockney Paints the Stage*, published in 1983 to accompany the large touring exhibition of the same name, the artist characterized the evening's first piece, the ballet *Le Sacre du printemps (The Rite of Spring)*, as 'kinetic', the second, *Le Rossignol (The Nightingale)*, as 'more like conventional opera' and the final work, *Oedipus Rex*, as 'a static narrative with music'. Hockney's response to these contrasts was to devise an appropriate visual parallel for each, linking them through the use of strong colour and by the simple device of circular motifs.

Le Sacre du printemps, long recognized as a major twentieth-century work, seems to have presented a daunting prospect at first but after discussions with John Dexter and the conductor James Levine, Hockney was able to think in terms of the 'cold landscape' which close listening of the music suggested to him as the most appropriate setting. The designs are fundamentally of two circular motifs, one – a bleak and stylized northern landscape – presented 174 frontally as a backdrop, and the other – a blue disc representing ice or a lake – viewed in perspective on the floor as the focus of the dancers' ritualized actions. Coloured lights transform the saturated hues of the backdrop (cobalt blue, purple and ultramarine) into much warmer tones to indicate the transition from winter to the life-giving forces of spring.

The circular sphere of action features prominently also in the adaptation from Sophocles, *Oedipus Rex*, for which Hockney devised a dignified and 173 austere setting. The colour scheme of red, black and gold was borrowed from the interior of the Metropolitan Opera itself, transforming the whole of

173 *Oedipus Rex: Chorus, principals, narrator, orchestra and masks,* 1981

174 *Set for Sacre with Dancers II* from *Le Sacre du Printemps,* , 1981

175 *Emperor and Courtiers* from *Le Rossignol*, 1981

this huge space into a part of the stage, as would have been the case with performances of the original drama in outdoor amphitheatres. By such means, as well as through masks with large features, clearly visible even at a great distance, Hockney was able to bridge the gulf between performers and audience and to bring to the tragedy a sense of intimacy without sacrificing its grandeur and formality.

Neither the *Rite of Spring* nor *Oedipus Rex*, however, provided Hockney with the kind of material that could bring out his real inventiveness as a designer. In the first piece the stage design had to be kept necessarily simple as a backdrop to the dancing, and the elemental imagery of nature was perhaps too generalized for an artist so habitually stimulated by specific visual experiences. *Oedipus Rex* likewise provided no real opportunity for the kind of detail in which he delights, in addition to which one senses that he was inhibited by its solemn tone and lack of action. The short opera *Le Rossignol*, 175 however, sandwiched between these two pieces, was much more obviously suited to his turn of mind with its fairy-tale story and atmosphere of enchantment. Armed with his camera, Hockney visited the Victoria and Albert Museum's collection of early eighteenth-century blue and white porcelain to gather sources for his twentieth-century chinoiseries. As with

the two other pieces, the centre of the stage was again marked by a circular motif, this time in the form of a platter representing the floor of the emperor's palace. Hockney's decision to present the spectacle fundamentally in the blue and white of his reference material convincingly transformed the stage into a setting for dreamlike action. In this context the sudden appearance of the gilded mechanical nightingale on a bright red cart is deliberately jarring, an abrupt intrusion of a different order of experience. Colour is the unifying agent and most insistently physical presence throughout the programme, the identity and mood of each piece defined as much by its boldly simplified colour scheme as by the character of its imagery.

On 19 May 1981, having already begun work on the Stravinksy triple bill, Hockney left Los Angeles for a three-week visit to the People's Republic of China in the company of Gregory Evans and the poet Stephen Spender, who had known Hockney for many years and who had worked with Nikos Stangos on the translations of Cavafy's poems for the book published in 1966. It was Stangos's idea to commission the artist and poet to record their observations as Westerners, in images and text respectively, with the express intention that the results be published in book form. *China Diary*, lavishly produced with eighty-four colour illustrations, appeared in the following year. Circumstances prevented Hockney from producing as many drawings as he would have liked, not only because of the brevity of their journey but also because of the intense curiosity aroused on almost every occasion that he attempted to work in public. For the most part, therefore, Hockney contented himself with the camera, producing a mixture of casual snapshots and landscape or still-life studies of great formal elegance; the admittedly attractive selection of these reproduced in the book, however, gives little indication of the innovations with the medium which he was to undertake early in 1982.

More interesting in terms of its repercussions on Hockney's future work was the effect of the trip on his drawing style. In being forced to devise a rapid system of notation with which to record his sensations, Hockney allowed himself a looseness and spontaneity of execution which in retrospect seems a logical development from his devotion to the achievements of Picasso. Inspired no doubt by his growing curiosity for Chinese brush paintings and by his direct confrontation with the country's scenery, he produced during this trip his first fully convincing watercolours; their apparent slightness masks a confidence in what can be achieved with just a few bold gestures of the brush to record something quickly glimpsed. The daring simplicity of the tiny watercolour *Man Walking, China* – in which a dark human silhouette and a pavement indicated by a few cursory lines are superimposed

176

176 *Man Walking. China*, 1981

on a broadly brushed wash – indicates the extent to which Hockney had by now freed himself of worries about what was expected of him. Of equal importance to Hockney's future work was his recognition of the value of memory as an adjunct to a direct recording of observations. The interrelationship of all these factors, and in particular his longstanding concern with the function of time in both hand-made and photographic images, emerged as an obsessive theme first in his photography and soon after in his drawing, printmaking and painting.

Hockney's activity as a draughtsman has for many years encompassed both essentially private jottings and more finished works on paper – what one might once have referred to as 'exhibition drawings' – either in the form of pen and ink line drawings or unashamedly decorative studies in coloured crayons. It is in the more private work that one would naturally expect to find the evidence of experimentation, as seems to be borne out by the evidence of the sketchbooks which Hockney began to keep in 1981. One of

231

these, published in facsimile in 1985 as *Martha's Vineyard: My Third Sketchbook from the Summer of 1982*, contains a mixture of media, techniques and styles, of highly structured compositions and absent-minded fragments and doodles. The results, although uneven in quality, as one might expect in a sketchbook, confirm Hockney's continuing attraction to a variety of stylistic approaches. Some of the crayon drawings and those executed purely in pen and ink are in styles associated with much earlier work, indicating that for Hockney the goal is to widen his range of possibilities and, like Picasso, to regard previously favoured methods and techniques as part of an ever expanding repertoire.

It is rarely a simple question, however, of returning to a former style. The former insistence in the pen and ink drawings on a considered, unbroken contour has given way to a preference for patterns of impulsive marks charged with a nervous energy; the crayon drawings, similarly, are often deliberately smudged or combined with watercolour techniques, lending them a slightly expressionist aspect. The combination within a single image of different media – black and coloured inks, crayon, felt-tip pens and

177 *Slow driving on the way to Skowhegan airport*, 1982

brushed paint – is part of the same bid for a flexible approach to drawing marked by lively and unexpected contrasts. Even in a drawing as apparently improvised as the double-page *Slow driving on the way to Skowhegan airport*, 177 Hockney appears determined to achieve a synthesis of approaches which might once have seemed irreconcilable, using new materials and methods to fuse the marriages of style and technique of his early work with the observations from life of his naturalist phase. The urge to strip away appearances to their essence, which Hockney so appreciated in oriental and early Modernist art, also finds form in the almost swashbuckling confidence of another drawing from this sketchbook, *Boy in baseball cap wearing Adidas* 178 *sweatshirt and shoes*.

Hockney's determination in the 1980s to delve under surface appearances also has a psychological dimension: this is particularly evident in the series of self-portraits which he undertook as his first act of virtually every day of a six-week period in the autumn of 1983. The subject is one which he had previously shunned, admitting as late as 1980 that the scarcity of self-portraits in his work may have indicated a refusal to examine himself too closely. He

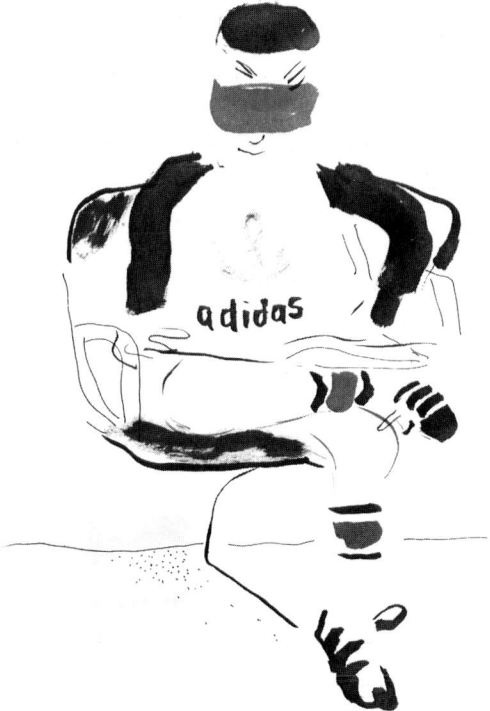

178 *Boy in baseball cap wearing Adidas sweatshirt and shoes*, 1982

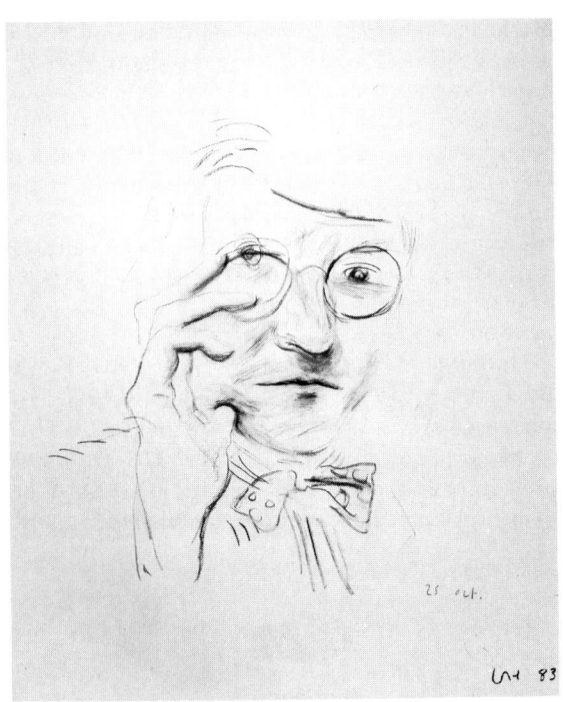

179 *Self-Portrait*,
25 October 1983

assumed that he would come to the subject when he was ready for it, and when he finally did so it was with characteristic zeal. 'I discovered I was getting older', he recalled matter-of-factly in the autumn of 1986. 'I discovered that my face didn't quite look how I thought without scrutinizing it. Somehow they were quite revealing to *me*.'

The self-portraits provide insights previously rarely glimpsed into the inner life of an artist with an unusually high public profile. We find that even such an eternal optimist, at the height of his fame, is susceptible to dark moods and to fluctuations in his self-esteem. In some of the drawings Hockney presents himself deep in concentration as if engaged in a scientific investigation, in others he is a figure of almost romantic aloofness. The most moving images, however, are those in which he sweeps aside self-consciousness and reveals himself emotionally naked and vulnerable. The importance of this group of drawings lies not only in their broaching of a new subject but in the demands their execution presented to Hockney's technical inventiveness and ingenuity as a draughtsman. Waking up bleary-

eyed is an unremarkable occurrence but what is extraordinary is Hockney's ability on the spur of the moment to invent a system of notation to represent himself in that state, as he did in his charcoal drawing of 25 October 1983. *179* Certain contours, such as that of his cheek or the rim of his glasses, are drawn more than once and with varying pressure, giving an effect similar to an unfocused image from a printing press. There is, moreover, a striking contrast in clarity between the boldly delineated bow tie, with its clearly visible pattern of polka dots, and the faintness of his hairline, which seems barely to have materialized. All these devices support the gesture of the artist's upraised hand and contribute to the sense that we are re-experiencing his effort to focus his eyes on his image in the mirror.

Throughout the 1980s Hockney's prime concern was to investigate how our eyes collect visual data over a period of time and how this is then interpreted by the brain in terms of distance and three-dimensional form. His primary tool in this research has been the camera, which from February 1982 for a period of two years became an obsession that dominated all his other work. He was set on this course almost by chance, motivated by the fact that he purchased a number of rolls of Polaroid film to document his work and then wished to dispose quickly of the remainder. The first of the more than 140 composite Polaroid pictures that followed, an image of the living-room, terrace and swimming pool of his Los Angeles house, laid out in the form of a rectangular grid, came about as much through play as by plan. Both this work and a slightly later, more subtly engineered composite titled *Blue Terrace*, of 8 March 1982, were closely related to the memory painting of *181* the house which Hockney had produced in London at the end of 1980. The *180* function of the painting had been to recreate the sensation of wandering through his Hollywood Hills house, a nostalgic bid for California open-plan architecture and sunshine in the midst of a grey British winter. Three separate canvases defined the imagined movement first from the interior to the porch – the narrow gap between the panels also functioning as the glass wall separating the two spaces – and then from the porch to the swimming pool and garden. In the photographs this movement was made actual, the whole architectural structure built up by means of fragments photographed in succession at different angles.

Hockney was excited by the implications of these photographs and pursued the technique relentlessly through to July, obsessed by what he perceived to be the inadequately understood Cubist discoveries about pictorial space. The main issue, as he stressed in November 1983, in his lecture 'On Photography' at the Victoria and Albert Museum, London, was that of dispensing with the one-point perspective from a fixed position established in the Renaissance, in favour of a system which he felt more accurately

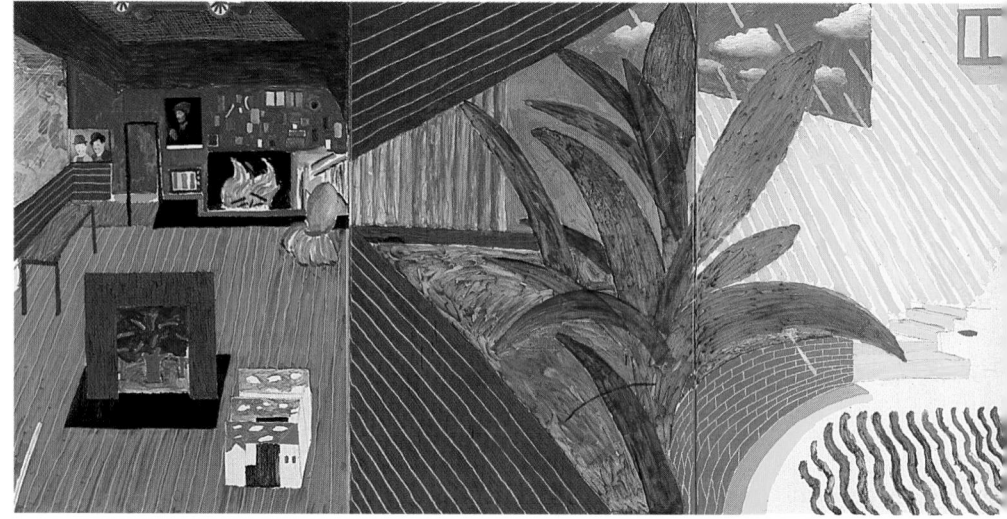

180 *Hollywood Hills House*, 1980

181 *Blue Terrace,
Los Angeles,*
8 March 1982

182 *Stephen Spende*
1985

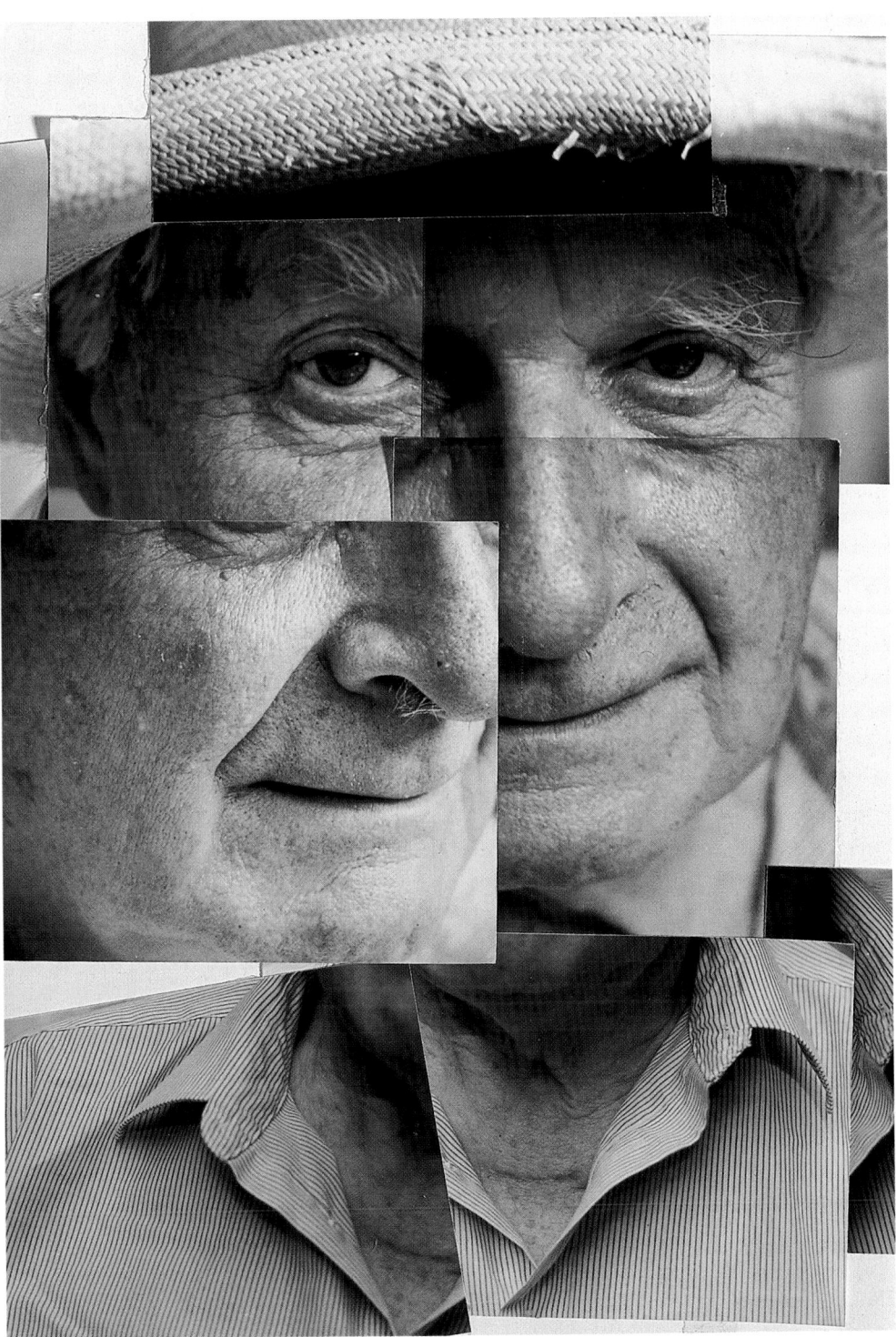

conveyed human perception, marked by 'many points of focus and many moments'. Wishing to overcome the limitations of the instant photographs – their lack of negatives from which to reprint, their tendency to fade and the restrictive grid system they imposed – Hockney had begun in May 1982 to produce photocollage 'joiners' from 35mm prints, some of which were later published in limited editions. Through these he became increasingly absorbed in the lessons of Cubism and particularly in the device for representing a three-dimensional form on a two-dimensional surface by means of fragmentary views of its different sides. The vivid portrait of Stephen Spender produced in 1985, although small in scale and structurally much less complex than the elaborate landscapes produced during these years, demonstrates well the benefits of the system in capturing truth to experience. Once the viewer has become accustomed to the fracturing of the image, there are evident advantages in terms of its animation as a portrait and in the information yielded about the variety of textures and about the sitter's features and facial structure.

182

With the Polaroids the results could be studied gradually during the process of constructing the image, but Hockney was frustrated by the grid format which he felt interrupted the spatial flow. The landscapes, still lifes and portraits produced with the 35mm camera, on the other hand, relied heavily on memory, first in the actual shooting of the pictures – since the artist had to bear in mind how they would fill the field of vision when pieced together – and later in the physical reconstruction of this composite image seen through time. The culmination of these experiments was the 41-page section of photographs and hand-drawn images especially produced and designed by Hockney for the December 1985 issue of *Paris Vogue*. The experiences gained through such techniques clearly confirmed Hockney's conviction not only about the interrelationship of sight and memory, which had struck him as early as the *Canyon Painting* of 1978, but also about the selectivity of vision, which had been an essential feature of his paintings and drawings at least as far back as the *Domestic Scenes* of 1963.

171

29, 30, 33

Those of Hockney's supporters who were alarmed at his prolonged love-affair with the camera during this period need not have worried, for the investigations which this work represented were clearly of a piece with all Hockney's art and were soon to have repercussions on his hand-wrought images. The large-scale painted environments which he produced in 1983 for the Walker Art Center touring exhibition, 'Hockney Paints the Stage', based on his earlier set designs, incorporated witty conceits translated from the photographic work. These environments as a group must be counted as Hockney's most significant painted work of the mid-1980s. Among them was a landscape based on *The Magic Flute* populated with stylized animals

painted in acrylic on laminated foam board: the artist's first essays for a post-Cubist sculpture. The actors within the environment based on *Les Mamelles de Tirésias*, each reconstituted from a series of small canvases defining the parts of the body as in a Surrealist 'exquisite corpse', rephrase in painterly terms the recent experiments in photographic form. In the context of this spectacle, the sense of people being pieced together from separate parts seems particularly apposite as a speculative aside on the interchangeability of personality and identity. In later paintings such as *Self-Portrait with David and Ann*, 1984, in which the artist pictured himself on several disconnected canvases, Hockney has continued to play with such formal devices as another strategy for reinventing the human figure as a convincing physical presence. *183*

The sense of travelling through an interior or exterior space which is an essential feature of Hockney's photographic work of the mid-1980s is manifest also in the 'moving focus' prints which he produced at the same time. Some of these prints veer dangerously close to pastiche in their stylistic appropriations from Picasso's drawing and in their sometimes lurid variants of Fauvist colour. One of the most successful in its restraint is *Pembroke Studio Interior*, 1985, drawn entirely on one surface but openly acknowledging the sources of its splayed-out representation of space and form in the kind of photocollage exhibited on the easel. *185*

Similar concerns shaped the major painting of the period, *A Visit with Christopher and Don, Santa Monica Canyon*, 1984. In this vast panoramic view Hockney returned to the subject of one of the best of his double portraits of the late 1960s by way of a more recent painting of the same size, the 1980 landscape *Mulholland Drive*. The photographic and drawn studies for the 1968 portrait of Isherwood and Bachardy had all conformed to the assumption of a pre-established pose and composition. By contrast, this new portrait, completed in the year before Isherwood's death, was based on a number of informal sketches of the two men engaged in their separate activities, supplemented by memories of many visits to their house overlooking the Pacific. The immense scale of the picture, twenty feet in width, demands that the spectator literally walk across the space, thus encouraging a physical sense of identification with the domestic situation represented. The fact that the portraits, moreover, occur at the two extremes of the picture reinforces our role as the link between them, introducing an intimacy and sense of involvement all the more remarkable given the mural-like scale of the work. *184* *170* *87, 88, 102*

'Cubism is a style, but not in an ordinary sense,' Hockney mused late in 1986. 'It's a very different way of looking and depicting, and as such it's not very well understood yet. People still refer to an ordinary, conventional picture as if it's very real.' As far as Hockney is concerned, therefore, his

183 *Les Mamelles de Tirésias*, 1983

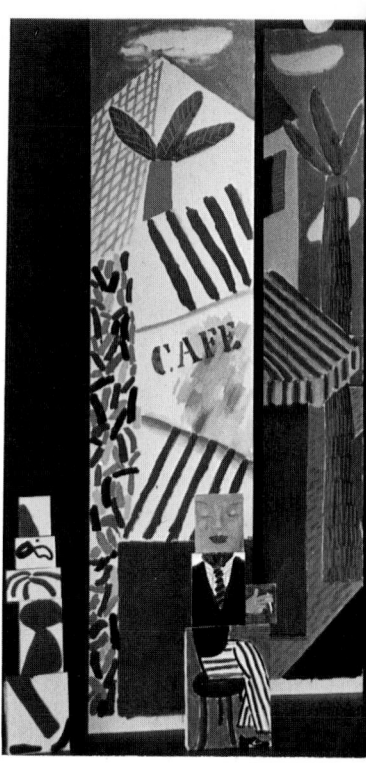

184 *A Visit with Christopher and Don,*
Santa Monica Canyon, 1984

increasingly personal reinterpretation of Cubism is neither a retrograde act nor a Post-Modernist joke but a still valid approach to representing experience. The liveliness with which discrete actions in quick succession are depicted in *David Graves Reading and Drinking*, 1983, vindicates Hockney's commitment to such methods.

186

The results of Hockney's experiments in printmaking with colour photocopiers in 1986 also provide their own justification. Working within the limitations of sheet size and standard colours available on the three office-quality machines which he had installed in his studio, Hockney discovered that by drawing each component separately and photocopying it in a chosen colour onto a single sheet of paper he was able to make limited edition 'home-made prints' in direct response to the process, without the need for assistants or elaborate procedures. Challenging conventional definitions of what constitutes an 'original' print, Hockney has used the photocopier not as a reproductive medium but as a printer of great flexibility. As the *Self-Portrait* of July 1986 indicates, the hues produced by the heat fusion of the coloured

187

185 *Pembroke Studio Interior*, 1985

186 *David Graves Reading and Drinking*, 1983

powders (toners) are of particular brilliance and intensity, especially if the paper is passed through the machine more than once. There are further advantages. One can combine, for instance, facsimiles of actual things – in this case a fragment of a striped shirt cleverly fulfilling the function of the artist's bust – with hand-drawn images. The latter, moreover, can be printed on the same kind of paper on which they were originally drawn, thus preserving their distinct qualities of line and surface according to whether they were drawn with ink, charcoal or crayon, painted on as a watercolour wash or applied in some other fashion. In his design for the book/catalogue of portraits, *Faces*, published in 1987 to accompany a retrospective exhibition of his portrait drawings, Hockney applied the photocopying technique to create virtually new works by selecting and manipulating details from original drawings.

In a two-page spread printed in the December 1986 issue of *Andy Warhol's Interview*, Hockney took even further these ideas about technology harnessed to the subjectivity of the personal touch. Rather than send a drawn or painted image to be reproduced photomechanically by offset lithography, he decided to supply the editors of the magazine with four separate pieces of artwork corresponding to the four colours of the printing process: yellow, magenta, cyan and black. Only when recombined in printed form does the image exist as intended. This, of course, is as good a definition as any of what

187 *Self-Portrait*, July 1986

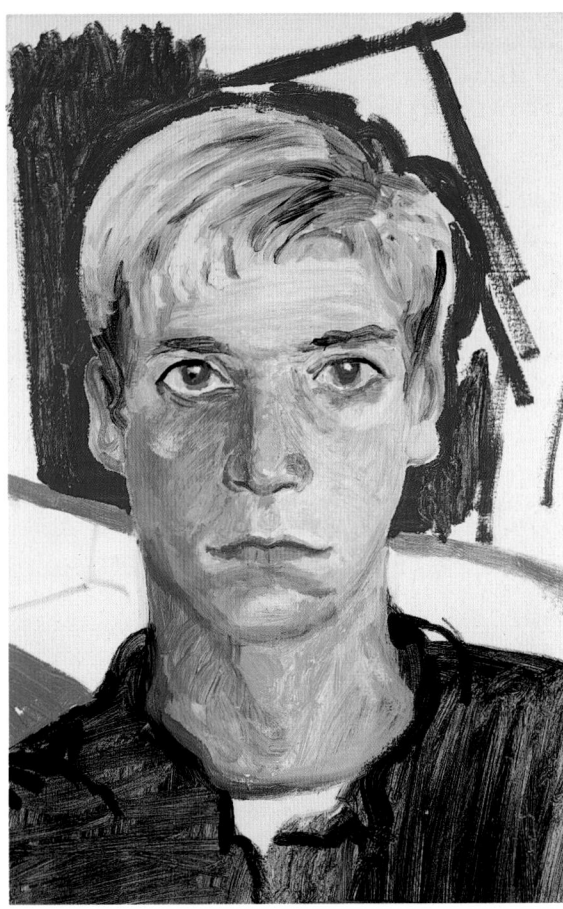

constitutes an original print. The startling immediacy of the marks and the brilliance of the colour are the things one notices first. The implications of such a method for personalizing the otherwise anonymous, apparently neutral, products of mass-produced printing are enormous, since it unmasks the lie and pretence of 'objectivity'.

In the final section of *David Hockney: A Retrospective*, the catalogue for the *189* major exhibition organized by the Los Angeles County Museum of Art in 1988, Hockney employed similar methods to create a sequence of new images in vibrant colours. The 23 pages of pictures are preceded by a title page on which he printed the bold declaration 'COMMERCIAL PRINT-ING IS AN ARTIST'S (direct) MEDIUM', adding in his own hand, as a kind of afterthought: 'layers can be removed.' The images are followed by a

more detailed, oddly punctuated, explanation that typifies his increasing concern with philosophical and theoretical issues:

> The pictures on the previous 23 pages were conceived of using the medium of printing ink on paper. I constructed them by drawing the four colours separately. Each colour was drawn in black-and-white on separate sheets of paper with the thought of the coloured ink in my head. The picture only exists when all four separations are put together. This happens here on this surface. They are therefore not reproductions in the ordinary sense but the original work (ie. this is the only form they exist in).
>
> They were proofed first on an office copying machine, without which it would not have been possible to construct them. New technologies have started revolutions that need not frighten us They can be humanized by artists. The office copier has opened up commercial printing as a direct artist's medium.

There is a certain crudeness about these images that is a sure sign of a novice coming to grips with the possibilities of an unfamiliar medium. There was no need for him to have imitated the shrill colours of four-colour process printing – magenta, cyan blue, yellow and black – at full strength, nor to have overlaid them quite so obviously or with such apparent disregard for the exact registration of one colour over another. Nevertheless, as with the 'home-made prints' he had produced two years earlier, the directness and simplicity of his approach provides the resulting images with their exuberant boldness and decorative appeal. The interlocking of shapes into a unified design, the blatant superimposition of one set of coloured forms over another, even the thin outlines of pure colour created by the slight misregistration of one plate over another also call attention to the process by which they have been created. As a result, they draw the viewer into the creative act in a way that would be unthinkable with a conventional reproduction of an existing image. The variety of textures, moreover, some of them created through the dissolution of form inherent in the photocopier, endows these pictures with a physicality generally absent in such commercially printed images.

Just as Hockney's experiments with photography from 1982 to 1985 provided him with the impetus to make discoveries that were fed back into his painting, so his prolonged investigation into new technologies through to the 1990s has helped to broaden his conception of art, to reshape his ideas about drawing and the handmade image and to question received ideas about what constitutes an original work of art. When he acquired a colour laser-copier, he began using it to create direct reproductions of his paintings, which excited him because they were much more vivid – both in their colours and in the subtlety with which they registered the brushstrokes –

than conventional reproductions printed from photographs. As he was quick to realize, it was not simply that one layer of interpretation had been removed in doing away with the camera as an intermediary; since the copy was made by laying the painting directly onto the copier's glass top, it also eliminated a layer of space, bringing our eyes into much more immediate contact with the surface of the original.

Hockney's excitement at this discovery led him to embark on a series of portraits of friends and family, painted very rapidly from life with a strong concentration on the face, on canvases that corresponded in size to the dimensions of the copier's surface. Paradoxically, given that they were made with a view to being mechanically replicated, these are among the most straightforwardly naturalistic pictures made by him since the mid 1970s, but they have a confident looseness that would have been unthinkable two decades earlier. Some of the colour laser copies that he made from these paintings, printed in sections so that the handmade depictions could be shown vastly enlarged, were hung at the Tate Gallery showing of the Los Angeles retrospective in October 1988; in addition, two single-page copies of portraits he had made in 1988 of his mother and of Ian Falconer were *188* included as loose sheets in the catalogue published for his exhibition 'Recent Paintings' at the Galerie Neuendorf in Frankfurt in May 1989, where they were paired with conventional colour reproductions of the paintings so that one could see the difference for oneself.

It was in October 1988 also that Hockney began to create drawings that could be sent to friends and acquaintances on his recently acquired fax *191* machine. Although limited to black and white, through a process of trial and error and by adapting procedures he had used in his home-made prints, he succeeded quickly in turning a utilitarian machine into yet another medium for making art. In particular, he discovered ways of enriching the tonal range and texture of the pictures by mixing different greys and by collaging together shapes from a variety of printed sources. Since his hearing was continuing to deteriorate, he was immediately attracted to the discovery of what he termed 'a telephone for the deaf', particularly as it allowed him to communicate his perceptions of the world around him not just through words but in images. Most of these early faxes were sent from the Malibu beachside house that he had acquired earlier that year, so the subject matter naturally reflected his new preoccupations with still lifes and especially with views of the sea outside his window. Hockney was thrilled to have found such a direct way of communicating with his friends through his art, and of democratizing further the dissemination of his work through channels that were by definition uncommercial, since the image received at the other end had no financial value and could be preserved only by being photocopied.

189 Image printed from hand-drawn,
four-colour separations, 1988

(Plain-paper fax machines, rather than those using thermal paper prone to fading, were introduced only towards the end of the six-month period in which Hockney was most assiduously involved with the process.) There was a subversive appeal in the production of images that could not be turned into commodities for the art market. Sharing his art in this form was an act of pure love and aesthetic appreciation, returning him to the innocent pleasure of picture-making for its own sake, which he had stubbornly and consistently maintained as his first priority.

As he succumbed to the obsession with sending faxes of increasing complexity to all corners of the globe, Hockney's telephone bills mounted astronomically, demonstrating conclusively the extent to which he was prepared to fund this activity from his own pocket. The most extreme applications of the technology included several public events: the faxing of a composite image consisting of 144 sheets, *Tennis*, to the 1853 Gallery at Saltaire, near Bradford, as a live event witnessed by spectators on 10 November 1989; his participation in the São Paulo Bienal from October to December 1989 exclusively in the form of faxes, and a large solo exhibition from October 1990 through to January 1991 at the Centro Cultural Arte Contemporáneo, Mexico City, which was again sent entirely

190

190 *Even Another* (fax drawing), 1989

by fax. While the fax drawings could not, in the end, be an adequate substitute for paintings, Hockney had succeeded in making some shrewd and provocative points about the nature of making and exhibiting art. To send an exhibition of paintings or framed drawings from one country to another involves huge expenditure on transport and insurance. Why not, therefore, send an entire show down the phone lines, making the art accessible, at much more modest cost, to even the most remote parts of the world? At an even deeper level, the fax drawings posed difficult questions about the value we ascribe to the 'unique', 'original' work of art. The fax drawings are the end product, not the reproduction of existing drawings with an independent existence, since the sheets to be faxed have been constructed from various combinations of materials with the express intention of being transmitted in that way. There is consequently no single 'original': not only can the same picture be faxed to different numbers, it can also only be physically preserved by being photocopied on receipt on to more stable paper.

Similar questions are posed by the 'computer drawings' and still video images that Hockney began to produce in his studio in 1990, with the images generated either on a still video camera or on a Macintosh computer using *195, 201* Oasis software and then printed out on a Canon Color Laser copy machine. He had briefly experimented with such technology in 1987, when he and other artists, including Richard Hamilton and Howard Hodgkin, were invited to create images using the Quantel Paintbox for a series of television programmes, 'Painting with Light', made by Michael Deakin of Griffin Productions and screened on BBC2. It was only in summer 1990, however, when he and his assistant Richard Schmidt attended a three-day conference about computers and printing, that he became sufficiently convinced that there were possibilities here for him to acquire the necessary hardware and software. As when investigating the possibilities of any new medium, including even watercolour or a new type of acrylic paint, Hockney began not with the intention of producing finished pictures but simply by trying to discover what could be done with that medium; in this case, the kinds of marks and textures that could be created, the qualities of the colours and the crispness of the photographic image. He began in August 1990 by turning the camera on his immediate environment for a series of *40 Snaps of My House*, which he produced for his own enjoyment, rather than for sale, in the spirit of his earlier private snapshots. As decoratively appealing and formally constructed as the best of his earlier single-image photographs made with a 35mm camera, these have a sumptuousness of colour that vividly captured the intense hues of his redecorated Hollywood Hills house and that have in turn influenced his preference in his paintings for saturated colours in delirious proximity.

191 *112 L.A. Visitors* (detail), 1990–91

Soon Hockney began also to make still video portraits of anyone visiting that house, posing each person against one of his large recent landscape paintings and then recording their body in four or five sections so that the laser-printed images could be pieced together again in the manner of a Surrealist 'exquisite corpse'. Both the space and the figure are here treated in a more conventional way than in the composite photographs of the early to mid 1980s, with the component parts allowing more detail rather than a variety of points of view or repeated glimpses of a particular part of the

191 figure. The resulting series of *112 L.A. Visitors*, 1990–1, published on seven sheets in an edition of twenty, demonstrates that even with a mechanical tool and the simplest compositional strategy, the artist's subjectivity and responses to his subject remain the overriding shaping forces. Taken together, these portraits of a wide cross-section of society – including assistants, artists, gallery owners, writers, curators, collectors, delivery men, friends and the cleaning lady – provide ample evidence, too, of the frantic comings and goings with which Hockney appears to be constantly surrounded, despite his protestations about the quiet life that he leads.

While the still video photographs could be described as something of a diversion, there were more lasting lessons to be learned from the computer drawings to which Hockney devoted himself with particular energy in 1991. As with the fax drawings, they were primarily for the artist's own amusement and for the entertainment of his friends, since he tended to give them away: he could see no reason to sell them, since an infinite number of identical images could be printed, without any loss of quality, from the same computer file. Only by erasing the file and any copies of it could one justifiably propose to produce a limited edition from it that would have any credibility in the marketplace. He had no hesitation in taking advantage of the freedom given to him by these essentially private circumstances and by the knowledge that any mark he made on screen could easily be obliterated or replaced. As a painter he had once envied the much greater risks that he felt able to take when making drawings, finding it much less inhibiting to work on paper than on canvas. Now he was in a position of being able to try out anything, secure in the understanding that no mark was irreversible and that he could continue reworking a picture, without any loss of the freshness of mark or vividness of colour, until he was satisfied.

Some of the first fruits of his labours with the computer, such as *Untitled*, 1991, bear comparison with earlier paintings that he had made in a similar

171 frame of mind, notably *Canyon Painting*, 1978. Once again landscape serves as the armature for an investigation into the essentially abstract properties of a repertoire of brightly coloured marks. There are intimations of sea, cliffside, winding roads and vegetation under intense sunlight, not openly described in

an illustrative manner but suggested through colour and form alone in such a way that they act as mnemonic devices, triggers to memories and associations. Such images were very much rooted in his experience of the Pacific coastline as viewed from his house at Malibu, and of the nearby Santa Monica Mountains where he had begun to take friends and acquaintances on hair-raising drives orchestrated to the music of Wagner. Such references had appeared on his canvases as early as *Big Landscape (Medium Size)*, 1988, and in a more naturalistic fashion in a group of small, Fauve-coloured landscapes such as *Thrusting Rocks*, 1990. It is telling, however, that this most extreme move towards abstraction, paralleled but not quite equalled in paintings such as *What About the Caves?*, 1991, seems to have occurred first in the computer drawings. It may well be that the physical distance between the motif and the Hollywood Hills studio that housed his computer, and also the fact that he worked there in an enclosed, essentially windowless, room, contributed to the more synthetic treatment of landscape and spatial sensations that he was able to devise using this process. Only in 1992, in his series of *Very New Paintings*, did this new approach take hold fully in his painted work.

192

194

193

The stylistic freedom that Hockney had long claimed for himself is much in evidence in his work since the late 1980s, which ranges backwards and forwards from the robust and brightly hued naturalism of portraits, still lifes, landscapes and interiors to pictorial conceptions that on first glance would tend to be labelled 'abstract'. Yet as the artist explained in his book *That's the Way I See It*, edited by Nikos Stangos from five years of conversations and published in 1993 as a companion volume to *David Hockney by David Hockney*, the distinction between abstraction and representation no longer seemed to him a valid one. 'I think, in fact, the more you go on the more you realize there's actually only abstraction.' Returning several times to this issue as one central to his thinking since at least as far back as the early 1980s, Hockney cites the example of oriental art in support of his argument: 'Looking at Chinese scrolls, at ancient Chinese paintings, had made me realize that if you were to ask the painters who made them, Are there two different kinds of painting, is there representation and abstraction?, the old Chinese sage painter would have said, No, it's all one; it's either all an abstraction or all representation. And I'm coming to believe that quite strongly . . .'

To ask whether a work of art is abstract – that is to say, self-sufficient and separate from the world that can be perceived through our eyes – or whether its function is representational is thus, in a sense, to pose the wrong question, since most if not all cases will involve an element of both. Taking Hockney's own recent paintings as the evidence, even the most closely observed depictions of his surroundings, such as the most elaborate of the computer

192 *Big Landscape (Medium Size)*, 1988
193 *What About the Caves?*, 1991

194 *Thrusting Rocks*, 1990

195 *Untitled*, 1991

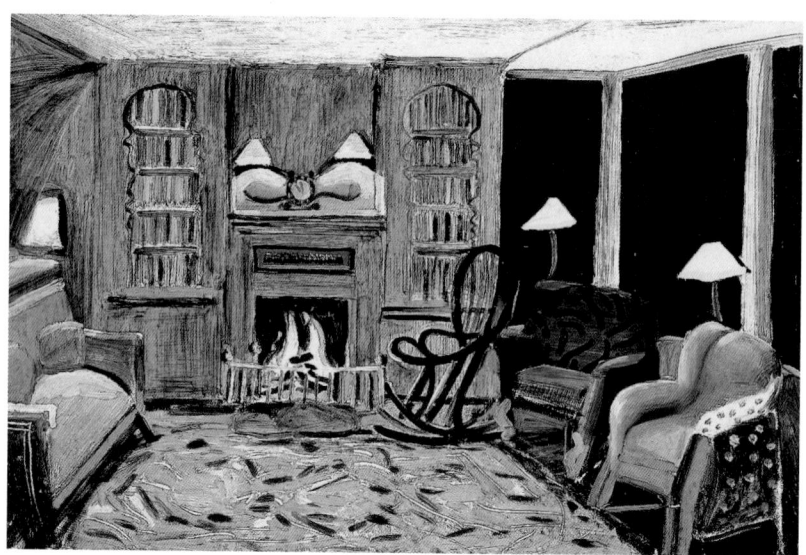

196 *Beach House by Night*, 1990

201, 196
200
drawings, *Beach House Inside*, 1991, or related paintings such as *Beach House by Night*, 1990, or *Livingroom at Malibu with View*, 1988, work as much on an emotional or physical level as they do on an intellectual one. They transmit not only information, in an illustrational sense, but also sensations through the relationships of painted forms. Conversely, any conjunction of forms, however rigorously it may appear to exclude outside references, is inevitably conditioned by the experience of the person who made it. Hockney ascribes his own growing concern with the representation of spatial sensations, for example, as a compensation for his increasing deafness, another way of situating oneself in the world.

In any case every convention that has been devised to represent the world, including photography, can only work as a substitute for the real thing insofar as a pact has implicitly been made between the artist and the viewer. Without such an agreement, it would simply not be possible to read the 197 image. With a teasing humour, Hockney reminds us in *Still Life with Book on Table*, 1988, of the extent to which we have trained ourselves to accept, as real, pictorial illusions that are self-evidently artificial. By choosing to depict a round table onto a round canvas in such a way that their upper edges coincide, and by conveying its material substance through a painted imitation of wood grain, Hockney provides us with highly physical and tactile sensations that heighten our experience of the subject as tangibly present. At the same moment, however, we remain conscious of these and other means that have been used to draw us in through our imagination.

As with Hockney's playful games with artistic devices in his pictures of the mid 1960s, not even the most gullible of viewers could believe, after a moment's reflection, that these disconnected flat strokes of colour actually constitute an arrangement of flowers and leaves in a vase. Yet even when we recognize that we are being duped, all the more cheekily given the artist's patent disregard for a highly wrought illusionism, the forms continue to work their magic as a plausible equivalent for something seen. The affectionate references to earlier art – to Renaissance tondos in the format chosen, to the 'tilting forward of the picture plane' achieved in the still lifes painted by Cézanne and, under his influence, by the Cubists, and to the *trompe-l'oeil* wood-grain also featured in Cubist paintings – contribute further to our willing collusion.

In the latter part of 1988, after the opening of his Los Angeles touring retrospective, Hockney spent much of his time at his new beach house in Malibu, where he embarked on an intense period of painting. Among the works made at this time were three paintings of chairs inspired by Van Gogh and a series of dazzling interior views of the living room of his Hollywood Hills house. *Van Gogh Chair*, 1988, was one of a number of works *198* commissioned from leading contemporary artists by the Van Gogh Foundation in Arles to mark the centenary of the artist's arrival in that town. Hockney was so pleased with his reinterpretation of Van Gogh's *The Chair* *123* *and the Pipe*, 1888–9 – the Arles-period canvas called to mind by a painting he had made more than fifteen years earlier, *Chair and Shirt*, 1972 – that he *112* decided immediately to paint another one for himself, as well as a version of a companion painting, *Gauguin's Chair*. In all of these he sought to emulate the immediacy of the Dutch artist's depictions of chairs as substitutes for human presence by exaggerating the very qualities that helped attract him to these pictures in the first place: their high-keyed primary and secondary colours and chromatic contrasts, the tangible forms created by the use of strong outlines, a highly tactile presentation of the paint surface and the adoption of a point of view that appears to catapult us towards the object represented. Rather than recreating Van Gogh's language, however, Hockney has rephrased these elements in his own voice, particularly through the use of the reverse perspectives that he had employed earlier in the decade for paintings such as *A Visit with Christopher and Don, Santa Monica Canyon*, 1984. *184*

Complex spatial games are employed to particular effect in the various interiors painted by Hockney during this period, such as *Small Interior, Los* *199* *Angeles, July 1988*, 1988. He had been making pictures of this room since 1980, when he painted *Hollywood Hills House*, and the assurance born of his familiarity with the subject is much in evidence. Space is treated now in a far more fluid way, taking a cue from the 'moving focus' prints of the mid 1980s

197 *Still Life with Book on Table,* 1988

198 *Van Gogh Chair,* 1988

199 *Small Interior, Los Angeles, July 1988,* 1988

200 *Livingroom at Malibu with View*, 1988

201 *Beach House Inside*, 1991

but now leading the eye on a delirious dance up, down and around the nooks and crannies of his daringly remodelled living room. In spirit and in the principles by which they are put together, these paintings have much in common with works by Hockney dating from as far back as 1962, governed as they are by notions about the selectivity of vision, by the coexistence of different modes of representation in demonstrations of astonishing versatility, in their plays on illusion and in their unabashased theatricality. But these new pictures could certainly not have been painted by him a quarter of a century earlier. Their stage-like appearance, for example, has been immeasurably enriched by the in-depth experience he had had by this time in designing for opera, most recently for a new production of Wagner's *Tristan und Isolde* for the Los Angeles Music Center Opera in 1987. Illusions take many sophisticated forms, through style, texture and not least by the use of multiple perspectives that draw us fully into the space. The selectivity of vision, generally treated in the pictures of the 1960s through the careful placement of a small number of motifs against a bare canvas ground, is now conveyed in a much more confident manner that allows the viewer far greater control, thanks to the large number and diversity of the resting points for the eye. The abundance of styles through which appearances are remade contribute to the boisterous atmosphere, proclaiming the freedom of being able to picture the world in such a variety of ways, but rather than jarring with each other they are pieced together with such deftness as to coexist happily as elements of a coherent and persuasive conception.

Hockney's intense involvement with opera design over an almost
202 continuous period of five years from 1987, with the staging of *Tristan und*
203 *Isolde*, through the preparation of a new production of Puccini's *Turandot*, which had its première at the Lyric Opera of Chicago in January 1992, to the
204 opening night of Strauss's *Die Frau ohne Schatten* at the Royal Opera House, Covent Garden, on 16 November 1992, had radical and far-reaching effects on his art in general. What these three productions of grand opera most obviously had in common was their astonishing use of space and colour to draw the audience mentally and emotionally into the action taking place on the stage. Sweeping vistas and plunging perspectives characterize, for example, the shipboard scene designed for Act I of *Tristan* and the dramatic cliffside created for Act III of the same opera; the fractured Chinese architecture, envisaged by Hockney in terms of 'harsh edges' and 'strong diagonals', against which the action of *Turandot* takes place; and *Die Frau's* distant landscape, stretching out towards the horizon and animated by the sparkling play of light on spheres suggestive of shrubbery, a view that recalls, perhaps unconsciously, the breathtaking sweep of the San Fernando Valley
170 as presented in the upper register of his painting, *Mulholland Drive*, 1980.

Although the three operas were commissioned by different companies, Hockney worked with two of the same close associates on all of them, ensuring a continuity and consistency of purpose: Ian Falconer designed the numerous costumes, taking the burden of this detailed work off Hockney while remaining mindful of the overall conception, and Richard Schmidt served as technical advisor, proving particularly useful in the preparation of the complex lighting changes that so startlingly alter the hues and the moods of each set. For the third opera, Gregory Evans also assisted him on the set designs, as he had first done for the French triple-bill in 1980. Even by the scrupulous standards that Hockney had set himself since designing *The Rake's Progress* in the mid 1970s, the degree of detailed planning involved in these three stage productions was overwhelming. Hockney was no longer content to make accurately scaled but small cardboard models; now he had a massive model of the stage erected in the studio, so that there was barely any room, let alone time, in which to paint, and he rigged up a miniaturized lighting system so that he could study precisely the effects wrought on the painted drops by the superimposition of shafts of light through coloured filters. He went so far as to make home video recordings of these changes to his models, accompanied by the full score, so as to prepare himself as extensively as possible in advance of the rehearsals in the theatres themselves. A perfectionist in such details, he knew from previous experience that the rehearsal period would never be long enough if these increasingly elaborate stage directions were left to the last minute.

Somehow, in the brief gaps in all this frantic activity, Hockney continued to find time to paint, and on these occasions to direct all his energies and new ideas into the studio with a passion and enthusiasm that were surprising even by his own sometimes manic standards. The designing of *Turandot* occupied him from September 1990 to March 1991, with a visit to Chicago to work out the lighting in July 1991. Leading up to this he produced an extended series of small canvases, exhibited as 'Things Recent' at the André Emmerich Gallery in December 1990, in which he expressed his delight in the environment in and around his Malibu beach house; and the extension of his landscapes into more experimental territory in a group of more abstract paintings such as *What About the Caves?*, 1991, which were shown together at the Richard Gray Gallery in Chicago in January 1992 to coincide with the opera's première. *193*

While the labour-intensive work on the operas may have taken him away from his paintings for prolonged periods, the discoveries that he made while working for the stage clearly once again fed back into his work on canvas. The dialogue between the studio and the theatre, which culminated in the investigations into space and colour of the *Very New Paintings*, can be traced

202 Model for *Tristan und Isolde* (Act I), 1987

203 Model for *Turandot* (Act I), 1990

204 Model for *Die Frau ohne Schatten* (Act III), 1992

at least as far back as *Big Landscape (Medium Size)*, 1988, an experimental *192*
work that he had put aside to study at his leisure but later agreed to donate to
an AIDS auction. Here, and more obviously in later works such as *Under and* *205*
Out of the Arch, 1989, and *What About the Caves?*, 1991, Hockney investigated *193*
ways in which he could convey the vertiginous sensations of the mountains
and sea in a pictorial language that is notionally more abstract and ambiguous
but still filled with numerous specific clues. There are frequent glimpses in
these works of the foamy sea, whipped by the wind; of caves and cliffs and
steep inclines; of an exuberance of plant life, with decorative patterns created
by the deep shadows cast by objects in intense sunlight. Shapes derived from
ordinary elements observed in the landscape, such as the railing featured in
Under and Out of the Arch and other works, have both a descriptive function
and a more purely formal one in leading us on a zig-zagging pictorial journey
through the space of the picture.

The *Very New Paintings*, or the *V.N. Paintings* as he decided to title them, come even closer to the opera designs in their stylized, enveloping spaces, in the exaggerated intensity of their colours and in the complexity of their combinations within a single scene, recalling the precision of his stage lighting. The spherical forms that contribute so much to the representation of space in the landscape used as a backdrop for *Die Frau*, conversely, can be understood in relation to the similar shadow-casting shapes featured on such

206 canvases as *The Fourteenth V.N. Painting*, one of three canvases in the series produced in June 1992 during a stay with his mother and sister in their new house in Bridlington, on the Yorkshire coast. There is little in these paintings to indicate whether they were painted near the motif from which they were inspired, or at some distance from it. They are, after all, synthetic images, distilled from memories as much as from direct observation.

While the *V.N Paintings* might at first appear to form an unexpected, even bizarre, departure from the styles that we have come to associate with Hockney, they are in fact very much the culmination of his recent investigations into landscape as the product both of optical perception and visceral experience. Yet his experiments with the latest technology, too, paradoxically infiltrate these paintings in which he has most startlingly reshaped his response to the natural world. The variety of texture within them, while suggesting a contrast of different substances – air, water, rock, foliage, dirt, scrubland – owes a strong debt to the solutions that he had devised in his fax drawings for representing colour and form through tone and pattern. The colours, while credible as observations of the southern Californian scenery at sunset, have at least as much in common with the artificial and exaggerated hues of the still video camera and laser printers with which he had begun to experiment in 1990. Through these various means, Hockney makes real for us a transcendent experience of beauty and pleasure magnified to the point of satiation.

In April 1995 Hockney presented the largest and most ambitious variants on his *V.N. Paintings*, measuring up to twenty feet in width, as the culmination of this development in a solo exhibition at L.A. Louver with the amusingly cumbersome title of 'Some Very Large New Paintings with twenty-five dogs upstairs and some drawings of friends'. The return here to a

184 panoramic format used previously for such paintings as *A Visit with Christopher and Don, Santa Monica Canyon*, 1984, provides a first taste for a project yet to be realized of paintings that come off the canvas and on to the walls and floors of the galleries in which they are shown. As early as 1983,

183 when he painted a series of walk-in environments as recreations of his set designs for the exhibition 'Hockney Paints the Stage', he had been curious about the possibility of extending his paintings into three dimensions, but

only a decade later did he return to this investigation with the thought of making works that would exist in their own right, if only temporarily, rather than as elaborate props for an exhibition. The first products of this more deliberate experiment with painted installations were *Painted Environment* 207
1–3, 1993, a set of multi-partite limited-edition colour laser prints from still video photographs documenting the earliest of these experiments in his Hollywood Hills studio. In each case, a recent painting is hung in the corner of the studio against walls and floor coated in a colourful pattern that seems to have emanated from the canvas at the centre. The sense of a transcendent force or source of energy billowing outwards into our space, when translated back into two dimensions, can only be hinted at. But the prospect of an exhibition in which visitors would walk through such a brightly painted space, surrounding themselves with coloured forms on all sides, promises to provide an experience of pure sensation that could in theory combine the dreamlike vision of Judy Garland's *Wizard of Oz* movie with the blissful trancelike state normally induced only by drugs. At the time of writing, such an experiment is under discussion. Only when realized will it be possible to say whether or not the theory, as attractive as it sounds, can work in practice.

Neither Hockney's versatility, nor his hunger to keep extending his repertoire, show any sign of waning. After devoting himself from 1993 to 1994 to yet another intense period of life drawing, both as a change of pace from the more abstract paintings and in anticipation of the retrospective of his drawings due to open at the Hamburger Kunsthalle in August 1995, he produced a series of forty-five marvellously fresh little paintings from life of his two faithful companions, his dachshunds Stanley and Booge. These 208
pictures, quickly painted by necessity because of the refusal of their subjects to sit still unless asleep, stylistically take as their point of departure the loosely naturalistic portraits that Hockney had been painting since 1988. Their tenderness, intimacy and good humour, however, exceed those qualities as conveyed in all but a few of those portrayals of his human friends. When they were exhibited together at the 1853 Gallery in Saltaire over the summer of 1995, after their first partial showing at the L.A. Louver Gallery, Hockney remarked that dogs took no notice of art but had only two overriding interests: 'Food and love, in that order.' What else is there? After all the theorizing, and notwithstanding his genuine excitement about new ideas and new ways of making pictures, Hockney retains a sense of proportion about what really matters and about the purpose of his art, however dangerously mawkish it may sound: to communicate the pleasure of being alive.

205 *Under and Out of the Arch*, 1989

206 *The Fourteenth V.N. Painting*, 1992

207 *Painted Environment I*, 1993

208 *Dog Painting 19*, 1995

Bibliography

Autobiographical Texts

Two texts by Hockney himself, *David Hockney by David Hockney* (London, 1976) and *That's the Way I See It* (London, 1993) remain the basic sources for any studies on him, to the extent that even those recent writers who claim to reject the artist's words as an essential tool for interpretation have quoted heavily from them. The lengthy text in the first of these books, edited by Nikos Stangos from twenty-five hours of taped conversations, is factually informative, entertaining and revealing of the processes by which his work is made. The 434 illustrations provide the most complete survey of Hockney's art between 1954 and 1975 available in a single volume. A selection of statements from this book accompanies 144 illustrations, some previously unpublished and covering work up to 1979, in *Pictures by David Hockney* (London, 1979), edited by Nikos Stangos and published in paperback only. *That's the Way I See It*, once again deftly knitted together by Stangos from many hours of conversation over a period of about five years, effectively takes up the story where the first volume left off. The emphasis this time, however, is less on autobiographical anecdote and more on the theoretical explorations that have increasingly underpinned Hockney's art. The result is a more professorial and speculative, at times rambling, account of the ideas that have shaped his varied production over a period of two decades; while lacking the immediate charm and intimacy of the first volume, only touching gently on the growing deafness and loss of friends to AIDS that have led to his increasing isolation and absorption in internalized dialogues, it demonstrates persuasively the depth and originality of thought of an artist who can no longer be dismissed by his detractors as lightweight.

Thames and Hudson Publications

Thames and Hudson, who initiated all these books, has effectively become the artist's British publisher, originating and collaborating with American publishers on a number of other volumes. *Paper Pools*, devoted to the single series of pictures executed in the summer of 1978, was the first of these in 1980. It was followed by *Hockney Paints the Stage* (in association with Abbeville Press, 1983), an impressively thorough account of the artist's work inspired by or made for the theatre. Conceived to accompany the major touring exhibition devised by the Walker Art Center, Minneapolis, it was supplemented in 1985 with a booklet documenting the three-dimensional reconstructions of the sets produced for the show. The texts by the artists, the directors John Cox and John Dexter, and the exhibition's organizer, Martin Friedman, tend towards anecdote but are rich in background detail. The artist's photographic experiments beginning with the Polaroids of 1982 are the subject of *David Hockney Cameraworks* (in association with Alfred A. Knopf, Inc., 1984), a massive and lavishly illustrated volume with a stimulating and engaging text by Lawrence Weschler.

Thames and Hudson's later publications have tended to concentrate more single-mindedly on specific aspects of Hockney's work. Of the most specialized interest is *China Diary* (1982), an account in drawings and photographs of the artist's three-week visit to China with Gregory Evans and the poet Stephen Spender, who supplied the accompanying text. An immaculately produced facsimile of a sketchbook from the summer of 1982, *Martha's Vineyards and other places*, was published in 1986; a projected second volume in black and white, *From Mustique to Mexico*, never appeared. *David Hockney: Faces* (1987), a collection of full-page details from portrait drawings dating from 1966 to 1984, was designed by the artist and is a virtuoso demonstration of his use of photocopiers as printing machines of great versatility; the text by Marco Livingstone discusses general aspects of the artist's portraiture and his approach to each of the sitters.

Prints

As one of the undisputed masters of contemporary printmaking, Hockney has been the subject of particular attention. Three of his series of etchings have been published in reduced form as books: *A Rake's Progress* (Lion & Unicorn Press, London, 1967); *Six Fairy Tales from the Brothers Grimm* (Petersburg Press in association with the Kasmin Gallery, London, 1970); and *The Blue Guitar* (Petersburg Press, London, 1977). A small but illuminating pamphlet was produced by the Victoria and Albert Museum, London, for the exhibition of the *Grimms' Fairy Tales* that they began touring in the early 1970s; this includes an informative and thought-provoking interview, 'David Hockney on Print Making'. *18 Portraits*, a small book with details of the large 1976 lithographs, was produced by Gemini G.E.L. to accompany the publication of the prints. Hockney's graphic work of the late 1970s is the subject of a small

but extremely well-illustrated book, *David Hockney: 23 Lithographs 1978–1980* (Tyler Graphics Ltd, New York, 1980), while the *Home Made Prints* executed on office photocopiers are featured in a catalogue co-published by the L.A. Louver Gallery, Los Angeles, and the Knoedler Gallery, London. A very substantial selection of Hockney's fax drawings was gathered together in a spiral-bound catalogue, *David Hockney Fax Dibujos*, published in 1990 by the Centro Cultural Arte Contemporáneo, A.C., Mexico City, with a brief introductory essay by the artist printed in Spanish.

Among the more general studies in which Hockney's work as a printmaker is discussed, the following are deserving of particular mention: Ruth E. Fine's exhibition catalogue, *Gemini G.E.L.: Art and collaboration* (National Gallery of Art, Washington D.C., in association with Abbeville Press, New York, 1984); Pat Gilmour's *Ken Tyler – Master Printer and the American Print Renaissance* (Australian National Gallery, Canberra, 1986); and Riva Castleman's *Seven Master Printmakers: Innovations in the Eighties* (Museum of Modern Art, New York, 1991).

The first catalogue of Hockney's graphic work was published in 1968 by the Galerie Mikro, Berlin, in conjunction with the Petersburg Press: *David Hockney: Oeuvrekatalog – Graphik*. It contains an essay by Wibke von Bonin, 'Two-dimensionality and Space in Hockney's Etchings'. This was superseded by the still indispensable and long out-of-print catalogue raisonné of Hockney's editioned prints, *David Hockney prints 1954–77*, published in 1979 by the Midland Group, Nottingham, in association with the Scottish Arts Council and the Petersburg Press, which illustrates full-page the 218 prints published by Hockney up to the beginning of 1977. The introduction by Andrew Brighton remains, as I wrote in 1981, one of the few essays on the artist which can be recommended without reservation as essential reading.

A full, updated catalogue raisonné of the prints, one that would include the rare uneditioned prints and also bring the documentation up to date, is badly needed. A catalogue raisonné of Hockney's prints is in fact being prepared by Jane Kinsman and will be published by Thames and Hudson in association with the National Gallery of Australia. In the meantime, only partial surveys of Hockney's graphic work are available: *David Hockney: Etchings and Lithographs 1961–1986* (co-published by Thames and Hudson with Waddington Graphics, London, 1988), with a good selection of plates and an introductory text by Marco Livingstone; *David Hockney: 25 Years of Printmaking* (CCA Galleries and Berkeley Square Gallery, London, undated [1988]), with an introduction by Craig Hartley edited down from articles published by him

in *Print Quarterly* (vol. V, numbers 3 and 4, 1988); and *David Hockney Grafiek/Prints* (Museum Boymans-van Beuningen, Rotterdam, 1992), an interesting selection (including some unpublished prints) enriched by Manfred Sellink's thoughtful commentaries.

Drawings

Hockney's drawings have been much less thoroughly explored. Long out of print but still worth seeking is *72 Drawings by David Hockney* (Jonathan Cape, London, 1971), which reproduces ink and crayon drawings dating from 1963 to 1971. A small but beautifully produced book, *David Hockney: dessins et gravures*, was published by the Galerie Claude Bernard, Paris, in 1975, with a text by Marc Fumaroli, 'Le portrait de l'artiste en jeune homme'. An unusually substantial catalogue, *Travels with Pen Pencil and Ink*, was produced by Petersburg Press in 1978 to accompany an American touring exhibition, 'Hockney's prints and drawings', which opened in Washington, D.C. and which had its final showing in 1980 at the Tate Gallery; it contains an introduction by Edmund Pillsbury. The Albertina, Vienna, in the same year published *David Hockney: Zeichnungen und Druckgraphik*, which is slightly less extravagant but equally useful in illustrating a number of heretofore unpublished drawings; the chronology and bibliography are both more comprehensive than usual, and there is a short, if confusing, preface by Peter Weiermair. At the time of writing, a catalogue by Ulrich Luckhardt and Paul Melia is in preparation for *David Hockney: A Drawing Retrospective*, opening in August 1995 at the Hamburger Kunsthalle and then touring to the Royal Academy in London and the Los Angeles County Museum of Art; a trade edition will be published by Thames and Hudson. The prospect of a catalogue raisonné of Hockney's prolific production of drawings seems remote and perhaps unrealizable, taking into account the number of drawings that have been sold or given away without first being photographed.

Photography

The first publication devoted to the artist's work with the camera was the 1982 catalogue of the exhibition at the Centre Pompidou, Paris, *David Hockney photographe*, with an introductory text by the artist; an English-language edition was brought out by Petersburg Press. *Photographs by David Hockney* (International Exhibitions Foundation, Washington, D.C., 1986) usefully brings together an essay by Mark Haworth-Booth originally printed in *Hockney's Photographs* (Arts Council of Great Britain, 1983) and the text of the artist's November 1983 lecture, 'On

Photography', first published by the André Emmerich Gallery Inc. A variant on the exhibition, *Hockney fotógrafo* (Caja de Pensiones, Madrid, 1985), contains an essay by Luis Revenga. Of special note is the December 1985 issue of *Paris Vogue*, which contains a 41-page full-colour section of the artist's photographs produced for the magazine. *Hockney on Photography: Conversations with Paul Joyce* (Harmony Books, New York, and Jonathan Cape, London, 1988), while not as thorough in its coverage as the previously mentioned *Cameraworks*, is well produced and benefits from the artist's quoted remarks.

Solo Exhibition Catalogues

Hockney has been the subject of numerous one-man shows, some of these accompanied by substantial catalogues, generally well illustrated and sometimes incorporating texts which until the 1990s were among the few pieces of critical writing available on the artist. The most important of these, *David Hockney: A Retrospective*, was published by Thames and Hudson in 1988 in association with the Los Angeles County Museum of Art for the exhibition that toured to the Metropolitan Museum of Art, New York, and the Tate Gallery in London. It contains essays by Henry Geldzahler, Christopher Knight, Gert Schiff, Anne Hoyt, Kenneth E. Silver and Lawrence Weschler, a brief chronology and the most comprehensive bibliography yet to be published.

Of the earlier catalogues, the most thorough in its coverage is *David Hockney: Paintings, prints and drawings 1960–70*, published for the large retrospective held at the Whitechapel Gallery, London, in 1970. There is a foreword and an interview with the artist by Mark Glazebrook, as well as an attempt at a complete catalogue of known works since 1960. A corrected hard-cover edition of this catalogue was published in 1970 by Lund Humphries, and a variation of it with additional essays was produced in the same year by the Kestner-Gesellschaft Hannover. In 1969 the Whitworth Art Gallery, Manchester, had produced a small catalogue with an introduction by Mario Amaya to accompany their more modest retrospective, *Paintings and Prints by David Hockney*. The Kunsthalle Bielefeld's slender catalogue, *David Hockney: Zeichnungen, Grafik, Gemälde*, 1971, includes a short introduction by Günter Gercken and a separate section on Peter Schlesinger. A more substantial publication is *David Hockney: Tableaux et Dessins*, for the retrospective at the Musée des Arts Décoratifs, Paris, in 1974. This includes an introduction by Stephen Spender, an interview with Pierre Restany, a chronology and a complete list of exhibitions; the selected bibliography updates that provided in the Whitechapel catalogue.

Among the more recent catalogues for solo exhibitions are those produced for two retrospectives, containing 90 and 76 works respectively, entitled simply *David Hockney*, the first organized by Marco Livingstone for Art Life, Tokyo, in 1989, which toured the Odakyu Grand Gallery, Tokyo, and three other venues in Japan; the second organized in 1992 by the Fundación Juan March, Madrid, and shown first at the Palais des Beaux-Arts, Brussels, with an introductory text by Marco Livingtstone printed only in Spanish and in French and Flemish respectively. Under the auspices of Art Life, Marco Livingstone also organized and wrote the catalogue for the more extensive *Hockney in California*, shown in 1994 at the Takashimaya Art Gallery, Tokyo, and three other venues in Japan; this was the first comprehensive examination of the subject through which the artist's many shifts of style and approach can most vividly be charted. Another Japanese catalogue, *Hockney's Opera*, was published in 1992 by the Mainichi Newspapers for a touring exhibition that opened at Bunkamura Museum of Art in Tokyo; it reproduces images not included in *Hockney Paints the Stage* and contains several essays including 'Text to Image' by Stephen Spender.

Other, smaller catalogues include *David Hockney: Paintings and Prints from 1960* (Tate Gallery Liverpool, 1993), with a text by Penelope Curtis, and publications focusing on specific paintings: *Doll Boy* (Hamburger Kunsthalle, 1991), with an introduction by Ulrich Luckhardt printed in Germany only, and *Mr and Mrs Clark and Percy* (Tate Gallery, London, 1995), with an essay by Catherine Kinley. Hockney's work of the late 1980s and 1990s has been well documented in the catalogues of shows held by the André Emmerich Gallery in New York (*Things Recent*, 1990, and *Some Very New Paintings*, 1993), the L.A. Louver Gallery in Venice, California (*Some New Pictures*, 1990, and *Some Very Large New Paintings, with twenty-five dogs upstairs and some drawings of friends*, 1995), the Richard Gray Gallery in Chicago (*Recent Pictures*, 1992), the Galerie Neuendorf in Frankfurt am Main (*Recent Paintings*, 1989), the William Hardie Gallery, Glasgow (*Some Very New Paintings*, 1993), the Nishimura Gallery in Tokyo (*Photographs of China*, 1989, *Paintings: Flower Chair Interior*, 1989, *New Pictures & Still Video Portraits*, 1992, and *New Works*, 1994), and the 1853 Gallery in Saltaire, Yorkshire (*New drawings*, 1994).

Group Exhibition Catalogues

A few catalogues for group exhibitions are worth seeking out, if only in some cases for the occasional statement by the artist. Such is the case with *Image in Progress*, held at the Grabowski Gallery, London, in

1962, and *The New Generation*, held in 1964 at the Whitechapel Gallery, London. Informative texts by Anne Seymour can be found in the catalogues of *Drawing towards Painting 2* (Arts Council of Great Britain, 1967) and *Marks on a Canvas* (Museum am Ostwall, Dortmund, 1969). Hockney's early work is set in context in *Pop Art in England: Beginnings of a New Figuration 1947–63* (Kunstverein Hamburg, 1976), *Pop Art* (Royal Academy of Arts, London, 1991) and in Marco Livingstone's essay 'Prototypes of Pop' in *Exhibition Road: Painters at the Royal College of Art* (Phaidon, Oxford, in association with Christie's and the Royal College of Art, London, 1988). The exhibition sponsored by the British Council at the Palazzo Reale, Milan, in 1976, *Arte inglese oggi 1960–76*, contains a short statement by Hockney and a selected bibliography.

Interviews and Statements

Hockney is one of the most interviewed artists alive today, and he has in addition produced a few written statements about his work – not least his two major books – which are more informative than almost any writing about him. His text for *Looking at Pictures in a Book*, the pocket-sized catalogue for his 'Artist's Eye' exhibition at the National Gallery, London, in 1981, contains intriguing speculations on the functions of photography and reproduction. In Hockney's *Picasso* (Hanuman Books, Madras and New York, 1989), one of a series of books in a tiny format edited by Raymond Foye and Francesco Clemente, various brief essays dating from 1983 to 1989 are usefully brought together. *Cambridge Opinion 37* (undated, January 1964) contains Hockney's statement, 'Paintings with two figures', which was reprinted in the 1970 Whitechapel catalogue. 'Beautiful or interesting', a conversation between Hockney and Larry Rivers, appeared in *Art and Literature 5* (undated, summer 1965) and was republished in edited form in John Russell and Suzi Gablik, *Pop Art Redefined* (Thames and Hudson, London, 1969). The journal of the Royal College of Art, *Ark*, published an article by Hockney, 'The point is in actual fact . . .' in 1967 (issue 41). A statement by Hockney concerning the Cavafy etchings and his proposal to illustrate Grimms' fairy tales was published in the supplement to the December 1968 issue of *Studio International*.

Interviews with Hockney have appeared in *Art and Artists*, April 1970; in *The Guardian*, 16 May 1970; in *Andy Warhol's Interview* issue 23 (July 1972) and 34 (July 1973); in the *London Magazine*, August–September 1973; in *The Listener*, 22 May 1975; in *Street Life* (London), 24 January–6 February 1976; in Peter Webb's *The Erotic Arts* (Secker & Warburg, London,

1975); in *Gay News*, no. 100, August 1976; in the November and December 1977 issues of *Art Monthly*; and in Peter Fuller's *Beyond the Crisis in Art* (Writers and Readers, London, 1980). Of particular interest is 'David Hockney in conversation with R.B. Kitaj', published in the January/February 1977 issue of *The new review*. Further statements by Hockney can be found in the Tate Gallery Report 1963–4; in *Gay News*, no. 101, August/September 1976 (a review of Lorenza Trucchi's book on Francis Bacon); in *The Artist by Himself: Self-Portraits from youth to old age*, edited by Joan Kinnear (Granada Publishing Ltd, St Albans, Herts, 1980), which reprints letters written in 1958 by Hockney to his parents; and as the foreword to Jeffery Camp's *Draw* (André Deutsch, London, 1981).

Articles and Reviews

In the bibliography included in the original edition of this book in 1981, it was claimed that reviews and articles about Hockney were at once too numerous and too slight to mention. While this sweeping statement remains essentially true, the annotated bibliography in the catalogue of the 1988 Los Angeles retrospective will now lead the reader to the most useful items preceding that date. In addition, special reference should still be made to the long and extremely detailed profile on Hockney by Anthony Bailey, published in *The New Yorker*, 30 July 1979.

Other Monographs on Hockney

Since the publication of this book in 1981, and more specifically of the revised edition in 1987, there have been a number of other overviews of Hockney and his work. The first of these, and the only biography published to date, is Peter Webb's *Portrait of David Hockney* (Chatto and Windus, London, 1988). More recently there have been several picture books with good general introductory texts, including *David Hockney* by Paul Melia and Ulrich Luckhardt (Prestel, Munich and New York, 1994), Kenneth E. Silver's *David Hockney* (Rizzoli, New York, 1994) and Peter Clothier's *David Hockney* (Abbeville Press, New York, 1995). Melia, shortly after writing his B.A. and M.Phil. dissertations on Hockney at the University of Manchester from the late 1980s through to 1991, also went on to edit *David Hockney* (University of Manchester Press, 1995), a collection of essays of variable quality that suffers at times from a surfeit of academic jargon but that includes an interesting analysis by Simon Faulkner of Hockney's image and relationship to the art world and 'swinging' London. While any of these may serve as a useful starting point for a reader unfamiliar with the detail of the artist's development, and though they include fresh insights in the case of an essay as brief as Silver's, disappoint-

ingly they all cover much the same ground. A picture book with a brief text in Japanese only, *David Hockney*, was published in the series Shinchosha's Super Artists (Shinchosha, Tokyo, 1990). Two other picture books, *Hockney Posters* (Pavilion Books, London, 1987) and *Off the Wall: Hockney Posters* (Pavilion Books, London, 1994), document the exploitation of Hockney's imagery in often decoratively pleasing posters. *Hockney's Alphabet: Drawings by David Hockney*, with written contributions edited by Stephen Spender, a charmingly offhand collection of initials drawn by Hockney, was published in 1991 (Faber and Faber, London) to raise funds for the AIDS Crisis Trust. Still badly needed is a more probing, analytical study of particular aspects of Hockney's work or a more in-depth exploration of his development as a whole.

List of Illustrations

10½ × 8½ (26·7 × 21·6). Private collection

44 *Square Figure Marching*, 1964. Crayon, 11 × 14 (28 × 35·5). Kasmin Ltd., London

45 *Boy About to Take a Shower*, 1964. Crayon, 13⅝ × 10¼ (33·3 × 25·4). Private collection, United States

46 *Nude Boy, Los Angeles*, 1964. Crayon and pencil, 12 × 10 (31 × 25·5). Douglas S. Cramer, Los Angeles

47 *Two Figures by Bed with Cushions*, 1964. Crayon. Size and location unknown

48 *Picture of a Hollywood Swimming Pool*, 1964. Acrylic on canvas, 36 × 48 (91 × 122). Private collection, Zurich

49 *Sunbather*, 1966. Acrylic on canvas, 72 × 72 (183 × 183). Museum Ludwig, Cologne

50 *Man Taking a Shower in Beverly Hills*, 1964. Acrylic on canvas, 65½ × 65½ (167 × 167). Trustees of the Tate Gallery, London

51 *Building, Pershing Square, Los Angeles*, 1964. Acrylic on canvas, 58 × 58 (147 × 147). Private collection

52 *The Room, Tarzana*, 1967. Acrylic on canvas, 96 × 96 (244 × 244). Private collection

53 *Wilshire Boulevard, Los Angeles*, 1964. Acrylic on canvas, 36 × 24 (91 × 61). Private collection, Los Angeles

54 *Different Kinds of Water Pouring into a Swimming Pool, Santa Monica*, 1965. Acrylic on canvas, 72 × 60 (183 × 153). Private collection

55 *Iowa*, 1964. Acrylic on canvas, 60 × 60 (153 × 153). Hirshhorn Museum and Sculpture Garden, Smithsonian Institution, Washington, DC, gift of Joseph H. Hirshhorn, 1966.

56 *Portrait Surrounded by Artistic Devices*, 1965. Acrylic on canvas, 60 × 72 (153 × 183). The Arts Council of England, London

57 *Blue Interior and Two Still Lifes*, 1965. Acrylic on canvas, 59⅞ × 59¾ (152 × 152). Virginia Museum of Fine Arts, Richmond

58 *A Hollywood Collection: Picture of a Pointless Abstraction Framed Under Glass*, 1965. Lithograph in six colours, 30 × 22 (77 × 56). Edition of eighty-five, signed in pencil, published by Editions Alecto and printed by Kenneth Tyler

59 *A Bigger Splash*, 1967. Acrylic on canvas, 96 × 96 (244 × 244). Trustees of the Tate Gallery, London

60 *Bob, 'France'*, 1965. Pencil and crayon, 19 × 22¾ (49 × 58). Private collection, Munich

61 *Michael and Ann (Upton)*, December 1965. Crayon, 10¾ × 13 (27·3 × 33)

62 *Kenneth Hockney*, 1965. Ink, 17 × 14 (43 × 35·5). Private collection

63 *Illustrations for Fourteen Poems from C.P. Cavafy: Portrait of Cavafy II*, 1966. Etching and aquatint, 14 × 9 (36 × 23). Various editions published by Editions Alecto and printed by Maurice Payne and Danyon Black

64 *Boys in Bed, Beirut*, 1966. Ink, 12½ × 10 (31·7 × 25·4)

65 *Illustrations for Fourteen Poems from C.P. Cavafy: In the Dull Village*, 1966. Etching, 14 × 9 (36 × 23). Various editions published by Editions Alecto and printed by Maurice Payne and Danyon Black

66 *Cleanliness is Next to Godliness*, 1964. Silkscreen in five colours, 35½ × 23 (90 ×

58·5). Edition of forty, signed in pencil, published by the Institute of Contemporary Arts and printed by Christopher Prater

67 *Polish Army, Ubu Roi*, 1966. Crayon, 14½ × 19½ (37 × 50). The Museum of Modern Art, New York

68 *The Polish Royal Family, Ubu Roi*, 1966. Crayon, 16 × 19¾ (41 × 50·2)

69 *California Art Collector*, 1964. Acrylic on canvas, 60 × 72 (153 × 183). Private collection, Seattle, Washington

70 *Beverly Hills Housewife*, 1966. Acrylic on canvas (diptych), 72 × 144 (183 × 366). Private collection

71 PIERO DELLA FRANCESCA *The Flagellation of Christ*, 1455. Tempera on Panel, 23⅛ × 32 (59 × 81·5). Galleria Nazionale delle Marche, Urbino

72 Betty Freeman. Beverly Hills, 1966. Black and white photograph. Collection David Hockney

73 *Peter Getting Out of Nick's Pool*, 1966. Acrylic on canvas, 84 × 84 (214 × 214). National Museums and Galleries on Merseyside, Walker Art Gallery, Liverpool

74 Photograph taken for painting *Peter Getting Out of Nick's Pool*, 1966. Colour polaroid photograph. Collection David Hockney

75 *Portrait of Nick Wilder*, 1966. Acrylic on canvas, 72 × 72 (183 × 183). Fukuoka Sogo Bank, Fukuoka, Japan

76 Nick Wilder, 1966. Colour photograph from a 35 mm negative taken by Mark Lancaster. Collection David Hockney

77 *Peter, La Plaza Motel, Santa Cruz*, 1966. Pencil, 14 × 17 (35·5 × 43)

78 *Peter (with head in hands)*, 1967. Ink, 14 × 17 (35·5 × 43). Private collection

79 *Dream Inn, Santa Cruz*, October 1966. Pencil and crayon, 14 × 17 (35·5 × 43). Collection David Hockney

80 *Peter Having a Bath in Chartres*, 1967. Watercolour, 13 × 16½ (33 × 42)

81 FRANÇOIS BOUCHER *Reclining Girl (Mademoiselle O'Murphy)*, 1751. Oil on canvas, 23½ × 28¾ (59 × 73). Walraf-Richartz Museum, Cologne

82 EDWARD HOPPER *Evening Wind*, 1921. Etching, 7 × 8⅜ (17·8 × 21·3)

83 *The Room, Manchester Street*, 1967. Acrylic on canvas, 96 × 96 (244 × 244). Private collection

84 *A Table*, 1967. Acrylic on canvas, 60 × 60 (153 × 153). Private collection, England

85 RENÉ MAGRITTE *Souvenir de Voyage, III*, 1951. Oil on canvas, 33 × 25½ (83·8 × 64·7). Private collection

86 *A Lawn Being Sprinkled*, 1967. Acrylic on canvas, 60 × 60 (153 × 153). Private collection

87 Christopher Isherwood, March 1968. Black and white photographs from 35 mm negatives. Collection David Hockney

88 Santa Monica, 1968. Black and white photograph from a 35 mm negative. Collection David Hockney

89 Henry Geldzahler, 1968. Black and white photograph from a 35 mm negative. Collection David Hockney

90 Christopher Scott, 1968. Black and white photograph from a 35 mm negative. Collec-

tion David Hockney

91 JACQUES-LOUIS DAVID *Madame Récamier*, 1800. Oil on canvas, 68⅜ × 96 (173 × 243). Louvre, Paris

92 Swimming Pool, Le Nid du Duc, October 1968. Colour photograph from a 35 mm negative. Collection David Hockney

93 *L'Arbois, Sante-Maxime*, 1968–69. Acrylic on canvas, 44 × 60 (113 × 153). Carter Burden, New York

94 Hotel l'Arbois, Sainte-Maxime, October 1968. Squared-up colour photograph from a 35 mm negative. Collection David Hockney

95 *Early Morning, Sainte-Maxime*, 1968–69. Acrylic on canvas, 48 × 60 (122 × 153). Private collection, England

96 *Illustrations for Six Fairy Tales from the Brothers Grimm: The Enchantress with the Baby Rapunzel*, 1969. Etching and aquatint, 11¾ × 10½ (30·1 × 27). Various editions published by Petersburg Press and printed by the Print Shop, Amsterdam

97 *Illustrations for Six Fairy Tales from the Brothers Grimm: The Sexton Disguised as a Ghost Stood Still as Stone*, 1969. Etching and aquatint, 17½ × 12⅜ (44·5 × 32·2). Various editions published by Petersburg Press and printed by the Print Shop, Amsterdam

98 Fred and Marcia Weisman, Beverly Hills, 1968. Colour and black and white photographs. Collection David Hockney

99 *American Collectors (Fred and Marcia Weisman)*, 1968. Acrylic on canvas, 84 × 120 (214 × 305). The Art Institute of Chicago, restricted gift of Mrs Frederick Pick

100 *Illustrations for Six Fairy Tales from the Brothers Grimm: The Pot Boiling*, 1969. Etching and aquatint, 7 × 8 (19 × 21). Various editions published by Petersburg Press and printed by the Print Shop, Amsterdam

101 *Armchair*, 1969. Ink, 14 × 17 (35·5 × 43). Baltimore Museum of Art

102 *Christopher Isherwood and Don Bachardy*, 1968. Acrylic on canvas, 83½ × 119½ (212 × 304). Private collection

103 *Peter*, 1969. Etching, 28 × 22 (69 × 54). Edition of seventy-five, signed in pencil, published by Petersburg Press and printed by Maurice Payne

104 *Flowers Made of Paper and Black Ink*, 1971. Lithograph, 39 × 37½ (99 × 92·2). Edition of fifty, published by Petersburg Press and printed by Ernest Donagh

105 *Henry Geldzahler and Christopher Scott*, 1969. Acrylic on canvas, 84 × 120 (214 × 305). Private collection

106 *Le Parc des sources, Vichy*, 1970. Acrylic on canvas, 84 × 120 (214 × 305). Marquis of Hartington, London

107 *Mr. and Mrs. Clark and Percy*, 1970–71. Acrylic on canvas, 84 × 120 (214 × 305). Trustees of the Tate Gallery, London

108 *Still Life with TV*, 1969. Acrylic on canvas, 48 × 60 (122 × 153). Private collection, England

109 *Le Nid du Duc*, April 1972. Colour photographs from 35 mm negatives. Collection David Hockney

110 *Rubber Ring Floating in a Swimming Pool*, 1971. Acrylic on canvas, 35¾ × 48 (91 × 122).

Dr J.H. Beare

111 *Three Chairs with a Section of a Picasso Mural*, 1970. Acrylic on canvas, 48 × 60 (122 × 153). Mr and Mrs Ahmet Ertegun

112 *Chair and Shirt*, 1972. Acrylic on canvas, 72 × 72 (183 × 183). Private collection, United Kingdom

113 *Mt. Fuji and Flowers*, 1972. Acrylic on canvas, 60 × 48 (153 × 122). The Metropolitan Museum of Art, New York, Mrs Arthur Hays Sulzberger Gift Fund

114 Hotel de la Mamounia, Marrakesh, March 1971. Colour photograph from a 35 mm negative. Collection David Hockney

115 *The Weather Series: Sun*, 1973. Lithograph in seven colours, 37 × 31 (94 × 77). Edition of ninety-eight, signed in crayon, published by Gemini G.E.L. and printed by Ron Olds and Donna Hirt

116 *Contre-jour in the French Style – Against the Day dans le style français*, 1974. Oil on canvas, 72 × 72 (183 × 183). Neue Galerie, Sammlung Ludwig, Aachen

117 Peter, Kensington Gardens, April 1972. Composite colour photograph taken from 35 mm negatives. Collection David Hockney

118 *Portrait of an Artist (Pool with Two Figures)*, 1972. Acrylic on canvas, 84 × 120 (214 × 305). Private collection

119 *Pool and Steps, Le Nid du Duc*, 1971. Acrylic on canvas, 72 × 72 (183 × 183). Collection of Halvor N. Astrup, Oslo

120 *Still Life on a Glass Table*, 1971–72. Acrylic on canvas, 72 × 108 (183 × 274·4). Collection of Mr and Mrs Ahmet Ertegun

121 *A Glass Table with Glass Objects*, December 1967. Ink. Size and location unknown

122 Royal Hawaiian Hotel, Honolulu, 11 November 1971. Colour photograph from a 35 mm negative. Collection David Hockney

123 VINCENT VAN GOGH *The Chair and the Pipe*, 1888–89. Oil on canvas, 36¼ × 28¾ (92 × 73). Trustees of the National Gallery, London (Courtauld Fund)

124 *The Island*, 1971. Acrylic on canvas, 48 × 60 (122 × 153). Private collection, New York

125 *Mark, Suginoi Hotel, Beppu*, 1971. Crayon, 17 × 14 (43 × 35·5). Private collection, London

126 *The Weather Series: Rain*, 1973. Lithograph in six colours, 39 × 32 (99 × 81). Edition of ninety-eight, signed in crayon, published by Gemini G.E.L. and printed by Ron Olds and Donna Hirt

127 *Celia*, 1973. Lithograph, 42 × 28 (108 × 71). Edition of fifty-two, signed in crayon, published by Gemini G.E.L. and printed by Serge Lozingot

128 *Celia in a Black Dress with Red Stockings*, 1973. Crayon, 25½ × 19¾ (65 × 50). Collection David Hockney

129 *Window, Grand Hotel, Vittel*, 1970. Crayon, 17 × 14 (43 × 35·5). Private collection

130 *Rue de Seine*, 1971. Etching, 27 × 21 (68 × 54). Edition of one hundred and fifty, signed in pencil, published by Petersburg Press and printed by Shirley Clement

131 *Sketch for Portrait of Nick Wilder and Gregory*, 1974. Crayon, 19¾ × 25½ (50 × 64·8)

132 *George Lawson and Wayne Sleep* (unfinished), 1972–75. Acrylic on canvas, 84 × 120 (214 × 305). Collection David Hockney

133 *Self-Portrait with Blue Guitar*, 1977. Oil on canvas, 60 × 72 (153 × 183). Museum Moderner Kunst, Vienna, on loan from Sammlung Ludwig, Aachen

134 *Artist and Model*, 1973–74. Etching and aquatint, 32 × 24 (81 × 61). Edition of one hundred, signed in pencil, published by Petersburg Press and printed at the Atelier Crommelynck

135 *Cubistic Sculpture with Shadow*, 1971. Acrylic on canvas, 48 × 36 (122 × 91). Collection David Hockney

136 *Cubistic Studies, Paris*, 1973. Ink, pencil and crayon, 14 × 17 (35·5 × 43). Kasmin Ltd., London

137 *Showing Maurice the Sugar Lift*, 1974. Etching, 36 × 28 (91 × 72). Edition of seventy-five, signed in pencil, published by Petersburg Press and printed by Maurice Payne, Kent Jones and Dany Levy

138 FRA ANGELICO *The Dream of the Deacon Justinian*, 15th century. Tempera on panel, 14½ × 17¾ (37 × 45). Museo di S. Marco, Florence. Photograph Borgi

139 *The Rake's Progress: Churchyard at Night* (Act III Scene 2), 1974–75. Three-dimensional model in coloured inks and felt tip pen on card, 16 × 21 × 12 (41 × 53·3 × 30·5). Collection David Hockney

140 *The Rake's Progress: Bedlam* (Act III Scene 3), 1974–75. Three-dimensional model in coloured inks and felt tip pen on card, 16 × 21 × 12 (41 × 53·3 × 30·5). Collection David Hockney

141 Drawing for the design for Roland Petit's ballet *Septentrion*, 1975. Crayon, 14 × c.28 (35·5 × 71). Private collection, United States

142 *Kerby (After Hogarth) Useful Knowledge*, 1975. Oil on canvas, 72 × 60 (183 × 153). Museum of Modern Art, New York; gift of the artist and J. Kasmin and the Advisory Committee Fund, 1977

143 *My Parents and Myself* (work destroyed), 1975. Oil on canvas, 72 × 72 (183 × 183).

144 *My Parents*, 1977. Oil on canvas, 72 × 72 (183 × 183). Trustees of the Tate Gallery, London

145 Mother c. 1976–77. Composite colour photograph from 35 mm negatives. Collection David Hockney

146 *Joe McDonald*, 1976. Lithograph, 41¾ × 29½ (105 × 75). Edition of ninety-nine, signed in pencil, published by Gemini G.E.L. and printed by Serge Lozingot and Edward Henderson

147 *Henry with Cigar*, 1976. Lithograph, 10¾ × 10½ (27·5 × 26·5). Edition of twenty-five, signed in pencil, published by Gemini G.E.L. and printed by Anthony Zapeda

148 *Gregory with Gym Socks*, 1976. Lithograph, 27¾ × 18¾ (70·5 × 47·5). Edition of fourteen, signed in pencil, published by Gemini G.E.L. and printed by Anthony Zapeda

149 *The Blue Guitar: Tick it, Tock it, Turn it True*, 1976–77. Etching in four colours, 21 × 18 (42·5 × 34·5). Edition of two hundred, signed in pencil, published by Petersburg Press and printed by Prawatt Laucharoen

150 *Looking at Pictures on a Screen*, 1977. Oil on canvas, 72 × 72 (183 × 183). On permanent loan to Walker Art Center, Minneapolis, from the collection of Mr and Mrs Miles Q. Fiterman

151 *Mother, Bradford*, 18 February 1978. Reed pen, 13⅜ × 10⅜ (34 × 26·4). Collection David Hockney

152 *The Magic Flute: A Rocky Landscape* (Act I Scene 1), 1977–78. Three-dimensional model in gouache on card, 33 × 42½ × 24½ (84 × 108 × 62). Collection David Hockney

153 *Grove with Three Temples* from *The Magic Flute* (Act I Scene 3), 1977–78. Three-dimensional model in gouache on card. 16 × 21 × 12 (41 × 53 × 31). Collection David Hockney

154 *Midnight Pool (Paper Pool 10)*, 1978. Coloured and pressed paper pulp, 72 × 85½ (183 × 218). Private collection, courtesy André Emmerich Gallery, New York

155 *Santa Monica Boulevard* (detail), 1978–80. Acrylic on canvas, 86 × 240 (218·4 × 609·6). Collection David Hockney

156 *Celia Amused*, 1979. Lithograph, 40 × 30 (102 × 75). Edition of one hundred, signed in pencil, published by Gemini, G.E.L.

157 *Divine*, 1979. Acrylic on canvas, 60 × 60 (153 × 153). The Carnegie Museum of Art, Pittsburgh, gift of Richard M. Scaife, 1982

158 *Kas Reading "Professor Seagull"*, 1979–80. Acrylic and charcoal on acid-free board, 60 × 40 (153 × 101·6). Private collection, United States

159 R.B. KITAJ *Moresque*, 1975–76. Oil on canvas, 96 × 30 (244 × 76.2). Museum Boymans-van Beuningen, Rotterdam

160 *Invented Man Revealing Still Life*, 1975. Oil on canvas, 36 × 28½ (91 × 72·4). Nelson-Atkins Museum of Art, Kansas City, Missouri, gift of Mr and Mrs William L. Evan, Jr

161 *Model with Unfinished Self-Portrait*, 1977. Oil on canvas, 60 × 60 (153 × 153). Private collection, Paris

162 *The Conversation*, 1980. Acrylic on canvas, 60 × 60 (153 × 153). Private collection

163 *Outside the Temple* from *The Magic Flute* (Act II Scene 7), 1977–78. Three-dimensional model in gouache on card, 16 × 21 × 12 (41 × 53 × 31). Collection David Hockney

164 *Ravel's Garden with Night Glow*, 1980. Oil on canvas, 60 × 72 (153 × 183). Mr and Mrs Morris S. Pynoos

165 *Harlequin*, 1980. Oil on canvas, 48 × 36 (122 × 91). Collection David Hockney

166 *Les Mamelles de Tirésias*, 1980. Oil on canvas, 36 × 48 (91 × 122). Private collection, San Francisco

167 *Le Plongeur (Paper Pool 18)*, 1978. Coloured and pressed paper pulp, 72 × 171 (183 × 435). Bradford Art Galleries and Museums

168 *Two Dancers*, 1980. Oil on canvas, 48 × 72 (122 × 183). Private collection

169 HENRI MATISSE *La danse*, 1909. Oil on canvas, 101⅝ × 153½ (258·1 × 389·8). Hermi-

tage Museum, St Petersburg

170 *Mulholland Drive: The Road to the Studio,* 1980. Acrylic on canvas, 86 × 243 (218 × 617). Los Angeles County Museum of Art, purchased with funds provided by the F. Patrick Burns Bequest

171 *Canyon Painting,* 1978. Acrylic on canvas, 60 × 60 (153 × 153). Private collection

172 *Nichols Canyon,* 1980. Acrylic on canvas, 84 × 60 (213·3 × 153). Private collection

173 *Oedipus Rex: Chorus, principals, narrator, orchestra and masks,* 1981. Gouache, 22 × 30 (56 × 76). Private collection

174 Set for Sacre with Dancers II from *Le Sacre du Printemps,* 1981. Gouache, 21 × 29½ (53·3 × 74·9). Private collection

175 Emperor and Courtiers from *Le Rossignol,* 1981. Gouache and tempera, 22½ × 30 (57 × 76). Collection David Hockney

176 *Man Walking. China,* 1981. Watercolour, 7 × 8 (18 × 20.5). Kasmin Ltd., London

177 *Slow driving on the way to Skowhegan airport,* 1982. Drawing from *Martha's Vineyard and other places: My Third Sketchbook from the Summer of 1982.* 24⅜ × 17⅞ (62 × 44). Collection David Hockney

178 *Boy in baseball cap wearing Adidas sweatshirt and shoes,* 1982. Drawing from *Martha's Vineyard and other places: My Third Sketchbook from the Summer of 1982.* 24⅜ × 17⅞ (62 × 44). Collection David Hockney

179 *Self-Portrait,* 25 October 1983. Charcoal on paper, 22 × 18½ (55·9 × 47). Collection David Hockney

180 *Hollywood Hills House,* 1980. Oil and collage on canvas, 60 × 120 (153 × 304). Walker Art Center, Minneapolis, Gift of Mr and Mrs David M. Winton

181 *Blue Terrace, Los Angeles,* 8 March 1982. Composite polaroid, 17½ × 17½ (43·5 × 43·5). Collection David Hockney

182 *Stephen Spender,* 1985. Photocollage. Collection David Hockney

183 *Les Mamelles de Tirésias,* 1983. Oil on canvas with separate elements, overall dimensions 134 × 288 × 120 (340 × 732 × 305). Walker Art Center, Minneapolis, Gift of the

Artist

184 *A Visit with Christopher and Don, Santa Monica Canyon,* 1984. Oil on 2 canvases, 72 × 240 (183 × 610). Collection David Hockney

185 *Pembroke Studio Interior,* 1985. Offset lithograph in 10 colours, paper 40½ × 49½ (102·9 × 125·7), with carved wood frame finished in white gesso, handpainted by the artist with acrylic paint, 46 × 55 (116·8 × 139·7). Edition of seventy, published by Tyler Graphics Ltd

186 *David Graves Reading and Drinking,* 1983. Ink, 14 × 17 (35·5 × 43). Private collection

187 *Self-Portrait,* July 1986. Home made print executed on a colour office copier on 2 sheets, overall dimensions 22 × 8½ (55·9 × 21·6). Edition of sixty. Courtesy David Hockney

188 *Ian,* 1988. Oil on canvas, 20 × 13 (51 × 33). Collection David Hockney

189 Image printed from hand-drawn, four-colour separations, 1988. Collection David Hockney

190 *Even Another,* 1989. Fax drawing, with xerox, marker, ink, 8½ × 11 (21·6 × 28). Collection David Hockney

191 *112 L.A. Visitors* (detail), 1990–91. From a 7-page portfolio. Edition of twenty. Each sheet 22½ × 30 (57·2 × 76·2). Courtesy of David Hockney

192 *Big Landscape (Medium Size),* 1988. Acrylic on 2 canvases, 48 × 36 (121·9 × 91·4). Private collection

193 *What About the Caves?,* 1991. Oil on canvas, 36 × 48 (91·4 × 121·9). Collection David Hockney. Photo Steve Oliver

194 *Thrusting Rocks,* 1990. Oil on canvas, 36 × 36 (91 × 91). Collection David Hockney. Photo Steve Oliver

195 *Untitled,* 1991. Computer drawing generated on a Macintosh IIfx computer using Oasis software, and printed on a Canon CLC500 Color Laser copy machine, unnumbered and unlimited edition, 11¼ × 16⅝ (28 × 43). Private collection

196 *Beach House by Night,* 1990. Oil on canvas, 24 × 36 (61 × 91·4). Collection David Hock-

ney. Photo Steve Oliver

197 *Still Life with Book on Table,* 1988. Acrylic on canvas, diameter 47¼ (124). Private collection

198 *Van Gogh Chair,* 1988. Acrylic on canvas, 48 × 36 (121·9 × 91·4). Private collection

199 *Small Interior, Los Angeles, July 1988,* 1988. Oil on canvas, 36 × 48 (91·4 × 121·9). Private collection, courtesy L.A. Louver Gallery, Venice, CA

200 *Livingroom at Malibu with View,* 1988. Oil on canvas, 24 × 36 (61 × 91·4). Collection David Hockney

201 *Beach House Inside,* 1991. Computer drawing generated on a Macintosh IIfx computer using Oasis software, and printed on a Canon CLC500 Color Laser copy machine, unnumbered and unlimited edition, 11⅛ × 16⅞ (28 × 43). Courtesy David Hockney.

202 Model for *Tristan und Isolde* (Act I), 1987. Gouache, acrylic, foamcore, plaster, photocopy prints, velvet, paper and wood, 50 × 45 × 57 (127 × 114 × 145). Collection David Hockney

203 Model for *Turandot* (Act I), 1990. Gouache, foamcore, acrylic, wood dowels, scrim material, string, moulded plastic, balsa wood, drinking straws, 48 × 96 × 82 (122 × 244 × 209). Collection David Hockney

204 Model for *Die Frau ohne Schatten* (Act III), 1992. Foamcore, velvet, paper, styroform, plaster, cloth, gouache, 85 × 90½ × 48 (216 × 230 × 122). Collection David Hockney

205 *Under and Out of the Arch,* 1989. Oil on canvas, 24 × 36 (61 × 91·4). Private collection, New York. Photo Stephen Oliver

206 *The Fourteenth V.N. Painting,* 1992. Oil on canvas, 24 × 20 (61 × 50·8). Collection David Hockney. Photo Steve Oliver

207 *Painted Environment I,* 1993. 16 colour laser printed photographs mounted on archival board, 36¼ × 44¼ (92 × 112·5). Edition of twenty-five. Courtesy David Hockney

208 *Dog Painting 19,* 1995. Oil on canvas, 18¼ × 25¾ (46·4 × 65·4). Collection David Hockney. Photo Steve Oliver

Index